EXTREME BEAUTY

TEXTURES – PHILOSOPHY/LITERATURE/CULTURE SERIES

Series editor: Hugh J. Silverman, Stony Brook University, Stony Brook, New York, USA

An interdisciplinary series, *Textures* addresses questions of cultural meaning, difference, and experience.

Extreme Beauty: Aesthetics, Politics, Death
Edited by James E. Swearingen and Joanne Cutting-Gray

Thresholds of Western Culture: Identity, Postcoloniality, Transnationalism
Edited by John Burt Foster Jr. and Wayne J. Froman

Panorama: Philosophies of the Visible
Edited by Wilhelm S. Wurzer

Between Philosophy and Poetry: Writing, Rhythm, History
Edited by Massimo Verdicchio and Robert Burch

EXTREME BEAUTY

AESTHETICS, POLITICS, DEATH

EDITED BY
JAMES E. SWEARINGEN AND
JOANNE CUTTING-GRAY

continuum
NEW YORK • LONDON

Continuum

The Tower Building, 11 York Road, London, SE1 7NX
370 Lexington Avenue, New York, NY 10017–6503

First published 2002

British Library Cataloguing-in-Publication Data
A catalogue record for this book is available from the British Library.

ISBN 0–8264–6009–7 (hardback)
0–8264–6010–0 (paperback)

Library of Congress Cataloging-in-Publication Data
Extreme beauty : aesthetics, politics, death / edited by James E. Swearingen and
Joanne Cutting-Gray.
 p. cm — (Textures)
Includes bibliographical references and index.
ISBN 0–8264–6009–7 — ISBN 0–8264–6010–0 (pbk.)
 1. Aesthetics. 2. Arts—Philosophy. 3. Political science—Philosophy. 4. Death. I.
Swearingen, James E., 1939–. II. Cutting-Gray, Joanne. III. Textures (New York, N.Y.)

BH39 .E98 2002
111′.85—dc21
 2002074090

The poem "The Language" by Robert Creeley is reproduced on pp. 44–5 from *The
Collected Poems of Robert Creeley, 1945–1975*, by kind permission of the University of
California Press, Berkeley.

Typeset by RefineCatch Limited, Bungay, Suffolk
Printed and bound in Great Britain by
Biddles Ltd, Guildford and King's Lynn

CONTENTS

GENERAL INTRODUCTION

James E. Swearingen and
Joanne Cutting-Gray

The title "Extreme Beauty" is borrowed from Mario Perniola's "Feeling the Difference," leading essay of this collection. Perniola investigates the central theme and sets the tone for these diverse studies in philosophy, literature, and culture. Hence the specialist reader may need few introductory remarks. However, the general reader might entertain a brief reflection on the interaction of philosophy and literature at the site of the crux between "feeling" and "difference" which issues in the term "extreme beauty".

"Extreme beauty" is enigmatic, even an oxymoron. What communication can there be on the one hand between a pleasing harmony that composes difference into unity, suspending desire, and, on the other hand, an excess exceeding all bounds, even marking, *in extremis*, the point of death? Has the experience of beauty been confounded with the experience of the sublime? Or has beauty been released somehow from subjective "experience" of an aesthetic object? The question of extreme beauty will certainly not be reached from the unity of knowledge but by feeling difference.

The term "difference", first in its common, prephilosophical sense, may be illustrated anecdotally for the non-specialist reader by a classic of American literature. In the first decade of the last century, historian and novelist Henry Adams privately printed his autobiography, *The Education of Henry Adams*, subtitled "A Study of Twentieth-Century Multiplicity" (1907). The book traces the growth of a distinguished nineteenth-century mind from the relative simplicities of its Enlightenment roots through decades of mounting social and intellectual perplexity as, vainly in his view, Adams seeks to reduce difference to the unity of understanding which he calls "education."

A century later, for us as for Adams, difference, in the everyday sense of identifiable persons and things-which-differ, multiplies endlessly. At the opening of a new millennium all sorts of differences – cultural, economic, ethnic, religious – unsettle social stability and dissolve the old dream of the unity of knowledge. And something else haunts the pages of the *Education*: no small part of the book's grandeur is a pervasive tone of melancholy that betrays nostalgia for failed unity. Arguably that very melancholy registers a felt difference beyond empirical differences, a sense of something "far more deeply interfused" (Wordsworth), like some unspeakable excess that no education can capture and no concept define.

Under the master trope of unity versus multiplicity, Adams conceives diversity within the logic of difference, even as the world at large still imagines a realm of plural identities and symmetrical forces without remainder. It is a fantasy that continues to nourish the utopian wish for unity and to suffer despair at the indefinite postponement of the return of the One. Even liberal tolerance of difference may belong covertly to the ideology of the One as balkanization of individual differences reaffirms the preeminence of the autonomous subject. The persistence of this logic of difference in the philosophical legacy of a thousand years may be commemorated by mention of Abelard's *Sentences*, Aquinas' *Summae*, the new science of the seventeenth century, and Hegel's *Encyclopedia*. When, after Nietzsche, philosophy awakened from the dream of essence and the one, moving outside the dialectic of same and other, many voices in the twentieth-century philosophic adventure undertook to think difference differently. In response to something unrepresentable, some no-thing asymmetrical with representation, these thinkers – Heidegger, Levinas, Blanchot, Lacan, Derrida, Bataille, Kristeva, Irigaray, and many others – acknowledge the partiality of categorial judgment. And so philosophy which once passed over and repressed whatever could not be represented in its concepts began to give thought to an always ambiguous and unsayable nonphenomenality that insinuates itself from the springs of unknowing where knowledge begins.

Enter the term "feeling". These intimations, not so much of an excess of the same as of an extreme and nonsymmetrical "other" that thematizing consciousness cannot locate – these intimations may promise more than latter-day efforts to *think* the unthought difference. As though difference that cannot be known may yet register on sensibility. As though one might *feel* differences that resist discursivity. If "feeling-access" to the inaccessible were entertained by philosophy, it might be philosophy still, but philosophy attuned differently. Would such a philosophy not proceed with a certain modesty about its own conceptual powers, letting difference be seen, as Levinas says, by a supplementary reduction of its own hypostases, preventing idolatry of its concepts? Thus might philosophy return things-heard to the hearing and things-said to the saying. Philosophy no longer deaf to what exceeds the concept, listening to its own daemon, Heidegger reading Hölderlin, Socrates practicing music.

As the twentieth century learned to respond to irreducible difference with a philosophy of unsaying, even a philosophy grown dizzy undoing its own words, art also took another path. Less a second path, one might say, than a punctuation in philosophy's sentences. If for Hegel art belonged to an aesthetics of harmony, to a past completed by the concept, art "after" Hegel belongs to conflict and enigma, art as *Ürsprung*, "The Origin of the Work of Art" after *Being and Time*. Art broke with the time of philosophy, intruding from nowhere like Kairos devouring Chronos, a syncopation in philosophy's dance. The poem, as Plato knew best, can be dangerous because it belongs to a time older than the world and disrupts the categories of knowledge that would enframe it. The poem is *felt*, and felt differently. No longer flattened into an objective thing or reduced to the "aesthetic experience" of the self-identical reader, the poem offers, not a theory, but echoes of infinite diversity, the resounding glory of

difference. Thus Blanchot can say that "Art – as images, as words, and as rhythm – indicates the menacing proximity of a vague and vacant outside, a neuter existence, nil and limitless; art points into a sordid absence, a suffocating condensation where being ceaselessly perpetuates itself as nothingness."[1] Sordid or randomly beneficent, at the margin of the primal and unthinkable no-thing, "art keeps awake everywhere the verbs that are on the verge of lapsing into substantives."[2]

Having learned to feel the beautiful as the ineffable singular on the hither side of definitions and ideals, before the distinction of universal or particular, the question arises, how does the term beauty, thus modulated, communicate with the second and third terms in the series "Aesthetics, Politics, Death"? Jacques Lacan's discussion of *Antigone* suggests possibilities.[3]

We imagine ourselves to have left the city behind and come up to the theater, citizens still but detached for a while from the constraints of the law. Our preoccupation with goods and services held in suspension, we are susceptible to an unpredictable revision of the city itself. In Creon we recognize the creature of political power. The object of his desire, foundation of his law, is a determinate good, namely, the regulation and repression of desire. His polity works by relegating the end of desire to some point beyond any present, a point that never arrives, binding his subjects to the service of goods by fear, a law without limits. Creon's principal hierarchy, descending from incest taboo, may require that he condemn Antigone's relation to Polynices as illicit. Yet it is he who has decided the foundation of the law and now uses it to judge her claims of kinship. She may be a citizen of Thebes and wife of his own son, but she may not scatter dust over the body of a kinsman with whom she has shared an incestuous womb. The ambivalence of that relation transgresses the foundation of Creon's law and shakes the foundation of his city. Confronted by a shining image of passion without sublimation or repression, his own repressed desire returns. He overreaches himself and hurtles toward an incalculable destruction.

Inadequate traditional readings of Antigone as representative of one political order in conflict with another overlook the fact that she and Creon do not properly coincide. Her image shines through all prohibitions, unbinds the very good his law seeks to secure. In disrupting the illusory object of constricted desire, she offers no alternative political content and even arrests criticism of his law. Her resplendent beauty, impossible coincidence of visual Apollonian form and imageless music of Dionysian excess – this beauty reveals the repressed limit, and exposes the first springs of the political imaginary. It is the face of desire itself freed from the egoisms of power. An extreme beauty that does not inhibit but gives air to desire.

In her address to the tomb which is not her own, Antigone anticipates her return to the dark body of maternal earth which gives place to the daylight world of the city. Her voice resounds with the passion that drives Creon and surges up within his law. That law expresses its debt to the tomb by sealing up in silence and forgetfulness the hidden place of its own origin, closing it off with the force of taboo. In feeling Antigone's difference we are transported beyond the discourse of political rationality to desire without repression, site of unharmonizable forces tending toward unpredictable political practice.

In the presence of this extreme beauty we respond already to the proximity of death, for in Antigone desire and death are the business of life. The beautiful, says Lacan, reveals desire in relation to death, without repression or sublimation. At the beginning of the play Antigone says she is already dead. Her speech is the voice of desire itself, both Dionysian lament for the life she will never know and anticipation of meeting mother, father, brother in the world below. She would tremble, if she did, not before Creon's good, but before the no-thing of her own being, before death. The unbearable splendor of her beauty structures desire enigmatically to reveal a limit whose apprehension lets the insubstantiality of her being and the disarray of the human condition shine forth, death in life. And in her it shines without pity or distress and without fear or apprehension.

If Antigone has come to terms with death, with her own non-being, what of us? What is the effect on us of this awful extremity of beauty? We have been drawn out of ourselves, suffered the shattering of the illusion of identity, felt ourselves differently as in an echo of a being permeated by radical difference. The theatrical illusion at an end, we will descend once more to the city, becoming anxious again for identities that we regard as our own, concerned for the limited desires of the everyday. We will reassume the repressions and sublimations that protect us from the boundless. Yet do we not return incalculably changed? Changed by apprehension of a limit which is our limit, exposure to the point of intersection between life and death which may be called extreme beauty?

THE ITINERARY

In Part One Perniola situates the question of difference at the margin of feeling and the aesthetic. Part Two begins with the turn from modernism to the postmodern in art. The three essays redefine the terms Surrealism, the avant-garde, and minimalism by distinguishing them from modernism and setting them in the context of the postmodern. Jean-Michel Rabaté studies André Breton's use of the Surreal in terms of the Hegel of the Spirit in Nature rather than the systematic Hegel of History. At its most provocative the essay describes the work of art as opening a different, more originary time than the categorial time of history and of modernism. Dalia Judovitz then shows Marcel Duchamp deconstructing traditional aesthetic values and rendering ambiguous the work of art and its context. In Duchamp, she says, the work always approaches and always postpones its arrival. Finally, Peter Williams proposes an "antiaesthetics" of precognitive sense-certainty which restores to art the materiality and the fluidity of body that had been eclipsed by modernism. This "aesthetics of subtraction" deliberately withdraws every feature from the work of art that has rewarded the philosophical expectations of traditional aesthetics.

The essays in Part Three, "The Impossible Place of Literature," bring us still closer to the enigmatic place of aesthetics. In a literary-critical and philosophical exposition of Plato's chora, Max Statkiewicz exposes the ambiguously feminine "place that gives place" as the setting of both the Platonic dialogues and the *polis*. Then Pierre Lamarche, focusing on the particular affect of

boredom in Proust, uses Blanchot to show how the neuter "it feels" inscribes itself in the Space of Literature as the interminable becoming of the work that never arrives. Joel Black echoes Perniola's theme of the eroticism of the inanimate, quasi-world of the simulacrum, in Cronenberg's film *Crash*, a kind of sexuality of cybernetics and technology, the orgiasm of the car crash.

In Part Four the intersection of political theory with aesthetic imagining gains historical perspective in Theodore Kisiel's discussion of Martin Heidegger and Hannah Arendt. He traces Arendt's non-foundational politics to the discursive being-with-others of *Being and Time* and, even more important, historicizes that proto-politics of being-with in the practical discourse of Aristotle's *Rhetoric*. David Halliburton continues the theme of the preceding essay by showing how Hannah Arendt draws her inventiveness as a political theorist from the poets. Michael Clifford, following the Deleuzean rhetoric of deterritorialization, dissects the tropes of fascism by examining an extreme psycho-political phenomenon: the aestheticized fascist state responding psychotically to its Other by cannibalizing difference and poisoning itself.

The essays in Part Five maintain the concern with de-centered feeling and contemporary issues of praxis, focused on the politics of post-colonialism. After foundational politics and in abstraction from the anarchy of feeling, a welter of differences insinuate themselves into political space. Moira Gatens consults Spinoza's coordination of affectivity and rationality to open the old identity politics to a social or political imaginary. Paul Patton further develops this post-colonial politics by tracking irreducible difference as it composes and decomposes the law. In the last essay in this section Alfred López exposes the imaginative site of post-colonial political construction in Joseph Conrad's *Heart of Darkness*. The untranslatable metaphor of this title opens linguistic space for a pre-political feeling of difference before there is language to capture it.

The concluding set of essays becomes witness to the enigma of difference at its most extreme philosophical frontier: death and glory in Heidegger, Derrida, and Levinas. First, Robert Burch engages with Perniola's discussion of death as conceived de-ontologically and in a culture of infinite simulacral substitutions (*La società dei simulacri*, 1980). At issue is whether Perniola's play of virtualities or Heidegger's being-toward-death escapes the metaphysics of death. Second, Kenneth Itzkowitz considers death as gift in Derrida, the responsibility of Kierkegaard's Abraham, and the "hypermorality" of Bataille. Then in the last essay Bettina Bergo evokes most of the themes of this collection by tracing the aesthetics of difference in Levinas' term "glory." After unfolding "glory" in *Otherwise than Being*, she sets Levinas' use beside Derrida's application of the term to the history of Western responsibility. The unsayable difference, to which all the drives of sensuous life respond and toward which the essays in this collection lead by various paths, renews at last the enigma and the splendor of Perniola's "extreme beauty."

This volume was conceived at the annual meeting of the International Association for Philosophy and Literature in Mobile, Alabama, May 1997. It has many debts. Mario Perniola's seminal essay both inspired and focused the theme of the collection. Members of the Executive Committee of the International Association for Philosophy and Literature provided invaluable advice

and assistance: Stephen Barker, Wayne J. Froman, Dalia Judovitz, Massimo Verdicchio, and Wilhelm S. Wurzer. The College of Arts and Sciences of the University of South Alabama, in particular Dean Lawrence Allen and Associate Dean J. Stephen Thomas, supported the conference handsomely from start to finish. Special gratitude is due as well to the following members of the university community: Associate Coordinator John Coker, Claire May, Gordon May, Carol Brown, Ann Leatherwood, Linda Payne, Lawrence Schehr, Steve Cohen, Caryl Lloyd, Lea Hotchkiss, Neill Matheson, Christina Busse, Scott Juengel.

First and last, the editors thank IAPL Executive Director and series editor Hugh J. Silverman whose efforts for over two decades have provided the primary forum for the encounter between philosophy and literature to a generation of American teachers, philosophers, critics, and scholars.

PART ONE

AN OTHER BEAUTY

INTRODUCTION

In "Feeling the Difference" Mario Perniola initiates the discussion of what he calls "the most original and important" philosophical "adventure" of the twentieth century, by tracing how difference registers in the field of aesthetics. Pausing to retrieve the term aesthetics from the epistemological frame of subject and object and the eighteenth-century standard of harmony, he follows the path of difference as it leads away from traditional aesthetics. Roland Barthes' notions of "bliss" (*jouissance*) beyond subjective pleasure, and "text" beyond the objective work, provide a point of departure. Notwithstanding the residue of subjectivism in Barthes' lexicon, Perniola takes his clues from the critique of text as an object encountered in experience and of desire as a lack that seeks the pleasure of fulfillment. "Text," not as representation but as delineation (*figuration*) or appearing, and "bliss," not as hedonism and desire but as pleasure in dissemination, open the way of difference. Freed from the tyranny of the feeling subject, the "I feel" becomes the impersonal "it feels." That is, feeling belongs to neither subject nor object but to "text." Yet the movement from the "I" to the "it" is not easy.

To develop the concept of the "it feels," Perniola adopts the ancient notion of suspension (*epochē*) in the region of sexual experience. What he calls "the sexual *epochē*" frees sexuality from the aim-directedness of desire as lack and sex as orgasm. This infinite suspension and excitation of feeling expresses itself in "the sex appeal of the inorganic" which elides the distinctions between self and not-self and between male and female in an affectively charged atmosphere where difference arrives. Sexuality, belonging no longer to the experience of the subject as a feeling which the subject possesses, undergoes dispersion in the impersonal "it" which feels.

Three modes of "the sex appeal of the inorganic" serve to show that gender, sexuality, and the erotic are not simply predicates of the human subject but belong to the world in general. The decomposition of metaphysical systems leaves "remnants," not "an aesthetics of trash" which restores identity in the guise of its opposite, but an "aesthetics of recycling," repetition or simulacrum of remnants. The essay ends not with an answer, another reduction of difference to unity of understanding, but with wonder and a question. We are left in wonder before unthematizable difference arising not in pursuit of difference as dialectical opposition but in the "between" of the simulacrum. And the question is, what is the way, the glory, and enigma of "extreme beauty" which, without explanation, Perniola invokes?

1

FEELING THE DIFFERENCE

Mario Perniola

I. AESTHETICS AND DIFFERENCE

Two different issues will be presented here. The first is the topic of feeling connected to a very long tradition of aesthetics which goes back as far as the eighteenth century. And the second is related to "difference" which has enabled the development of an extremely important philosophical trend of today.

The conjunction of aesthetics and the "thought of difference" must be considered neither as obvious nor easy. In fact, if we analyze aesthetic thought strictly speaking (which recognizes and identifies itself as such), we will find that the issue of difference has been entirely left aside.[1] The so-called traditional aesthetics is connected either to Kant's *Critique of Judgment* or to Hegel's *Aesthetics*: in fact both the aesthetics of life (e.g. Bergson and Simmel) and of form (e.g. Bell and Fry) are a consequence of Kantian thought, whereas Hegel's philosophy has enabled the development of cognitive aesthetics (e.g. Croce and Gadamer) and of pragmatic aesthetics (e.g. Dewey and Rorty). Traditionally, aesthetics has implied the ideals of harmony, regularity, and organic unity; what is essential to aesthetics is to try to overcome a conflict and aim towards a relief of tensions; the aesthetic is to tend towards peaceful solutions, to search a moment in which pains and struggles are in abeyance, if not even completely abolished.

In contrast, the "thought of difference" started with Nietzsche, Freud, and Heidegger, who rejected the aesthetic reconciliation: it goes towards experiencing a type of conflict which is far greater than any dialectical contradiction. Difference is linked with the exploring of an opposition between two terms, the relation of which cannot be explained as a polarity. Therefore this great philosophical adventure – in my opinion the most original and important of the twentieth century – goes under the notion of "difference." Difference marks a greater dissimilarity than the logical concept of diversity or the dialectical one of distinction. In other words, if we want to experience the difference, we need to reject both Aristotelian identity and Hegelian dialectics. It is no wonder that the thinkers of difference do not belong to traditional aesthetics: they have initiated a new theoretical tendency independent of Kantism and Hegelianism. If they are alien to modern aesthetic tradition, this is not due to their lack of interest towards feeling: just the opposite is true! The enquiry about feeling pushed them to put Kantian and Hegelian aesthetics aside.

It is dubious whether the notion of "difference" can even be considered as a real concept, alongside the concept of "identity" (which is the center of Aristotelian logic) or the concept of "contradiction" (which is the center of Hegelian dialectics). The starting point for difference should be found not in the horizon of pure theoretical speculation, but in the field of impure feeling: here we are dealing with unusual and uncanny experiences, which are ambiguous, excessive, irreducible to identity. The thought of difference has found its inspiration in this type of sensitiveness, which has a family likeness with drug addiction and perversion, with handicaps and disabilities, with "primitive thought" and "other" cultures. To sum up, it is a type of feeling which has nothing to do with the main features of modern aesthetics, nurtured by aspirations of achievement and reconciliation.

We can now understand the suspicious attitude towards aesthetics among the fathers of the thought of difference. Nietzsche thought that aesthetics was an aspect of optimism unaware of tragic experience. Freud believed that aesthetics dealt with topics connected to positive emotions, inspired by the beautiful and the sublime, leaving out those aspects of feeling characterized by negative emotions, such as the "uncanny" (*das Unheimliche*). Heidegger maintained that aesthetics belonged to Western metaphysics (to a thought oblivious to the sense of Being). What's more, the French thinkers of difference (Blanchot, Bataille, and Klossowski) have begun an approach to works of literature and art which has nothing to do with aesthetics. Even the Italian philosopher Michelstaedter, considered as the main proponent of this tendency in Italy, was completely hostile towards Croce's aesthetics.

II. BLISS AND TEXT

It has only been recently that the thought of difference has explicitly dealt with aesthetic issues, thanks to Derrida's *Truth in Painting* and to Deleuze's *Francis Bacon: Logic of Sensation*.[2] However, I do not take these as my starting point. Instead I have chosen Roland Barthes' *The Pleasure of the Text*.[3] In this small book the author develops an inquiry on feeling which undoubtedly exceeds the ancient analysis of pleasure (both Plato's pure pleasure and Aristotle's desensitizing pleasure) and the modern analysis connected to eighteenth-century aesthetics and the idea of a disinterested pleasure (Kant).

The core of Barthes' discourse can be found in the relation between pleasure and literature. But he changes deeply the two notions, shifting both the pleasure and the work from the logic of identity to the experience of difference. Beyond pleasure he discovers *bliss* (*jouissance*), and beyond literary work he discovers text. Bliss is a feeling which overcomes the distinction between pleasure and pain: it includes what is unpleasant, boring, and even painful. Bliss implies the loss of the subject, the disappearance, the "fading" (Barthes) of personal identity, leaving forever every cautious and careful calculation of gratifications. As an experience of excess, bliss hits individual consciousness like a lightning bolt, shaking it and damaging it. The attempt to overcome the hedonistic feature of pleasure had already been carried out by traditional aesthetics through the introduction of the notions of "tragic" and "sublime"; but

the type of bliss Barthes talks about implies something more than the "tragic" and the "sublime." In fact bliss is closely connected with sexuality. Barthes continually underlines the perversity of bliss, i.e. as extraneous to any type of finality and ejected towards an infinite and insatiable exploration of the new. But bliss might also appear as an excessive and psychotic repetition, as a compulsion to repeat that overthrows and abolishes all the conventional meanings thanks to mimetic and obsessive reiteration. This happens when we continually repeat a word until it ceases to be a word and becomes mere sound. So in Barthes' notion of bliss we can find a series of opposite features: bliss implies both licentiousness and masochism, both the flagrant excitement of fashion and the uncanny sexuality of pain. Bliss is at the same time frivolity and "death instinct." Barthes manages to free aesthetic feeling from that ascetic and sublimated dimension which had seemed its essential element; he also introduces it into contemporary experience. He turns the old aesthetic category slightly, moving it away from its regressive and idealistic background and pushing it closer to the body.[4]

Barthes uses a similar strategy moving from the notion of "literary work" to "text." But what does "feeling the text as a body" mean? Thanks to which type of perversion might a work of art become a text? The first condition is to set the literary work free from its ideological aspect: as long as we keep thinking that the work conveys a historical, political, cultural or psychological meaning, we will still consider it in its identity, as a *product* with its own logical and moral unity. On the contrary, as soon as we accept that the work belongs to difference, it necessarily breaks away from its own fulfillment: it is no longer an object entirely determined by its author, entirely independent of its fruition; on the contrary, the reader carries on the generative activity of the author in a never-ending process. However, this does not mean that the text might be abolished in its communication, nor does it mean that reception becomes more important than production. The opposite is true! The text cannot be reduced to a dialogue between subjects: it is intransitive, atopic, paradoxical. Barthes compares it to a cloth not because it covers a hidden meaning, but because it is folded like a texture. In other words, nothing is excluded from the text. It does not belong to the dialectical logic of dialogue, which is articulated in both the conjunctions and the disjunctions of discourses. The text is autonomous and independent of the speaker's and listener's subjectivity, of the reader's and writer's identity. Therefore we have an essentially important shift for aesthetics: the transit from "I feel" to "it feels." The whole field of all affections and emotions shifts into the neutral space of the text. If masochism is, as we have seen, the perversion of pleasure, fetishism is the perversion of literary work. Fetish is a kind of animation of the inorganic, a coincidence of abstractiveness and materiality. In fact the text is, according to Barthes, something that feels, that desires, that enjoys.

III. THE *EPOCHĒ* AND THE NEUTRAL

In the philosophy of the seventies, Roland Barthes is, in my opinion, the thinker who has linked sexual feeling most closely to cultural practices. This project has been realized in a perspective inspired by the thought of difference,

namely by those experiences which cannot be reduced to traditional aesthetic ideals. Perhaps only Luce Irigaray has offered such a significant contribution, following other but not essentially divergent paths. However, Barthes' thought is imprisoned in a difficult problem: he is unable to get rid of a subjective idea both of bliss and of text. Bliss sometimes falls back into a kind of hedonism (based on the idea of an enlargement and an extension of the boundaries of pleasure), and sometimes falls back into a kind of eroticism (based on the idea of the infinity and insatiability of desire). But neither hedonism nor eroticism allows us to go beyond the subject; they are paths which take us back to aesthetics rather than the way of difference. Regarding the text, a similar process takes place: Barthes' polemic against the institutionalization of text (namely against the specialism of theoreticians and critics) leads him to emphasize the personal, episodic, and incidental aspects of his own writing which ends up far away from philosophy (this is particularly clear in his latest works).[5]

Nevertheless, we can find in *The Pleasure of the Text* tendencies which go in an opposite direction from the subject, leading towards a radicalization of feeling the difference. The two main tendencies leading away from the subject are the *critique of desire* and the idea of *the text as a thing*. According to Barthes, the infinity of desire, which, in the opinion of many authors, seems to be a guarantee of its philosophical character, in fact spreads deception: the difference is not absence! As long as I keep thinking of the alternative to Western metaphysics as a lack, I am imprisoned in a traditional way of thinking the opposites: this way (already considered by Aristotle) is connected to an experience of the opposites which is smaller, not bigger, than the dialectic contradiction. Second, the idea of the text as a thing, is not explicitly stated by Barthes; but in my opinion it is implied in the distinction between *representation* (*représentation*) and *delineation* (*figuration*). Whereas the text as *representation* is an indirect way of thinking connected to the traditional structure of knowledge articulated on both the subject and the object, the text as *delineation* is a type of direct appearance that draws it towards the phenomenological meaning of "thing." While the text as an object falls entirely into traditional metaphysics and aesthetics, the text as thing belongs to the horizon opened by the notion of difference.

But there are two other issues that might help us to clarify and simplify these difficult and puzzling questions. These are the experience of the *epochē* and the notion of the *neutral*. Barthes talks about both of them, but they do not reach an eminent place in his work. However, it is only through them that sexual feeling and the thought of difference can be connected: only through them do sexuality and philosophy show their essential belonging to each other. As we have seen, the question that haunted Barthes' mind can be thus expressed: how can we possibly come out of the subjectivity of feeling? How can we release sensations, affections, emotions from the tyranny of the "I feel"? How can we reach the impersonal "it feels"? How can we manage to find a land that is different from and extraneous to conventional feeling, in which personal experience founded on subjectivity at last collapses? Western philosophy has known the answer since the times of the ancient Greeks: as a matter of fact, it was Skepticism and

Stoicism which for the first time introduced the experience of the *epochē*, of the suspension of passions and subjective affections. Passions were, according to the Stoics, all reducible to four fundamental ones: pleasure, pain, desire, and fear. Suspension must not be considered as complete insensitivity, but as a sort of "indifferent participation," "sober drunkenness," a distant feeling. In other words, it seems as though I were not feeling myself, or better, as if I were "a thing that feels" in an impersonal way and without boundaries, without realizing where my corporal identity finished and the body of another entity started. It is a feeling which eliminates the separation between self and not-self, between internal and external, between human beings and things.

I believe that this feeling cannot be defined according to hedonistic categories. It goes beyond pleasure and pain; but it also goes beyond bliss, because bliss (like ecstasy) refers to an experience which is too spiritual, whereas in this case what is essential is the way of being of the thing which can be abstract, but not spiritual. At the same time, the erotic categories are inadequate: desiring implies trying to reach something, and therefore that we are lacking something. However, the way of being of things implies an availability that is not a real metaphysical presence. In the idea of availability we can find a much more opaque feature which on one hand goes towards virtuality and on the other goes towards exchange-value and money. This type of feeling is not only extraneous to any practical and cognitive intention, it also does not belong to aesthetics, because it has nothing to do with aesthetic sublimation, with the denial of the sexuality that it implies.

Although the concept of the *epochē* has been in use in philosophy since ancient times, it has been applied by Western thought in a shy and chaste way. There has been both a cognitive *epochē* (the ancient one belonging to Skepticism and the modern one to Phenomenology); and there has been a moral *epochē* (belonging to Stoicism and to Neo-stoicism). But up until now, we have never had a sexual *epochē* in Western culture, because orgasm has always been considered essential to sexual intercourse; any suspension in sexual intercourse has been thought as a means through which pleasure might last longer or desire be intensified. Sexuality has been seen as a way of satisfying a need; but it has hardly ever been considered as a philosophical experience enabling the exploration of unknown lands.

The sexual *epochē* takes us towards a sexuality beyond pleasure and desire, no longer directed towards the achievement of orgasm, but suspended in an abstract and infinite excitement, regardless of beauty, of age and shape. So we can distinguish two types of sexuality: a vitalistic one, based on the distinction of sexes, full of hedonism and eroticism, and an inorganic one, beyond the opposition of male and female, that can be defined as neutral. In a recent book I have baptized this second type of sexuality with the expression "the sex appeal of the inorganic."[6] But the neutral must not be understood as a harmonic way of reuniting the sexes, as a dialectical synthesis of their opposition. On the contrary, the neutral is the arriving point of the difference, so irreducible to unity and identity. In other words, a neutral sexuality can be neither sublimated nor neutralized: eliminating the distinction between male and female, it gives way to many other distinctions, allowing for infinite sexual virtualities. This is in

fact the essence of sexuality, as the Latin word shows, the *secare*, the establishing of distinctions, the making of differences. However, before being able to go this way, we have to free ourselves from the distinction between male and female, the aim of which is to confirm identity and to sanction discrimination.

IV. TWO TYPES OF THE "SEX APPEAL OF THE INORGANIC"

The "sex appeal of the inorganic" can be considered in many ways. If the "inorganic" is the natural mineral world, neutral sexuality is fed by the arousal caused by an inversion of human beings into things, and things into living entities. I claim this phenomenon as the "Egyptian type" of inorganic sex appeal, following Hegel, according to whom in ancient Egyptian culture mankind was reduced to a thing and things had human faculties.[7] In the so-called "egyptomania" that has been an important cultural fad for a very long time, we can grasp a sexual excitement full of fetishism, sadomasochism, and necrophilia, among which the best-known is the bondage evoked by mummies. If we also remember that Egypt was the birthplace of ideographic writing, we will attain that conjunction between sexuality and textuality that Barthes examines in *The Pleasure of the Text*.

Another type of inorganic sex appeal uses electronic technology and cybernetics. We could define it as "cyber" inorganic sex appeal. It is inspired by a desire to overcome every type of natural limit, and it questions itself on the feeling of cyborgs, i.e. the science-fiction character whose organs have been replaced with artificial devices (for instance, telecameras in the place of eyes, aerials instead of ears). Cyber opens a "post-human" or "postorganic" horizon, within which human sensitivity migrates from the human to the computer. Therefore we face up to the issue of Artificial Feeling, which has a basically experimental feature. However, the most interesting aspect of this perspective is not to provide a substitute for real sexuality (which is what happens in cybersex), but to enhance neutral sexuality. In fact this is directly connected to the philosophical experience of the *epochē*. Thanks to this experience I am still able to perceive my body as a thing, for instance as clothing or as an electronic device. In other words, Artificial Feeling is not to be considered as a copy of natural feeling, but the means through which we can enter a different feeling, a different sexuality, a neutral one, no longer based on the identity of consciousness, but overflowing and excessive. I become an extraneous body, I deprive myself of any kind of subjective experience, I eject my own organs and my feelings, I become the difference.

V. PSYCHOTIC REALISM

In addition to the "Egyptian" and the "Cyber" types, there is yet another type of inorganic sex appeal that in my opinion is far more worrying than the previous two. As one of the main features of inorganic sexuality consists in trying to eliminate the boundaries between ego and not-ego, between the self and the extraneous, between the self and the not-self, it seems to be very near to madness, indeed to that particular type of madness defined as psychosis. The

result of psychosis is the identification with the external world: one is fascinated by the outside world. One becomes what one sees, hears, and touches: the body becomes a whole with the surface of the outside world. Frequently this impulse becomes cosmic: for instance, Daniel Paul Schreber's renowned *Memoirs of a Neurotic*, a classic psychiatric work of the end of the nineteenth century, depicts the process through which the loss of identity coincides with the availability to become anything.[8] Schreber feels that his own body no longer belongs to him: it can become the Virgin Mary or a prostitute, a patron saint or a northern woman, a Jesuit novice, a young lady who resists a French official while he is trying to rape her, as well as Prince Mogol, or something abstract, for instance the cause of weather conditions and so on. This experience is linked to an excitement which can become the only reason for life.

The disturbing aspect of this phenomenon is its spread in contemporary artistic sensibility. The most advanced artistic trends break the traditional separation between art and reality: what has emerged is a kind of "psychotic realism" which has blown up all sorts of mediation. Art loses its distance from reality and gains a physical and material aspect never experienced before: music becomes sound, theater action, painting has a visual and tactile consistency. Works of art no longer imitate reality; they immediately become reality. They become mere extensions of human faculties, which no longer belong to the subject, because the subject has disintegrated into radical exteriority. Aesthetic experience fades away.

The origin of this artistic trend dates back to the last century. The present "psychotic realism" might be considered as the arriving point of Naturalism, the artistic tendency which flourished in literature in the last decades of the nineteenth century. According to the German philosopher Wilhelm Dilthey, Naturalism tries to catch reality in an immediate way not stopping even in front of the physiological and of the brutal.[9] Dilthey maintains that Naturalism represents the end of a conception of life and of art that started in Europe in the Renaissance. The poetics of mimetic reproduction of reality implies a complete triumph of the mere empirical fact that is the oblivion of the European philosophical and artistic inheritance. Similarly, many years later the philosopher Georg Lukács used Naturalism as the polemical target of his aesthetics.[10] He attributed to it the same features as Dilthey, namely confusion between art and life, reproduction without criticism of reality, apology for what exists.

Since Dilthey's and Lukács' times, Naturalism has taken its features to extreme consequences. Just now we can find these radical developments in the most up-to-date artistic and literary fashions. For instance, Bret Easton Ellis' and James Ellroy's novels are shocking expressions of a naturalistic intention of describing the cruellest crimes with complete indifference.[11]

Psychotic realism in visual arts arose at the beginning of the nineties in many important international exhibitions, as well as in a few trendy reviews.[12] Performance artists like the Spanish actor Marcel Lí Antunez Roca, the French Orlan, the Australian Stelarc, the Czech Jana Sterbak can be considered as borderline cases: they use their bodies to carry out dangerous experiments, which are directed towards the discovery of new forms of perception and feeling.[13]

Cinema and video, in particular, have taken to extremes the project of reproducing a real fact caught in the very moment it happens. This has been a target of cinema since its origins (the Lumière brothers); we can find the same intention in documentary cinema (from Dziga Vertov to the *cinéma-vérité* of the sixties, to Visual Anthropology). In the nineties this issue has been reconsidered more radically: for instance, Wim Wenders in his film *A Lisbon Story* develops an interesting reflection regarding the possibility of identifying image and reality: Wenders raises a paradoxical hypothesis according to which this identification would be possible only if the images were not seen by anybody, not even by the film makers![14]

Psychotic realism shows its limits just in the case of cinema for two reasons. First, it is difficult to appreciate the brutal reproduction of these harsh realities (sex, extreme violence, death) as manifestations of difference: "gore," "splatter," and "trash" are not philosophical experiences! Secondly – and I believe this reason is more significant than the first – there is no certainty that what we are watching is real. In fact, today we can manipulate any type of visual document via electronics (as the movie *Forrest Gump* shows). Therefore, we end up losing the truth-effect that has been the main reason for the excitement of these productions. We could add that electronics, and not morality, has eliminated Naturalism and the *cinéma-vérité*.

Contemporary philosophy has not been left untouched by what I have defined as "psychotic realism." Two contributions are particularly important: Jacques Derrida's notion of *disgust* and Julia Kristeva's notion of *abjection*. Derrida takes his starting point from the idea of "negative pleasure," for instance the sublime which goes against the interest of the senses (according to the definition given by Kant).[15] But the sublime is linked to an idealizing experience in which the negative dimension is totally sublimated and overcome. The same occurs in the representation of evil which can be assimilated and purified by art. There is only one dimension that cannot be absorbed by aesthetics: the *disgusting*. It cannot be ransomed by art: in fact disgust seems to be irremediable and unmentionable, the totally different, the other absolutely different from the system. However, the experience of disgust still has something to do with pleasure: vomiting relieves us from repulsive things. Does this mean that logocentrism is powerful enough to include even vomiting? Can we not come out of the logic of identity and of the logic of dialectical contradiction? In order to find an answer to this question, we have to shift from aesthetics to anthropology, from an a priori consideration of feeling to an empirical inquiry. In fact, Kant in his *Anthropology* takes human senses into account, distinguishing the objective senses (hearing, sight, and touch) from the subjective ones (taste and smell). Perhaps it is just in smell that we can find something more disgusting than vomiting, something more unmentionable and obscene, something on which the hierarchical authority of logocentrism cannot work. In fact, according to Kant breathing implies a deeper type of swallowing than eating. Smell allows us to have a more disgusting experience than disgust caused by food; so it is the vicarious feeling, the supplied feeling that is the double of disgust. To sum up, we can reach the difference not through the opposite (otherwise we will fall back into dialectics), but through duplication,

repetition, and simulacrum! The biggest opposition is still not big enough to be different from its opposite: only simulacrum, only repetition can reach the difference.

Even more closely connected with psychotic realism is Kristeva's analysis of abjection, the essential feature of which is the collapse of the boundary between inside and outside.[16] Her account is carried out on three levels: psychoanalytic, historical, and literary. According to Kristeva, the outcoming of internal contents (like urine, blood, sperm, excrement) becomes the only object of sexual cathexis: the overflow enhances the identity of the subject, because it implies its existence. Sacrificial religions tend to exclude the mingling between inner purity and outer impurity, whereas Christianity, as a turning point, internalizes and spiritualizes impurity, introducing abjection in culture and literature.[17]

VI. TOWARDS THE "EXTREME" BEAUTIFUL

The question concerning the "aesthetics of difference" has reached some rather disappointing results: can the farthest point of the aesthetics of difference indeed be disgust and abjection? One must not forget that the essential feature of the thought of difference consists in the effort of thinking beyond categories of Western onto-theology: but in the notions of disgust and abjection it is easy to grasp the heritage of Gnosticism, or at least an attitude of absolute hostility towards the world and the human body. Everyone knows that this attitude has occurred very often in Western culture, for instance in Christian mysticism. To sum up, our research of an extreme negativity, the total abandonment of any criticism of the most brutal and disgusting reality, makes us fall victim to spiritualism, to fanaticism, to the most repressive tradition. The effort towards emancipation, the motive force of difference, is cruelly defeated.

The aesthetics of difference cannot be an aesthetics of disease, of trash, of abjection, because they are an indirect way of confirming identity and positivity. Not only do they confirm, but also they restore an identity without cracks: if man and the world are a garbage-dump, being, the good, and the beautiful are transcendent. According to Nietzsche and to Heidegger, onto-theology and metaphysics have gone to pieces: the only things left by these constructions are *remnants*. But even the negative offers mere *remnants*: it is naive to think that the negative owns a kind of integrity and autonomous splendor and to think evil as if it were good. The real problem is: what can we do with these *remnants*? How can they be recycled? Therefore, what we have here is not an aesthetics of trash, but an *aesthetics of recycling* trash, illness, psychosis.

In conclusion, we started with the question, what does "feeling the difference" mean? For Roland Barthes it meant to enjoy the text. However Barthes' discourse implied another insight based on the notions of *epochē* and the *neutral*: an experience that I have defined as the "sex appeal of the inorganic." What's more, the sex appeal of the inorganic can be understood in various ways and sometimes as disgust and abjection. My way is yet another: it goes towards the "extreme beautiful."

PART TWO

ART AND THE TURN TO THE POSTMODERN

INTRODUCTION

In this section we trace Perniola's theme of the "aesthetics of difference" at the boundary of modernism and the postmodern. The distinction between modernist theory and postmodern critique recognizes that where modernisms propose rival, totalizing artistic practice or systems of thought, the postmodern is nonpositional in the sense that it subjects to criticism the very possibility of modernism's desire. Like the age-old attempt to reduce the enigma of the work of art to the intelligible by inventing "isms" and "ologies" of all kinds, classification into historical schools substitutes knowledge for the immediacy of the sensible. From the perspective of the modernist desire for universal judgment, an art that actively practices "difference" by inhibiting identity necessarily appears obscure, absurd, impoverished, sometimes nightmarish. As points of extreme contrast, abjection in Kristeva and disgust in Derrida show how postmodern art registers alterity as the singular. The following essays trace ways in which Surrealism, the avant-garde, and minimalism disrupt the ontology of aesthetic objects and exhaust the difference between identity and difference.

Jean-Michel Rabaté in his essay "Breton's Post-Hegelian Modernism" looks to French Hegelianism, specifically André Breton as opposed to Kojève, to chart the locations and dislocations among modernisms. In place of radically a-historical readings which seek to locate modernism in a sequence of other historical "isms," Rabaté reads Breton's move away from Dadaism toward the Surreal as a critique of modernism and "a new thinking of modernity" that prefigures the postmodern. For Breton, art in general and the Surreal in particular require a different discourse when rational categories and history as ordinarily conceived fail. Exemplified in his work *Les Pas Perdus*, Breton figures this new dialectic, the Surreal, as a synthesis between love and revolution, madness and dream, where Nature and Logic are reunited and where Hegel is less the philosopher of History than the philosopher of Spirit in Nature. As a passional and primordial philosophy of immanence, Surrealism is both a mediation *and* a madness. Hence in valorizing the Dionysiac potentialities in Nature, the "madness" of Breton's Surrealism opens "portals" on difference or, to shift the metaphor, responds feelingly to rationally inaccessible difference.

Duchamp offers another example of how the postmodern feels the temporal difference. Dalia Judovitz, in "Postponing the Future: Marcel Duchamp and the Avant-Garde," describes how Duchamp's aesthetic practices appropriate traditional artistic forms and icons in order to defer their "pictorial becoming." Mass-produced objects, mechanical reproductions, and prosaic, utilitarian materials virtualize the representational presuppositions of painting. For

example, his "nudes" often reduce the body to volume, to an abstract structuring, and they reduce motion to a literalized kinetics. Judovitz claims that Duchamp's avant-garde dissolving of pictorial certainties while continuing to "draw" upon them constitutes a postmodern aesthetics. The resulting anti-works challenge "knowledge" of the visual. His figures as disembodied, reduced to the mechanics of motion, thwart our privileging of cognition and the visual in aesthetic experience. Hence, Duchamp's "punning" on artistic presuppositions postpones the realization of the work of art as an object of consumption, calling attention to the time of its appearing rather than to the space of an object.

The third essay rereads postmodernism with emphasis on sense-certainty rather than the logic of indeterminacy. In "When Less is More, More or Less: Subtraction and Addition in (Post)Modernist Poetics," Peter Williams makes a case for "an antiaesthetics of the unpresentable," by questioning the categories which define the work of art and challenging the view of minimalism as a dead-end. The essay neither treats indeterminacy as an end in itself nor recoils before the critical backlash that credits only determinacies. In contrast, it reveals minimalism as the harbinger of a new aesthetics that embraces the "now" by a subtracting, unsaying, or leaving-out which connects anti-narrative with "sense-certainty." Frank Stella and Agnes Martin "subtract" all representational elements from their work. Using the naked materialism of flatness and grids to map surfaces that shunt the eye to the margins of the canvas, their works orient our attention to "recalcitrant" surfaces. Similarly, poets Robert Creeley, John Ashbery, and Samuel Beckett "mine the resources of grammar" to create a literalist, minimalist aesthetics that shifts poetics away from rational categories and determining judgments.

In the turn to the postmodern these various media expand our capacity to feel the difference loosening appearance from the poles of subject and object, and sensibility from the hierarchy of understanding. Feeling the difference arrives without mediation, difference in pure transit. Instead of cognitive sensibility that orders and reconciles, these works incite an openness to being affected, abrading even the closeness of things alongside us in the world. They work from the hither side of the traditional ontology of philosophy and aesthetics, denuding the one of its unity and abandoning the subject in the nominative form.

2

BRETON'S POST-HEGELIAN MODERNISM

Jean-Michel Rabaté

In recent years, it has become increasingly clear that Surrealism offers one of the most crucial and contested cultural sites of the twentieth century: whoever wishes to revisit the systematically coupled terms of "modernism" and "the avant-garde," whoever wants to problematize the links these terms imply between historical categories and philosophical schools, will sooner or later have to reopen the debate surrounding Surrealism. More than a decade of discussions has been marked by Peter Bürger's forcible opposition between the two concepts.[1] Bürger radically opposes these two categories, defining "modernism" as the antithesis of the "avant-garde." Modernism would be stamped by a wish to "aestheticize politics" while remaining trapped in a dissociation between revolutionary forms and a conservative content; on the other hand, the avant-garde idea to "politicize esthetics" attempts a synthesis of art and revolution. For Bürger, American and English high modernists such as Pound, Eliot, H. D., and Wyndham Lewis do not share much with Dadaists and Surrealists.

If the rift between Breton and Bataille that marked the beginning of the decline of the French Surrealist movement before the Second World War can be understood as the consequence of an increased politicization of all movements in the thirties, the same cannot be said of the clash that opposed Breton and Tzara in the twenties and led to the creation of Surrealism as opposed to Dadaism. My main contention would thus be that a history of French Hegelianism sheds more light on the break-ups, splits, dissociations, and tensions between various modernist factions than a trans-historical opposition between avant-gardes and modernism. I will argue that Breton's Hegel is less the philosopher of History than the philosopher of the Spirit in Nature. The recent publication of Gwendoline Jarczyk's and Pierre-Jean Labarrière's *De Kojève à Hegel: 150 ans de pensée hégélienne en France*[2] has historicized in an original way the numerous misprisions that characterize Hegel's diverse and intriguing influence on French poets, philosophers, and practitioners of the avant-garde.

The starting point of my examination will be André Breton's first critical collection, *Les Pas Perdus*, a book whose paradigmatic status can lead to a new understanding of the complex negotiations between modernism and the avant-garde that presided over the birth of Surrealism. In 24 chapters, Breton

presents a diary of his progressive break with Dada, and the enactment of a paradoxical neo-Hegelian program aiming at a dialectization of art and history. In this curiously sinuous and non-linear account, Breton, who starts off as a Dadaist and concludes a convinced Surrealist, lays down the foundations of a critique of modernism and of a new thinking of modernity. Such a double movement is uniquely over-determined by an ambivalent relationship with a Hegel he criticizes for being too "idealistic" but from whom he borrows the concept and the practice of an "overcoming" (*Aufhebung*) of other rival movements. According to Breton, Tzara had reduced the Hegelianism of which he is accused to a theory and practice of "objective humor." The first step in Breton's critique will thus be an attempt at overcoming the facile wordplays of a Dadaism that appears as committed to a strategy of systematic self-contradiction.

I. *PAS PERDUS:* "THE LOST STEPS OF THE NOT LOST"

Breton's title can be interpreted either as "lost or wasted steps," and is often used in the phrase *"Salle des pas perdus,"* meaning "Waiting Hall" – or, conversely, as "those who are not lost." In one of the most surprising analyses of "Lâchez tout," Breton presents himself with an unflattering lucidity. He explains that he has just moved to Place Blanche, a notorious red-light district near Pigalle, and that some of his friends have thought him dead:

> You are right to call me to order [*de me rappeler à l'ordre*]. After all, who is speaking here? André Breton, a man who lacks courage, who has hitherto satisfied himself with derisive actions perhaps because he felt too strongly that he was unable to achieve what he wanted. It is true that I am aware of having stolen everything from myself several times already; and I find myself less than a monk, less than an adventurer. However, I do not despair of catching up with myself, and now, early in 1922, in this beautiful and festive Montmartre, I still wonder what I may well become.[3]

In a "step" that curiously seems to anticipate Bataille's strategies of erotic disruption, Breton opts for mobility and modernity, hoping to remain "in the move," even if this entails that he prefers to follow the prostitutes at night rather than sleep with the illusion of absolute knowledge:

> There is nowadays a philosophy of the precipitation of all things into their contraries, and of the solution of the two into one single category, which itself can be reconciled with the initial term and so on until Spirit reaches the absolute idea, reconciliation of all oppositions and unity of all categories. If "Dada" had been that, indeed that would not have been too bad, although to Hegel's sleep resting on his laurels I much prefer the bumpy [*mouvementée*] existence of the first little whore. (*OC*, I: 262)

Dada is clearly accused of latent Hegelianism, that is, simply of idealism. Breton's choice of the peripatetic "movement" of prostitutes soliciting or

accosting customers over aesthetic "movements" would mark an ironic preference for Aristotle against Hegel.

The announced demise of Dada is reiterated in another passage of *Les Pas Perdus:* "Dada has gone, and this, an observation not a judgment, will not please the owners of Montmartre's little bars who are, as everyone knows, the last guardians of our tradition" (*OC*, I: 306). After all, isn't it better to walk up and down the streets than parade in cheap cabarets! The ominous term of "tradition" that returns as a *"rappel à l'ordre"* in this essay devoted to defining "the character of modern evolution" had indeed been launched by Drieu La Rochelle, who, as early as 1920, challenged Breton, who was asked to "compromise himself" on issues of ethics and politics (*OC*, I: 1407–8) – an idea that did not yet imply Drieu's later drift to the right but that curiously announces Pound's strictures in *Guide to Kulchur:* "The sorting out, the *rappel à l'ordre,* and thirdly the new synthesis, the totalitarian."[4]

When Breton and Tzara were fighting in January 1922 about a forthcoming Paris meeting grandiosely called the *"Congrès international pour la détermination des directions et la défense de l'esprit moderne"* (*OC*, I: 434), even Breton's friends contested the very terms of the title – especially the idea that here might be such a thing as the "modern spirit." If Breton subsequently pretends to avoid "using the phrase 'modern spirit'" (*OC*, I: 295), one can nevertheless note that the break with Tzara and Dadaists hinged around the idea of modernity. Tzara and Duchamp would endlessly repeat: "Dada is not modern," and Breton himself has to concede the fact in the article devoted to Max Ernst in *Les Pas Perdus*: "Dada does not present itself as modern" (*OC*, I: 245). However, the whole drift of *Les Pas Perdus* is to discern the "laws" and the "tendencies" of "modern evolution" (*OC*, I: 294). Between 1920 and 1924, Breton, often against his closest friends, keeps elaborating the conditions of production of the "modern": for instance, according to Breton, it is in 1923 that Desnos invents a "modern sense of wonder" (*OC*, I: 473). Breton adds: "Symbolism, Cubism, Dadaism have long ceased to be, *Surrealism* is the order of the day [*à l'ordre du jour*]" (*OC*, I: 473). This *"ordre du jour"* echoes with the *"rappel à l'ordre"* demanded by Drieu, but Drieu had a crucial forerunner, Vaché. As early as his "Disdainful Confession," Breton admits to having fought with Vaché over the term of "the modern": [Vaché] who "reproached me, I think, for this will towards art and modernism, which, since then . . . But let us not anticipate" (*OC*, I: 199). With the acknowledgement of his own *"volonté d'art et de modernisime,"* Breton seems to situate Vaché closer to Dada than Surrealism. But the ominous "let us not anticipate" seems to beg the entire issue in this account of how a dead Dada had to be "overcome" and transformed into a really living movement, Surrealism.

In fact, Vaché's role, so crucial and enigmatic at once in *Pas Perdus*, is less to think a "Dada before Dada" than to launch a radical critique of the only predecessor that Breton could accept as a precursor in modernity, namely Apollinaire. Vaché had already written: "We do not recognize Apollinaire any more, since we suspect him of being a little too clever in art, and to patch up Romantism with a telephone wire and not to understand his own dynamos" (as quoted in the sixth issue of *Littérature*). The dead Vaché comes back to assassinate symbolically the dead Apollinaire, who dies a second death between

the first article of *Pas Perdus* – chronologically, that is ("Guillaume Apollinaire," written in 1918 when Apollinaire was still alive) – and the last essay in the collection, called "The character of modern evolution and of what is related to it" (Breton's Barcelona lecture of 1922).

In the later essay, one can note that Breton has grown markedly severe: Apollinaire appears as the "last poet" (*OC*, I: 303) but also as a "specialist," a term that is rather negative in the context. Is Breton implying that Apollinaire has turned into a specialist of modernity? The second text quotes Apollinaire's last article on "the new spirit and poets," but to denounce "the inanity of his meditation and the uselessness of so much noise" (*OC*, I: 293), whereas the first essay managed to introduce almost surreptitiously the word "surrealist" about Apollinaire's famous *Mamelles de Tirésias* (*OC*, I: 214). Through this post-humous "dialogue of the dead," Breton combines the heritage of Apollinaire – from whom he steals the idea of modernity – and from Vaché, whose sense of derision forbids him to enact the role of the "last poet" for too long. Even the *Mamelles de Tirésias* has missed the secret of "modern gaiety, both deep and tragic" (*OC*, I: 215). One can therefore understand the architecture of *Pas Perdus*, a collection of essays that begins and closes with a critical assessment of Apollinaire's modernity, a modernity that has to be radicalized, in a gesture that revolves around the whole issue of tradition. For Apollinaire as for Breton, the problematics of modernity entail that tradition has to be reinvented.

Apollinaire had already suggested a slogan that was then taken up by Pierre-Albert Birot in the avant-garde journal *SIC* (April 1916):

Thus French Tradition
IS THE NEGATION OF TRADITION
Let us follow tradition[5]

The apparent paradox develops the logics of a Hegelian "negation of negation" that Dada had attempted to subvert by abusing it. Dada's semantic extravagances aimed at prohibiting any backsliding into common sense or the wisdom of nations (that would assert that any tradition is always prepared by the negation of another tradition). Breton, who cannot follow either Dada's negations or Hegel's circular negation of negation, nevertheless needs the word *Surrealism* as a new dialectical stepping-stone. This is what he expounds later, in the second Manifesto of Surrealism when he hopes to have produced the synthesis between love and revolution, madness and dream, a synthesis that would have been missed by Hegel and by Marx: "Now I do not fear to assert that nothing had been done that would go in that direction before Surrealism, and that, at the point where we found it, for us as well, *under its Hegelian form, the dialectical method was of no use*. We too had to break with idealism and the very word of 'surrealism' should prove it . . ." (*OC*, I: 793–4). In spite of this admission of impenitent nominalism, Breton derides the stuttering of purely verbal dialectics, and follows Engels who denies that dialectics should stop at "The rose is a rose. The rose is not a rose. Nevertheless the rose is a rose" (*OC*, I: 794). For Breton, unlike Gertrude Stein, the rose is not sufficient as a rose, even if its presence is reiterated by a performative language; the rose must culminate in a

bunch, a bouquet that cannot be anything but the collective movement called Surrealism!

Breton's dialectical rose seems closer to Mallarmé's "absent one," since the only presence that is acknowledged is that of a real garden:

> We had to . . . push the "rose" forward into a profitable movement of less benign contradictions and see it successively as the rose that comes from the garden, the rose that holds a particular place in a dream, the rose that cannot be isolated from an "optical bouquet," the rose that can change its properties entirely through automatic writing, the rose that only keeps what a painter wants to keep of its properties in a surrealistic painting, and finally, the rose that is quite different from itself when it returns to the garden. (OC, I: 794)

The movement enacting a curiously dialectical circle seems to encapsulate what is at stake in *Pas Perdus*. Breton indeed surmises that he may not have approached the rigor of the Marxist concept of contradiction, and that he risks remaining at a purely verbal level. In the *Second Manifesto*, he also rails at "revolutionary conversions of a religious type" (meaning those who have left the Surrealist movement to join the Communist Party) but adds: "The spirit is not a weather cock, at least not only a weather cock" (OC, I: 796). Why this strange reservation of "not only"? Would this be an admission that one can never entirely escape from the turning wheel of fashion? The phrase points obliquely toward Pascal's famous comparison of man with a weather vane in his *Pensées* so as to stress human frailty and inconsistency. In fact, Pascal has already been parodied by Lautréamont: "The spirit of the greatest of men is not so independent that he could not be troubled by the least noise or *Hullabaloo* around him. . . . One does not need the noise of a weather cock, of a pulley. The fly will not reason well now. A man is humming at its ears."[6] This striking inversion recurs in the "After Dada" chapter of *Pas Perdus*: "'The spirit, it has been said, is not so independent that it cannot be troubled by the least noise or *Hullabaloo* around it.' What then can one predict for the spirit, if it itself enjoys generating the hullabaloo?" (OC, I: 261). In both cases, a similar Hegelian Spirit goes astray, either to entertain the sterile agitation of Dadaism, or to reject poetry and choose the political abnegation of Communism.

These examples show how Breton's thought is determined by the recurrence of certain tropes, since rhetorical figures are figures of thought for him. His title (*Les Pas Perdus*) thus turns into a productive conceptual and dialectical trope. The figure creates meaning by subtle shifts that end up creating an autonomous space. This also explains why Breton carefully chose 24 articles among those he had published in various magazines to build up the architectonic structure of *Pas Perdus*, a strategy that clearly cannot be accounted for by literary coincidence. The essays perform a double "revolution" of the clock, a double spin that negates and then negates the negation. Could the calendar revolution provide a model for the Surrealist Revolution? One might think so, if one follows the hint given by Breton when he narrates a rather funny exchange between Gide and Cravan. Cravan had asked: "Where are we at with time?" Gide merely said:

"Six and a half," without seeing further (*OC*, I: 401). Breton, who is surely less naive than Gide when facing avant-garde tactics of temporal estrangement, would no doubt have answered that it is both — and always — noon and midnight. A redoubled twelve thus adds up in a double twist the heritage of Vaché's negation and the legacy of Apollinaire's poetic affirmation.

II. FROM *NADJA* TO THE MADNESS OF THE DAY

The beautiful title of *"Les Pas Perdus"* had been announced by Breton in advance, so as to keep the rights to it, as it were. The title originally announced a collection of automatic writings, a single-author continuation of *Magnetic Fields*. One can thus read in his *Notebooks* for 1920–21: "We fill out pages of this writing without a subject. We witness how facts we had not even dreamed of are being produced, how mysterious alloys are generated. We walk on as in a fairy tale. 'Les Pas Perdus'" (*OC*, I: 620). In the same context, one can note an extension of the same idea of "*pas*" in one vignette of the notebooks that looks as if it had been culled from a fragment of Barthes' *Lover's Discourse*: "Waiting. One does not move without saying: this gesture had to be made in order for her to arrive, and so on. Each movement takes on the character of a magnetic pass, as if to force one of her steps" (*OC*, I: 621). Automatic writing brings the proof that serendipity works, that words can mesmerize the loved one, and above all, that movement is better than immobility. "Her steps" will be those of a puppet who has been manipulated by a writer who knows how to capitalize on the windfalls of objective chance.

This is why the phrase "lost steps" could not but echo throughout Nadja's discourse. It follows from Nadja's mediumistic predispositions that Breton, who thinks he is going to educate the young woman by giving her two previously published books, has in fact to learn the meaning of these "steps" from her. When Breton gives her his two books, *Les Pas Perdus* and the *Manifesto of Surrealism*, she immediately remarks: "Lost steps? But there's no such thing!"[7] Nadja then leafs through the book and immediately starts freely associating, hallucinating a scene in which she sees a man lost in a forest. Soon after she finds Death in some lines of Jarry quoted in *Les Pas Perdus*. Nadja exemplifies Breton's ideal reader: she reads fast and intensely, and jumps quickly from texts to real life. The "wild" reader roaming the streets of Paris prefers the encounter with reality to libraries or museums so as to force aesthetics out of its usual refuge.

One could even say that the whole novel appears as the narrative unfolding of the phrase "lost steps." Indeed, Nadja herself had been anticipated by one character briefly and tantalizingly mentioned in *Pas Perdus*, this beautiful woman who happened to look "so lost" (*"L'Esprit Nouveau,"* in *OC*, I: 258). When Nadja appears in the novel, she is seen as the only person who takes real "steps" toward freedom. In a long purple passage, the first real speech he delivers to her on the very day of their encounter, Breton explains to Nadja his theory of freedom:

One could surmise that it is with this speech that Breton both seduced

Nadja on the spot and tried to free her even from the fetters of seduction. Besides he is careful to take a critical distance in his account: "(What I can say on this subject is sufficiently apparent, particularly if I should ever decide with it concretely)." (N, 69)

The second part of the novel attempts to deal with this issue "concretely" by showing how Nadja is both "lost" and "not lost." She fits the description of Stendhal's heroes in the *First Manifesto*: "We really find them where they are most lost by Stendhal" (*Où nous les retrouvons vraiment, c'est là où Stendhal les a perdus*) (*OC*, I: 316). Hence the literary and personal program: Breton has to lose the lost woman in order to gain access to his own writing. Like a Beckettian Mr. Knott, Nadja intuitively translates negation as serial steps ("pas *pas*-perdu" or "*pas-pas* perdu"). The Hegelian idea is caught in its progress, it reintroduces negativity as a step forward of the Spirit. Breton's formula announces that "nothing is ever lost" for a writer who can dare to waste some of his time in these great open halls that are *salles des pas perdus* – waiting rooms in stations, waiting halls in tribunals. Jarry and Apollinaire loved these neutral spaces in which everything can lead to a fateful encounter – and Hegel also believed in the possibility that the tribunal of History would ultimately recognize that "there are no lost steps."

"Perhaps life needs to be deciphered like a cryptogram" (N, 112): here is the fundamental discovery of *Nadja*, that the activity of deciphering is not neutral, but discloses or puts into play the "madness of light" – Blanchot's *Folie du Jour*, or in more Hegelian terms, the madness of manifestation, Hegel's *Folie der Offenbarung*.[8] The first to start reading signs in a slightly crazy way was Nadja herself, who, drawing from many shady adventures which did not stop at prostitution and drug-peddling, narrated to Breton how she had "wandered all night long in the Forest of Fontainebleau with an archeologist who was looking for some remains which, certainly, there was plenty of time to find by daylight . . ." (N, 113). Her privileged space is, however, the streets of Paris, "the only region of valid experience for her," "the street, accessible to interrogation from any human being launched upon some great chimera." The one time Nadja decides to miss a rendezvous with Breton, he runs into her at an earlier time and then keeps catching glimpses of her during the week following their encounter. Nadja seems to prove in her flesh all the major tenets of Surrealist doctrine so that Breton can comment on Nadja's habit of telling herself stories by writing: "Does this not approach the extreme limit of the surrealist aspiration, its *furthest determinant*?" (N, 74).

In fact, as the development of the novel's "plot" confirms, Nadja's exemplary function forces her to become the real specter at the end, a specter similar to the ghost Breton felt he was turning into at the beginning. The return of this double ghost at the time of the book's writing – in the summer of 1927 – gives an even more poignant quality to the figure encountered in the fall and winter of 1926. Breton sees himself as summoned in front of a tribunal of shadows and attempts to account for his grave failures with the living woman; his writing finds its impetus in the problematization of its absence of foundations. This could be identified with a negative transcendentalism since we start from a

collapse, an erosion of values. Purely literary narcissism has been hollowed out by a new sense of responsibility. The "lack of moral basis" alluded to in the opening pages (N, 12) in connection with a sense of "irreparable loss" can be countered if and only if Breton manages to accept that time is not fixed in a figure of eternal grief. This refusal of a melancholic mourning finally entails a meditation on certain Hegelian motifs such as the "end of history" and also leads to the invention of a new aesthetics, an aesthetics of surprise leading toward the future.

III. THE PASSION OF CRYSTAL

Nadja closes with a superb passage summing up the concept of "passionate" beauty but not without having quoted Hegel on history and *Aufhebung*. There, Breton speaks directly to his new love, Suzanne, who has replaced Nadja after having "exploded" into his life with an intensity unknown before. However, as he explains, this irruption has not vitiated the ending he had planned for his narrative; the narrative was indeed to conclude on the theme of love. To its triumphant assertion is nevertheless added a new sense of moral uneasiness:

> "It's still love," you used to say, and more unjustly, you would also say: "All or nothing." I shall never dispute this rule, with which passion has armed itself. At the most I might question it as to the nature of this "all" – whether, in this regard, it must be unable to hear me in order to be passion. As for its *various movements*, even insofar as I am their victim – and whether or not it can ever deprive me of speech, suppress my right to exist – how could they divorce me from the pride of knowing passion itself, from the absolute humility I should feel before it and before it alone? I shall not appeal its most mysterious, its harshest decrees. It would be as if I were to try to stop the course of the world, by virtue of some illusory power passion has over it. Or to deny that [quoting Hegel] "each man hopes and believes he is better than the world which is his, but the man who *is* better merely expresses this same world better than the others".
>
> (N, 158–9)

Here, Breton is quoting a Hegel revisited by Croce.[9] Hegel rails at the *Schöne Seele*'s illusions (the "beautiful soul" in whom Lacan will later see a model for Dora's hysteria[10]) and at her belief that she can impose ideal values onto the world. Hegel's realism states that the course of the world always proves the idealist wrong and ultimately crushes her or his pretensions. In its very radicality, passion, as a force of the world, can also crush individuals; like Nadja, they cannot resist its decrees, appeal against them or avoid them. Thus Breton's personal attitude combines pride for having known passion, and humility because, having known it, he must admit to being powerless (he has been unable to save Nadja). The only hope he may entertain will not lie in an effort to be superior to the world but in an attempt to reproduce it better than the others.

The transparency aimed at in the first pages is thus an ethical effort geared towards the best reproduction of a complex world. In *Nadja*, the figure Breton

finds for this pellucid dream is that of the "glass house" through which any account of his life will seem as "etched by a diamond." In *Mad Love*, it becomes the generalized trope of the "crystal forest" in which everything will be diaphanous: "The house where I live, my life, what I write: I dream that all that might appear from far off like these cubes of rock salt look close up."[11] Such a trope "crystallizes" a deep structural homology between "the world" and the "subject" and inscribes passion or desire as natural. All of which finds its source in Hegel's *Philosophy of Nature* as translated into French by Véra. Hegel explains the process of differentiation and accounts for it by means of the term of "figure." A "figure" is the mechanism of individuality through which form manifests itself in a material way. The Hegelian "figure" traverses three different moments: first, magnetism corresponding to the "abstract principle" which is produced in its "free existence"; then electricity, through bodies attracting and repulsing each other, thereby differentiating themselves; finally chemical processes realizing a totality in which bodies represent different stages (*PN*, II: 561). Since the Hegelian notion of figure culminates with the crystal ("The figure in its reality is the Crystal") (*PN*, II: 569), Nature is therefore the greatest artist: crystals develop in such a "regular and graceful way" that people "will not take them for natural productions but will attribute them to the art and work of men" (*PN*, II: 566). But both still lack something: magnetism remains deprived of finality while crystal is deprived of movement. These two missing elements will only be supplemented by the intervention of the Spirit in Nature when it understands how crystallization externalizes an interior concept.

Breton is thus a Hegelian in so far as Hegel allows him to think the fundamental "madness" of manifestation. The sudden irruption of light into the world generates a sort of drunken epiphany, the Dionysiac revelation of all the powers and potentialities of Nature. Much later, when he praises Marcelle Loubchansky's paintings for their visionary quality in the fifties, one can witness how Breton is still commenting on Hegel's Philosophy of Nature. The painter has managed to create a beauty that remains half-way between magnetism and crystal-like transparency in a tension that is characteristic of Breton's own texts: "if it were ever a question of coaxing her secret from her, I think it would have to be sought in the direction of *magnetism*. . . . The secret would also have to be sought in the direction of the *diamond*."[12] Breton tends to use Hegel's vocabulary whenever he attempts to articulate the unity of mind and nature, and this appears more markedly after 1930. Indeed, the formulations of the *Second Manifesto of Surrealism* still evince a great ambivalence about Hegel, who is first quoted with due respect in connection with morality and "loyalty" in order to prove that any action is collective (*OC*, I: 792–3), but is then shown to have failed utterly: the following page admits the "colossal failure" (*avortement colossal*) of the Hegelian system which must now be replaced by historical materialism. Hegelian dialectics are declared to be wanting and deemed inapplicable to the new fields of investigation discovered by the Surrealists. However, Breton keeps using the term of *surclassée* when he writes that "philosophy is now overcome" (*OC*, I: 795), which translates rather literally Hegel's *Aufhebung*. Much has been written about Breton's original version of Marxism,

and his brief stay in the French Communist Party. Breton chose his camp in the late thirties, opting for Trotsky against Stalin, which did not prevent him from returning to Hegel in his aesthetics.

However, the Hegel who is adduced by Breton is neither the Hegel of today, nor the German philosopher of his immediate contemporaries. Breton is not so much concerned with the philosopher of History as with the philosopher of the Spirit in Nature, who deals with matter, form, color, magnetism, crystals, electricity, etc. This corresponds to Breton's general aesthetic program as outlined in *Surrealism and Painting* (roughly at the time of the encounter with Nadja):

> Everything I love, everything I think and feel, predisposes me towards a particular philosophy of immanence according to which surreality would be embodied in reality itself and would be neither superior nor exterior to it. And reciprocally, too, because the container would also be the contents. What I envisage is almost a communicating vessel between the container and the contained. Which means, of course, that I reject categorically all initiatives in the field of painting, as in that of literature, that would inevitably lead to the narrow isolation of thought from life, or alternatively the strict domination of life by thought. (*SP*, 46)

The utopia of a life identical with art and thought is a condensed version of Hegel's synthesis of the concept with the Absolute and with its historical and empirical manifestations. To say that the "Surreal" is the "Real" would remain meaningless if this did not lead to a philosophy of Relation or Mediation.

All this stems from Croce's decisive influence on Breton in his life-long dialogue with Hegel. We have seen how the Hegel quote found at the end of *Nadja* already derived from Croce's essay on Hegel, whose French version Breton had read closely. Croce's account of Hegel's system allows us to understand how the whirl of "surrational" insights which Nadja was able to arouse could lead Breton to a deeper awareness of the manifestation as mediation *and* as madness. In his chapter on dialectics, Croce examines the accusation of heady facility and abstruse glibness often leveled against Hegel. The Italian philosopher Rosmini, for example, had concluded an account of the dialectics of being and non-being with the allegation that "the system of Hegel finally only attempts to *render being mad, to introduce madness into everything*" (*CQVM*, 23). Far from denying such a charge, Croce endorses it and quotes a famous sentence from the Preface to the *Phenomenology of Spirit*: "Truth is thus the bacchanalian revel, where not a member is sober; and because every member no sooner becomes detached than it *eo ipso* collapses straight-away, the revel is just as much a state of transparent unbroken calm."[13] He then follows Hegel and praises madness as a "higher form of wisdom" (*CQVM*, 24) when it is capable of destroying abstraction and launching dialectics as the only process capable of uniting life and thought.

However, Croce turns more incisive when examining Hegel's theses on art and aesthetics. Croce sees Hegel as the victim of a sort of "panlogicism" intent on putting art in the shadow of philosophy. What Croce attacks systematically

is Hegel's belief in the "death of art" (*CQVM*, 106), the domination of all art-forms by philosophy which "thinks art" just at the moment of its demise. This is restated more cogently in Croce's *Aesthetic*: "The Aesthetic of Hegel is thus a funeral oration: he passes in review the successive forms of art, shows the progressive steps of internal consumption and lays the whole in its grave, leaving Philosophy to write its epitaph."[14] Croce demonstrates that the belief in an art reduced to an inferior philosophy invalidates the whole of Hegel's aesthetics. The same applies in the case of Hegel's philosophy of history. Croce sees Vico as the model of Hegel, a model Hegel should have followed more closely. Hegel pretends to be attentive to the idea of history, but discards events as mere "facts" once they contradict his rational scheme. By a curious reversal, Hegel's philosophy of history ends up by negating real history (*CQVM*, 117). For, as Croce stresses, Hegel's Nature does not know history (*CQVM*, 130).

It is the combination of an ahistorical philosophy of magnetism and crystal-lography and of a dynamic philosophy of history based on Vico's *New Science* that provided Breton with a harmonious solution to Hegel's aporias. It is not necessary to wait with the owl of Minerva until night has fallen on Nature and Spirit alike. The openness to the new entails that no one, not even Hegel, can stop the flow of time, as the conclusion of *Nadja* makes clear: "It would be as if I were to try to stop the course of the world, by virtue of some illusory power passion has over it" (*N*, 159). If one cannot arrest the course of history, art has the privilege of opening our eyes to the true function of manifestation as such for it makes us believe in a surreal light coming from our eyes. Without such light, no vision would be possible: "I believe that men will long feel the need to retrace to its true source the magical river that flows from their eyes, bathing with the same light and the same hallucinatory shadow those things that are and those things that are not" (*SP*, 7). The power of art derives from this turning the river back to its source, from reaching toward a pre-original mode of desire that serves as a quasi-transcendental constitution of vision itself.

These quotations should suffice to show that the Hegel postulated by Breton has very little to do with the Hegel presented to French intellectuals in the thirties and who was so influential on Bataille, Queneau, and Lacan – namely that of Kojève. The split between Breton and Bataille is accountable for in terms of a *differend* over Hegel. Breton's Hegel corresponds to an older "French Hegel," a Hegel glossed and translated by Véra, who always stresses the systematic aspect of a thought in which Nature and Logics are reunited. This is the "old" Hegel who has totalized all aspects of his philosophy. Bataille, on the other hand, threads his way in an agonistic dialogue with a younger Hegel, closer to Hölderlin but anticipating Nietzsche, a Hegel who has been mediated by Kojève's rich and novelistic recreation of the few dramatic figures to which he reduced the *Phenomenology of Spirit*. As we know, Kojève's central thesis climaxed on the notion of the "end of history." Much as Hegel replaced a Napoleon he had earlier identified with the World-Spirit of Bismarck, founder of a truly modern State – Hegel's historical equivalent of absolute knowledge – in a similar fashion, Kojève saw Stalin as the new absolute master.[15] Breton

could never accept this thesis, no more than he could accept the idea that history is brought to a close once the Spirit has passed through all the stages of its development. For Breton as for Croce, art can and, indeed, must lead the way whenever history reaches a dead end, since it already contains the categories which allow for an overcoming of the purely aesthetic domain.

CONCLUSION

The famous 1929 Preface to the new edition of the *Manifesto of Surrealism* could provide a fitting conclusion. There Breton tries to account for the fact that he has not "always been a prophet" (*OC*, I: 401), while refusing to update his text in a vain effort at making it appear more relevant. He thus underscores his "lost bets" (*paris perdus*) and dissociates between his personal "self" (*moi*) and the objective truth of his thinking – or of his writing (*OC*, I: 402). Such a position would be close to that of Joyce explaining that a man of genius never makes mistakes: "His errors are volitional and are the portals of discovery."[16] The encounter with Nadja proves to have been such a "mistake" or "lost step." Breton's missteps, his many *faux pas* nevertheless provide portals leading to an exploration if not always to a discovery. What he nevertheless "discovers" is that the problematics of modernity cannot be dissociated from an understanding of the laws of History and an awareness of the laws of Nature. The Modern Spirit will have to be Hegelian or will not be, such might be Breton's claim. Whether we agree with this thesis or not, it is only when we have understood the historical ramifications of French Hegelianism that we can be in a position to understand French Modernism and to rethink its links with the issue of modernity in general.

3

POSTPONING THE FUTURE

MARCEL DUCHAMP AND THE AVANT-GARDE

Dalia Judovitz

Although contemporary with avant-garde artistic movements such as Cubism, Dada, and Surrealism, Marcel Duchamp's first pictorial, soon to become non-pictorial, and even anartistic practices come to radically question our understanding of modernism and the avant-garde. While Clement Greenberg considers Duchamp as the very incarnation of vanguardism, since he laid down the precedents for everything that art has done in the fifty-odd years since, he also associates Duchamp with the desire to liquidate cultural traditions through the cult of the new.[1] Despite his well-recognized affiliations with these avant-garde movements, Duchamp attempts to chart a very particular strategy, one that is not merely based on a reactive rhetoric of negation. Rather, as this study will show, Duchamp devises a strategy whose aim is not to liquidate pictorial traditions, but rather to "draw" on them, appropriating them speculatively in order to postpone their pictorial becoming.

Duchamp shares with the Dada movement the effort to challenge artistic norms of representation through the strategic juxtaposition of different media, thereby undermining the preeminence of painting as a privileged artistic language.[2] His discovery of ready-mades and his supposed abandonment of painting by 1918 led to the mistaken assessment of his work as embodying not merely the negation of painting, but its very liquidation. The manifest provocative and humorous qualities of his works have obscured their persistent conceptual thrust, which is to question the artisanal and mimetic premises that underlie painting by playing them against notions of mechanical reproduction.[3] For Duchamp will deploy mechanical reproduction as a conceptual device that enables him to literalize the mimetic impulses of painting while outwitting it as a representational medium.[4] Thus Duchamp will continue to "draw" upon painting recovering its conceptual potential even while stripping it bare of its material properties.

Duchamp's *Nude Descending a Staircase No. 2* (1912) was rejected by the Salon des Indépendants, since according to Duchamp, Cubists such as Gleizes found

that the: "'Nude' wasn't in the line that they had predicted. Cubism had lasted two or three years, and they had already had an absolutely clear, dogmatic line on it, foreseeing everything that might happen" (*DMD*, 17).[5] For Duchamp this work represents a double challenge not merely to his public but also to his Cubist peers (Metzinger and Gleizes) whose artistic and intellectual expectations sought to doctrinally control the exhibition of the work. Duchamp rejects Cubism not just as an artistic movement but as a discipline with a set aesthetic program. The subsequent exhibition of this work in The New York Armory Show in 1913 shocked the public, since the abstract nature of the work failed to provide an appropriate visual referent for its title. This discrepancy violated the conventional norms associated with the nude as a pictorial genre, since, as Duchamp notes, "*A nude should be respected*" (*DMD*, 44).

In *Nude . . . No. 2* (Figure 3.1), Duchamp reduces the anatomical nude to a series of successively fractured volumes suggesting the act of descent: "I discarded completely the naturalistic appearance of a nude, keeping only the abstract lines of some twenty different static positions in the successive action of descending."[6] He expands the notion of Cubist abstraction by interfacing it with an allusion to another medium, that of photography and chronophotographic freeze-frame techniques.[7] What is at issue here is a challenge of the pictorial medium through sequential photography that implies a critique of vision as a cognitive medium traditionally conflating spectatorship with pleasure. The splintering of vision into a series of frames that fragment and abstract both the identity of the nude and the process of movement inscribe into the painting an interval, a temporal dimension. This strategy of delay also redefines and defers notions of visual reference associated with photography. While appealing to techniques of mechanical reproduction such as photography to redefine the pictorial medium and its subject matter, Duchamp succeeds in redefining painting itself as a medium whose plasticity includes temporal considerations.

This picture presents the viewer with a "vertigo of delay," to use Paz's term, rather than a vertigo of acceleration.[8] Duchamp's interest in kinetics is here conceptual: the movement in the painting is produced through the decomposition of the graphic elements. The staggered motion of the "nude" demonstrates an analysis of movement rather than the futurist seduction with the dynamics of movement.[9] However, the kinetic character of the nude is not merely the thematization of movement as a pictorial fact, but also reflects Duchamp's effort to question the nude as a pictorial genre, by departing from the classical reclining or standing nude in order to put it into motion (*DMD*, 30). Just as movement is in the "eye of the spectator," an abstract deduction articulated within the work, so the sequential fragmentation and movement of the nude emerges as a rhetorical twist on cubist painting.

Nude Descending a Staircase No. 2 is the first of Duchamp's serial works, having been preceded by *Nude Descending a Staircase No. 1* (1911), only to be followed by Duchamp's full-sized photographic and hand-colored facsimile entitled *Nude Descending a Staircase No. 3* (1916), which is further reproduced as a miniature pencil and ink drawing entitled *Nude . . . No. 4* (1918) for Carrie Settheimer's doll house. Joseph Masheck notes Duchamp's typical reliance on

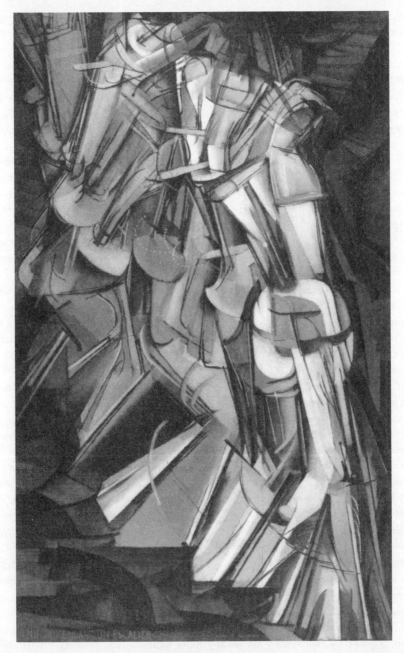

Figure 3.1: Marcel Duchamp, *Nude Descending a Staircase No. 2* (1912). Philadelphia Museum of Art: The Louise and Walter Arensberg Collection

photography as a way of returning to the technical sources of the "original" painting.[10] This self-illustrative and self-reproductive aspect of Duchamp's series *Nude Descending a Staircase* demonstrates his efforts to redefine the notion of pictorial production, by exploring the notion of seriality, both as a generative device based on reproduction and as a temporalizing device, insofar as the notion of the series comprises temporal intervals. This attempt to redefine the pictorial through its serial deployment recalls Duchamp's earlier training and interest in engraving. Engraving is one of the earliest forms of mechanical reproduction that involves a different way of conceiving the plastic image. Not only is the visual appearance of the engraved image the result of multiple reproductions, but its very identity as an image is defined through a technical process, involving a set of temporal intervals or delays. Engraving as a medium challenges the autonomy of the pictorial image, insofar as the image acts as temporal record of multiple impressions. Duchamp's use of self-reproduction in the *Nude Descending a Staircase* series suggests his interest in engraving as a way of challenging both the uniqueness of paintings and conventional notions of pictorial production.

Duchamp began working on ready-mades in 1913, but these works were initially relegated to the privacy of Duchamp's studio.[11] It took Duchamp several years not only to label them as ready-mades, but also to realize their conceptual potential in usurping the notion of art objects. According to Duchamp, the label *ready-made* seemed perfect for "these things that weren't works of art, that weren't sketches, and to which no art terms apply" (*DMD*, 48). Through the gesture of exhibiting these mass-produced objects as art objects, Duchamp exposes the conditions of possibility of art. The ready-made is a visual lure; it is the perfect copy of an object, since it *is* the object itself.[12] By displaying actual objects, rather than representations of objects, Duchamp is undermining the mimetic impulses associated with conventional painting. The task of painting to represent the world is now literalized in the presentation of actual objects, whose prosaic and anartistic character challenge our very understanding of the meaning of art as a representational system. It is precisely the visual redundancy of the object to that which it represents, that expropriates the object of its proper character, so that it can function as a punning hinge, undecidably an object and/or art object. Rather than postulating art as a form of expression, Duchamp uncovers the fact that art inheres less in the object itself than in the institutional context that frames it and makes it legible. The ready-made stages the gratuitous conversion of an ordinary object into a work of art, while undermining through this very gesture the notion of an art object.

Although the ready-mades initially appear as the total denial and abandonment of painting, since they are mass-produced industrial objects, I will argue that they continue to engage conceptually and draw upon painting. But the question is: how? Duchamp's claim that, "The choice of ready-mades is always based on visual indifference and, at the same time, on the total absence of good and bad taste" (*DMD*, 48), suggests his radical denial of both pictorial and artistic criteria. However, this "visual indifference" and lack of taste as regards the choice of the object does not necessarily imply a conceptual indifference. I will briefly examine some ready-mades to make my point. His *Bottle Dryer*

(*Égouttoir*, 1914) reflects, in the punning nature of its French title, Duchamp's rejection of taste (*goût*, in Fr.) and his gesture of flushing art down the drain (since *égout* means drain or sewer, in Fr.). But why a bottle dryer? The answer lies in his comment on the *Chocolate Grinder* (1914), where he explains: "I couldn't go into the haphazard drawing or the paintings, the splashing of paint. I wanted to go back to a completely *dry* drawing, a *dry* conception of art. . . . And the mechanical drawing for me was the best form for that dry conception of art" (*DMD*, 130). Duchamp's desire for a "dry conception of art" is punningly literalized in the *Bottle Dryer*, a work which, unlike the *Chocolate Grinder*, is not a mechanical drawing, but an actual industrial prototype. As an instance of "dry art," this work references painting to the extent that it suggests that painting may be relieved of its material properties as a liquid medium by being hung out to dry. The *Bottle Dryer* drains painting of the "splashing of paint," while alluding to its former condition as a wet medium.

If this interpretation may appear a little far-fetched, let's test it against another work *In Advance of the Broken Arm* (1915), a suspended snow shovel of galvanized iron. Given Duchamp's reluctance to invoke the intervention of the hand, in the case of the ready-mades, this work alludes precisely to what Duchamp had decried in the case of painting, the intervention of the artist's hand (*la patte*, or paw). Duchamp's denunciation of the hand is tied to his efforts to redefine painting and art as conceptual, rather than purely manual practices. Why then is the arm broken in the title and what does it have to do with a suspended snow shovel? The answer to this question lies in another work *Comb* (*Peigne*, 1916), a grey steel comb marked with the punning inscription "3 or 4 drops of height (or odor) have nothing to do (or make, or iron) with savagery" (*3 ou 4 gouttes d'hauteur n'ont rien faire avec la sauvagerie*). Why a comb, you may ask? The title of this work in French provides the answer, to the extent that the word for "comb" (*peigne*) is also the subjunctive of "to paint" in French (*que je peigne*), meaning I ought to or should paint. In other words, this work expresses Duchamp's supposed obligation to paint as a gesture that he considers only to lay aside. The fact that he no longer paints does not mean, however, that he is not engaged in another gesture of making (*faire*). For while he refuses the splashing of paint and the "intoxication of turpentine" (ref. to inscription, 3 or 4 drops of odor), he is engaged in another form of making (*faire*) which is conceptual in nature, hence the inscription of savagery. Appropriating the iron (*fer*) comb, which he did not make (*faire*), Duchamp redeploys it through the addition of a title and an inscription alluding to painting. This gesture of making involves his "drawing" upon painting, delaying pictoriality through the visual and verbal redundancy of an object that holds it at bay.[13] If the arm is broken in *In Advance of the Broken Arm*, we now learn why and how. For this ready-made holds painting at an arm's length as it attempts to redefine it as a conceptual operation. But why the snow shovel, you may ask? The snow shovel alludes to the basic condition of painting: like snow it is a wet medium which achieves its realization as art once it dries. These ready-mades embody the postponement of art's pictorial becoming, since their humorous "dry" nature, as mass-produced objects lacking any artistic character, nonetheless continues to reference the activity of painting.

In *Fountain* (1917; photograph of lost original by Alfred Stieglitz), the strategic 90-degrees rotation of a lavatory urinal and its placement on a pedestal invalidates its functional role as a machine for waterworks and establishes it as yet another instance of "dry art."[14] Renamed the "Buddha of the Bathroom" or the "Madonna of the Bathroom" due to the shape and the shadow on the photograph urinal suggesting a veil, the isolation of this plumbing fixture evokes bodily associations: the evanescent odor of the urinal continues to haunt the metaphorical fountain. However, rather than merely referencing the body, this olfactory condition also alludes to the possibility of painting insofar as it is the "dried" imprint of a "wet" medium, bearing the fleeting odor of turpentine.

But this initial allusion to painting is also reinforced by the reproducible character of this work. Since it is mass-produced, *Fountain* shares with the other ready-mades the fate of being a perfect copy, an antidote to pictorial representation. Its serial reproduction through molds makes it difficult to distinguish from an original, thereby undermining the representational impulses of painting. Duchamp takes on this question of difference between an original and its copy, not in the context of art but that of mass production, by elaborating the notion of the *infra-thin*: "The difference/ (dimensional) between/ 2 mass-produced objects/ [from the same mold]/ is an infra thin/ when the maximum(?)/ precision is/ obtained" (*Notes*, 18). The reproduction and, hence, repetition of the object generates an infinitesimal difference making this object more or less similar to itself. As Duchamp explains, "In Time the same object is not the/ same after a 1 second interval – what/ Relations with the identity principle?" (*Notes*, 7). By drawing our attention to the temporal dimension involved in the process of mass production, Duchamp inscribes a delay, an infra-thin difference, into the principle of identity. This inscription of a temporal dimension disrupts the immediacy of the object, just as the title *Fountain* delays the spectator's expectations regarding the urinal as a receptacle.

But for Duchamp, the notion of the *infra-thin*, as the infinitesimal difference that distinguishes an object from its mold, also has gender implications insofar as he designates their separation: "separation has the 2 senses male and female" (*Notes*, 9). Although it represents the quintessential male instrument, the urinal as a mold also contains the potential inscription of femininity, reinforced by its oval shape as a receptacle.[15] The reversibility of gender that he scripts in the intimate space separating an object from its mold radicalizes the notion of reproduction through the deployment of gender. Gender emerges as an effect of the play of minute differences, a rhetorical condition that opens up the referential status of these terms. Duchamp's manipulations involving reproduction delay the advent of painting, both as gendered subject matter and as medium, by instantiating this conceptual destiny in industrial objects whose anartistic nature interrogates the premises that underlie the constitution of art objects.

These ready-mades embody the postponement of the pictorial becoming of art, insofar as they are instances of dry art that evoke, through their dehydrated condition, the wetness and splashing of painting now left behind. Duchamp's discovery of the ready-mades emerges as a chess-like move to outwit Cubism, not by turning to abstraction, but by abstracting the object through its literal reproduction also understood as a delay tactic.[16] Duchamp's strategic move

literalizes the mimetic aspirations of painting while outwitting it as a represen-
tational medium. He undermines pictorial mimesis by substituting mass-
produced objects for represented ones. In so doing, he reduces mimesis to a
mechanical convention whose non-artisanal character coincides with the indus-
trial prototype. Duchamp's reproductive strategy disfigures through exact pre-
sentation the notion of pictorial representation founded on mimesis. Thus the
ready-mades continue to "draw" upon painting, even as their reproducible
character challenges the meaning of painting, and ultimately of art.

Concurrent with his elaboration of the ready-mades, Duchamp produced *The
Bride Stripped Bare by Her Bachelors, Even*, also known as *The Large Glass* (1915–
23; a multi-media work that combines oil, varnish, lead foil and wire, and dust
on glass mounted between two glass panels). Considered as one of the master-
pieces of twentieth-century art, and as the summation of the Duchampian
corpus, this work comes to mark Duchamp's radical break and abandonment of
both painting and conventional art.[17] His comments on *The Large Glass* under-
line his desire to abandon oil painting and the artistic conventions it involves:
"From Munich on, I had the idea of the Large Glass. I was finished with Cubism
and with movement – at least movement mixed up with oil paint. The whole
trend of painting was something I don't care to continue. After ten years of
painting I was bored with it. . . ."[18] Duchamp's desire to strip painting bare by
transposing imprints of his pictorial works to glass leads to the redefinition of
this work as a strategy of delays. This work defines a passage through painting
as it is being reconceptualized through reproduction, that is, a process of
drawing upon painting as a way of challenging pictorial conventions and the
confines of pictorial space.

The subtitle of *The Large Glass*, "Delay in Glass" (*Retard en Verre*), attests to
Duchamp's continued efforts to move beyond the notion of painting by
refusing to assimilate this work to a "picture on glass":

> Use "delay" instead of picture or painting; picture on glass becomes delay
> in glass – but delay in glass does not mean picture on glass – It's merely a
> way of succeeding in no longer thinking that the thing in question is a
> picture – to make a "delay" of it in the most general way possible, not so
> much in the different meanings in which "delay" can be taken, but rather
> in their indecisive reunion "delay" – /. (*WMD*, 26)

Duchamp introduces the notion of delay as a way of holding both painting and
pictorial conventions at bay. This strategy of postponement does not involve
the mere transposition of painting into another medium, but rather, the delay
of the pictorial by impeding its becoming a picture. Duchamp's deliberate
choice of glass as a medium functions to remind the viewer of the mimetic
impulses of painting, insofar as it sought to provide a window onto the world.
However, by literalizing this ambition through transparency, Duchamp denies
one of the signatory marks of painting, that of figure–ground relations. He
reduces the notion of pictorial background to a ready-made, one that changes
with the position of the glass. The referential relations between figure and
background now emerge as no longer internal to the logic of the image, but as a

product of its chance encounters with the world. This gesture liberates the subject matter of painting, the figure, from its referential relations to painting, as well as, redefining it as an allegorical apparition that recalls pictorial conventions only to suspend their pictorial becoming.

The Large Glass (Figure 3.2) is divided into two regions, separated by three fins of glass perpendicular to the plane of the work, that are described by Duchamp as belonging respectively to the Bride and the Bachelors (*WMD*, 39).[19] Both of these regions are generated as reflections and projections of his previous pictorial works: the literal transposition of the Munich *Bride* (1912; oil on canvas) and *The Chocolate Grinder, No. 2* (1914; oil with thread on canvas) on the upper and lower panels of the *Glass*, respectively. The Pendu femelle is a visual excerpt, a silhoutte cut-out of Duchamp's finger-painted *Bride*. Duchamp had attempted to print the Pendu femelle by projecting a negative of the *Bride* onto the surface of the glass treated with a photosensitive emulsion. Since this print did not develop properly, Duchamp used lead fuse wire to draw the silhouette, which he painted in by using gradations of black and white, so as to simulate a photograph of the *Bride*. The deployment of these elaborate technical strategies for reproducing the *Bride* on glass, not in its original colors, but as a black-and-white photograph, draw attention to the material and technical conditions of its production as a reproduction. Duchamp's efforts to strip bare painting coincide with a strategy of reproduction of the *Bride*, one that delays its pictorial becoming through its deferral as a series of impressions engraved on glass.

Such a conclusion might seem far-fetched, were it not to be understood in light of Duchamp's consistent efforts to challenge the painting by rethinking it as a function of different media of mechanical reproduction such as engraving, photography, and cinema. These allusions are reinforced in The Top Inscription, grafted onto the Bride, which is described as "cinematic blossoming (controlled by electrical stripping)" (*WMD*, 42). This section contains the Draft Pistons, three exposures that are recorded imprints of transpositions of photographs of a plane of square gauze that is molded into different shapes by the movement of air drafts. These elaborate transpositions emphasize Duchamp's efforts to question the pictorial image, since his attempt to draw upon the painted *Bride* by her literal transposition onto the *Glass* delays its impact as pictorial event. The redundancy of the *Bride*, achieved through reproduction, derealizes her pictorial uniqueness, by presenting her, not as a unique entity, but as a multiple. The very fidelity of her reproduction on glass reflects back upon the pictorial original to undermine its unique identity. The reproduction of the *Bride* is a perfect projection, insofar as it involves literal transposition, but, given the reversibility of the glass, fidelity emerges as a pun, with an ironic twist. Duchamp literalizes the dilemma of painting in the age of mechanical reproduction by putting it in front of a mirror, but this "mirror effect" entailed in reproduction is used to undermine its pictorial premises.

In the lower half of *The Large Glass* known as The Bachelor Apparatus, Duchamp's reproduction of *Chocolate Grinder, No. 2* (1914) serves to reiterate his desire to abandon painting. The significance of this work resides in the fact that it led him to think that he could "avoid all contact with traditional

Figure 3.2: Marcel Duchamp, *The Bride Stripped Bare by Her Bachelors, Even* (*The Large Glass*) (1915–23). Philadelphia Museum of Art: Bequest of Katherine S. Dreier

painting" (*DMD*, 37). An instance of Duchamp's interest in mechanical draw-ing, this work represents the beginning of his investigation of a "dry form of art," that would rival through its mechanical qualities the visual immediacy of painting.[20] Duchamp's interest in the chocolate grinder also reflects an allusion to both painting and pigment, since "The bachelor grinds chocolate himself" (*WMD*, 68). As a powder that can be molded into different shapes, chocolate enables him to conceive of color not as a material pigment, but as a conceptual projection, an "apparition in the negative" (*WMD*, 70). These reflections attest to his efforts to question and move beyond the conventional notion of color, by seeking to dry out its pictorial intent.

The lower region of the *Glass* contains several other examples of the effort to redefine color as a function of various mechanisms of projection, since according to Duchamp "perspective resembles color" (*WMD*, 87). Above the Chocolate Grinder are the Sieves or Parasols, seven cones traditionally used in treatises on perspective to construct or correct visual distortion. Their presence alludes to Duchamp's attempts to correct the immediacy of the visual, by revealing it as a construct, as the delayed effect of projection. The coloration of these cones is based on dust that was raised or "bred" over several months and then fixed. Duchamp's use of this "dry" non-pictorial dust in order to generate belatedly the "effect" of color thus emerges as a projection of time rather than pigment. The "dry" nature of this enterprise postpones the liquidity of paint. The Oculist Witnesses, a set of three reproduced oculist charts to the right of the Sieves, are engraved as silvered, shimmering rings. They bear witness to the potential dangers of pictorial vision, when its mediated character as a mechanism of projection is left unexamined. They are described in terms of their reflective potential, since they bounce up "mirrorically" as splashing drops to the upper region of the Glass, known as Nine Shots. This group of nine holes drilled into the glass was generated by the imprint left by shooting matches dipped in paint from a toy cannon. These potshots at painting target a point that "*corresponds* to the vanishing point (in perspective)" (*WMD*, 35), thereby alluding to the possibility of rethinking color from the modality of perspective. Describing the section of Oculist Witnesses as a "Mirrorical return" (*WMD*, 65), Duchamp underlines the mechanisms of projection in *The Large Glass* by playing on notions of reflection and reversibility. In so doing, he reifies painting by "drying out" its material content through conceptual operations.

While in fact Duchamp's *Large Glass* radically breaks with previous pictorial traditions, the irony is that Duchamp's reproductions of his pictorial works redefine the *Glass* as a compendium of his previous efforts. Distancing itself from the tradition, the *Glass* delays through reproduction the pictorial logic of his former works. If *The Large Glass* has been called a "delay in glass," this inscription of temporality into the work is not purely of a phenomenological order. Rather, it represents his effort to inscribe a historical and conceptual dimension into both painting and conventional art as a whole. It temporalizes both the visual construction and consumption of the work by postponing and thus delaying its retinal impact. This inscription of temporality also coincides with Duchamp's deployment of the reiterative logic of reproduction, as a repe-tition that takes the form of differential play. Recalling Nietzsche's critique of

representation as elaborated through the notion of the eternal return, the production of a new work is redefined in the mode of "appropriation," strategically drawing upon previous artistic traditions. By valorizing the notion of reproduction and the multiple, Duchamp inscribes into the artwork a deferral or postponement that opens the work to posterity, to forms of future speculative appropriation and expenditure. Duchamp's redefinition of the artwork in the mode of reproduction and appropriation opens up the horizon of art as a strategic field of production. Thus Duchamp's postmodernism emerges less as a development in a historical progression, than as a premise whose history is already posted in modernism itself.

4

WHEN LESS IS MORE, MORE OR LESS

SUBTRACTION AND ADDITION IN (POST)MODERNIST POETICS

Peter Williams

Under the gaze of the aesthetics of modernism the movement known as minimalism in the arts can occupy only a marginal position. The specific minimalist works of painting and poetry that this essay will reflect on offer a unique encounter between modernist theory and postmodern critique, at the point where a totalizing aesthetic has the effect of obscuring art forms that inhabit domains beyond the framework of reason. From the perspective of modernism's dream of universal judgment, minimalism shows up as "impoverished," "indeterminate," in art as "a species of comment upon picture making."[1] Negatively sublime and sublimely negative, these works play upon an interrogation of the habits of cognition embraced and celebrated by modernity. In short, they invite an antiaesthetics of the unpresentable. Before turning to works by Frank Stella and Agnes Martin, Robert Creeley, John Ashbery, and Samuel Beckett, we may recall briefly Nietzsche's familiar diagnosis of the pathology of modernisms.

In modernism, Nietzsche recognized, and postmodernism recognizes, a dissociation of intelligence and sense, the mind and the body, morality and motivation which threatens our capacity to apprehend the world directly and leads to an existence of "fair illusions" and the preference of thought over being. *The Birth of Tragedy* traces the causes of this pathology back to the Socratic influence that emerged in classical Athenian culture which involved an idealization of the world in a movement of thought away from the world as directly perceived and felt.[2] And, in a parallel substitution, what was found by abstract thought behind or beyond the sensuously present, that is, that which was intelligible, was foregrounded as "the real." Understanding thereby replaced the immediacy of sensuous experience as providing the criteria of reality and, according to Nietzsche, this Socratism turned life into a solvable puzzle.

Understanding, according to postmodernist critique, is fundamentally an act

of intellectual appropriation. Consciousness inhabits a position from which a text or work of art makes sense, from which "authoritative" understanding may "master" or "overcome" the work.[3] This translation of enigma into the already known reduces the alterity of the world to identity, as consciousness expands to grasp what is foreign or alien. Thus alterity reduces to homogeneity and the world becomes the unconscious domain of a subject whose act of understanding colonizes the space of alterity and collapses that complex and three-dimensional space into the reassuring two dimensions of a mirror. Hence, to understand a work of art is to subsume it under a law.

Every case of understanding is an exercise in cartography that redraws an alien terrain to make it an extension of familiar space. In the process the alterity constitutive of the world becomes a Lacanian Imaginary for the subject, who can then think of the world as his or her own. This process, called "reason" by modernity and "determining judgment" by Kant, belongs to the Enlighten-ment project and gained authority in a neo-Cartesian, self-evident way. The authoritative framework of reason is conventionally taken as real, for reality in a world, like realism in a picture or painting, is employed by common sense and endorsed by habit. Postmodernist versions of irony have played upon this nat-uralization of the habitual and resulted in a proliferation of maps for many more terrains. The irony in postmodernist irony is that recognizing alternative frameworks, however liberating and suggestive of new avenues of exploration and inquiry, builds no worlds. As Nelson Goodman points out, "Mere acknow-ledgment of the many available frames of reference provides us with no map of the motions of heavenly bodies; acceptance of the eligibility of alternative bases produces no scientific theory or philosophical system; awareness of varied ways of seeing paints no pictures."[4]

While drawing attention to the need for a postmodern aesthetics, here we may only note the contemporaneous rejection of the formal innovation and experimentation of modernity itself in favor of a "subtracted postmodernism," a postmodernism stripped bare that is not a condition of our modernism, but is rather constituted by its rejection of the modernist project itself. On the level of representation, the deep structures and psychological labyrinths of modernist and romantic symbolic systems that stood as a test of the reader's interpretive fortitude are replaced by the literalness of surfaces and the confrontation with positive form, bulked space, that is phenomenologically bound with the actual-ity of what Heidegger terms "thingness." And in a parallel movement, the notion of consciousness is redirected away from its humanistic casting as an autonomous self-awareness pivoting on its own rationality towards the notion of consciousness as centerless, awaiting engagement with and orientation by things in the world.

Postmodernism attempts to articulate an immediacy of sensory apprehension that is older than judgment, in a language that breaks with the deep structures and totalizing theory of the conscious subject. Hegel's critique of the vanity of consciousness describes its "conceit which understands how to belittle every truth, in order to turn back on itself and gloat over its own understanding, which knows how to dissolve every thought and always find the same barren Ego instead of any content. . . ."[5] Postmodernism can embrace immediacy as

the ground for representationally subtracted works of literary and plastic art. By casting the notion of thingness in its weaker version of sense-certainty, understanding is confounded in its pursuit of mastery and determinate rationality by a kind of Derridean *differance* that focuses on language as the middle term. Hegel focuses, for example, on the Now: the now that is night, countered by the same now that is day:

> The Now that is Night is *preserved*, i.e. it is treated as what it professes to be, as something that it *is*; but it proves itself to be, on the contrary, something that it is *not*. The Now does indeed preserve itself, but as something that is *not* Night; equally, it preserves itself in face of the Day that it now is, as something that is also not day, in other words, as a *negative* in general. (PS, 60)

While Hegel points out that the Now is a negative not entirely immediate but mediated by the fact that it is not something else, he also aligns its indifference to temporal determinacies since it is the same Now that it was before. This indifference and simplicity, Hegel considers, are the concrete qualities of a universal that is "the true [content] of sense certainty." For Hegel, the Now is better apprehended than comprehended.

Hegel's alignment of language and sense-certainty anticipates the texture and density of the postmodern concentration upon language as a way of questioning representational categories. Indeed, Hegel later returns to language as the bearer of the truth and "sincerity" of the speaker's collective "spirit" for others. Whereas "moral consciousness" has presented itself as "still dumb, shut up within itself within its inner life," Hegel now asserts that "language . . . emerges as the middle term, mediating between independent and acknowledged self-consciousnesses; and the *existent self* is immediately universal acknowledgment" (PS, 395). The social dimension of this inward spirit of the "ethical paradigm" emerges more fully with Hegel's qualification of it as "law and simple command" (PS, 396). Thus language emerges as a more or less explicitly performative praxis rather than as a referential form. Rather than signifying or representing "meanings," language, for Hegel, enacts social values.

Hegel, along with the rest of us, knows that nothing is simply "given." There are no uninterpreted experiences, so sense-certainty fulfills only a limited function. But as a theory about the nature of reality, namely, that what is most real is particular objects, sense-certainty can constitute a positive ground for a postmodernist poetics attempting to articulate the Now without recourse to modernity's passion for universality. As a concrete form of this poetics, minimalism was a harbinger of a new aesthetics. It brought narrative and the articulation of understanding to the limits of figurative language. By apprehending the flat, recalcitrant surfaces of minimalist artworks and the repetitious and mutated grammar of minimalist literature, minimalism embraces the Now by linking postmodernity's hostility to narrative with the substitution of sense-certainty for understanding.

In the visual arts, minimalist artists such as Frank Stella and Agnes Martin made paintings that censured the rhetorical habits engendered by Abstract Expressionism which, they claimed, relied upon ways of talking about art and the world that were deceptive and sentimental. By subtracting all representational elements from their work and then embracing grids of flat, undifferentiated surfaces, Stella and Martin resisted the "loose" finish and make-or-break improvisation in paintings by artists such as Pollock, Kline, and De Kooning. Their work corresponded too conveniently to that inner condition articulated by Sartre that became the staple of liberal humanism, of oneself as perpetually unfinished or in a constant state of "becoming." By resolving pictorial finish methodically and definitely, Stella abolished the sites of resonance between the viewer's search for understanding and the ambiguous vulnerability that dominated modernist forms of representation. In particular, Stella moved to thwart the tendency of those who sought to find humanistic values on the canvas by subtracting every pictorial element that could be considered representational: "If you pin them down, they always end up asserting that there is something there besides the paint on the canvas. My painting is based on the fact that only what can be seen there *is* there."[6]

As if to provide concrete counter-examples to Adorno's claim that "in every work of art something appears that does not exist," Stella's black paintings and the succeeding series done in metallic paints deny the viewer access to an inner or virtual dimension of the art object.[7] No matter where one tries to see beyond the surface of a canvas like *The Marriage of Reason and Squalor*, the eye is shunted to the periphery of the painting – to the bounds of the object – by the grooves of exposed canvas separating the bands of black. Stella further emphasized his paintings' non-representational qualities by mounting some of his canvases on stretchers as thick as the stripes are wide. In these simple ways, he proposed blunt new relations between the viewer's awareness of the painting as a fabricated thing, and his or her confidence in it as a bearer of "meaning." By complicating and refining relations between the surface pattern and the external shape of each canvas, Stella forces us to see the object *as* the idea by denying signification any ground other than that identical with the object's physical presence.

Nothing is more hostile to narrative than the regularity and repeatability of geometry, and Stella and Martin both employed geometric compositions to emphasize the flatness of surfaces as a way of emptying their works of all allegorical content. When we look at Martin's *Night Sea*, for example, we confront an apparently empty, grid-like surface of pale blue, broken up regularly and repetitively by strictly measured grids of golden axes – a flattened, geometric space that crowds out any dimensions of the real and replaces them with the lateral spread of a single surface. By reading the grammar of that surface, we can see how minimalist use of representational subtraction demonstrates that flatness, like the circle, is an abstraction that can be represented but which never has an equivalent existence in descriptive language.

Unlike traditional perspective, Martin's grid does not map the space of a room or a landscape or a group of figures onto the surface of a painting. If it maps anything, it maps the surface of the painting itself. It is a transfer in

which nothing changes place so that, roughly speaking, the physical qualities of the surface are mapped onto the aesthetic qualities of the same surface. And these two planes, the physical and the aesthetic, are demonstrated to be the same plane; co-extensive, and through the abscissae and ordinates of the grid, co-ordinate. Considered this way, Martin's *Night Sea* is naked and determined materialism which orients all our attention to surfaces.

The optics of this attention are of a bivalent structure that encourages our eye to travel outward from the work, compelling us to acknowledge the world beyond the frame. Starting from any point on the canvas and traveling centrifugally, the eye tracks gold leaf lines either vertically or horizontally over the different distillations of blue to the frame and then, involuntarily, beyond. The painting itself, then, becomes a fragment, a small piece cropped from an infinitely larger fragment. At the same time, the reciprocal axis operates. A centripetal reading that moves from the outer limits of the painting inward leads the eye to an obfuscating crisscrossing of lines which are a constant re-presentation of everything separating *Night Sea* from the world, from ambient space and other objects. It is an introjection of the boundaries of the world into the interior of the work, and it is a mapping of the space inside the frame onto itself.

Like the painters Stella and Martin, postmodern poet Robert Creeley refuses to adopt poetic forms derivative from modernist poetic traditions. Creeley turned to a literalist aesthetics in order to evade the deep structure and symbolic forms so fundamental to his modernist forebears. His was an alternative way of realizing ideals of poetry as a particular form of understanding that falls beyond rational categories and determining judgement. Poems such as "The Language" point to nothing outside themselves, existing instead as sinuous and self-sufficient gestures that simply respond to the poet's formal choices.

Locate *I*
love you some-
where in

teeth and
eyes, bite
it but

take care not
to hurt, you
want so

much so
little. Words
say everything.

I
love you
again,

> then what
> is emptiness
> for. To
>
> fill, fill.
> I heard words
> and words full
>
> of holes
> aching. Speech
> is a mouth.[8]

Like Martin's grids, this poem rejects any descriptive act, any act that leaves the object of attention outside the poem, in favor of an exploration of immediate sensation. Creeley employs the different tendencies of a predominantly associational disposition to deflect our attention from any transcendent qualities of the language toward the sensation of speech emerging from the textures and details of sensuous experience. The poem's language is not self-referential, but often oblique and evocative rather than direct and descriptive. And the surprising conjunction of images, combined with a fullness in the first four stanzas and an emptiness in the second four, exemplifies a movement between presence and absence that rhymes with the inward and outward movement of Martin's grids. Both compose a text of the sensuous world by seizing upon the perspectives of particular bodily phenomena. "I love you" does not then presuppose thought or cognitive activity, and it is not the representation of some inner workings. The language *is* the thought because for Creeley, thought without language is empty.

The affect of Creeley's words is gained simply from their location in a context of particular associations, and their meaning must be formed by a kind of deduction I would term a "gestural meaning" immanent in speech which, in this case, assumes the palpability of "a mouth." Here is minimalism at its purest, exemplifying the capacity to mine the resources of grammar without elaborating complex and abstract interpretive structures. What matters is the present – not cast in terms of some metaphysical absolute, but as the locus of particular trajectories of association that are emptied of value if forced to deal with suprasensible questions. These processes do not entail the relativism or indeterminacy so often embraced by postmodernist theory, but simply the recognition that we can base our thinking about sense-certainty on our capacity to feel the difference between the language as a descriptive category and language as an immediate expression by an embodied being in the phenomenal world.

One could then say that minimalism embraces the Now by reducing the range of the meaning-to-say from the said. This strategy of representational subtraction marks a crucial shift in an aesthetic sensibility away from modernist conceptions of the artist or writer – autonomy, expressiveness, creativity – and toward the potential of the chosen medium to shape artistic outcomes. Ashbery calls this movement "leaving out,"

I thought that if I could put it all down, that would be one way. And next
the thought came to me that to leave all out would be another, and truer, way
 clean washed sea
 The flowers were
These are examples of leaving out.[9]

This leaving-out is the emblem for a postmodern poetics that moves away from
content and representational detail toward an intentional frame of reference
where the understanding or sense of an object gathers from the connotations it
generates. Accompanying this shift is an aesthetic recognizing the positive
value of a precipitant vacuum created by the subtracted form. The aesthetic
domain once occupied by the modern disposition to universal judgment gives
way to the subjective texture of the time it takes to reconcile oneself to the
minimalist object's true and complete emptiness. The subject's inhabiting of
time thus displaces her inhabiting of space; so thematization, tied as it is to the
particulars of spatial detail, assumes a secondary importance to sensory
provocation.

Samuel Beckett's "Still" is another minimalist text where the syntax takes on
extreme forms of contraction and expansion.[10] "Still" begins with an ironic
weather report: "Bright at last close of day the sun shines out at last and goes
down." This first sentence verbally mimes the stillness of the entire text in a
stasis of verbatim repetition ("at last") and redundancy ("sun shines out" repeats
"bright"). These condensed sentences subtract many parts of speech and often
omit articles and the pronoun "I," as in "Even get up certain moods and go
stand by western window. . . ." A man who usually sits still follows the sun's
semi-circular path with his head and eyes, as the word still is repeated 24 times
(the number of hours in a day?), reminding us of the sun's cycle. The minimal
gestures of the character's hand rhymes with the course of the sun as it "rises"
and then "hangs" as if to "sink."

Physical movements in "Still" are mechanical, while all human positions are
angular and precise as if to echo the minimalist emphasis upon geometry.
Because the protagonist sits in a chair constantly facing south, he must turn his
head 90 degrees to see the sun setting in the west. At all times, arms are bent at
right angles to lie along the armrest; legs are "broken right angles at knees";
trunk is straight and therefore at right angles to the thighs. With the absence of
personal pronouns, the composition of these discrete body fragments fails to
constitute a whole being who is undeniably present. And while the character
appears static, "close inspection" reveals that he trembles all over and that his
breast rises and falls with his breathing.

In order to make sense of "Still," we are compelled to pay close attention to
its subtracted grammar, which gives the added impression of stasis because of
the numerous participles (watching, staring, standing, sinking, fading) and the
reiteration of the word "still" as seven sentences begin with variations of "quite
still." Also, reiterations of "here" and "same place same position," of "now" and
"always" give the illusion of stillness in space and time; and recurrence of the
adverbs "normally" and "again" also suggest a regular daily cycle. Cycles and
orbits operate within the grammar itself, where identical phrases reappear for

the second and third descriptions of the armchair, "small upright wicker chair with armrests." And when the body undergoes its examination, the syntactic form as well as the figure's form stays in place as three consecutive sentences begin: "Legs side by side . . .," "Trunk likewise . . .," "Arms likewise . . .," ("Still," 48). The narrator self-mockingly exaggerates the cyclical quality of his descriptions of the hand with "etc." and "ditto" (". . . hangs there trembling as if half inclined etc.," "thumb on outer edge of right socket index ditto").

Yet the language, apparently still, does move somewhat as subtle modulations make the prose tremble. Semantic shifts occur when various denotations and connotations dwell within repeated words; for example, still, among its other meanings, can measure degree, as in "less light still" (compare "even less light"). Thus we have difference underneath a superficial sameness as the reiterated "still" adapts to its varied linguistic contexts. The title word itself never actually stays still, recurring everywhere as a different part of speech: here an adverb, here an adjective, here a noun; the word is shifty and unstable, offering both density and flexibility of meaning.

It is tempting to say that the linguistic features of "Still," identified above, are motivated by the narrative task at hand: Beckett is attempting to depict very subtle and cyclical movements of a character through very slight shifts in the prose. "Still" therefore evokes a near-static world in a near-static grammar; what minimal movement is possible occurs in fragmented phrases and in slow motion, in the illusion of change produced by successive frames. Such a description, however, may be too neatly analogical when one considers the burden of Beckett's task and when one recognizes that in the transposition of the kinetic into the grammatical, syntax sometimes breaks down. Instead, the narrator explicitly communicates the impossibility of his linguistic challenge. In perhaps the most coherent sentence of the piece he says, "Quite still then all this time eyes open when discovered then closed then opened and closed again no other movement any kind of course not still at all when suddenly or so it looks like this movement impossible to follow let alone describe" ("Still," 49). Either the immediacy of stillness is impossible, or it is impossible to follow or capture in language. The piece closes reverberating with three renditions of the title word: no change over time (the character still sitting), no movement (sitting still), and no sounds (stillness).

These works of art are marginal: they question the categories by which we define them, subordinating form or genre to the potentials and limits of their media to shape aesthetic effect. And it is in the play of these limits and potentials in the form of representational subtraction that their gestural surfaces are created. Creeley's language, for example, dissolves the notion of language as a medium of expression for articulating an understanding of the "self" or what lies outside and beyond it. And in *Company*, Beckett claims that such understanding, in the form of mental activity, must be kept at a low level: "In order to be company, he must display a certain mental activity. But it need not be of a high order. Indeed, it might be argued that the lower the order the better. Up to a point. The lower the order of mental activity the better the company. Up to a point."[11] Indeed, Beckett and Martin are fellow travelers because Martin,

expressing a similar fate for understanding, hoped that her use of the grid form encouraged the viewer's eye to participate in an uninterrupted, non-selective "free and easy wandering" conducive to a "holiday state of mind."[12] She suspends the magnetism of understanding in the form of mental activity and substitutes sense-certainty for the firmness of closure and the seduction of thematization. Working with subtraction, and with what Beckett terms "impotence," is then an effective way for postmodernist poetics to position mimetic language as less powerful than phenomenalism. Subtraction and impotence are not only sublimely negative categories for a postmodernist aesthetic of surfaces, but they also provide the basis for a positive critique of the mimetic power of language to substitute for things, and of the conventions that preside over that substitution.

This critique marks the difference between thematization and dramatization or gesture: Beckett dramatizes embodiment with a "midget" grammar; Creeley dramatizes his formal choices by giving love a palpability that can be bitten; Ashbery dramatizes the Now by leaving out. Beckett casts these gestures as "unsaying" – a concern that Emmanuel Levinas defines more generally as the problem of "the attachment of thought to being," identifying the negative dialects of subtraction in the form of "unsaying" as a proper mode of philosophizing.

> I have spoken somewhere of the philosophical *saying* as a saying which is in the necessity of always unsaying itself. I have even made this unsaying a proper mode of philosophizing. I do not deny that philosophy is a knowledge, insofar as it names even what is not nameable, and thematizes what is not thematizable. But in this giving to what breaks with the categories of discourse the form of the *said*, perhaps it impresses onto the said the form of this rupture.[13]

Subtraction, leaving out, and unsaying are broader than an aesthetic interest primarily focused on the use of language in literary representations: these subtractions are, according to Levinas, "a form of the said that breaks with the categories of discourse." And in breaking the categories of discourse, this postmodernist impulse cannot leave modernist literature and art works as they were before. It has shifted the site for the investigation of the relation of words and phenomena from within the structural alternatives provided by genre and its conventions to the exteriority of an epistemic concern with negative knowledge. This is why the minimalist texts I have identified never completely abandon the referential function of words: rather than abstracting representational elements of the language like the moderns, minimalists subtract them. Reading minimalist literature becomes a radical exercise in "unwording" in the same way that reading minimalist artworks becomes a radical exercise in default: no longer the formal articulations of "grammar and syntax" or "figure and ground" but a reduced, positive form, bulked space, that directs our attention towards intentional frames of reference.

How do postmodernist forms of negative knowledge and the critique of understanding align with Hegel's embrace of the nowness of sense-certainty

and his connection of language with social value? If we return to the passage quoted earlier from Ashbery's "The New Spirit," he goes on to say, "These are examples of leaving out. But, forget as we will, something soon comes to stand in their place. Not the truth, perhaps, but – yourself. It is you who made this, therefore you are true. But the truth has passed on." The "you" that stands in for the place of leaving out is the immediate relationship that forms between the poem and its reader which substitutes a conditional, momentary *true* for a metaphysical, suprasensible Truth. This momentary bond is as brief as it is abiding; it consists of the act of subtraction which leads to a sublime excess of affect, or aura, to use Benjamin's term, that alters or sustains a real life by marking the limit point of language and representation. Here, in the Kantian sense, cognitive and imaginative processes inhabit discordant antinomies. For Beckett, this is the point where language encounters silence rather than silence simply being the absence of language; for Creeley, the hesitation of the short lines of "The Language" and the use of enjambment as a conversational technique suggest the graceful stumbles of everyday speech. What is therefore apprehended as the true for postmodernist theory comes into the world as an aspect of language or, in Martin's case, grammar, and this engaged intimacy between representational subtraction and representing consciousness alters the way in which immediate notions of the real are attached to those of the true.

A concentration upon language and the world beyond the frame returns us to Hegel's linking of value and social discourse. Ashbery's insistence upon leaving out plays upon the value of that discourse as strongly as Beckett's midget grammar works as an inverted analogue for an embodied existence in the phenomenal world. The immediacy of this subtracted form is felt in the truth it adds to the common experience of embodied subjectivity, and to what is true for the experience of each embodied subject. This is precisely why the affect of this postmodernist poetics is so strong, and why critics have difficulty conceiving of a positive reading of minimalist works. The density of their disembodied and subtracted surfaces seems to close off emergence at the surface level only, emphasizing instead process as content. The result: a strong sense of presence in these works, delineated by ambiguous zones of representational subtraction.

PART THREE

THE IMPOSSIBLE PLACE OF LITERATURE

INTRODUCTION

The essays in Part Three draw us closer to the gap between literature and the void of its perpetual becoming. Three meditations on the enigma of literary art broach the rift that Blanchot calls "the space of literature": Plato's chora in the drama of the *Timaeus* as the place of literature and point of departure for political ideology, the feeling of boredom and the impossible arrival of Proust's book to come, and the consequences of transforming the representational into the virtual in Cronenberg's film of J. G. Ballard's novel *Crash*.

Max Statkiewicz's "Chora and Character: Mimesis of Difference in Plato's *Timaeus*" renews the dispute between philosophy and *poiesis* in Plato in the context of a new generation of Plato scholarship. Socrates' familiar critique in the *Republic* offers an apparently static image, a tableau of the ideal state, a pattern of silent, motionless figures, mediated by a (repetitive) movement of dialogue. However, the dramatic setting, his repetition of a conversation that occurred earlier in Piraeus, casts doubt on the site of that political ideology. Even as the *Republic* undercuts or displaces its own static images of mimetic truth, in form and in the character of the ironist Socrates, it remains silent on the *topos* of that figure of motion. Two days (in dramatic time) after the *Republic*, the "same" Socrates who had displaced mimesis in a critique of "the tragedians and the rest of the imitative tribe" appears in quite different character. Now he speaks as a "wanderer" and a "vagrant," one who, as Statkiewicz says, moves "on the margin of philosophical and political discourse in the company of the poets and sophists." The question is about the placement of the dis-placed, characterless "character," a mimesis still, but a destablized or decentered mimesis. In a chiasm of chora and character this later Socrates is a spokesman of "errant cause" who is capable of performing difference, a figure of chora dis-posed to interrogate the place of the earlier timeless, paternal, philosophical *topos* from a *topos* of uncertainty.

As Statkiewicz echoes Irigaray's "miming" of mimesis and Kristeva's return to the empty source of the symbolic order, chora becomes a dissembling site, not a concept but a place, yet not *a place*, not even a *dis-placement*, but a *placing*, a "medium in which the images of the eternal paradigm might appear . . . a material support that pre-exists" the poetic. Thus the *Timaeus* evokes the place that both it and the *Republic* require in order to take place. Chora works as a disseminating medium, a feminine space of indeterminacy in which mimetic structures can appear. Statkiewicz not only stresses the maternal or "irreducible materiality" of the chora but shows how it situates mimesis within its

"chiasmic" borders, transforming the mimetic into an unstable place of play, the place of "Platonic theater."

Pierre Lamarche, in "The Place of Boredom: Blanchot Not Reading Proust," brings Blanchot's *Le livre à venir*, the book to come, to Proust's *À la recherche du temps perdu*, a book about how the work "incessantly refuses itself to its author." The issue of temporal disjunction between producing a work, the book to come, and the lethargy of the process, the inability to write the work to come, creates an absence, a suffocating ennui, a "space of literature." Proust's interminable novel opens upon the abyss of its unmaking through "false starts, endless detours, labyrinthine digressions," enacting its own postponement. Lamarche offers a provocative answer to the question that every reader has asked: how can a novel so purposely tedious and monotonous lend a sense of consequence to the "luxurious ennui" itself? And why?

The space of literature in which Proust articulates subjectivity registers as enigma, a feeling of difference interpreted by Bataille and Blanchot as pure passivity. In contrast to a Hegelian active working, this postmodern "disworking" enacts the "unworking," "worklessness," "idleness," and "inertia" of the uneventful. In the famous episode of the madeleine a past feeling is relived, triggering a moment that simultaneously gives and takes back. A haunting, empty, teetering moment, a discontinuous moment of inspiration registers as "boredom" on the centered subject, either Proustian character or the reader. Although boredom in *Either/Or* belongs to an essentialized subject, for Lamarche, boredom is closer to the "it feels" of Barthes' textuality. Such a disruption of irretrievable inspiration also lets the time of narrative appear as uncanny, a "dense, ponderous continuity," a suspension into the void, into the space that art gives. The time of this space irrupts and annihilates the subject, setting him in the rift between world and the boundless other. The space of literature neither yields to the will of the subject to express its own time nor projects a time to come. This moment, Lamarche insists, turns boredom into Blanchot's "emptiness as plenitude," an achievement that he compares with Heidegger's *Grundstimmung* of boredom in everyday life which opens the possibility of living "authentically."

Joel Black's essay "Literature, Film, and Virtuality: Technology's Cutting Edge" enters on the less charted virtualities of the age of technology. It discusses the Cronenberg film of J. G. Ballard's 1973 novel *Crash*. In a narrative that illustrates Perniola's "cybersex," Black examines how both film and novel eroticize the inanimate, locating the erotic in machines and in their capacity for mutilating and destroying the human body. Technology, especially, but not exclusively, the automobile, blurs the distinction between the virtual and the real, and in the film version hazards a disturbing "hyperreal" (including bionic body parts) in which there is *only* the simulacrum. Where the novel stops short of the hyperreal by providing an ethical limit to the erotic charge of machinery and technological violence, the film follows Baudrillard in rejecting the security of the limit. Eroticizing the inanimate transfers passion from the human to the non-human machine, sexual fulfillment only in the presence of the image of technological violence or in the actual wreck itself. In another and equally disturbing displacement, it is not the crash and

death of the famous that excites feeling – the movie stars of the narrative or the Princess Diana of the news media – it is the voyeurism of the crash, the crash *in idea*, as narrated. Baudrillard's decentered models of simulation provoke ambiguous intersections between technology's nonsexuality and the sexuality of its representations.

5

CHORA AND CHARACTER

MIMESIS OF DIFFERENCE IN PLATO'S *TIMAEUS*

Max Statkiewicz

> The difference within mimesis *is* the difference within difference.
>
> Naomi Schor[1]

It is important to determine the place, the status of a margin, since it is only from a margin that margins may be legitimately examined. A margin is, however, an uncertain place, a *topos* of uncertainty. One is bound to lose the sense of boundaries (*margines*, *fines*) when entering a marginal region. A margin is, by definition and paradoxically, indefinite. It marks and blurs the difference between the main corpus (text or body politic) and its outside by dissolving the border (*margo*) of separation. Another place, a place of an other, banished but not released – margin constitutes the dreadful oxymoron of an "internal exile." A place of an other supposed to sanction the identity of the same, it is made to stand (*stehen*) against (*gegen*) the same: objectified. It resists precisely by refusing the status of an *object*, by not offering resistance to the (op)pression of the same, by refusing its own topicality, its proper place. Through its very dis-position a margin can defy the center, cause the fall of an empire. Margin is the most eccentric of places; far from the familiar and domestic: *unheimlich*. It is hardly a place at all, a non-place: *atopos*; not so much topos as "chora," at least the chora of Plato's *Timaeus*, a marginal region *par excellence*. It is the site of an other, an "errant cause," which, as Althusser says, the philosophical logos, the demiurgic philosopher or philosopher king, has never been able to subdue.[2]

Is it not illegitimate to bring together two notions, two words, such as chora and character, under the pretext of a common first letter, a common character?[3] But the letter chi (χ, *khei* or *khi*) is not common; it is a mark of a bringing-together (*sumballein*) of a particular kind, a coupling that at the same time entails a separation (*khōrismos*) and a necessary displacement. Chi symbolizes the intertwining reversal of the chiasm, a rhetorical figure and an ontological and epistemological structure, adopted by Plato in the *Timaeus* and more recently

by Merleau-Ponty in *The Visible and the Invisible*.[4] The chiasm may also be considered, as Derrida has suggested, the privileged pattern of deconstruction in its disrespect for the logic of fixed boundaries, for the rigorous topology of the center and the margins, and for the political typology of assigned places and rehearsed roles.[5]

As a part of the divine mimetic production of the world, the chiasm of the same (*tauton*) and the other or radically different (*thateron*) in the *Timaeus* (36b–c) belongs apparently to the realm of copies, of images. However, when (dis)placed in the context of "errant causality" or chora, it breaks the paradigm/copy opposition and reintroduces theatrical and political mimesis as the place of ideology.

The ideology of places is what connects the *Timaeus* to the politics of the *Republic*, at least if we take seriously Socrates' introductory *mise en scène* of the former. The introduction and the following conversation should be placed, I suggest, in the larger context of the "old dispute" between philosophy and the poetic or mimesis. This context is marked by the frame of Socrates' opening lines in the tenth book of the *Republic*:

> – Speaking in confidence, for I should not like to have my words repeated to the tragedians and the rest of the imitative tribe (*pros . . . hapantas tous mimētikous*) – but I do not mind saying to you all, that all these things seem to be ruinous (*lōbē einai*) as to the judgement of the hearers who do not possess as an antidote (*pharmakon*) a knowledge (*to eidenai*) of how they really are.[6]

The frame is closed by Timaeus' opening lines in the sequel dialogue to the *Timaeus*, the *Critias*:

> . . . if unintentionally I have said anything wrong (*para melos*), I pray that [the god] will impose on me a just retribution, and the just retribution of him who errs is that he should be set right. Wishing, then, to speak truly in future concerning the generation of the gods, I pray him to give me knowledge (*epistēmēn*), which of all medicines (*pharmakōn*) is the most perfect and best. (*Critias*, 106b; Jowett)

The two passages apparently resemble each other in their appeal to knowledge as a *pharmakon against* mimesis. The reduction of ambivalence in the term *pharmakon* among modern translators seems warranted by the characters' general epistemological faith and, in the cited texts, by the opposition between "ruin" (*lōbē*) and "knowledge" in the first citation and between "error" and "knowledge" in the second. Both speakers, Socrates (in the *Republic*) and Timaeus (in the *Critias*), point to knowledge (*to eidenai, epistēmē*) as a proper remedy (*pharmakon*) against the poison (*pharmakon*) of mimesis: drug against poison, drug against drug.

As a matter of fact the word *pharmakon* does not explicitly designate mimesis here, but Socrates does use the word *pharmakon* in other passages of the *Republic* (382c and 389b) to characterize the useful, so-called "non-true lies" (e.g. the

"myth of metals"), included in the category of mimesis; and Timaeus refers to his own *mimetic* (in more than one sense) myth when speaking of a *pharmakon* in the *Critias*. Also, the dramatic setting of our two passages marks the difference and suggests "clearly" the ambivalence of *pharmakon*. Socrates speaks the lines in the *Republic*, the philosopher condemning all imitators. In the *Critias*, the speaker – Timaeus – is himself an imitator, although he is at the same time a philosopher and a politician. Indeed, in his response to Timaeus, Critias maintains, with the approbation of all the participants in the discussion, that "all that is said by any of us can only be an imitation and representation by resemblance and by images (*apeikasia*)" (*Critias*, 107b). The phrase "all of us" designates – with the possible exception of Socrates – philosophers. The association of philosophy with mimesis, the possible exclusion of Socrates from the club of philosophers, this is the end of the world of the *Republic*. What had happened in the meantime? The "beginning of the world" had been (dramatically) narrated by Timaeus.

The composition of the *Timaeus* and *Critias* on the one hand, and that of the *Republic* on the other, are not considered to be contemporaneous in Plato scholarship.[7] Dramatically, however, only two days separate one intellectual conversation from the other, at least if one identifies the discussion summarized by Socrates at the beginning of the *Timaeus* with the one described in the *Republic*.[8] It is true that in Socrates' recapitulation of the earlier conversation concerning the ideal *politeia*, the themes of the old dispute and of mimesis seem to be left out. Socrates goes through "the chief points of the *Republic*" – in Jowett's list: "Separation of classes," "Division of labour," "The double character of the guardians," "Their education," "Community of goods," "The women to share the pursuits of men," "The nuptial lots," "Transposition of good and bad citizens" – without saying a thing about artists and their products, about impersonators, about the moral, political, and ontological shortcomings of mimesis (Jowett, 3–5).

It does not take long, however, for mimesis to reappear. After having evoked the tableau of the (ideal) *Republic*, Socrates points to the insufficiency of such a static picture, to the lack of life in it, lack of action, of drama. The deficiency of the ideal State seems to be paradoxically its "stately" perfection. In the process of catharsis (*Rep.*, 399e) the founders of the republic, the painters of the perfectly self-same tableau (*Rep.*, 500c–e) apparently purified it of all difference, of all motion and of life. Eternal and ideal, sheltered from the contingency of becoming, the *immortal* "heavenly model" (*Rep.*, 592b) is not *viable*. In order to live it has to be incarnated, has to enter the region of corruptible matter, to face death. The timeless and immutable being has to face the time and motion of becoming. The purpose of the *rendezvous* in the *Timaeus*, says Socrates, is to render motion to the *tableau*, to prompt the republic to action, to show it functioning, rendering justice, fighting, etc. Socrates' hosts, the guests of yesterday, are to repay the debt of *logoi*, words, discourses, and dramatize the *Republic* for him and for the readers of the dialogue.[9] Can they do this without engaging in mimesis – that is, without engaging in what was vehemently criticized in the previous conversation?

Socrates seems to believe so. Although the performers of the drama are

designated in advance, he pretends to engage in the preliminary "casting." Somewhat paradoxically, but in keeping with the principles set out in the *Republic*, he excludes the professional performers, actors, pretenders, imitators (*mimētai*). More surprisingly (for the readers of the *Republic* at least), Socrates eliminates also himself; and he pretends not to be surprised. He is unable to celebrate the city and her citizens in a befitting manner but he does not say why. However, when he moves to the exclusion of the poets, he points clearly to the issue of mimesis. Although he does not intend to deprecate them, Socrates calls the poets "a tribe of imitators." They can imitate perfectly and with ease what is familiar to them (*hois an entrophēi*), but that which is beyond the scope of familiar education (*to d'ektos tēs trophēs*) is too difficult to carry out in action and still more difficult to imitate in words (*Timaeus*, 19d–e). Is Socrates restating here the terms of the old dispute that jointly rejected the poetic and the mimetic? Or is he rather questioning the competence of poets, inexperienced in politics? What exactly is his own position, the place from which he pronounces his judgment? It seems that, far from explicitly taking the philosophical side of the dispute, Socrates places himself on the side of poets, pretending, as it were, to be such as pretenders are. If mimesis is here related to the rule of justice in the political (anti-)drama "one man one (social) role" – just as it was in the second and the third books of the *Republic* – it is surprisingly a pretender (*hupokritēs*) who plays the role of a judge (*kritēs*).

The same judgment falls upon the other marginal characters of contemporary political life, the Sophists. The Sophists cannot paint the ideal city because they are not familiar with any city, do not possess a place of habitation, a proper place (*idia oikēsis*). They wander from one city to another, not belonging to any actual social structure. Socrates calls them "errant" (*planētai*; *Timaeus*, 19e). Ontological *stability* – *status* – is here expressed in economic and political terms (*oikos* and *polis*). A stability which the Sophists – and again Socrates, by association – lack, is what in the *Republic* is thematized as type (*tupos*) or character (*ēthos*). Character is understood there not so much in the sense of "moral ethos," prominent in Aristotelian ethics, as in the sense of a social and dramatic type, a neo-classical and modern notion of *dramatis persona*, which can be traced to Theophrastus' *Kharaktēres*, to the fifteenth chapter of Aristotle's *Poetics*, and eventually to Plato's own *Protagoras*, *Ion*, and *Meno*. Another word which Socrates could have used here to characterize the notion of a determined social status as a necessary condition of a correct political outlook is "chora" (*khōra*). In fact, he *had* already used this word in the sense of a social status, type or character at the beginning of the dialogue in the last heading of his summary of the prior conversation (*Timaeus*, 19a). There, "chora" designated a class position which, although theoretically and ideologically (through the myth of metals, *Rep.*, 414, 415) fixed, was to be secretly corrected by those who established the order "in the first place," the philosophers. It is certainly not a matter of indifference that in the *Timaeus*, the concept of chora as determining social characters or types appears initially in the political context of displacement, which in the *Republic* was associated with the mimetic impersonations of characters by the pretenders, the actors (*hupokritai*), and was condemned.

Apparently it is not the problem of *dis*placement, however, but that of

*em*placement that brings the chora to the foreground of Timaeus' discourse.[10] "Anything that is must of necessity be in some place (*en tini topōi*) and occupy some room (*khōran tina*); what is neither on earth nor somewhere in heaven is nothing" (*Timaeus*, 52b). This general requirement of being is not new when stated by Timaeus. Zeno and Gorgias had already argued the point from different perspectives.[11] What is unique to the *Timaeus* is its inclusion in the framework of mimesis and of universal emplacement. A need for emplacement is translated into the need for a medium in which the images of the eternal paradigm might appear. It is the very structure of the mimetic/poetic mechanism that demands a material support that pre-exists it.

The chora of the *Timaeus* is sometimes understood as "matter" in the sense of "timber-stuff" (*hulē*) in the wake of the Aristotelian interpretation. This interpretation is based on the common experience of artists and craftsmen obliged to take into consideration the resistance of material used in their productions. The divine craftsman of the *Timaeus* is not free from this common preoccupation of all other *dēmiourgoi*.[12] The demiurge of Timaeus' myth is not just an artist or artisan (architect, painter, potter, husbandman, weaver, sculptor), that is, a member of the third class, the class of workers and farmers according to the legal division and the ideology of the *Republic*.[13] Some of the tasks performed by the demiurge, such as the settling of cities and colonies or political persuasion, belong to the competence of the members of the first class, philosopher-rulers, the "painters" of cities (*Rep.*, 500c–e), the "founding fathers" who perform, according to Socrates of the *Republic*, the function of *patres familias* "in a large scale." In this perspective the chora, compared by Timaeus to a mother and nurse, stands for all that the patriarchal order encounters in its task of "formation": the irreducible materiality of a gendered matrix, the *mat(t)er*.[14]

Thus, the chora of the *Timaeus*, a place of material-maternal resistance, a given to be reckoned with, is also to be understood (in accordance with the first meaning of the word in the dialogue and with the associations that it will later generate) in terms of social, political, sexual resistance. The ideal medium of the demiurgic production of images might be compared to the "canvas," the tablet (*pinax, tabula*) of the philosopher-painters, the founders of the State in the *Republic*, who are indeed characterized by Socrates as "artificer(s) (*dēmiourgoi*) of justice, temperance, and every civil virtue," imitators constantly referring to the divine model (*Rep.*, 500c–e). They are allowed to purify their medium (*katharan poiēseian an*), i.e., to perform the "catharsis" of the city-state so as to be perfectly able to trace on it the schema of the constitution and of the characters of men (*Rep.*, 501a). In fact, any foreign interference should be eliminated before the proper act of "mimetic" constitution begins. The result is to be a homogeneous picture without even traces of difference. The "clean slate" should allow an exact reproduction of the forms and schemata of the paradigm, eliminating any "margin of play" between the same and the other in such a purified medium.

The same attempt at a "cathartic mimesis," a mimesis purified of all difference, is conducted in the *Timaeus* by the narrator and his demiurge. The first part of Timaeus' discourse is an attempt to make mimesis the principle of differentiation between created things, the principle of generic and specific

identification. According to Timaeus' closing statement at the beginning of the *Critias*, it will eventually become the principle of knowledge concerning the generation of the gods, creation of the world, of man, etc. Mimesis functions thus, paradoxically, as a supplement to an antidote (science as *pharmakon*), which, as a poison (*pharmakon*), it was supposed to require in the first place. Here, the logic of *pharmakon* threatens to upset the whole demiurgic operation.[15] To counter this threat, a rigorous separation (*khōrismos*) of the two kinds of mimesis – the bad and the good – a sort of "scientific catharsis," is needed.[16] The latter, homogeneous, pictorial or iconic mimesis does not seem to interfere directly with the ideology of class division in the *Republic*. The same cannot be said, however, of the former – heterogeneous, hypocritical or dramatic mimesis – the other mimesis, mimesis of the other or absolutely different. Only the iconic – "resembling" – mimesis could be allowed to play a role in the operation of the demiurge.

Dramatic, heterogeneous mimesis is to be rejected not only as useless in the process of creation but as a threat to its result, to the established order of identities and differences of character. Indeed, the main task of demiurgic action is strictly to delimit the boundaries of created things, to sort them out, to "purify" them. Theoretical purification of mimesis is a prerequisite of cosmic and political purification. It is an uncertain operation since one of its terms, mimesis of/as difference or errancy, may in fact question the very possibility of separation. In the *Timaeus* the difficulty is manifest in the treatment of the so-called chiasm of the same and the other or different. When shaping the soul of the world, the demiurge fuses, in a complex way, the indivisible and divisible substance, the same and the other, and he "splits the resulting blend (*sustasis*) in two from one end to the other with a lengthwise slit. He fixes these two bands across one another at the center, in the form of a *khei*" (*Timaeus*, 36b–c). Subsequently, the violent action of the demiurge neutralizes this initial chiasm. The arms of the *khei* are forcibly bent to form a circle, and then the circle of the other is subjugated to the circle of the same (36c–d). For the second time the dialogue questions the mimesis of/as difference or errancy. The first time, before Timaeus' narration (and in order to make it possible), Socrates played the representative of all marginal and wandering tribes and withdrew from the conversation (*Timaeus*, 19d–e). He left the place to those who are firmly established in the cities, mimetically disposing of mimesis. In the theater of the sky, by contrast, the subterfuge being unavailable, the violence of the demiurge appears necessary.[17] However, a chiasm, the figure of opening up, is not easily made into a circle, the sign of closure. Timaeus will have a hard time defining the erratic, heterogeneous motions of the wandering stars (*planētai*) in terms of the perfectly regular, homogeneous course of the fixed stars.

The question of the original emplacement of the world or, in other words, of a medium capable of receiving the images of the demiurgic, mimetic (re)production, is inscribed in this theme of deviation or errancy. Indeed, the name of "errant cause" (*planōmenē aitia*) introduces the whole section on the chora in the middle of the *Timaeus* (48a). It will also point to the same/different polarity when it comes to considering the problem of essential identification of the elements, in the well-known form of the Socratic question *ti esti?* ("what is?")

Only reference to the paradigm of the Intelligible Forms can preserve the identity of fire and the other elements which, when considered outside mimesis of identification, remain in constant transition. Resemblance is the very principle of the appellation *toiouton*, "such as," "of such sort," "of such character," and thus the only principle of identity applicable to the fleeting, although recurrently appearing images. The chora is considered the supplement of this mimetic identification.[18] It is introduced as a necessary medium – a mirror, a movie or television screen, *camera obscura* – supplementing the mimetic schema of the demiurgic (re)production of the world. As such, it has to be manageable, malleable as plastic (*ekmageion*), as gold or as a perfume base (*Timaeus*, 50b–c). It has to be "soft," "smooth," "level," in "itself" characterless:

> . . . if there is to be an impress presenting all diversities of aspect, the thing in which the impress comes to be situated cannot have been duly prepared unless it is free from all those characters which it is to receive from elsewhere. . . . [T]hat which is to receive in itself all kinds must be free from all characters; . . . that which is duly to receive over its whole extent and many times over all the likenesses of eternal things ought in its own nature to be free of all the characters. (*Timaeus*, 50d–51a; Cornford)

Such an absolute indetermination would seem to require a neutral word to designate "it." Timaeus may have that in mind when referring to the chora as "this" (neutral thing): *touto*. But the gender of the noun "*khōra*" is feminine (just as that of "*dēmiourgos*" is masculine) and Timaeus does not complain of the fact. On the contrary, he stresses the femininity of the chora by comparing "her" to a mother and nurse (*Timaeus*, 49a, 50d). Towards the end of the dialogue he introduces the erratic (*planōmenon*) movement of matrix or womb (*mētra kai hustera*) in order to explain the indeterminacy of the feminine soul (*Timaeus*, 91c). The apparent contradiction of "she" and "it" is perhaps responsible for the ambiguous "status" of the chora in the dialogue, its being a "site of ambivalence," in Judith Butler's phrase (*Bodies That Matter*, 49). Mother, nurse, virgin, in the rhetoric of Timaeus and the interpreters of the dialogue, the chora, as an "all accepting" (*pandekhēs*) receptacle (*hupodokhē*), is also the space of indeterminacy, of the effacement of all character, a space beyond kind, genre or gender (*exōgenous*), to use the Sophoclean designation of excluded heroes or monsters.[19]

For the feminist writers the chora – characterless and yet feminine – is not nearly as perplexing as it is for Timaeus. Its indeterminacy is the effect of the common image of femininity as the other, the different, the foil against which the image of the dominant masculinity in the West has been determined. Luce Irigaray, for example, interprets the chora of the *Timaeus* as the epitome of woman's condition characterized by the lack of character, lack of a clearly delineated form or face (*prosōpon*): "She herself is without figure or face or proper form, for otherwise '(she) would take the impression badly because (she) would intrude (her) own shape'" (50e).[20] The paradox of "characterless femininity" or "feminine neutrality" is not paradoxical in face of the common, masculine "doxa," since this neutrality is necessary to secure the identity of the masculine.

Elizabeth Grosz makes even more explicit the argument that femininity has acquired in the West, in the "Platonic" West, the "characterless character" that may be comparable to the malleability, the suppleness of the chora in the *Timaeus*. She points to several features of the Platonic chora, such as self-obliteration for the sake of others, engendering without possession, receiving without giving and giving without receiving, evading "all characterization including the disconcerting logic of identity, of hierarchy of being, the regulation of order." She concludes: "It is no wonder that chora resembles the characteristics the Greeks, and all those who follow them, have long attributed to femininity, or rather, have expelled from their own masculine self-representations and accounts of being and knowing (and have thus *de facto* attributed to the feminine)."[21] The portrayal of the feminine as the "dumping ground" of the masculine representation of the world constructed by the demiurge is certainly present in Timaeus' phallogocentric discourse, for example in the last section of the dialogue where women are said to be the result of the second generation of cowardly and unjust men (90e–91a). Such a ground, like all that is repressed, presents a threat of return. In the case of the chora in the middle of the *Timaeus* it is the danger of a *mise en abyme* and of chaos.

For Timaeus, however, the chora is ambiguous – a "characterless" and "neutral" ground of the mimetic process of phenomenal representation and, at the same time, an effect of representation – and perplexing. She/it is "difficult and obscure" (*khalepon kai amudron*, 49a). When trying to elucidate it/her, one is in danger of being entangled in "strange and unfamiliar considerations" (*atopos kai aēthos*, 48d). It/She receives impressions in a "wonderful manner that is hard to express" (*dusphraston kai thaumaston*, 50c). She/It "partakes of the intelligible in the most puzzling way" (*aporōtata*), and it/she is "very hard to apprehend" (*dusalōtotaton*, 51a–b). In fact, she/it can be apprehended only by "a sort of bastard reasoning" (*logismōi tini nothōi*, 52b).

However, somewhat paradoxically, the "reality" of the chora is strongly maintained – notwithstanding its dread-like mode of perception (52b). Its stable and permanent (*aei on*, 51a; cf. 49e) presence allows one to call her/it "this" or "that" (*touto, tode*), in contradistinction to the only resembling, to the "such" (*toiouton*) of the images (49d–50a). It is, however, precisely the deictic reality of "this" chora that *shows* the fragility of the mimetic identification of *toiouton*. The very lack of a determined character of the medium makes room for all imaginable characters, shows their relative contingency, their demiurgic, *poietic* origin. The chora opens up a "leeway," a *Spielraum*, a space of a play with the illusions of mimesis. The images received in the chora are likely to be marked by her/its indeterminacy, her/its ex-centricity (*atopia*), by the lack of clearly drawn lines, boundaries, by its *aporia*. When unthought, the demiurgic (re)production gives the impression of a natural process. Once in the limelight, it has the effect of displacement, of defamiliarization, of the loss of an *idia oikesis*, of the *Unheimlichkeit*. It is when displaced in the chora that phenomena "appear" necessary and random at the same time ("of necessity" and "at random" – *ex anankēs, to tukhon*, 46e).[22] "Errant necessity" gives the chora the "character" of an "ungodly" playground for the divine artificer.

In Timaeus' account, the chora consists of the shaking motion compared to

the movement of a winnowing basket. But the "purification" (*katharsis*) which is said to be its goal is never accomplished. The "regionalization," which is a step in that direction, seems to be accompanied by the opposite drive of "*de-regionalization*" or radical marginalization, which defies any possibility of a proper, essential assignment of place.[23] It is only when read in this way that the chora, in its "ungodly" (*hotan apēi tinos theos*, 53b) condition, can be said to conserve the energy and the (im)proper state of imbalance, irregularity (*anōma-lia*, 52e). The ungodly resists the *logos* incarnated by the demiurge. Lack of properties, of characters, far from rendering a medium pure and flexible, is rather like a void for Kant's dove: it thwarts flight, resists by not resisting, by not offering any point of resistance, any resting place. Receiving all characters without exception, the chora lets them play against each other, displaying the contradictions of the order of images and simulacra: *kosmos* and "ideology."

The chora is certainly not an ideal canvas for the rational painter.[24] "Imagine the shock of the Demiurge," writes Casey, "that eminently rational creator who intends to model the world on the pattern of an unchanging Form, when he confronts the crazy-quilt, irregular motions . . ." (37). To be sure, the reality of the chora *consists* in the *resistance* of play on a cosmic scale, a resistance to the ordering and stabilizing *poiesis* of the demiurge; but it involves also a textual resistance that sets in ("irregular") motion the margins of Plato's dialogue, a resistance to the narrator, to the interpreters of the dialogue, to the philo-sophical recuperation of mimesis. Theater, stage and characters, "Platonic theater" is the best "image" for the chora as a support of images.[25] A third genre which questions the model/image dichotomy and an other or different which questions the same/different dichotomy, a "scene of emplacement," in Casey's formulation (Casey, 34), the chora is also what disrupts Timaeus' discourse and displaces the simple pattern of demiurgic mimesis. A name for a strictly delimited social role and a defended range of political power at the beginning of the *Critias* and of the *Timaeus*, the chora becomes in the middle of the latter a name for an irregular movement that questions all strict boundaries. The chiasm of the same and the other or the different, which had been violently circumscribed and submitted to the perfect circle of the same in the first part of the dialogue, is here *mis en abyme* by the chora and receives its (im)properly ch(i)asmatic character.

The only possible determination of the chora, "her" feminine character, does not remedy the effect of abyss. In fact, femininity in Western imagery is associ-ated with chasm, abyss, a fluidity and errancy of immeasurable motion — "*la donna è mobile*" — confusing, dissembling, seducing. A necessary medium of the cosmic representation, the material/maternal chora contains also the seeds of disturbance, of chaos. As the abyssal stage of theatrical mimesis of/as difference, it is a revolutionary space *par excellence*. When Irigaray and Kristeva question the logos imposed by the demiurge, they oppose the motility of the maternal chora to the violent, hardening effect of the mirror stage, initiating the process of consolidation of the paternal symbolic order. It is in reference to the *Timaeus* that Kristeva has chosen the key-notion of her theory of the poetic (revolution-ary) language: "semiotic chora." [26] It designates the metaphorical space of a pre-Oedipal and pre-specular, unmediated relationship between mother and child.

But the effect of the semiotic chora does not end there. The "enigmatic and feminine" motility of the chora can become a source of rupture with the established political, religious, aesthetic order of representation, a source of revolutionary practice. As in the cosmogony of the *Timaeus*, the play of the chora in the production of discourse, according to Kristeva, allows a *mise en abyme* of the symbolic order of the Same.

It is also the abyssal playground of the chora and the hystera in Plato's *Timaeus* and the *Republic* that provides Irigaray with the stage for miming and undermining the representational setting of the patriarchal speculative system of Western philosophy. "To play with mimesis" is, for Irigaray, "to resubmit herself – inasmuch as she is on the side of the 'perceptible,' of 'matter' – to 'ideas,' in particular to ideas about herself, that are elaborated in/by a masculine logic, but so as to make 'visible,' by an effect of playful repetition, what was supposed to remain invisible: the cover-up of a possible operation of the feminine in language."[27] *La mystérique* is Irigaray's word for "the trap of mimesis" set by feminine writing, by her own writing, for all that claims to be "self-as-same." It opens up "the abyss of her prodigality, her madness, expansion and dissipation of self," a space of infinite difference, of "a-typical, a-topical mysteria" (*Speculum*, 192ff.). The objective of "mimicry" and "masquerade," of the play of repetition with the paternal symbolic order of the same is to dis-play the chasm of the – necessary and dangerous – chora by frustrating the ideological operation of camouflage.

The long third part of the *Timaeus* is an example of an attempt at such covering up of the abyss. It does not succeed. The result of the effort, by the demiurge *et al.*, by the philosophical logos, should not be read in the ostensible conclusion of the dialogue: "Here at last let us say that our discourse (*logos*) concerning the universe has come to its end (*telos*)" (92c; Cornford).[28] The beginning of the *Critias*, to which I alluded initially, seems a more reliable conclusion to the *Timaeus*, as far as the unreliability of philosophical mimesis is concerned. Mimesis is reaffirmed as universal, and is radically questioned. In the *Republic*, the consternation of Socrates before the "injustice" of dissemblers, of those who do not respect the rigorous separation of functions (*erga*) and of places (*khōrai*), resembled the shock of the demiurge and the narrator before the "characterless character" of the chora in the *Timaeus*. The spectacle of false doctors, false shepherds, false politicians, and especially of those who make a profession of falsifying in defiance of ergonal boundaries, sophists, prostitutes, actors, etc., launched the investigation into the nature of justice and remained constantly behind the formation of the (ideal) Republic as the philosopher Socrates' nightmare.

The Socrates of the *Timaeus* is, however, another, different character, a character of an other, a wanderer, a vagrant (*planētēs*), characterless like the chora itself/herself; and just like the chora, he tends to resist the demiurgic, paternal logos of the dialogue, and eventually receives those who receive him, his hosts: Timaeus, Critias, Hermocrates, philosophers and politicians *par excellence*, readers perhaps, in the ranks of poets and performers, moved by the spirit of theater (*hē tou theatrou dianoia*; *Critias*, 108b).[29] Is this all-receiving (*pandekhēs*) character the same as the philosopher of the *Republic* and other dialogues? He *is*

the same if we understand "the same Socrates" in the way of the chora, the receptacle (*hupodokhē*) in the *Timaeus*, as the (im)proper *this* (*touto*), capable of "performing difference," of receiving all properties, all characters and thus able to dis-play the mimetic play-ground of the chiasm of the same and the other or radically different. (Dis)placed (*anakhōromenos*) on the margin of philosophical and political discourse in company of the poets and sophists, Socrates as chora is better "placed" to question the topology, the politics and ideology of places, which the philosophers and the politicians of the *Republic* tried rigorously to establish by eliminating all traces of dramatic mimesis.

6

THE PLACE OF BOREDOM

BLANCHOT NOT READING PROUST

Pierre Lamarche

> Inspiration is, they say, magic; it works instantly, without
> time's long approaches, without intermediary. That is to say:
> one has to waste time, surrender the right to act and the power
> to produce.
>
> The purer the inspiration, the more dispossessed is he who
> enters the space where it draws him, where he hears the origin's
> closer call. It is as if the wealth he comes into, that super-
> abundance of the source, were also extreme poverty, were
> indeed refusal's superabundance, and made of him the one who
> does not produce, who wanders astray within an infinite
> idleness.
>
> *The Space of Literature*

It is not by accident that Blanchot's *Le livre à venir* begins with a chapter
devoted to Marcel Proust. Proust's *À la recherche du temps perdu* is *the book to come*.
It is a book about the *work* that is the *book*, which is to say: it is a book about the
making of a book that incessantly refuses itself to its author, and in so doing
opens up its proper space, which is the space of the book's own un-making; the
space of false starts, endless detours, labyrinthine digressions, lies, confusions,
neuroses, biographies wittingly and unwittingly altered, lost opportunities,
oblivion, sickness, death, denial, self-delusion on a colossal scale, and time
prodigiously wasted in anticipation of the flash of inspiration that will make
possible the possibility of the making of the book – a possibility already actual-
ized in the an-achrony between book and work. It is a book that goes nowhere,
very slowly, and arrives, finally, at its own origin, lying prostrate and
incomplete at the threshold of its coming. It is the key to Blanchot's *Le livre à
venir*, wherein the process is laid bare through which the advent of the book to
come – the book of the future – is announced in the pages of the books of those

writers who would offer the last word on – unveil the abysmal source, and thus foreclose upon the future of – the book.

The origin, the source, the inspiration of *À la recherche* – the book to come – enacts, in the immensity of its boredom, the idleness that opens up Blanchot's space of literature, wherein *tous livres à venir* first announce, almost imperceptibly, their coming:

> Had I been less firmly resolved upon settling down definitively to work, I should perhaps have made an effort to begin at once. . . . [But] it would have been puerile, on the part of one who had waited for years not to put up with a postponement of two or three days. Confident that by the day after tomorrow I should have written several pages, I said not a word more to my parents about my decision [to become a writer]; I preferred to remain patient for a few hours and then to bring to a convinced and comforted grandmother a sample of work that was already under way. Unfortunately the next day was not that vast, extraneous expanse of time to which I had feverishly looked forward. When it drew to a close, my laziness and my painful struggle to overcome certain internal obstacles had simply lasted twenty-four hours longer. And at the end of several days, my plans not having matured, I had no longer the same hope that they would be realized at once, and hence no longer the heart to subordinate everything else to their realization: I began again to stay up late, having no longer, to oblige me to go to bed early one evening, the certain hope of seeing my work begun next morning. I needed, before I could recover my creative energy, a few days of relaxation, and the only time my grandmother ventured, in a gentle and disillusioned tone, to frame the reproach: "Well, this famous work, don't we even speak of it any more?", I resented her intrusion, convinced that in her inability to see that my decision was irrevocably made, she had further, and perhaps for a long time postponed its execution by the shock which her denial of justice had administered to my nerves and under the impact of which I should be disinclined to begin my work. She felt that her scepticism had stumbled blindly against a genuine intention. She apologized, kissing me: "I'm sorry, I shan't say another word," and, so that I should not be discouraged, assured me that as soon as I was quite well again, the work would come of its own accord to boot.[1]

I will begin by assuring the reader that the "Not Reading" in the subtitle "Blanchot Not Reading Proust" is not a weak attempt at mimicking a paradoxical, Blanchotian formulation, that would be made good upon by a, probably weak, attempt at mimicking a paradoxical, Blanchotian analysis of Blanchot on Proust. This is not my intention. The subtitle gestures towards the relative paucity of Blanchot's writings on Proust; a surprising paucity given the powerful resonances between the two, borne out by Proust's enactment of many of the crucial elements of Blanchot's notions of *l'oeuvre*, *désoeuvrement*, and *l'espace littéraire* (i.e., of *the work*, *worklessness*, or *unworking*, and *the space of literature*). Blanchot mentions Proust often: in *The Space of Literature*, *The Infinite Conversation*, *The Unavowable Community*, and elsewhere. He devotes seventeen

significant pages to Proust at the beginning of *Le livre à venir* and mentions him
at points throughout the body of that book. But apart from this chapter at the
beginning of *Le livre à venir* – entitled "The Experience of Proust" – there is
no sustained reading of him, to my knowledge, in Blanchot's corpus. Kafka,
Mallarmé, Hölderlin, René Char, Marguerite Duras, and others, all receive
much more sustained attention in Blanchot's works than does Proust. Nonethe-
less, Proust's kinship as a writer with Blanchot's literary theory has been noted.
Joseph Libertson's ground-breaking work *Proximity: Levinas, Blanchot, Bataille
and Communication* identifies Nietzsche, Freud, and Proust as the three great
"anti-intellectualists of modern thought," who have "sought to give formal
meaning to consciousness' experience of an incumbence of alterity in a dimen-
sion outside of manifestation – this experience being irreducible to the correl-
ation of Same and Other as power and superior power which has characterized
the West's thinking of communication."[2] As such, Nietzsche, Freud, and
Proust inaugurate the project of articulating subjectivity as the

> . . . enigma of a closure which has the capacity or inclination to be affected
> by the exterior . . . a capacity [that] cannot be deduced by principles such
> as correlation, determination, relation or non-contradiction [i.e. principles
> of the "formalist," or "intellectualist" tradition], because these principles
> articulate this very enigma. They describe an economy exhausted by the
> principles of autonomy and power . . . in which an essentially untroubled
> identity enters into the rectitude and reciprocity of relations with other
> identities. (Libertson, 7)

And so Nietzsche, Freud, and Proust were, on Libertson's view, the first to
systematically trouble this "untroubled identity" that had emerged within "an
economy exhausted by the principles of autonomy and power," an identity that
had been the labor of the intellectual history of the West. Working from and
within this tradition, we ultimately find in the work of Levinas, Bataille, and
emphatically in Blanchot, a thinking that refuses to "characterize alterity as
power or effectivity, and [a] concomitant tendency to thematize subjectivity
itself as a radical passivity or heteronomy: not a dependence upon another
power, but a pure passivity in a reality without power" (Libertson, 2). This
notion of subjectivity as "radical passivity or heteronomy" in a "reality without
power" links Proust to Blanchot and unites them with the other "anti-
intellectualist" figures of modernity. Articulating the sense and the stakes of
this provocative characterization of subjectivity occupy much of the three
hundred-odd pages of Libertson's book.

I would like to begin examining the resonances between Proust's work (pri-
marily *La recherche*) and the key notions of *l'oeuvre* and *désoeuvrement* within
Blanchot's theory of the space of literature, by making a few remarks regarding
the function of these concepts within his work. Almost every serious com-
mentator on Blanchot has something to say about the notions of *l'oeuvre* and
désoeuvrement, notions which are intricately bound up with one another. An
exhaustive analysis of these difficult terms cannot be undertaken here. However,
Blanchot's *oeuvre* should always call immediately to mind the idea of the work

of art, of artistic, particularly literary, activity, and also the notion of a more general work that functions as a counterpoint to the Hegelian conception of work as labor, the labor of the negative. We should think of art, but not exclusively; we should think of Hegel, and an anti-Hegelian work as well.[3]

For Hegel, work, or labor, is roughly an expression of mastery over, and appropriation of, nature, through the activity which forms, shapes, and thus negates it. All work accomplishes, actualizes, brings about the completion of, some *thing* (most significantly – the self, human self-consciousness raised above sheer "natural" animality, or blind, un-reflexive self-interest). Ultimately all work participates in the process of the accomplishment, the actualization of Absolute Spirit, which is actualized in the world in the guise of absolute human freedom, a freedom which is the final accomplishment of work and as such is the *telos* of History. When all work is done, humanity is freed from nature, and thus Absolute Spirit is made concrete in the world insofar as humanity has been freed *by* its accomplishments *to* the achievement of its collective and total comprehension of a fully subdued natural world. All that we have created and achieved through our collective work, and works, expresses and actualizes humanity's *completion* through its complete mastery over, and domination of, nature at the end of History. In the advent of such a cosmic accomplishment – a cosmic closure – the future itself is foreclosed. Here we must grant all the myriad problems of interpreting Hegel's notion of the "end of History" while setting them aside.

For Blanchot, however, *l'oeuvre*, most pointedly the work of art and especially of writing – the labor of writing – accomplishes nothing, except the interminable opening up of its own space, its own milieu, which is the space in which nothing *really* happens, the space of fiction. It is a sign – *the* sign – of a movement that achieves, inaugurates, grounds, creates, closes upon, sets up, nothing; the *unreal*, the *inactual* (fiction) in whose space is found the work's own peculiar (un)achievement and domain. And so the work is always already caught up in the milieu of an "unworking," a "worklessness," an "idleness," an "inertia," an "uneventfulness" – Blanchot's *désoeuvrement*. But this space of worklessness and idleness wherein nothing is, really, created, and nothing, really, happens, is not at all nothing and nowhere purely and simply. In the initial quotation from *The Space of Literature*, Blanchot describes this space which is opened up through the work/worklessness of the writer who struggles to close on the source of her inspiration – both as the space of "wealth," of a "superabundance of the source," and as the space of "extreme poverty," that makes the writer, the would-be writer, into "the one who does not produce, who wanders astray within an infinite idleness."[4] The writer, in the time and at the moment that inspires the work, is the one who, precisely, does not work – the one who wanders astray, eyeless within a Gaza infinitely idled and idling. And, one might ask, who in the Western literary tradition fits this description of a writer struggling to locate the source of his inspiration, the source of his work? Who struggles to begin writing and writes incessantly about his struggle to begin writing? Who best fits this paradigm of a writer awaiting his inspiration, trying to close in on the source of inspiration that will allow him to locate his place within the space of literature through his work; a work that,

day after day, year after year, does not come, that frustrates him, that will not allow him to begin, that he must wait to come to him, and that ultimately does not cease to come to him, in its monumental wealth, until the very moment of his death, in a hotel room whose walls are lined with cork?

The errant image of the one who wanders astray is projected into the *space* of literature that Blanchot is seeking to open. It is his antidote to the profanity of Hegel's moribund, sober, rational, calculative space of production and accumulation – an accumulation that begins as the resolute self-consciousness which is the surplus residue of a bondsman's servitude, and is first unworked in the writer's self-dissolution within the work. This "infinite idleness," or work-lessness, is the writer's condition as she begins to work – and as she incessantly, with each new word, begins to work again – since her work appears to her only in the form of its own absence; the absence marked by the infinitude of the blank space that precedes the first word, and that follows every last word to the end of the page and on to the next page, and to the next, to the end of the pad of canary yellow paper, and on to the next pad, and to the next, interminably. Or the absence that is marked by the flashing cursor on a computer screen; the permanent sign of the incessance of all of those who work similarly in a later technological age. No word, or sentence, or page, or naive and charmingly hopeful "*the end*" will ever put an end to her, or to our, work. The writer's work is an always *not yet there*, that demands nothing of her, except that she write – i.e., except that she bring forth – from the poverty and the wealth of her infinite idleness, staring at the cursor, fingers poised to respond to a call that asks nothing of her – that she bring forth an unreality, an imaginary space of superabundant plenitude, but one that is utterly removed from the space of the actualized; the world, the world of accomplishments, the world that is the product of work as Hegel conceived it. Work as power, as mastery, as domination, as creation, accomplishment, achievement, and completion. The only demand of Blanchot's work is, interminably and incessantly, to efface that world – to "unwork" (*désoeuvrée*). Hence the work of writing "devotes itself to the pure passivity of being" (Blanchot, 27), a passivity we have seen punctuated by Libertson, who reads Blanchot's project as an attempt, once again, to theorize subjectivity as a "radical passivity," "a pure passivity in a reality without power" (Libertson, 7).

Blanchot's reading of *À la recherche du temps perdu*, as it appears in *Le livre à venir* – "The Book to Come" – opens with a chapter devoted to Proust and to the book whose narrator's grandmother is certain that it will "come of its own accord," though it never really does, or rather it comes only as the monumental, incessant, interminable task of its own *in*completion.[5] Blanchot relates the following movements that animate Proust's work: The movement through which time the destroyer turns, strangely, back on itself, and abolishes itself within the precious moment of simultaneity that provokes Proust's involuntary memory. The movement through which the moment of simultaneity becomes a pure time whose essence is found in the annihilation of space; in emptying space/time of the objects and events that customarily fill it. The movement through which this time outside of time which is an empty, bankrupt space, is transformed into the pseudo-outside of time which is the time of the narrative,

the *récit* – time dissimulated within the imaginary space of literature. The movement through which the time of the story effaces the identity of the writer, articulating nothing but the imaginary past of a being already entirely imaginary (the movement through which the work, and the author of the work, are unworked). And finally, the movement through which a remarkable, though arid and desolate, plenitude figures the first movement of simultaneity that opens up the space of the work; an interminable space, an incessant work, never completed, ended only by death.

The "long time" during which the narrator "used to go to bed early," the time announced in the very first sentence of *La recherche*, is a time that destroys. This time that destroys has struck from the memory of the narrator all trace of the village of Combray except two floors and a slender staircase in his grandparents' house, at seven o'clock in the evening. It not only obliterates the past of the narrator, banishing his memories into an exile from whence they may never return, but it also infects and consumes its corporeal victims, returning Swann, Marcel's grandmother, Elstir, Albertine, St. Loup and others to dust and ashes. Its effects are laid bare in the ravished face of M. de Charlus in *Time Regained*. This time, Blanchot notes, is capable of a very strange turning (*d'un tour plus étrange*) that is instigated by the visceral experience attending a physical object. Time *itself* turns; the "subject" who lives through time is incapable of instigating the turning, and powerless against its inexorable irruption. Time is capable of turning around, against itself, and annihilating itself in a moment of simultaneity through which a past sensation is relived – not an echo, or a copy of that sensation, but the sensation itself. This simultaneity tears the fabric of time, opening an exterior, an *hors du temps*, in the simultaneous presence of two disparate events – a "felt simultaneity of incompatible events."[6] This is the time triggered most famously by the madeleine in the Overture to *Swann's Way*, and in a handful of other critical passages throughout *La recherche*. During these precious moments the interstitial time between the events is erased and time annihilates itself: ". . . here then is death, that death which is the work of time, suspended, neutralized, rendered innocuous and inoffensive" (Blanchot, *Livre*, 21).

This place of death, which is the work of time in uniting two separate events into a single presence, abolishes the interstitial course of time and thus opens up a vast empty space that is traversed spontaneously in the moment of simultaneity. This *space* has been emptied, it has become freed from all of the events which ordinarily fill it – it articulates a "pure time," without events, a "vacant shifting" (*vacance mouvante*). And what could this space then be, but the time of the narrative – the *récit* – which is not outside of time, but which is *experienced* as outside of time in the form of a space, "that imaginary space where art finds and disposes of its resources" (22). The empty space of decades announced in the "all of a sudden" – "*Et tout d'un coup le souvenir m'est apparu*" – when the mystery of the madeleine finally reveals itself, and the narrator spontaneously traverses the spatio-temporal terrain that separates him from his childhood in Combray. We read through this charming narrative the nothingness of these intervening decades emptied of the relentless detail of their eventfulness. This is the imaginary space of Proust's literary resources, and his story is dissimulated in this space of literature. It is a shifting absence without *real* events, without the

obstruction of *real* presence, in an always becoming emptiness, insofar as in this imaginary space, the mundane world of *reality* – of things, and events, and creative, purposive work – is infinitely deferred. These experiences of simultaneity are ultimately the inspiration of the book, precious moments flooded with emotion that abolish time and empty space of its mundane objects and moribund occurrences, and thus allow the one who experiences them – the narrator, Marcel – to open up the imaginary space of his work, that space which is "an emptiness, always becoming" (23). From this emptiness, this pristine space unworked and idling, pours forth in its virtual plenitude, *the work*, which for the writer is a work always *becoming* in every word that announces itself within this space, and always *to come* in the oblivion that follows every word. Proust has discovered the secret of writing and of artistic inspiration, that by ". . . a movement of distraction that has turned him away from the stream of things, he is placed within the time of writing where it seems that time itself, instead of its being lost in events, puts itself to work in writing" (24).

And what space and what time do you inhabit, as you read these words? Can you begin to imagine the space and time lived in by the one who wrote these words, in the moment they were written, in the moment that the writer's idleness, no longer lost in events, put itself to work? Are these not sacred spaces, sacred times, as Bataille might put it, infinitely removed from the senile fixations of Limited Economy?

But the particular experience of simultaneity that supposedly inspired the narrator's work, and through which time sets itself to work in writing – where did it come from? How did it happen? Who experienced it? In what time? In what world? (24). Proust's narrator tells us that the actual event that sets him to begin after so many years occurs after the war, at a time when much of the novel had already been written. Has Proust lied to us? Blanchot answers that he never owed us the truth, and he'd be incapable of giving it to us even if he did (25). The Proust whom we suspect of lying is the narrator of the story, the one who is neither the son of Adrien Proust nor the writer who has finally found the power to write. He is the incessantly emerging space of a shadowy metamorphosis: This Proust is the space in which the narrator becomes the protagonist of the book, the one who, in the story, writes a story about the metamorphoses through which he becomes the myriad subjects whose experiences he relates (25). The Proust who recedes into the narrative, whose body dissolves into the work leaving nothing but the trace of the hand that writes. The Proust who is "the exigency of writing itself" (284). This imaginary experience of writing's exigency "can only take place in an imaginary time, . . . making of that which is exposed there an imaginary being, an errant image, always there, always absent" (27). The imaginary time of *La recherche* is dissimulated within the imaginary space of literature, effacing the identity of the writer in the movement of a work that articulates nothing but the imaginary past of a being already entirely imaginary. Both the work and the writer become virtual, belonging to a world unworked, as Blanchot says. Imaginary time, then, is both the time of reading and the virtual time of the fiction. They constitute an unworking of the merciless time of our quotidian reality. It is not a negation of this time; time itself fears only the Sphinx, it is unafraid of words scratched on a

page, and read, within time. Rather, it is an unworking, an idling of the time wherein work is actualized, and life drips away.

The final movement that Blanchot articulates within the frame of Proust's work brings us to the theme of boredom, to time languorously, luxuriously, prodigiously wasted. His previous movements spring from the initial turning in which time doubles back on itself in the narrator's experience of those precious moments of simultaneity that spur the process of involuntary memory. Blanchot suggests that Proust's writing is, ultimately, a response to the joy of those moments of inspiration through which he is catapulted beyond the world of instrumental concerns and useful labor (27). He notes that *Jean Santeuil*, Proust's dry-run for *La recherche*, recounts the same moment of simultaneity and the corresponding recognition of artistic inspiration that we find in the final volume of the later novel.[7] Proust wanted, above all, to write a book excluding everything that was not of the order of one of these magical moments. He hoped that *Jean Santeuil* would be that book, and he wrote of it:

> Can I call this book a novel? It is perhaps less than that, and much more; it is the essence of my life, recollected without anything inessential interfering with it, in those hours of rupture (*déchirure*) during which it flows out (*découle*). The book has not been made, but rather gathered together.
>
> (Quoted in *Livre*, 31)

Jean Santeuil, written between 1895 and 1900, is ultimately set aside, disavowed, in favor of that work-unto-death that becomes *La recherche*, despite the fact that Proust has already given us the answer to his decisive question. He has already explained the secret of writing and its inspiration; it has already revealed itself in the description of a magical moment of simultaneity on the shore of Lake Geneva in *Jean Santeuil*. What could possibly justify undertaking *La recherche* – a book that literally kills its author – when its secret has already been exposed? How does *La recherche* differ from *Jean Santeuil*? The answer is obvious. In the latter, the disparate moments of simultaneity – those brilliant, starry moments (*points étoilés*) of the narrator's life – are separated by an unfigured void; they come one after the other in the course of a narrative less than one quarter the length of *La recherche*. By contrast, in *La recherche*

> ... a massive, uninterrupted work, [Proust] manages to add to these shimmering moments an emptiness *as plenitude*; thus, this time, making those stars sparkle brilliantly, since they no longer lack the immensity of the emptiness of space to stand out against. And so it is through its dense, ponderous continuity that the work brings into relief what is most discontinuous – the intermittency of those luminous moments of inspiration through which the possibility of writing comes to him.[8]

La recherche: more than a million and a quarter words, according to Terence Kilmartin in his translator's note to the Vintage paperback edition. A handful of sparkling moments, in which a visceral sensation leads to the experience of simultaneity of events that triggers involuntary memory – an experience of

overwhelming emotion. But what of the rest of the novel? What takes place in the interstitial, imaginary space/time between these moments, which at times is protracted for well over a thousand pages? The dull minutiae of a life that the narrator himself believes is largely wasted. These monumental, ponderous minutiae of the work make those glittering moments of simultaneity stand out in all their brilliance against the background of an idled life. And it makes *of* those moments the spur to a monumental task of incompletion emerging from the poverty and the wealth of a space of monotonous idleness, worklessness, languor, waste, loss . . .

Let us admit, finally, without fear: *La recherche* is much of the time a boring book. The life it narrates is staggeringly arid. The book is full to bursting with the facile, banal detritus of that life. The endless salons of the Verdurins and the Guermantes comprise an empty, meaningless realm of idle talk – the "signs of worldliness," in Deleuze's phrase – which the narrator pursues, then retreats in weariness from, and finally returns to briefly at the end of his days. All is senseless chatter among the secondary characters of the book – the Cottards, the Norpois, the Blochs, Françoise the housekeeper, and on and on. The framework of the narrator's existence is composed of what Beckett referred to as those "adamantine columns of enduring boredom" that stand at the entrance to the habituated worlds the narrator inhabits – the salons, the hotels, the bedrooms, the monotonous cliques he habitually attaches himself to. Indeed, boredom is the "adequate performance" of the "fundamental duty of Habit," in Beckett's words.[9]

Gilles Deleuze concurs, and underscores the *necessity* of the narrator's worklessness and idleness. For Deleuze, *La recherche* is the story of an apprenticeship to the interpretation of signs: the signs of "worldliness," of love, and of sensuous impressions, all three of which converge in the signs of art. The narrator must waste his own time in the boredom of his days, since time wasted and *not* given over to creative activity is time shot through with a wealth of signs – the raw material for the apprenticeship to signs that ultimately leads to artistic inspiration. Only time wasted, time passed by and consigned to the slag-heap of experience, can ever be regained. And so one has to waste time, before the work will come – the work through which time wasted will be regained, resplendent in its wealth of signs. The narrator – and the reader – must waste time before the incessant, interminable task of opening up an imaginary space of unworking, before the work/unworking ending only in death, will come.[10]

The magnitude of Proust's achievement in boredom as he traces the worklessness of the work and the dispossession of the writer may be recognized in its resonance with the Heidegger of 1929–30. In a lecture course at the University of Freiburg on "The Fundamental Concepts of Metaphysics" he returns to the concept of anxiety which *Being and Time* had described as the fundamental mood of *Dasein*.[11] He now characterizes the *Grundstimmung* or the most basic, precognitive experience of our particular historical period as boredom. The lengthy discussion distinguishes between simple impatience with dull objects, people, events, situations, etc., and what he calls profound boredom – *tiefe Langeweile*. In profound boredom the mundane world of everydayness – the world we live in as *fallen*, lost in "the they" – submerges in

complete indifference. We are mesmerized or "enchanted" by time itself which comes into focus in its three-fold horizon through the experience of utter and complete indifference to anything past, present, or futural that has become familiar to us in our tedious, everyday lives. Thus, the possibility of living in the time granted to us — authentically, rather than lost in the triviality of the everyday — first comes into view. In "Fundamental Concepts" boredom rather than anxiety figures the *Augenblick* — the moment of vision which unveils sheer existence and genuine possibilities. Boredom is thus the origin of all doing and acting, the *Ursprung* of authenticity. Boredom also allows the world itself to emerge from out of the dull patina of everydayness in its delightful strangeness and novelty. As the everyday recedes in our tedium, the wondrousness of sheer being emerges.

Heidegger's ontology of mood enables us to see why the tone of *La recherche* — beyond its trivial and dull minutiae — is of a luxurious ennui, what Beckett referred to as its "adamantine columns of enduring boredom." Insofar as the work itself is permeated by a dull boredom, it resonates with both the poverty and plenitude of Heidegger's moment of vision and the event of inspiration within Blanchot's space of literature. And for the reader it figures the origin of all genuine possibility for experience that can efface our moribund everydayness.

This luxurious boredom of the narrator's idled life is most poignant and *pathetic* in the volume *La prisonnière* — "The Captive." The narrator's companion Albertine is placed under house arrest. Marcel's love for Albertine knows only, as Bataille put it, an "impossible jealousy." What makes Marcel's jealousy impossible is the time he and Albertine spend apart. This is a time permeated by the possibility of a life of which Marcel can have no inkling. Albertine is a liar, as he knows almost from the start; but whether she lies to him about her life or tells the truth doesn't matter. There can be no verification of her activities, and besides, "tomorrow" signals the permanent possibility of time, Albertine's time, stolen from Marcel. So he imprisons her in his home, has her followed on the few occasions when she escapes, and in general, does whatever is possible to monopolize her time. It is true that the time spent together bores Marcel. Near the end of *The Captive* he sums up his sentiment: "I felt that my life with Albertine was on the one hand, when I was not jealous, nothing but boredom, and on the other hand, when I was jealous, nothing but pain."[12] Nonetheless, the specter of Albertine's time, during which she does god knows what with god knows whom (or nothing, for that matter), makes Marcel crave this boredom. It is the horror of the unknown of Albertine's time that attracts and binds him to her. He seeks to devour her time; that is what he loves about her — her time, not her person. She is nothing more, and nothing less, than a "mighty goddess of Time" (*Captive*, 393), of the void, the superabundant emptiness.

Marcel is not the only one who is bored by this arrangement. In the weariness of the cage she willingly enters, cut off from a field of experience she might have entered, enveloped by the nothingness of Marcel's impossible jealousy — a jealousy that seeks nothing other than the permanent continuance of mutually shared, and gargantuanly vapid, time — Albertine's thought turns lightly to the

vulgar, letting it slip that she'd rather go *"me faire casser le pot,"* than spend another boring night with boring Marcel and his boring friends.[13] A dull boredom permeates *La recherche*. It is the work's substance and its gift: useless, wasted time.[14]

So how does the boredom of *À la recherche du temps perdu* enact the worklessness of the space of literature? It does so by effacing the moribund world of our ordinary concerns. And it "accomplishes" this by leading us, slowly, ponderously, almost imperceptibly, through a desert – an arid, incessant, interminable landscape – into a night in which the stars shine brightly.

7

LITERATURE, FILM, AND VIRTUALITY

TECHNOLOGY'S CUTTING EDGE

Joel Black

> In most sci-fi movies it's usually the elite who are on the cutting edge of whatever's going on, but I think it's quite the contrary. It's going to be a grassroots-type movement. Those are the ones who are not fighting it, not analysing it, not organizing it. They're just experiencing it.
>
> David Cronenberg[1]

> 'They're trying to reduce the number of accidents here, not increase it.'
> 'I suppose that's a point of view.'
>
> J. G. Ballard, *Crash*

In retrospect, all the controversy over the release of David Cronenberg's *Crash* seems beside the point. Despite the fact that this film – adapted from British writer J. G. Ballard's 1973 novel about the eroticism of car crashes – won a jury prize at the Cannes Film Festival in 1996 and opened no. 1 at the box office in France and Canada, its American release was delayed until the following year, largely because of the scruples of Ted Turner at Fine Line, the U.S. distributor, who worried that "people with warped minds are going to love this movie – I worry about the first teens that try it."[2] As it turned out, Turner needn't have fretted. The film was neither a commercial nor a critical success: those teenage Americans who did see the film seem to have found it boring, while those reviewers who didn't condemn the film out of hand were confused. Most critics were unable to make sense of the characters' voyeuristic interest in car crashes. Stephen Holden, for example, simply lumped *Crash* together with two other current pictures – Lynne Stopkewich's *Kissed*, and Kirby Dick's *Sick: The Life and Death of Bob Flanagan, Supermasochist*. "These films," Holden claimed,

arrive at a time when not only has eroticism been discussed to death on

talk shows but biomedical research has reduced sex to a science. In the age
of the organ transplant, the sex change, the testosterone patch and Dr.
Ruth, it is increasingly difficult to imagine erotic fulfillment as a mystical
fade-out at the end of a movie.[3]

Instead of being found a controversial or even a problematic subject, Cronen-
berg's unsettling presentation of the erotics of technology proved easy to
ignore, if not to deny. Far from revealing technology to be the last – and
perhaps the most intense – bastion of eroticism in post-industrial society, and
far from exploring the link between technology's seductive appeal and the
death wish, *Crash* could simply be seen as confirming the sad but comparatively
reassuring truism of the *end* of eroticism in the age of mechanical reproduction.

Half a year after its American release, however, the unheeded thesis of the
eroticism of car crashes was spectacularly demonstrated for all the world to see
by the death in late August 1997 of Princess Diana, her companion Dodi
Fayed, and their drunken driver in a Paris underpass. The news media found
themselves in the frenzied situation of reporting a tragedy of enormous public
interest – ratings for entertainment news shows on TV shot up by as much as
30 per cent – even as they were themselves perceived as being largely respon-
sible for the crash. The paparazzi tailing the Mercedes carrying Diana and Dodi
had been desperate to photograph the celebrated couple, preferably in some
form of amorous contact. But the paparazzi's unforgivable offense was that
some of them were alleged to have taken photos of Diana and Dodi *after* the
crash, in the wreckage of the automobile while Diana was still alive. These
photos, which under different circumstances the tabloids might have paid vast
sums to acquire, became incriminating evidence of the photographers' role in
the crash. (This didn't stop a photograph claiming to show Diana in the
crushed Mercedes from surfacing on the Internet, although this was later
denounced as a fake.)

Although few made the connection, the circumstances of Diana's death
ought to have been a stunning vindication of Cronenberg's film after the
reactions of corporate shock and critical neglect. One writer who made the
connection was Salman Rushdie, who noted as "one of the darker ironies" of
the tragedy that "the themes and ideas explored by Ballard and Cronenberg,
themes and ideas that many in Britain have called pornographic, should have
been lethally acted out" in this event. Rushdie proceeded to identify the "two
erotic fetishes" in our culture that Ballard had revealed in his novel, the
combination of which had caused such an outcry.

We live in a culture that routinely eroticizes and glamorizes its consumer
technology, notably the motorcar. We also live in the Age of Fame, in
which the intensity of our gaze upon celebrity turns the famous into
commodities, too – a transformation that has often proved powerful
enough to destroy them. Ballard's novel, by bringing together these two
erotic fetishes – the Automobile and the Star – in an act of sexual
violence (a car crash), created an effect so shocking as to be thought
obscene.[4]

Contrary to the views of many of Ballard's readers and Cronenberg's critics, eroticism was far from dead in postmodern culture. Rather, as Bataille had observed decades earlier, it flourished precisely at the site of violent death.[5] Ballard had merely brought Bataille up to date, further specifying the erotic imaginary by introducing the additional elements of celebrity and technology into the equation: the events that left the most lasting impression on the public's collective fantasy-life were the death of a president, a princess, or a movie-star in a motorcar.

Following Ballard's logic, further distinctions are inevitable. For example, the reason that the death of Princess Grace of Monaco (a princess *and* a movie star) wasn't as erotically charged as that of Princess Diana was that Princess Grace didn't die with her lover, and – perhaps as a consequence – wasn't surrounded by picture-taking onlookers at the scene of the crash. JFK's assassination met both of these conditions, but his death occurred in an open car in a public space in mid-day, and lacked the elements of intimacy and secrecy associated with the scene of Diana's death (the closed car and the tunnel). The accumulation of these details contributed to the impression that Diana's violent death was not only an erotic event, but *the* erotic event of the time.

Most of all it was the presence of cameras at the crash site and their proximity to the dying princess that eroticized and transformed Diana's death from a sexual spectacle into a virtual sexual assault in which every viewer becomes an accomplice. Rushdie elaborates this point:

> The object of desire, in the moment of her death, sees the phallic lenses advancing upon her, snapping, snapping. Think of it this way, and the pornography of Diana Spencer's death becomes apparent. She died in a sublimated sexual assault. . . . The brutal truth is that the camera is acting on our behalf. If the camera acts voyeuristically, it is because our relationship with the Beauty has always been voyeuristic. If blood is on the hands of the photographers and the photo agencies and the news media's photo editors, it is also on ours. . . . We are the lethal voyeurs . . . (68)

Once the camera quite literally enters the picture – once it is drawn into the frame that it so carefully constructs – its intrusive, phallic, mediating role is suddenly revealed, raising a host of ethical issues concerning privacy, decency, voyeurism, and greed. With the camera in the picture, we pass (as Rushdie's diction attests) from the benign realm of erotic spectacle to the malign domain of pornographic assault. The question of moral responsibility returns with a vengeance as soon as we are made aware, as happened in the case of Diana's obscenely publicized and public death, of the media's (and our own) voyeuristic intrusion into those enclosed, semi-private spaces, such as the interior of an automobile, where the private intimacies and death-agonies of real people occur. Rushdie leaves open the question whether "we can collectively accept that our insatiable, voyeuristic appetite for the iconic Diana was ultimately responsible for her death" (69), and we may indeed wonder whether the outpouring of grief after Diana's death was a tacit admission or a disavowal of collective complicity.

The media's coverage of Diana's death, and of their own role in that event, dramatically brought Ballard's and Cronenberg's marginalized explorations of technoeroticism and celebrity onto center stage. The erotic allure of car crashes, especially those involving celebrities, was no longer a pathological subject of satiric or exploitative fiction that corporate moguls could deplore and mainstream critics could ignore, but was suddenly revealed as a fact of modern life. Ballard and Cronenberg had heralded the crisis of a society given over to spectacle in which privacy was elusive and intimacy illusory, a society in which "reality" was thoroughly "mediated" by the media and in which the boundary between fantasy and real-life was increasingly susceptible to violent collapse.

The novel *Crash* portrays this crisis through its relentless focus on the violent violation of borders, specifically the all too palpable interface between artifice and nature – "the erotic collision of technology and the human body."[6] The automobile provides Ballard with an apt metaphor for making his readers aware of their contradictory responses to technology. At once familiar and disturbing, auto accidents elicit both a sense of awe as an index of power, speed, and mastery, and a sense of dread as a brutal violation of privacy and bodily integrity. Ballard's novel describes an all but total loss of intimacy in a brave new world in which existence is thoroughly mediated by technology, and nowhere more visibly than by that most familiar and seemingly personal of machines, the automobile. Just as Michel, first-person narrator in Gide's *L'Immoraliste*, is never so much alive, sexually sensitized, and free from customary social and moral ties as he is after his recovery from a nearly fatal illness, so a new and unsuspected world of erotic possibility and perverse sexuality opens itself up to the first-person narrator of *Crash* after he survives a serious collision in which a man was killed. Before the accident, the relationship of the narrator ("a 40-year-old producer of television commercials" named "James Ballard" after the author) and his wife Catherine had deteriorated to the point where he felt that he had become for her "a kind of emotional cassette, taking my place with all those scenes of pain and violence that illuminated the margins of our lives – television newsreels of wars and student riots, natural disasters and police brutality which we vaguely watched on the colour TV set in our bedroom as we masturbated each other."[7] After the accident, however, Catherine takes a new interest in James, becoming "fascinated by the scars on my chest, touching them with her spittle-wet lips" (Ballard, 51). The scars are not only simulations of orifices, new erogenous zones that promise unsuspected sexual experiences, but visible signs of visceral violence that are far more stimulating – because they're so much more immediate and "real" – than the media-mediated "violence experienced at so many removes [that] had become intimately associated with our sex acts" (Ballard, 37) in the masturbatory bedroom sessions prior to the crash. The stimulating violence associated with James's car accident represents an initial incursion of the marginal realm of the pornographic into intimacy's inner sanctum. Hereafter, sex will only be possible in cars, as James discovers during his affair with Dr. Helen Remington, a fellow survivor in the collision that killed her husband: "only in the car could she reach her orgasm," and could he "mount an erection" (Ballard, 120, 82). With the loss of intimacy,

sexual arousal is only possible in that most public, cramped, and potentially lethal of places – the automobile.

The idea of automobiles as a sexual turn-on is hardly a new insight. The "revelation of man's sex relation to the motorcar" had already been a cliché when it was pointed out by Marshall McLuhan early in the 1960s,[8] and, as Garry Wills has recently added, "the blending of cars with sex and violence has been a staple of the advertising world for most of this century."[9] Still, Ballard's novel was sufficiently shocking for him to feel it necessary to write an introduction to the French edition, within a year of its original publication, in which he stressed the cautionary nature of the work. In this introduction, Ballard identified his novel as a work of science fiction, although he noted that unlike his "previous novels of world cataclysm set in the near or immediate future," *Crash!* – the exclamation point was later abandoned – describes "a cataclysm of the present day . . . a pandemic cataclysm institutionalized in all industrial societies that kills hundreds of thousands of people each year and injures millions." Declaring that science fiction was by no means "an unimportant minor offshoot" but "represents the main literary tradition of the twentieth century, and certainly its oldest," Ballard credited the genre for attempting "to place a philosophical and metaphysical frame around the most important events within our lives and consciousness" (Ballard, 1994, 97). But if Ballard had written *Crash* as a science-fiction novel to place "a philosophical and metaphysical frame" around key events in our existence, he was now surrounding this literary-philosophical frame with a meta-philosophical frame in the form of a critical introduction.[10] This supplementary, critical frame had the express didactic and moral purpose of warning about a strange world beyond the border of our daily existence that threatens to intrude on our private intimacies – a "brutal, erotic and overlit realm that beckons more and more persuasively to us from the margins of the technological landscape," and that has encroached upon the intimacy of the dimly lit bedroom (itself an echo of the paternal bedchamber, the site of the primal scene).

A quarter-century later, with the release of Cronenberg's film, Ballard once again provided commentary for his novel. Unlike Anthony Burgess, who added a preface to later editions of *A Clockwork Orange* repudiating Stanley Kubrick's cinematic adaptation, Ballard praised Cronenberg's film as being even more extreme than the book. Because it is so extreme, however, Ballard has felt obliged to reiterate the distinction between the reality of car crashes and their artistic representations. He has insisted, for instance, that "I've never said crashes are sexually exciting. I've been in a car crash, and I assure you it did nothing for my libido. . . . All I've said is that the idea of car crashes is sexually exciting, and that's very different and, in a way, much more disturbing, because it is curious that we should attach to this violent and mutilating event any sort of exciting possibility."[11] Or as Claudia Springer succinctly puts it in her book *Electronic Eros*, "Technology has no sex, but representations of technology often do."[12]

The problem is that this key critical distinction between the nonsexuality of technology and the sexuality of representations of technology – or Ballard's distinction between the non-erotic nature of car crashes, and the

hyper-eroticism of the *idea* of car crashes – is virtually absent from the text of the novel itself, which is presented from the post-crash perspective of the narrator "James Ballard" whose perceptions have become exclusively attuned to the marginal zone of pornographic technology. Adopting Ballard-the-narrator's perspective, Jean Baudrillard had already claimed in 1981 that "in *Crash*, there is neither fiction nor reality – a kind of hyper-reality has abolished both."[13] Reading the novel from the narrator's traumatized perspective of the world as a hyperreal domain beyond moral judgments and ontological distinctions, Baudrillard deliberately ignores the context of Ballard-the-author's extra-literary remarks. Indeed, Baudrillard wilfully ignores *any* context beyond the text of the novel, treating the text as lacking external limits or internal distinctions. In short, he contests the author's claim that *Crash* is a cautionary tale. "*Crash* is hypercritical," he writes, "in the sense of being beyond the critical (and even beyond its own author, who, in the introduction, speaks of this novel as 'cautionary . . .')" (Baudrillard, 319).

Baudrillard's view of *Crash* as a limit-less, hypercritical text is paradoxically based on a reading from the limited perspective of the novel's traumatized narrator. Ballard's attempts, since the novel's original publication, to provide an extratextual perspective are easy to ignore, especially since he has given his own name to his narrator whose initiation into the hyperreal is supervised by the character Robert Vaughan. Variously described by the narrator as a "hood-lum," a "TV" or "renegade scientist" (Ballard, 19, 63, 110) who "seemed to hover like an invigilator in the margins of my life" (65), Vaughan leads a fully transgressive, transmarginal existence of "complete confinement in his own panicky universe" while remaining "at the same time open to all kinds of experiences from the outer world" (123). Ballard-the-narrator plays Marlow to Vaughan's Kurtz, following him into the heart of darkness of the post-industrial "age of the automobile accident" (57), meticulously studying "imaginary automobile disasters and insane wounds" as "the keys to a new sexuality born from a perverse technology" (13). In this phantasmagoric world governed by the play of simulacra, one can no longer distinguish between the real thing and its representation, reality and fantasy. Wounds sustained in wrecked automobiles are presented as new sexual organs in the body, "tem-plates for new genital organs, the moulds of sexual possibilities yet to be created in a hundred experimental car-crashes" (177). Given such perceptions on the part of Ballard-the-narrator, it's understandable that Ballard-the-author has had to provide contextual frames and marginal commentaries for his highly unstable text – frames that Baudrillard perversely refuses to recognize. The valiant attempts by critics like N. Katherine Hayles and Vivian Sobchack to defend Ballard's novel from Baudrillard's intervention by insisting that it *does* present clear-cut borders between reality and simulation and between nature and technology, are unable to dispel the need for contextualization and commentary – including, of course, their own.[14]

Unlike Baudrillard, Cronenberg acknowledges a distinction in the novel between the narrator's inner world and external reality: "In the book you're in the head of the character James Ballard. There's that interior monologue thing that fiction does so beautifully, and which movies cannot do at all" (*CC*,

194). Such a literary distinction is difficult to maintain in film given what Cronenberg calls the "immediacy of movie reality." The ostensibly reliable mediating perspective of the documentary camera makes it difficult to repudiate the film's transmarginal content as the warped viewpoint of an unreliable narrator. And while it's still possible for most readers – even if not for Baudrillard – to read Ballard's novel as presenting car crashes as a metaphor for humans' relation to technology, and as presenting the visceral impact of wreckage on the body as a metaphor for the effect of an increasingly technologized world on the psyche, this relation becomes completely ambiguous in the film where signifier and signified become interchangeable. Is the car crash a metaphor for intercourse (what the Germans aptly call *bumsen*) – and here it should be noted that the two principal styles of car crashes are head-on and rear-end, corresponding to the two favored sexual positions – or is intercourse a metaphor for car crashes?[15] Neither sex nor car crash is given precedence in the film, but each is presented as being equivalent and equivocal.

Scenes of sex and car crashes abound in commercial film; they are only disturbing in Cronenberg's film because of the way they are conflated and fused in one and the same act. But these scenes are also filmed differently than in mainstream films. Instead of the big-budget car crashes in Hollywood action pictures, often in slow motion using multiple cameras and a variety of angles extending the instant of the crash into a prolonged, choreographed spectacle, Cronenberg intended his crashes "to be fast, brutal and over before you knew it. There's not one foot of slow motion. No repeated shots. I wanted to make them realistic in a cinematic way, because it's the *aftermath* that is delicious: that can be savoured and apprehended by the senses" (*CC*, 203). The sex scenes are also presented unconventionally, not as isolated moments that are embedded in and separable from the narrative – what Cronenberg calls "lyrical little interludes" that can "be cut out and not change the plot or characters one iota." Rather, in *Crash* "very often the sex scenes are *absolutely* the plot and the character development. You can't take them out" (*CC*, 199). The disequilibrium resulting from such a series of sex scenes that can't be distinguished from the plot is reinforced by the way the scenes are framed. Cronenberg explains how he would put the camera "more *outboard* of the car body so that the windshield pillar was halfway through the frame, and the other half is looking right down the car body" (*CC*, 202). By alternating such partial, external shots with close-ups in the dim, confined space of cars, any overview or total view of the whole is left undisclosed. (Only in the final scene does the camera move back from a close-up of the couple James and Catherine beneath her wrecked car.) We are only given glimpses of body parts, fragments that always seem to exceed whatever frame might contain them. Perhaps this was Cronenberg's way of tapping into a book that he found to be "hermetically sealed" (*CC*, 190).

Perhaps the most telling sign in Ballard's novel that he is writing about the erotic *image* of car crashes rather than about the eroticism of car crashes themselves is his pervasive references to celebrity. Anticipating the paparazzi's hot pursuit of Princess Diana's Mercedes, Vaughan's big project, which he endlessly rehearses in the novel, is to collide "into" Elizabeth Taylor's Rolls-Royce. All of his bizarre automotive and sexual rituals throughout the novel are presented as

foreplay leading up to this final consummation in which he perishes with the actress. "[E]verything lies in the future for her," Vaughan tells the narrator. "With a little forethought she could die in a unique vehicle collision, one that would transform all our dreams and fantasies. The man who dies in that crash with her . . ." (Ballard, 1994, 130). Vaughan's obsession with Taylor is the key dynamic in the novel, and illustrates Ballard's often expressed view about the crucial role that media-icons play in people's fantasy lives: "Celebrity uncontaminated by actual achievement has enormous liftoff capacity. . . . This puzzles us and triggers a curiosity about the real nature of these people whose fame you can't justify."[16]

Cronenberg also anticipates the paparazzi swarming around the site of Diana's accident. In one dream-like, nocturnal scene, he shows the crash-enthusiast Vaughan photographing a highway accident, and even interfering with the rescue workers who are trying to reach the victims trapped inside the vehicle. Cronenberg thus extends Ballard's metaphor of automobile-technology to the apparatus of the camera itself. In the process, the celebrity-theme is transformed, most noticeably in the absence of any reference in the film to Vaughan's obsession with Taylor, or for that matter, to the actress at all. This significant departure from Ballard's novel can be explained in part by the fact that the film was made and set a quarter-century after the book when Taylor was no longer the erotic icon she once was. In 1973 Ballard could evoke the fantasy of Taylor's death in a car crash; this would hardly be possible in the late 1990s when the aging actress was campaigning for AIDS research and waging her own battle against cancer, two debilitating illnesses that couldn't be further from the sudden, violent spectacle of automobile disasters. It's conceivable that Cronenberg could have substituted a contemporary actress possessing some of Taylor's former glamour and appeal as the object of Vaughan's fantasy – Liv Tyler for Liz Taylor – but such a revision would no doubt have run into legal and security problems. Besides, such crude updating was unnecessary since Cronenberg devised a way to incorporate the theme of the public's fascination and obsession with celebrity in his film that does not involve Vaughan's prospective crash with a living movie star; instead, he plays up the novel's references to Vaughan's *retrospective* project involving the meticulous study of *past* celebrity deaths in automobiles. The film is filled with references to the violent deaths of such celebrities as Jayne Mansfield and Grace Kelly, of literary figures like Camus and Nathanael West, and, of course, of President Kennedy. In the role of Vaughan, Elias Koteas meticulously studies these celebrity crashes in order to re-enact them, to restore their fading reality – or, a more likely possibility, to channel their auratic hyperreality into the mundane present.

One of the film's most memorable scenes is developed from a minor incident in the novel: Vaughan and a veteran stunt driver named Seagrave are shown re-enacting James Dean's 1955 fatal collision with student Donald Turnupseed down to the most minute detail before an avid audience at an abandoned sports stadium at twilight. After the crash, which Seagrave barely survives, the event is raided, not by the police, as Vaughan explains, but by the transport authorities. Vaughan then cryptically remarks that the authorities have no idea of what any of this is all about. What it's about, at least in the short term, is

Vaughan's next collaboration with Seagrave which is to recreate the Mansfield crash. Later in the film, Vaughan is devastated when he discovers that Seagrave couldn't wait and, on his own, has dressed up as Mansfield and killed himself in a re-enactment of her death.

Neither the simulated crash scene of Dean nor that of Mansfield appears in the novel. Instead, Ballard-the-narrator describes Seagrave's resentment at having to fill-in as a stunt double for actors and actresses in dangerous car crash sequences. After one such staged crash in the novel, Seagrave nurses "a grim concussion-fantasy" in which he imagines "film stars forced to crash their own stunt-cars" (Ballard, 103). And when he dresses up as Taylor in order to assume her role in an automobile commercial in which she will play a crash victim, he watches "Vaughan with some resentment, as if Vaughan had forced him to dress up each day in this parody of the actress" (110). But after the deal involving the commercial falls through, Seagrave sets out on his own to play the part he's been rehearsing. Ballard-the-narrator comments on Vaughan's devastation:

> Later, I realized what had most upset Vaughan. This was not Seagrave's death, but that in his collision, still wearing Elizabeth Taylor's wig and costume, Seagrave had pre-empted that real death which Vaughan had reserved for himself. In his mind, from that accident onwards, the film actress had already died. All that remained now for Vaughan was to constitute the formalities of time and place, the entrances of her flesh to a wedding with himself already celebrated across the bloody altar of Seagrave's car. (187)

While Seagrave is portrayed in the novel as an unredeemed realist who resents having to double for living actresses like Taylor in violent crash scenes, but who is determined in any case to play his part to the hilt and to die "her" death, Cronenberg portrays him as the inveterate stuntman who loves dressing in drag and whose ultimate desire is to re-enact Jayne Mansfield's death. And while a certain pathos is conveyed by the novel's depiction of Vaughan's disorientation after discovering Seagrave's impersonation of the living actress Taylor's death, Vaughan's/Koteas' devastation at Seagrave's re-enactment of the Mansfield crash (down to the detail of the tiny dead dog) borders on the absurd. Cronenberg portrays Ballard's characters as purely mimetic beings who can only impersonate and never improvise. Without Vaughan's ultimate goal of staging his and Taylor's death – a grotesque parody of fans or paparazzi stalking media-icons – the project of making the car crash into a fecundating technique or "fertilizing event" lacks specificity and suspense. Koteas' character loses its edge in the film and merely unravels towards the end, leaving James Spader and Deborah Unger (as James and Catherine), both of whom have supposedly come under Koteas' spell, to rather pointlessly try to work out their own auto-erotic consummation by themselves. (In the novel, the narrator's fantasy about his wife's death in a car crash is directly linked to Vaughan's obsession with Taylor's death [181] – a linkage that is lost in the film where Spader's consoling words to his wife after her car overturns in the final scene make it seem that automobile accidents are just a way for them to get their kicks.)

And yet, by depicting Vaughan's endeavor to obsessively recreate the fatal crashes of dead celebrities rather than plan his death in a collision with a living celebrity, Cronenberg has remained true to Ballard's original vision, updating it for the postmodernist nineties. The film-maker simply took the writer at his word when, in his 1974 introduction, he observed the reversal that had taken place between fiction and reality: "We live inside an enormous novel. For the writer in particular it is less and less necessary for him to invent the fictional content of his novel. The fiction is already there. The writer's task is to invent the reality." Aside from the fact that as a film-maker engaged in adapting a work of literature for the screen, Cronenberg found the novel *Crash* "already there" for him in a literal sense, he also recognized the mythical status of car crashes and other technological disasters in contemporary culture even prior to Princess Diana's death. The JFK assassination (which Ballard has called "a peculiar kind of car accident"),[17] the Challenger explosion, and the mystery of TWA flight 800 are past events that have never been satisfactorily explained and that therefore remain cultural fictions that need to be re-enacted and studied again and again. Yet how easy it has been for audiences to dismiss Vaughan and the other characters in Cronenberg's film (like the paparazzi in pursuit of Diana) as sociopaths despite the fact that "reality TV" routinely captivates those same audiences with graphic news-images of live police-chases and shoot-outs, horrific accidents at race tracks, boat races, and air shows, as well as celebrity deaths. Executions may not be televised, but the public is endlessly treated to images of sudden and violent death in the form of live news broadcasts of a variety of disasters which can be scrutinized and studied, and which are calculated to elicit a precise erotic frisson.

Indeed, it seems in some ways that Cronenberg has been truer to Ballard than Ballard has been to himself by showing Vaughan's meticulous but modest simulations of the car crashes of dead celebrities like James Dean and Jayne Mansfield, and avoiding any reference to his hubristic aspiration to stage his own violent death with a living cultural icon like Elizabeth Taylor. Since car crashes and assassinations involving celebrities have attained the status of myths in the popular imagination, as Princess Diana's death has so vividly shown, we may find ourselves fantasizing about them, and even re-enacting them in real life. ("The fiction is already there," as Ballard wrote; "the writer's task is to invent the reality.") If Cronenberg's film seems more a Baudrillardian than a Ballardian work, this is because he has followed the Baudrillardian implications of Ballard's insight that Ballard himself could not entirely accept. Thus while Vaughan in Cronenberg's film is a cult historian who has dedicated himself to re-enacting the fatal collisions of dead celebrities, in Ballard's novel he remains a type of creative artist who studies the past only in order to produce something new and unprecedented. The characters in Ballard's novel are nostalgic for the real which they can only attain through violence – as the narrator says, "The crash was the only real experience I had been through for years" (Ballard, 39) – while Cronenberg's damaged characters seem fully at home in the Baudrillardian hyperreal against which the "real" can no longer be opposed.[18] Throughout the film, Cronenberg appears to be following Baudrillard's philosophical reading of Ballard's novel, rather than the novel

itself. Specifically, he follows Baudrillard's program "to put in place 'decentered' situations, models of simulation, and to give them the colors of the real, the banal, the lived" (Baudrillard, 311). Yet without the internal narrative thrust of Vaughan's anticipated *Liebestod* with Taylor, and without the external frame of critical commentary that Ballard has provided in his introductions and interviews, Cronenberg's film has trouble standing on its own. Its lack of any formal center makes it appear to lack a moral center as well. The novel and the film need each other.

Indeed, I wouldn't recommend Cronenberg's film to anyone who hasn't read *Crash* and perhaps Baudrillard, since Ballard's novel and Baudrillard's philosophical analysis provide the frame or supplement that the film needs if it is not itself to become a decentered exercise, an unintelligible model of simulation. Some form of critical context may be necessary, not so much to protect impressionable teenagers from Ballard's ideas and Cronenberg's images, but rather to alert readers to the uncritical pronouncements of film reviewers. It would achieve what Ballard sought to do with his novel from the start: "to place a philosophical and metaphysical frame around the most important events within our lives and consciousness."

PART FOUR

THE RHETORIC OF THE POLITICAL

INTRODUCTION

The essays in Part Three responded to the postmodern crumbling of foundations via the aesthetics of felt difference by showing how the enigmatic space of literature exceeds the boundaries that the subject of rationality would erect to control contingency and hem feeling in. In Part Four those topics are transposed to the site of the political with emphasis first on rhetoric and the language of everyday life. The speech and action of rival intentions belongs to a political space of difference where identities congeal and dissolve in temporary and provisional stabilities. A second emphasis considers how fluid political identities may be fed by myth-making, story-telling, and poetry that lead toward an unknown praxis. A third examines crossroads of fascism and cannibalism where the rhetoric of politics as production results in the state as a work of art that consumes itself.

Theodore Kisiel's "Rhetoric, Politics, Romance: Arendt and Heidegger, 1924–26" concerns a love affair. Not only the romance between the philosopher and his brilliant student and its disruption by his brief flirtation with Nazism, but a mutual love affair with Aristotle. After a generation of intense controversy over Heidegger and the political, Kisiel clarifies that debate by historicizing Arendt's nonfoundational, postmodern political theory. Contrary to the notion that Heidegger lacked a theory of *phronesis*, Kisiel demonstrates, sometimes from still unpublished documents, the indebtedness of both Heidegger and Arendt to the practical philosophy of Aristotle, which in their hands, opens conceptual space for a "proto-politics." We learn that in the 1924 Marburg course "Ground Concepts of Aristotelian Philosophy," Heidegger locates the origin of theoretical discourse (from the *Metaphysics*) in the *logos* of everyday Greek life, anchoring truth as verification in the practical judgment of contextual truth. The 1924 text "Being-here and Being-true According to Aristotle" (the Ruhr talk) provides ontological exposition of the three classical genres of public speech: deliberative political speech, judicial or forensic speech, and epideictic or ceremonial speech. These categories from the *Rhetoric*, imported into the Daseinsanalytic of *Being and Time*, locate, Kisiel argues, "the domain of politics within the ontological field of Da-sein." In short, Heidegger clarifies ontologically the discursivity of the speech community as being-with, in Kisiel's words, "a life having and had by speech, a political life that expresses itself by speaking in community with others, and a practical life pervaded by speech." Arendt situates political speech and action at the same ontological site, in the discursive community where possibilities of "plurality" in speech and action flow from the perpetual beginnings of natality, the political ontology of the human condition.

David Halliburton's essay "Hannah Arendt: Literary Criticism and the Polit-
ical" renews the encounter of political rationality and the social by exploring
how, for Arendt, *poiesis* functions in the arena of political discourse. The ques-
tion is about the relation between poetic and political thinking: why does
Arendt perpetually resort to the poets, ancient and modern, in the context of
political theory – from Homer as the father of the Greek *polis* to the Declaration
of Independence as America's great founding poem? For her, poetic narrative
memorializes moments of great human action which lend proportionality to
the context of worldly action and nurturing of the political imaginary. Thus to
accuse Arendt of nostalgia or utopianism, as though claiming that she idealizes
and aestheticizes the Greek *polis*, confuses imaginative models with historical
actuality.

Halliburton's topic, Arendt as literary critic, illuminates the space of human
appearing in the distinction between poetry and history. The difference is as
important for Arendt as for the Aristotle of the *Poetics*, except that, for her,
poetry, unlike history, is not a product of *labor* and calculative rationality. The
poem, without *arche* or *telos*, belongs to natality; for natality escapes reification
and therefore escapes history. When history retrieves past acts, dimensions of
historical event remain concealed, unavailable to the historian. Thus Hal-
liburton can show Arendt reading *Billy Budd* as setting the French Revolution
not only in its narrow social context but in what, for Melville, is the wider
context of absolute good and evil. The "great" act (from Aristotle's *megethos*,
greatness) is a "complete" human meaning: "great" not on a scale of absolute
value, but great with respect to human proportion, distinction, or virtuosity;
and "complete," not in the sense of totalizing, but as an imaginative space of
relations or a poetic "world."

Michael Clifford's essay "The Politics of Fascism, or Consuming the Flesh of
the Other" seeks to account for the inherent tendency of fascism toward geno-
cide. It argues that fascism experiences difference in a unique way. Beginning
with the economics of desire in Deleuze and Guattari, Clifford rereads fascism
in terms of their trope of "territorializing." Following *Anti-Oedipus* in under-
standing the socius as inscribing determinate shape on the indeterminacy of
"body without organs," he then parts company with Deleuze and Guattari at
the point where they read fascism in terms of a totalizing moment of the
capitalist socius that protects against completely destabilizing schizophrenia.
Clifford argues that unlike the perpetual and inclusive disintegration and
reintegration of the capitalist socius, fascist identity is an essentialism that
preserves its viability within the flows of desire by first marginalizing and then
cannibalistically consuming (de-marginalizing) its Other. Speaking in the
shadow of Arendt, one might say that the fascist state projects its ideal as a
work of art, but art belonging to the order of production. Whereas totalitarian-
ism seeks to secure its foundations by assimilating difference into the one, the
fascist state, threatened more radically by the insecurity of its own foundations,
must cannibalize its Other. The fascist subject not only delineates itself as an
aesthetic ideal *over against* the Other, it requires the extermination of its Other,
consumes "the flesh of the Other," and goes mad. By analogy with Perniola's
"psychotic" form of inorganic sexuality, such abjection, while seeking to

incorporate the alien identity into itself, turning other into the same, transforms itself into the intermediary, passage, or "transit" for difference. Like an ingested virus, the cannibalizing of difference infects fascism itself, turning the machinery of its own organism against itself. Or say that in consuming the other it poisons itself, for it dissolves the essential which it seeks to preserve and enhance, as when Kristeva says that genocide, in search of abjection, expresses rage against the symbolic order. So in its unique effort to globalize its own originary delineation of the flows of desire fascism destroys itself.

8

RHETORIC, POLITICS, ROMANCE

ARENDT AND HEIDEGGER
1924–26

Theodore Kisiel

Public records at the University of Marburg have Johanna Arendt enrolled in three semesters of courses and seminars by Martin Heidegger, in WS 1924–25, SS 1925, and WS 1925–26.[1] A more private archival record suggests a much fuller curriculum of lengthy tutorials, at once philosophical and romantic, which supplemented the official university courses. Arendt will later refer to her encounter with philosophy in Marburg as the time of her "first amour," as if love and philosophy were inseparable. Despite the clandestine nature of their love affair in the provincial town of Marburg, the married associate professor and the beautiful young student nevertheless found occasion for lengthy conversations in discreet locations. The baseline of these conversations had to be Heidegger's then burgeoning Daseinsanalytic, taking concrete shape in this period against the background of his deconstructive interpretations of Aristotle in the form of two texts that would prove to be the two penultimate drafts of the book that appeared in 1927, *Sein und Zeit*.[2] An especially opportune time for lengthy discussions of his prolific but not yet public productions in this germinal period would have been the break between their first two semesters together. In April 1925, Heidegger wrote to Arendt in her home city of Königsberg to invite her to attend his "Kassel Lectures," a series of ten semi-popular lectures to be held in five days in Kassel, about 50 kilometers from Marburg. Only one other student of Heidegger's, Walter Bröcker, would attend – to record the only extant transcript of that lecture series – and he could be counted on to be discreet about the matter. Nevertheless, the same precautions they had already taken in Marburg would have to be continued in Kassel in order to keep the full depth of their relationship hidden from the public: in their first rendezvous in Kassel, she was to take the street car from the train station to the end of the line, wait for him at a designated bench in a nearby park, and they would go on from there.

This example of Heidegger's secret liaisons with his women students invites a forewarning about my title. My topic is not the factual romance between perhaps the last two great romantics in the history of German philosophy, but the romantically flavored cluster of concepts and conceptual approaches conveyed in those "first Marburg days" by our young professor to his enthralled student.[3] These ideas and approaches were later destined to be transmuted by the student in her own unique way, who thereby at once "remained faithful and did not remain faithful" to these ideas, "and both in love".[4] So reads Hannah Arendt's dedication of *Vita activa* (1960) – her German rendition of the book *The Human Condition* (1958) – to Martin Heidegger, but never sent to him, which reflects both her Jaspersian sense of authentic communication as a "loving struggle" and the anarchically plural sense of the philosophical community that flows from the unique occasionality and insuperable "temporal particularity" (*Jeweiligkeit*: "to each its while") of *Da-sein*. The ultimate goal of philosophical communication already for the early Heidegger, reflecting Arendt's later sense of the authentically political, is never the creation of heideggerianized parrots reiterating the jargon of authenticity, but the hortatory appeal to each person who truly hears it to confront and develop her own sense of facticity, of being-here, be it conservative German provincial peasant of the *fin-de-siècle* culminating in the First World War or expatriate Jewess of the mid-twentieth century, and communicate from this irrevocably unique vantage of the facticity of one's own generation. As Heidegger puts it to his very first habilitation student, Karl Löwith, three years before Arendt appeared in his life:

The one thing that matters for us is to understand each other in agreeing that what counts [in philosophical "objectivity"] is for each of us to do one's utmost radically by going the limit for what and how each understands the *unum necessarium* ["one thing necessary," the demands exacted by one's own historical facticity of being-here]. We may be far apart from one another in "system," "doctrine," or "position," and yet *together* as only human beings can genuinely be together: in existence.[5]

The philosophical rather than voyeuristic intent of my topic corresponds to Heidegger's forewarning to himself in *Sein und Zeit* (310), that any ontology is irrevocably ontically founded, that his own ontic ideal, say, in the choice of his heroes (*SZ*, 385, 371), enters into the shaping of his formal ontology of Dasein, here in its sense of authentic existence. The peculiar character of the intense philosophical apprenticeship undergone by Hannah Arendt in her "first Marburg days" later carried over into her own Daseinsanalytic of the active life of politics, first entitled *The Human Condition*.[6] She wrote it in the 1950s, after decades of expatriate engagement in the political life of the times, under the spell of her fragile reconciliation with the Heidegger family initiated in early 1950. She thereby entered into a mutually self-deceiving and opportunistic *ménage à trois* that in strangeness exceeds any of the precedents to be found in German arts and letters, be it the non-conformist relations that developed between Friedrich Schlegel and Dorothea Mendelsohn, Friedrich Schelling and Caroline Schlegel, or Friedrich Nietzsche vis-à-vis Cosima Wagner and Lou

Salomé. Arendt for a time fancied herself in her relation with the later Heidegger still to be "the passion of his life," his very muse, while Elfride and Martin had already gone through this scenario with several later students, none, to be sure, as talented and as prominent as Hannah Arendt. They were to repeat that same scene more than once in the coming decade. Hannah may have been the first of Heidegger's "relationships," but she was by no means the last. Despite Heidegger's repeated requests to his women-correspondents to destroy the incriminating letters exchanged between them, the Heidegger Archive in Marbach contains at least a half-dozen documentable relationships of sustained duration, some reaching well into the fifties, at a time when Heidegger pretended to Hannah Arendt that he was content with his later life with Elfride. We now have the important German edition of the correspondence between Arendt and her husband and shall soon have the complete correspondence between Heidegger and Arendt edited by Ursula Ludz. But all this is only the beginning. The definitive book on *Heidegger und seine Frauen* is far from being presented in its full documentary glory. Hannah Arendt's repeated assertion, "Heidegger is a fabulous liar," was far truer than she knew. So be it. The only real present regret for posterity is that we are now paying the price for Heidegger's "womanizing," which, no less than his involvement with Nazism, contributed to the archival circumstances that have forced upon us a wholly family-controlled Collected Edition of his works notorious for its amateurishness and mediocrity.[7]

THE HUMAN CONDITION AS DASEINSANALYTIC AND ARISTOTLE'S PRACTICAL PHILOSOPHY

In October 1960, upon informing Heidegger that he would be receiving a copy of *Vita activa* from the German publisher, Arendt wrote:

> You will notice that the book bears no dedication. If things had gone right between us – I mean not just you, nor me, but *between* – I would have asked you whether I could have dedicated it to you. For the book had its origin directly from our first Marburg days and in every way owes just about everything to you. As things are, this seemed to me impossible. But at least I wanted to tell you, in one way or another, the naked truth.
> (*EE*, 121/114)

In an earlier letter (May 8, 1954) summarizing her current work in response to a curt query from Heidegger, Arendt had already "paid homage to his mentorship" (*EE*, 122/115) in naming two topics that had their origin in "what I had learned from you in my youth" (*EE*, 109/100), namely, (1) the relationship between action and speech as distinguished from work and labor, and (2) philosophy and politics ("in your interpretation"). In a public address shortly thereafter in the same year, she in fact pinpoints the Heideggerian concept that mediates between these two themes:

> It may be ... that Heidegger's concept of "world," which in many

respects stands at the center of his philosophy, constitutes a step out of this difficulty [of philosophy's penchant for the solitary singular versus the political plural]. At any rate, because Heidegger defines human existence as being-in-the-world, he insists on giving philosophic significance to structures of everyday life that are completely incomprehensible if man is not primarily understood as *being together with others* [*die Mitwelt*, in Arendt's German rendition].

And in an appended note: "It is almost impossible to render a clear account of Heidegger's political thoughts that may be of political relevance without an elaborate report on his concept and analysis of 'world.'"[8] In her "first Marburg days" much more than in *SZ*, this "elaborate report" articulated itself according to Heidegger's distinction between *Umwelt, Mitwelt, Selbstwelt* (environing world, world-with-others, self-world) and further sub-distinctions like the work-world and thing-world, the public world ("common world") and domestic world. In *SZ* there is the undeveloped distinction between the public "we-world" and one's own and nearest, private "domestic environment" (*häusliche Umwelt*: *SZ*, 65). Arendt's *HC*, in its refined distinctions between labor, work, and action, could itself be construed as just such an "elaborate report," which however temporarily puts aside the "self-world" of thinking/willing/judging.

It is often said that the student Arendt was apolitical in her early interests, almost as apolitical as the early Heidegger himself. Indeed, orthodox Heideggerians, who in defence of the master wish to insulate his thought from his life, especially his political life, even make the claim that Da-sein itself is apolitical, akin to Sartre's observation that "Dasein doesn't seem to have a sex life" and Levinas' "Dasein never seems to get hungry." The emerging archival record of the "first Marburg days" shows that this is decidedly not the case in all three arenas, especially in the context of the Greek precedents to Dasein that Heidegger was then developing in idiosyncratic glosses of original texts like Aristotle's *Rhetoric* and *Politics*. We have since 1992 had the *Gesamtausgabe* volume of Heidegger's lecture course entitled "Plato's *Sophist*," the very first course by Heidegger that Arendt attended in Marburg, and Arendt scholars might have already noted the degree to which this course is governed by the distinctions between the rhetorician, the sophist-politician, and the true philosopher. Perhaps one of the last lectures in the winter semester course on *Logik* that Arendt attended occurred on January 15, 1926, as the decision for her to leave Marburg was first being broached. In an hour that in retrospect seems like a personal farewell address, Heidegger for the very first time in his Daseins-analytic schematizes the two extreme modes of being-for-the-Other, in formal terms that find their immediate concretion as much in communal-political as in personal-pedagogical contexts: at the one extreme, the mode of leaping in and dominating the other by taking care of her concerns, as in a welfare state, and at the other extreme, of leaping ahead and liberating the other to her maturity, freeing her to care for her own concerns, especially the *"unum necessarium"* of fundamental care, as Heidegger fancied himself to be doing pedagogically vis-à-vis his students (*Genesis*, 386).

Generally speaking, we find Heidegger in these "first Marburg days" deep into his Greek-Aristotelian phase of development toward the systematic structures of Da-sein, the unique human situation, what Arendt will later retitle "the human condition." Heidegger the phenomenologist was in the midst of redirecting his ontological paradigms for the Daseinsanalytic away from the traditional theoretical habits of science and wisdom, with their orientation toward eternal being and permanent presence. Instead he was resituating Da-sein in the more practical virtues of temporal-historical being that Aristotle called the art of making, the know-how of getting around with things in the environing world (Division One of *SZ*), and the prudence of acting, circumspective insight into human action, first of all the "ethical" action of the self responsive to its self-situation (Division Two of *SZ*) but also the "political" action of the self responsible for others, its *Mitwelt*. A first understanding of Dasein in these practical contexts gave the young Arendt plenty to think about regarding "the relationship of speech and action as distinguished from work and labor." Moreover, Heidegger's career in Marburg began during the politically charged year of national crisis of 1923, after the French had occupied the Ruhr region and inflation accelerated stratospherically. Both events combined to escalate, to a fever pitch, the propaganda speeches and putsch actions of an already severely factionalized internecine politics in the Weimar Republic. From this charged propaganda background Heidegger will make the first tentative steps to locate the domain of politics within the ontological field of Da-sein by way of the phenomenological counter-example of the civic politics in Aristotle's *Rhetoric*.

Scholars of Arendt's "political thought" interested in delineating its Heideggerian roots will accordingly find two still unpublished Marburg documents of special interest, to which the young Arendt had access, at least in outline form, by way of Bröcker's transcripts and Heidegger's direct "mentorship":

SS 1924 (Marburg): "Grundbegriffe der aristotelischen Philosophie" (in Karl Löwith's transcript entitled "Aristoteles: Rhetorik II").

December 1–8, 1924: "Dasein und Wahrsein nach Aristoteles (Interpretation von Buch VI der Nikomachischen Ethik)." Lecture tour through the Rhine–Ruhr valley, still under French–Belgian occupation.

Although the references to politics in these two pieces are usually brief and sometimes exegetically allusive, it nevertheless becomes clear that Aristotle's *Rhetoric*, "the first systematic *hermeneutics* of the everydayness of being-with-one-another" (*SZ*, 138), depicts a speech community, a being-with that is at once a speaking-with, whose basic goal is coming to an understanding agreement with one another, *hermeneia*, communication and the accord that it brings in the public sphere. It is by way of this proto-rhetoric out of the Greek context that a rudimentary proto-politics begins to take shape in Heidegger's emerging fundamental ontology (SS 1924: 16–29, 47–55, 97).[9] In view of the close proximity, indeed the "equiprimordiality," of rhetoric and politics (ergo of speech and action) in a Greek loquacity that places a primacy on the political, what is

being situated ontologically is in fact a rhetorical politics and political rhetoric of an everydayness in crisis. For the early Heidegger, the more ontological Greek *Urtext* of political philosophy is Aristotle's *Rhetoric* and not Plato's *Republic*, which will play a different role on a later, more fateful occasion of his political development. At this early stage, the *ethos* of Greek civic discourse is held up as a paradigm in counterpoint to the propaganda-ridden speech community of the Weimar Republic; each will serve as an example contributing to the formal ontological structure of the "interpretedness" (*doxa*) of the "everydayness of being-with-one-another," whose least common denominator is *das Man*, the anonymous undifferentiated Anyone. In this double context, Heidegger makes clear how deeply the Greek definition of the human being as a life possessed by speech is rooted in the self-interpretation of Greek Dasein as a being-with-one-another in the *polis*. He suggests its equivalent in the crisis of 1923–24: the modern human being, especially German Dasein, is the living being that reads the newspapers (SS 1924: 41), in a publicity determined by the daily "pulp" journalism.

The double-take on Aristotle's political philosophy in 1924 in fact begins in the very first Marburg course of WS 1923–24, in Heidegger's first attempt to demonstrate the equiprimordial convergence of the two Greek terms for "phenomenon" and "speech" in the methodology of phenomenology. Heidegger stresses how deeply practical that human language is for the Greeks, such that an equiprimordiality is developed between practice and speech. In the end, Heidegger brings together three separate definitions of the human animal gleaned from the Greek canon, regarding them as equiprimordial in their defining limit: a life having and had by speech, a political life that expresses itself by speaking in community with others, and a practical life pervaded by speech. Since life always means being in a world, this means that humans both occupy the world and are occupied by it, practically, politically, and, most basically, discursively. The world is always a discursive space, functioning in practical ways that precede and underlie theoretical assertorics and demonstration, aiming an understanding agreement with others about something. In sum, *logos* for the Greeks is the highest possibility of being human, what it means to live well with others in everydayness at its political and practical best.

Since the practical is normally understood in contrast to, and thus in terms of, the theoretical, it is better to speak of a protopractical understanding that Heidegger wishes to draw upon, a know-how of what it means for us to be with others among things in the world that comes simply and directly from already having lived and acted in the arena of the world. In short, the know-how that comes simply from the primal "action" of be-ing, i.e. being-with-one-another. Ever since 1922, Heidegger oriented this protopractical temporal ontology from the five excellent habits of being-true according to Aristotle's *Nicomachean Ethics*, Book 6, which will be rehearsed for his Ruhr audience in late 1924. Two of these ontological habits are theoretical, two practical, and a fifth, *nous*, governs and guides these four, which accordingly are called the dia-noetic virtues. As a virtue, each is a habit of excellence, something that is had by us, or better, like language, a habit that has us, determining how we have and hold ourselves in the world and "be-have." Only the habit of *nous*, direct contemplative seeing

of being, is regarded by Aristotle as beyond language. This will change with Heidegger, who will re-place eternal *nous* by a temporal "clearing" comprehending being by way of the ecstatic unity of Da-sein's con-textualized and thus very finite temporality. The excellent habits of being-true oriented to "beings that can be otherwise" are pretheoretical practical excellences, knowing how to get around in one's occupation with things and circumspective oversight into human actions. Such circumspective insight at its most authentic always begins with the conscientious response to the demands of one's own situation, then accommodates one's self-referential action to the situation of others in authentic solicitude "for-the-sake-of-others" (*SZ*, 123) in "leaping ahead and liberating" the others (*SZ*, 122, 298). Such a liberation movement is the seed of an authentic politics in Heidegger, which of course can only be sustained by an authentic rhetoric, by a language that transcends the everyday in the direction of the lifetime considerations of destiny. Since these two pretheoretical, protopractical dispositions of being-true constitute the respective ontological paradigms of the two published Divisions of *SZ*, and the more "theoretical" habits of trueing are now to be derived from these two ways of coping with historically varying contexts, "*je nach dem*," it is clear that the "science" that Heidegger is after no longer has as its "objects" merely the traditionally static ones of constant presence, but in particular the ec-static ones of past self-finding and future self-projection. The comprehensive "theoretical" virtue, the authentic understanding of philosophy, in turn would now become the comprehensive temporal science of the ever unique human situation. This unique temporal "clearing," the *nous*-surrogate that would provide the temporal standards (*ethos*) for human dwelling in its makings (Division 1) and actions (Division 2), would have been the topic of the unwritten Third Division of *SZ*. The temporal science of the ever unique human situation, which is "in each case mine (ours)," with each human being or generation allotted its own time, must accordingly develop those uniquely temporal universals sensitive not only to the distributive "each" (*jedes*) but also to its varying narrative contexts, "*je nach dem*." Such novel universals adaptable to the changing situations of history might therefore be called *jeweilige Universalia*, the temporally particularizing universals. Aristotle had already observed that "being is not a genus," cannot be reduced to the indifferent common generic universal, of the All or Anyone, but is very much oriented to the distributive plurality of particulars.

Outside of not noting the methodological approach of formal indication in order to arrive at such universals in proximity with the particular and individual (and equally the plural), Dana Villa's inventory of themes that Arendt drew from the early Heidegger is thus reasonably complete: ". . . Heidegger's emphasis upon finitude, contingency, and worldliness as structural components of human freedom; his conception of human existence as disclosedness or unconcealment; the distinction between authentic and inauthentic disclosedness, and his view of the 'there' or 'Da' of Dasein as a space of disclosedness or 'clearing.'"[10] It has been observed that, among Arendt's works, *HC* is particularly prominent in its "Heideggerian concerns with 'disclosure,'" notably in the revelatory reciprocity between action and speech that is reminiscent of the

"equiprimordiality" between thrown project and discursivity in *SZ*, both understood as fundamental modes of disclosure. *HC* has also stood out in its "agonal and highly individualistic view of politics," as a measure of authenticity in politics, as opposed to the stress on cooperative participation in public affairs found in Arendt's later works.[11] We have only to add the nostalgia for the Greek *polis* that many commentators have found in Arendt as a way of introducing our examination of the two Heideggerian texts on Aristotle: "[the] full significance of Arendt's transformation of Heidegger's ontology requires a more detailed examination of Heidegger's reading of Aristotle in the period from 1923 to 1925. Arendt, as opposed to Heidegger, found in Aristotle's concept of *praxis* the key to a new revaluation of human action as interaction unfolding within a space of appearances."[12] A summary of Heidegger's two readings of Aristotle in 1924 is out of the question here.[13] We are primarily interested in the Aristotelian terms transposed by Heidegger into his Daseinsanalytic that Arendt herself will later adapt to her own political ontology of the "human condition."

SS 1924: "GROUND CONCEPTS OF ARISTOTELIAN PHILOSOPHY"

The basic aim of the course is to understand some of Aristotle's ground concepts in their native growth (*Urwüchsigkeit*) out of the soil from which they sprang and continue to stand (*Bodenständigkeit*). That native soil was the Greek language. A glance at the Lexicon of *Metaphysics* V shows that Aristotle developed some of the most basic terms of his philosophy by way of a refinement of ordinary everyday Greek, the *doxa* of its language. In the native soil of the Greek language, for example, Aristotle's central word for being, *ousia*, finds its practical roots in the domain of household goods, property (*Habe*, having), and real estate (*Anwesen*, which in the German also means presence). In placing *ousia* first in his philological analysis, Heidegger is initiating his own life-long project of re-placing the ousiological elements of "being as having" and habit operative in the Greek fixation upon the real estate of an eternal world, the basis for its metaphysics of constant presence. He wants instead to translate these elements of Greek Dasein into the kairological language of a native German Dasein that never possesses itself but is always dispossessed, thrown into the world temporarily, in this timely ec-static situation, always underway in its project of life toward death.

Significantly, Aristotle does not include speech itself, *logos*, in his lexical list of 30 terms, even though, as the authentic *doxa* that lends itself to philosophical insight, it is clearly the operative preconcept behind all of them. Heidegger therefore goes to Aristotle's practical philosophy to draw out the native soil and natural growth of Aristotle's implicit sense of *logos* being applied to his metaphysical concepts. Possessive of and possessed by speech in a practical life thoroughly pervaded by speech, understanding human being born into a practical and political world accordingly has hearing, *akouein*, responsiveness to speech, as its most fundamental mode of perception (SS 1924: 15). Aristotle's formulation here of the primacy of hearing in understanding is striking,

inasmuch as the model theoretical life will for him, by contrast, have the direct
intellectual seeing of knowing as its most fundamental form of perception. This
nous is accordingly without speech, speechless, beyond language and its human
world, thus "divine."

Following Aristotle's acoustic attunement toward finite human language
rather than his theoretical vision of things eternal, Heidegger now situates the
"political animal" within his own fundamental ontology of Dasein as being-in-
the-world. Speech has the basic function of making a world manifest to one
another and, in that communicative sharing, at once manifesting being-with-
one-another in mutual accord and active concert, the locus of the political.
What speech first makes manifest politically is that I am one-among-many and
thus one-like-many, *das Man*, in an average concrete being-with-one-another.
This is not an ontic fact but an ontological how-of-being, the how of everyday-
ness. The true bearer of the common universal of averageness called the Anyone
is our language (23). The domineering prevalence of the Anyone properly
resides in language, in the prevalence of the self-evident "what one says" and
"how one sees things" first and foremost, which the Greeks called *doxa*, opinion
(27), that will provide the major premises of rhetoric. It at once points to the
possibility of forms of being-with-one-another authentically by way of a more
developed being-in the *polis* (23), those of *hoi aristoi*. As many readers of *SZ* like
Pierre Bourdieu have long suspected, *das Man*, *hoi polloi*, "the many" under-
stood not as a loose sum of individuals but as a public kind of power of
anonymity, apathy, and indifference to uniqueness built into the repeatability
of any language, is the baseline category or "existential" of Heidegger's prop-
erly political ontology. Bourdieu calls it Heidegger's "rhetorical ontology"
inasmuch as language itself is the proper locus and *modus operandi* of the
Anyone.[14] This "rhetorical-political" realm of language that circumscribes the
self-evidence of public opinion (27) even provides the basis for the "universal
validity" so indispensable for "agreement" in the objective sciences (23), not to
speak of the generic universals of the traditional metaphysics of constant pres-
ence of eternal natures. "*Eidos*, the look of the world as *one* sees it," involves
"what is called universality, universal validity, a claim to a kind of averageness"
(23).

AN ARENDTIAN ASIDE

Heidegger had first introduced the "category" of the averaged Anyone two
years earlier in an introduction to a planned book on Aristotle – the Anyone as
opposed to the ex-sistential self that in its uniqueness "stands out" from the
crowd, hence common names (what) in distinction from proper names (who)
and generic universals as distinguished from indexically distributive universals
(the "existentials"). These parallel still other oppositions in Heidegger's fun-
damental ontology, like everydayness versus unique lifetime, decadence versus
transcendence, inauthentic versus authentic. Michael Gottsegen has exposed a
similar axiological matrix of dichotomizing categories in Arendt's political
ontology: uniqueness and uniformity, lasting and passing, freedom and
necessity, public and private.[15] The first is the most formal, that of heterothesis

in the medieval transcendentals – the selfsame is a self in not being an other – which Arendt adapts to her political purposes in many subtle ways, beginning with the tension between the sameness of equality and the unique differentiations of original plurality. She finds many supportive precedents for this in the tradition, like Aristotle's distinction between the great who "dare the extraordinary" and the commonplace ordinariness of the everyday (*HC*, 205f.)

From the fashion salons of the French court to the expanding standardization of modern industrial society to the stateless masses "concentrated" for systematic dehumanization in the "corpse factories," Arendt in her several works beginning with *Origins of Totalitarianism* provides numerous historical examples demonstrating that Heidegger's formal category of the leveled and averaged Anyone absorbed in the everyday world of things reaches far beyond the "political." But this was Heidegger's existential-ontological intent in rooting this everyday with-world deeply in the instrumental environment of the work-world, and Arendt does not criticize this least-common-denominator "existential" on that score. Instead, "we find the old hostility of the philosopher toward the *polis* in Heidegger's analyses of average everyday life in terms of *das Man* (the 'they,' the rule of public opinion, as opposed to the 'self'), in which the public realm has the function of hiding reality and preventing even the appearance of truth."[16] While questioning his withdrawal from the public and political realm into the time-honored solitude of the philosopher, Arendt does not deny the continuing topical relevance of Heidegger's portrayal of the prevalence of the obfuscating power of anonymous publicity in contributing to our present "dark times" and "determining every aspect of everyday existence." In fact, she lauds him for the "uncanny precision" of his "analyses (which, in my opinion, are undeniable)": "In our context of present 'humanity in dark times,' the point is that the sarcastic, perverse-sounding statement, *Das Licht der Öffentlichkeit verdunkelt alles* (the light of the public obscures everything), went to the very heart of the matter and actually was no more than the most succinct summing-up of existing conditions"[17] Although Heidegger is given no "profile in illumination" among her particular century's "men and women [who] in their lives and their works" have kindled such illumination in, of, and for our dark times, his illuminations of the "incomprehensible triviality" of the common everyday world, his play of truth as concealing unconcealment, his acoustical sense of the secret soundings of language, are felt throughout, both implicitly and explicitly, and especially keenly in the profile of Walter Benjamin (*MDT*, 189, 195f., 201, 204f.) Take, for example, her account of the public cover-up of the catastrophes and "monstrosities of this century which indeed are of a horrible novelty" (*MDT*, ix):

> ... until the very moment when catastrophe overtook everything and every-body, it was covered up not by realities but by the highly efficient talk and double-talk of nearly all official representatives who, without interruption and in many ingenious variations explained away unpleasant facts and justified concerns. When we think of dark times and of people living and moving in them, we have to take this camouflage, emanating from and spread by "the establishment" – or "the system," as it was then

called – also into account. If it is the function of the public realm to throw light on the affairs of men by providing a space of appearances in which they can show in deed and word, for better and worse, who they are and what they can do, then darkness has come when this light is extinguished by "credibility gaps" and "invisible government," by speech that does not disclose what is but sweeps it under the carpet, by exhortations, moral and otherwise, that, under the pretext of upholding old truths, degrade all truth to meaningless triviality. (*MDT*, viii)

Arendt's resolution to this continuing conflict with the public realm is not retreat but reformation, in order to restore "the power of illumination which was originally part of its very nature" (*MDT*, 4) by recreating the "in-between" of the with-world through its differentiation into an egalitarian plurality, uniting unique persons to one another through a common but pluralized world, as a "space of appearances in which [true individuals] can show in deed and word . . . who they are and what they can do," who are then sung in the history of the commonweal.

The closest that Heidegger comes to such a framework is in his exploration of a science of history that would arise from an authentic historicity. Such a historiography would not find its "objectivity" in the universal validity exacted by the universality of the Anyone, but by manifesting its universal in the unique (hero, deed, event) with which it is confronted in its possibility (*SZ*, 395). The context also makes reference to Dasein's unique beginning of birth, for Dasein's unique history, whether individual or generational, is played out between the extremes of its birth and death, and *historical* possibility is drawn from "being toward the beginning" (*SZ*, 373) more than from being toward the end, death. But Arendt's framework of human plurality, as a condition of possibility of interaction and speech, coupled with the spontaneous initiative that comes from generational natality, both of which are implied in Heidegger's formal indication of temporal uniqueness as "in each instance mine in its while," remains a remarkable conceptual breakthrough toward the authentically political within the analysis of Dasein.

DECEMBER 1924: "BEING-HERE AND BEING-TRUE ACCORDING TO ARISTOTLE"

This talk was, according to Heidegger, initially drafted as a fragment in "1923–24," still near the peak of the Ruhr crisis, but not actually delivered in as many as six cities in the Rhine–Ruhr valley until December 1924. The postponement and delayed delivery probably reflects the turmoil in the region even after the international tensions had eased after the government's capitulation in 1923, followed by ongoing negotiations of the Dawes Plan of reparations payments in 1924. French and Belgian forces were still very much present in the Ruhr in December of 1924. The orator Heidegger might therefore have felt a little like Fichte in 1808, delivering his *Addresses to the German Nation* in a Berlin still occupied by the Napoleonic armies. The apparently straightforward gloss of the Aristotelian texts comes alive against the

background of the tensions of the current events of the day. As the first cousin of the well-known later talk marking the turn to the later Heidegger, "On the Essence of Truth" (1930–43), the Ruhr talk provides a general conceptual frame for situating rhetoric/politics in Heidegger's developing ontology of practical truth and untruth, the contextual truth of human actions and human lives rather than the verificationist truth of judgmental statements.

Contrary to the later talk on truth, the opening section of "Speech and Judgment" spends little time on the declarative sentence, traditionally the locus of truth as correspondence through the scientific "demonstration" that "lets something be seen" as it is. Heidegger is in a hurry to get to the more practical and "crucial" kinds of judgment (*krinein*) at issue or in abeyance in everyday speech situations. The everyday speech situation that generates practical judgments is far richer than mere judgment. Its prejudicative possibilities, not always reducible to mere preludes to judgment, include requests, wishes, questions, imperatives, exclamatories, pregnant pauses, and other punctuations not subject to the hyperjudgment true or false. Better, they point to a more original, comprehensive, and tacit sense of what it means to be true. On the everyday level, *logos* does not mean judgment, concept, or even reason, but simply speech, which includes every form of discursivity and articulation, even the non-verbal kinds of sheer action (e.g., passive versus active resistance in the Ruhr crisis). The investigation of this spectrum of phenomena of speaking to one another belongs to rhetoric, which, as the study of *logos* in its very first fundaments, could also be called the very first "logic." Understood as the hermeneutics of everyday life of the Greek *polis*, classical rhetoric has identified three moments of discourse, which generate three genres of civic speech-making. Heidegger's matter-of-fact summary of the three clearly bore immediate relevance to the German *polis* of 1923–24. For his Ruhr-audience had repeatedly been addressed by all three forms of public discourse in its two years of crisis:

1. The properly political speech seeks to persuade or dissuade a popular assembly or deliberative body of a certain decision or resolution of a crisis, say, in matters of war and peace. The speaker does not seek to educate his audience about a state of affairs, but wishes rather to atune his audience to his own convictions on the present condition of the state and counsel on the future course of action. Germany at this time continued to be inundated by propaganda from factions both right and left about the "November betrayal" of the 1918 armistice and the call to overthrow the "November criminals" of a Weimar Republic inept in its handling of a continuing series of state crises.

2. The judicial speech before a court of law addresses a judge and jury. On trial for treason for his instigation of the Munich putsch, Hitler had in the past year successfully made the entire nation the audience and jury of the speech in his own defense.

3. The festive (epideictic) speech is intended to bring the auditor into the presence (*Gegenwart*) of some admirable and noble deed or person. It may involve either praise or censure, designed to elicit admiration or outrage

toward folk heroes and their acts, like "Benedict Arnold" or the police spies who betrayed Albert Leo Schlageter, a younger compatriot from Heidegger's home region and university executed by the French for acts of sabotage in the Ruhr. The Heidegger of 1924 does not say this, but Schlageter's example of witness and death speaks directly to the titular theme of his talk: being-here itself as being-true, the truth of a life that comes from the resolute authenticity of Dasein. By way of story-telling to sing the deeds of great political actors, Arendt too points to the vital role of the epideictic in the political. But she will deplore Heidegger's 1933 speech on Schlageter for its "mythologizing confusions of Folk and Earth as a social foundation for his isolated Selves [of a totalitarian state]. It is evident that such conceptions can lead one only out of philosophy into some naturalistic superstition."[18]

Heidegger then summarizes the ontological elements of these three speech situations of an everydayness "exponentialized" by crisis:

1. Deliberation over a future course of action, judgment of a past action, reliving the presence of a praiseworthy action: the temporality of the three genres of speeches of a *polis* punctuate the rhythms of its public life, of political everydayness.
2. These speeches have as their *telos*, not the communication of expertise on the everyday matters at issue, but rather the auditors themselves, aiming to win the audience over to a view of things by way of forming a receptive disposition, which sometimes involves transforming another prevalent mood, typically the apathy of the Anyone. The *pathos* of the listener is therefore the most basic of the three classical means of persuasion and opinion-formation, the "trusts" that inspire "confidence" in the speaker and his speech: *pathos – logos (doxa) – ethos*.
3. The kind of demonstration in the everyday *logos* is not a matter of logical proof or scientific procedures. They are instead enthymemes, the abbreviated syllogisms of rhetoric, literally curt speech that goes directly "to the heart" (*en-thymos*): striking examples (Schlageter), memorable punch lines, emotionally charged but pithy tales ("November betrayal"), narrative "arguments" that hit home. The public speaker draws upon the way one on the average thinks about things, the popular *doxa*, from which he selects the seldom stated major premises that found his abbreviated but striking conclusions about how things look and what seems to be the case. For the thinking of the crowd is shortwinded, having absolutely no interest in the lengthy process of getting "at the things themselves." The Greeks, who loved to talk, had a strong sense of this most immediate phenomenon of speech, of being with one another in common gossip, chatter, and idle talk. The human being even for Aristotle is not first of all the rational animal but one who dwells in ordinary language and idle talk, with neither time nor inclination to speak primordially about things themselves. Socrates and Plato in particular took arms against the prevalence of idle talk, which Heidegger identifies as one of the inescapable concealments of truth, the

concealment of and by opinions in which daily life on the average first of all and most of the time operates.

More dangerous than the concealment of daily rhetoric is the concealment of sophistry. It puts originally disclosed matters forward in the guise of matter-of-fact self-evidence; it parades pseudo-knowledge as a familiar possession obscuring the need to return original disclosures to their sources, constantly interrogating their *authentically* original concealment. Through the prevalence of the catchphrase, cliché, and polished concept, the sophist disguises and distorts the truth with inflated rhetoric.

Thus, in his first listing of the three modes of concealment, Heidegger attributes two of them directly to the language of rhetoric, first the authentic *doxa* or folk wisdom latent in any indigenous language, and second the calculative use of that wisdom by sophistry. Correlatively, the three modes of becoming true, of trueing, the process of wresting matters out of concealment, are:

1. Disclosing beings by way of opinions commonly held about them, since such everyday views do contain a partial glimpse into the being of their beings.
2. Pressing into those unfamiliar original domains of being that have never been revealed and about which we remain ignorant. Once again, as both Aristotle and Heidegger illustrate, the protopractical *doxa* latent in our language provides some initial assistance in this task.
3. Struggling against the chatter that gives itself out to be knowledgeable and disclosive of the way things are. This struggle involves tearing off the disguises of the concealing catchphrase and cliché, exposing not only the underlying being of things but also the forces of concealment that militate against its discovery.

Despite the deceptive machinations to which *doxa* is subject, it has for Heidegger, following Aristotle, displayed its "trueing" functions in two ways: as a linguistic source of philosophical insight into the world, and as a partial truth that, by sufficient broadening and reorientation, allows for accord in historical being-with-one-another. *Doxa* is the "space" in which Arendt situates the authentically political, as a "space of appearances and opinions," so it is important to note that Heidegger's ramified Aristotelian account of it (SS 1924: 50–65) in like fashion characterizes *doxa* as "the authentic orientedness of being-with-one-another in the world" (58). It is the average intelligibility in which the Anyone moves, in what one "on the whole" means about things and about oneself (23). It is the "authentic discoveredness" of being-with-one-another in the world that grows out of speaking with one another in and out of everyday concerns (58). Even though *doxa* has a certain fixity in its peculiar familiarity and confidence in what first shows itself, that about which one has an opinion is always open to discussion and thus to "negotiation" (59). For opinion belongs to the realm of "that which always can be otherwise" and is accordingly always capable of revision. It is the "art" of rhetoric, which is

always conditioned by the politics in which it stands (51), that seeks to guide us to the right decision for resolute action in a crisis (56). In such deliberations, the appropriateness of the judgments are to be evaluated not only in terms of the viewpoint being expressed and what speaks for it, the doxic context out of which it arises (63), but also how the opinion is presented (*ethos* of the speaker) and how the auditor stands to the opinion (his *pathos*). Has the speaker, for example, risen above partial views to an oversight of the whole of the problematic situation, its *kairos* and full temporal horizon? If he is fully acquainted with the situation, is he perhaps not saying all, veiling his own position and view of the matter? Is he resolute and prudent in his insight (*phronesis*) into the issues at hand and competing views? Is he attuned to the mood of his audience as well as that of the situation, etc.? It is not clear to me that Arendt, in her formal stress on the space of *doxa*, has done full justice to these latter two, equally primordial, contexts of the situation of speech/action.

A final word on the third context. In Aristotle's *Rhetoric*, *ethos* is the "character" of the speaker, his bearing, his manner of holding himself in the world and toward others, his be-having, judged to be appropriate or not in this speech situation of judgment and action, persuasive or not by and for his audience. In Heidegger's ontological framework, *ethos* in its display of conviction translates into the particular resolve manifested by the speaker in his speech, and the way he attempts to bring others to the same resolution regarding the current *kairos*, this moment of decision in polity and policy (66, 76). And resoluteness is the receptive response to the Heideggerian call of conscience. The politician-orator projects himself as the authentic conscience for the other, through his prescient insight leaping ahead in order to liberate others to the new situation. More inauthentically, at the other extreme of how one is for the other, he leaps in and dominates the other (*SZ*, 122, 298). Heidegger's choice of words for these extreme formal options suggests a peculiar relationship between politics and pedagogy at the protopractical level. In the indifferent extreme of becoming the "conscience" of the "hollow" crowd, this may amount to mass manipulation.

Ethos translated as character thus finds deeper roots in a worldly framework of responsive openness to a shared situation of action. Only the later Heidegger will perform the middle-voiced turn on this "mode of persuasion," from having to being-had in one's be-having, that he had already performed on *logos* and *pathos*. In the later Heidegger's turn from human being to being itself, *ethos* shifts toward the situation itself that evokes thought and speech. Here, Heidegger can appeal to the older Heraclitean sense of *ethos* as (1) haunt, abode, and accustomed dwelling, therefore as (2) custom, usage (*Brauch*), the habit of a habitat, the tradition which articulates, restrains, sustains, and guides the "character" of a speaker as well as the "be-having" of a people ("German Dasein") and nourishes its resolve. Accordingly, *ethos* is (3) the history and destiny of a people in its shared actional *topoi*, which prefigure patterns of behavior, its ways of having and holding and taking possession of itself. If the human being is distinguished from the animal by being the shaper and cultivator of worlds for dwelling, this cultivation is achieved by being responsive to the aura of usage, the mores that belong to a particular place, its fables, myths, and stories

developed over its history that enter into the filigree of its language. This is not as arch-conservative as it sounds, when we couple it with a sense of being that is always that which "also can be otherwise," especially in the generational exchange at the core of historicity (*SZ*, 385f.). It is something that happens to us, as it were, from the outside, from the historical context into which we ourselves happen to be thrown, like our character and destiny: the authoritarian-militaristic ethos of Germany early in the century, the democratic ethos of America in the year of the millennium, Heidegger's romanticized work ethic of peasant building and dwelling, Jünger's heroic ethos of the hard, earthy military life with the Dionysian destructiveness of technological weaponry, the ethos of civic discourse as opposed to propaganda rhetoric typically coupled with threats of force, or the tonality of current "political correctness."

The later Heidegger's move is a further reminder that rhetoric's three modes of persuasion are highly intercalated contexts that subtly guide us in our situational decisions: the deeply rooted customs of a country looming as a fatality, the sustaining resonances of its language, the mood of the times forced by circumstances of crisis. The milieus of a community, its language, and its mood delimit the contexts out of which we can come to understand Heidegger and Arendt, linked in "loving strife," and about whose political persuasions so much inflammatory rhetoric has recently circulated.

HANNAH ARENDT

LITERARY CRITICISM AND THE POLITICAL

David Halliburton

Few modern thinkers have had as much success in the region between philosophy and literature as Hannah Arendt, except, of course, Heidegger. While most of us think of Arendt as a political theorist, possibly *the* political theorist of the twentieth century, she has also had uniquely important things to say about the relations among literature, philosophy, politics, and political philosophy.

All her life Arendt studied, quoted, and wrote about literature. Literature in general and poetry in particular were paradigm sources for her political theories and distinctive practices. Her commentaries offer many insights into literary works and their relationship to the political world.

Arendt's observations sometimes catch the reader off-guard, but not because of any disrespect for hermeneutic principles and practices. Her readings often persuade, surprising us with textual meanings that are not immediately apparent, or discovering unexpected subtleties side by side with singular provocations. Arendt ranges far and wide in the European canons. An ardent admirer of Greek poetry and thought, she credits Homer with creating, if not quite a capacity for impartial judgment – for Arendt the highest of human faculties – at least the practice of balanced literary representation. The point is apt because Arendt herself strives to maintain an equilibrium between disinterested interpretation and solemn moral judgment. She writes perceptively on modernists like Franz Kafka, Bertolt Brecht, Walter Benjamin, R. M. Rilke, and René Char, and her close friend W. H. Auden. Existentialists who attracted her attention include Jean-Paul Sartre, Albert Camus and André Malraux. At the other end of the political spectrum, Georges Bernanos is studied in the context of a Catholic revival that Arendt considered to be a significant movement following World War II. From a broader social and aesthetic point of view, she establishes the claim of K. P. Moritz to be the first novelist to explore the self in a secularized world and shows the intricacies of the version of Last Judgment that Broch delivers in *The Death of Vergil*. Beginning with *The Human Condition*,

she draws on Isak Dinesen to underline the significance of those life-stories without which the human condition would be unintelligible.

Arendt approaches the Heideggerean theme of thinking as thanking in verses from Osip Mandelstam while weaving together a number of original points about the roles of, inter alia: Marcel Proust in the context of Anti-Dreyfusard antisemitism; Benjamin Disraeli in devising a modern doctrine of race; Thomas Carlyle in urging heroism in social reform; and Rudyard Kipling in providing elements of an imperialist ideology while contributing, in *Kim*, a memorable story of human brotherhood. Arendt's reading of Herman Melville's *Billy Budd* brings new light to the fateful roles played by the makers, and the un-makers, of the French Revolution. Finally, Arendt, like Heidegger, turns frequently to the paradigmatic authors of Greek antiquity, not only Homer, Plato, Aristotle, Sophocles, Vergil, Ovid, Euripides, Lucretius, and Pindar, but the Pre-Socratic Heraclitus and Anaximander.

WORKS OF ART

Before turning to Arendt's readings of specific texts, let us consider her broader view of the work of art. An initial premise is that works of art are worldly *things*: tangible entities in an artifice of human making fashioned so as to become relatively immutable. "Because of their outstanding permanence, works of art are the most intensely worldly of all tangible things ... their durability is of a higher order than that which all things need in order to exist at all; it can attain permanence through the ages."[1] The work of art can even achieve immortality – not the state claimed for human souls and bodies but something originating from souls and bodies, especially, from human hands.

Arendt locates the originary power of the art work in the capacity of thought, which, in transcending the needs and wants and feelings of the self, releases "a passionate intensity" (*HC*, 168) into the world. To be fully a worldly thing, this intensity must, however, undergo reification. In her visionary conception, this becomes an all but miraculous process. "In the case of art works, reification is more than mere transformation; it is transfiguration, a veritable metamorphosis in which it is as though the course of nature which wills that all fire burn to ashes is reverted and even dust can burst into flames" (*HC*, 168). For all this the proximal inspiration is the following passage from Rilke's poem "Magic":

> zu Asche werden Flammen,
> doch, in der Kunst: zur Flamme wird der Staub.
> Hier ist Magie.[2]

At a stroke, the poet inverts the Biblical "ashes to ashes and dust to dust." From which it follows that any worldly thing may spring to life, provided that there are human hands to work its material, be it sheets of paper on which to write or draw, or stone from which to mold a statue. In becoming tangible in the world, the work of art pays the price of cutting itself off from life, becoming "a dead letter"; but not indefinitely; for, as the phoenix rises from the ashes, the

"dead letter" comes back to life. The temporality of such seeming deadness is a state of expectancy culminating in new birth. We are reminded of Arendt's all-important concept of *natality*, of being born in the world, a concept to which this discussion will return. The state of being in question is exemplified in any ecphrastic poem. In Keats' "Ode on a Grecian Urn" the urn is, paradoxically, both lifeless – the figures cannot move – and animate – though no longer living. Through the grace of poetic transformation they can no longer die.

Of poetry in general she says,

> Poetry, whose material is language, is perhaps the most human and least worldly of the arts, the one in which the end product remains closest to the thought that inspired it. The durability of a poem is produced through condensation, so that it is as though language spoken in utmost density and concentration were poetic in itself. Here, remembrance, *Mnēmosynē*, the mother of the muses, is directly transformed into memory, and the poet's means to achieve the transformation is rhythm, through which the poem becomes fixed in the recollection almost by itself. It is this closeness to living recollection that enables the poem to remain, to retain its durability, outside the printed or the written page, and though the "quality" of a poem may be subject to a variety of standards, its "memorability" will inevitably determine its durability. . . . Of all things of thought, poetry is closest to thought, and a poem is less a thing than any other work of art . . . (*HC*, 169–70)

One is struck by the distinction between poetry and language – a view Heidegger would hardly endorse. For Arendt, there is language – apparently basic communication in words – and there is poetry, an inspired function of heightened communication. Then she closes the gap between the two concepts by suggesting that language becomes poetry by a unique process of condensation.

The figure of Mnemosyne as mother of the muses in sentence three belongs to remembrance. For Arendt mere retention needs a boost to become full-fledged memory, the means of which she calls rhythm. Here one wishes for some further development. Surely rhythm, though essential to poetry, is not what sets it apart. Hardly less significant are allegory, symbolism, genres, rhyme, tropes, tone, and the range of grammatical, syntactical, and rhetorical moves belonging to style and the meta-discourse of stylistics. For Arendt rhythm remains close to recollection, a short-term version of mnemonic retention somehow different from the more permanent office we call memory but critically important in everyday life, where it helps such recollection operate in the everyday world.

Arendt interweaves memory and recollection with story-telling, history, poetry, politics, and that supreme capacity for discerning the truth of things which is judgment. She often quotes Dinesen's aphorism, "All sorrows can be borne if you put them into a story or tell a story about them." The statement serves as the initial epigraph of the chapter on action in *The Human Condition*. A story exerts transformative power, translating mundane facts and events into

something memorable. As in distilling, what results from the process is some-
thing that did not exist before; something that needed the already existing
ingredients and yet possessed the superior capacity of changing the terms, so to
say, of *how* they exist. In the crucial statement that follows, Arendt employs the
more "spiritual" term transfiguration.

> The transformation of the given raw material of sheer happenings which
> the historian, like the fiction writer . . . must effect is closely akin to the
> poet's transfiguration of moods or movements of the heart — the trans-
> figuration of grief into lamentations or of jubilation into praise. We may
> see, with Aristotle, in the poet's political function the operation of a
> catharsis, a cleansing or purging of all motions that could prevent men
> from acting. The political function of the storyteller — historian or novel-
> ist — is to teach acceptance of things as they are. Out of this acceptance,
> which can also be called truthfulness, arises the faculty of judgment —
> that, again in Isak Dinesen's words, "at the end we shall be privileged to
> view, and review it — and that is what is named the day of judgment.[3]

JUDGING ARENDT JUDGING

The volumes on willing and thinking in *The Life of the Mind* were to have led to
a volume on judging, which she considers the defining faculty in the political
realm. Because she believes so strongly in the relevance to that realm of litera-
ture, judging emerges as definitive in the realm of criticism as well. Such a
statement can seem banal. What critic, after all, does not judge? Yet critics
often do not declare decisions about writers and their testaments. Some try to
suspend their assumptions to make their critiques appear transparent. This
strategy may betoken the influence of Edmund Husserl's technique of
bracketing or disconnecting the assumptive life-world so as to arrive at "pure"
descriptions of consciousness as such.

Forming judgments that are hermeneutically responsible as well as rhetoric-
ally persuasive requires reflection. At once retentive and projective, reflection in
itself is not necessarily, though it may become, political. How it may do so is
explained by a consequence of transcendence: ". . . whenever I transcend the
limits of my own life span and begin to reflect on this past, judging it, and this
future, forming projects of the will, thinking ceases to be a politically marginal
activity."[4] Judging is here the estimation of what can be in such a way as
ultimately to constitute both memory and future being, and an imperative way
of doing this is, again, through the mediation and transfiguring power of story
in all modes, whether in fiction, history writing, or poetry.

Arendt recreates an ideal-case situation reminiscent of mass behavior in
periods of pre-totalitarian agitation. "When everybody is swept away unthink-
ingly by what everybody else does and believes in, those who think are drawn
out of hiding because their refusal to join in is conspicuous and therefore
becomes a kind of action" (*LM*, I: 192). Such an "everybody" recalls
Heidegger's *das Man*, the "they" who repeat received wisdom without question
or contestation, who, instead of challenging the status quo, keep their smiles

open and their mouths shut. Compare Germany in the 1920s and 1930s. Perhaps because she assumes the reader won't miss that connection, Arendt passes over in silence the fact that the most recently conspicuous of "those who think," Heidegger, entered the actively political sphere only to show himself unable either to exercise needful judgment or to take commensurate action in that sphere.

Where judging is concerned, Heidegger was perhaps too beholden to the kinds of constraining habits and rules that Arendt comments on below:

> . . . it turns out that the purging component of thinking (Socrates' mid-wifery, which brings out the implications of unexamined opinion and thereby destroys them – values, doctrines, theories, and even convictions) is political by implication. For this destruction has a liberating effect on another faculty of judgment, which one may call with some reason the most political of man's mental abilities. It is the faculty that judges particulars without subsuming them under general rules which can be taught and learned until they grow into habits that can be replaced by other habits and rules. (*LM*, I: 192–3)

In political and cultural revolutions Arendt finds a nexus of particulars need-ing to be judged if we are to understand how the world has come to its present state. "Examples," says Kant, "are the go-cart of judgments" (*LM*, I: 272). Such exemplarity is for Arendt as well suited to an inquiry into political history as are instances of historical "reality." For the facts of reality need to be distilled into an intelligibility in human terms, and great writers are the needed alem-bic. Herman Melville's *Billy Budd* springs from the events of the French Revolution and explores the ethical vicissitudes of worldly conflict in general, the ultimate such conflict being that between good and evil.

That conflict was in the thoughts of the architects of the Revolution as they attempted to remake the world without recourse to institutionalized religion. But the unexamined aspect of this process, to Arendt, is the meaning of Jesus of Nazareth, who would inspire the world to believe in unqualified goodness, and in the way this issue was taken up in the aftermath of the Revolution, in the person of the Christ figure, Billy Budd. For Arendt, Billy embodies goodness beyond any knowable virtue, even as Claggart embodies evil beyond any know-able wickedness. So far Arendt may be saying the obvious. In returning Jesus to the world in the form of Billy, Melville was able

> to show openly and concretely, though of course poetically and meta-phorically, upon what tragic and self-defeating enterprise the men of the French Revolution had embarked without knowing it. If we want to know what absolute goodness would signify for the course of human affairs . . . we remember that the poet but embodies in verse those exaltations of sentiment that a nature like Nelson's, the opportunity being given, vitalizes into acts.[5]

One turns to poets and novelists because historical actors cannot know the

end of their story. Melville can. In Billy Budd he judges and finds wanting the Rousseauesque postulate that human beings are born naturally good and are corrupted by society. The problem is that, when Billy Budd by natural impulse strikes dead his false accuser, he ceases to be good. Then Captain Vere enters, personifying civic virtue and rationality, and we begin to see the fateful results of applying absolutes in the realm of politics. Virtue such as Vere's may not be as transcendental as goodness, Arendt argues, but it endures in the world because it can be incorporated into institutions that endure. In sum, "the absolute – and to Melville an absolute was incorporated in the Rights of Man – spells doom to everyone when it is introduced into the political realm" (OR, 84).

While it seems fitting that the innocent Billy should end on a note of compassion, in Arendt's opinion compassion does not fit into that space between persons that is the realm of politics and action. In that space people talk and argue with one another because they share interest in worldly things and express themselves in speech. This, Billy with his stammer can never do. For him the world has no fitting place, as it has no place for an abstract natural goodness postulated and adopted as a precept by many of the leading revolutionaries. Thus on Arendt's reading, Melville's answer to his own question as to why the French Revolution eventually went awry is "that goodness is strong, stronger perhaps even than wickedness, but that it shares with 'elemental evil' the elementary violence inherent in all strength and detrimental to all forms of political organization" (OR, 87).

MATTERS ANCIENT AND MODERN

Like Heidegger, Arendt measures modernity against antiquity not only by Homer, Plato, Aristotle, and Sophocles, but Anaximander, Heraclitus, and Parmenides, applying their texts to political philosophy ancient and modern. Her use of Homer early in *The Human Condition* is a case in point: "Action alone is the exclusive prerogative of man; neither a beast nor a god is capable of it, and only action is entirely dependent upon the constant presence of others" (HC, 22–3). In a footnote she observes that Homer does not celebrate the deeds of the gods but the relationship between the gods and human beings:

> It seems quite striking that the Homeric gods act only with respect to men, ruling them from afar or interfering in their affairs. Conflicts and strife between the gods also seem to arise chiefly from their part in human affairs or their conflicting partiality with respect to mortals. What then appears is a story in which men and gods act together, but the scene is set by the mortals, even when the decision is arrived at in the assembly of gods on Olympus. I think such a "co-operation" is indicated in the Homeric *erg' andron te theon te* (*Odyssey* i.338): the bard sings the deeds of gods and men, not stories of the gods and stories of men. (HC, 23)

In concentrating on what is specific to the human condition, Arendt follows the lead of the poet, first great cultural authority in Western letters. And

another kind of firstness: "Similarly, Hesiod's *Theogony* deals not with the deeds of gods but with the genesis of the world . . . it therefore tells how things came into being through beginning and giving birth, constantly recurring. The singer, servant of the Muses, sings 'the glorious deeds of old and the blessed gods' . . . but, nowhere, as far as I can see, the glorious deeds of the gods" (*HC*, 23). The statement illustrates Arendt's paradigmatic privileging of human birth. In an implicit move against Heidegger's preoccupation with *Dasein* in relation to mortality, she focuses on the condition of possibility for all human action, *natality*. Not labor or work but "action has the closest connection with the human condition of natality; the new beginning inherent in birth can make itself felt in the world only because the newcomer possesses the capacity of beginning something anew, that is, of acting." This statement clearly contests the priority of Heidegger's being-towards-death, which fulfills its finitude in the very process of disappearing from the world. Arendt responds with what might be called being-*from*-birth. She can then go the way that Heidegger earlier tried and failed to go, the way of the political: "Moreover, since action is the political activity par excellence, natality, and not mortality, may be the central category of political, as distinguished from metaphysical, thought" (*HC*, 9).

As the writers she invokes constitute an elite, so do those who have managed to act in the world. I employ the past tense because, on Arendt's reading of history, action is by definition political, and because politics, as developed by the early Greeks, has been largely replaced by the social, the everyday realm in which masses of persons unable to act must be satisfied merely to behave. Still thinking in Homeric terms, Arendt then defines the elite of actors reigning over against the mass of behavers: "To belong to the few 'equals' meant to be permitted to live among one's peers; but the public realm itself, the polis, was permeated by a fiercely agonistic spirit, where everybody had constantly to distinguish himself from all others, to show through unique deeds or achievements that he was the best of all (*aien aristeuein*). The public realm, in other words, was reserved for individuality" (*HC*, 41). The fiercely agonistic spirit to which Arendt refers may reflect her own independent judgment of the spirit of the *polis*; but the featuring of violence is uncomfortably reminiscent of the Heidegger of the early 1930s and of *Introduction to Metaphysics* (1958) where he describes the violence with which the human being, as exemplified in Sophoclean tragedy, is bound to act; not to mention Carl Schmitt's call to fight the enemies of the state by any means available, however violent. In any event, Arendt comments: "*Aien aristeuein kai hypeirochon emmenai allon* ('always to be the best and to rise above others') is the central concern of Homer's heroes (*Iliad* vi. 208), and Homer was 'the educator of Hellas'" (*HC*, 41).

Arendt's unmistakable knack for locating just the quote she needs for her purposes is nowhere more in evidence than in her observations on Heidegger's Will-not-to-will. After his failure in politics Heidegger turns away from will and its exertions to listen for a voice of conscience summoning human beings away from the mode of *das Man* and the routines of alienated daily life. Conscience signifies *Schuld*, debt, obligation or guilt, a source of which Arendt finds in Goethe's aphorism, "One who acts always becomes guilty" (*LM*, II: 194).

The problem, argues Arendt, is that no one is guilty if everyone is. Even Billy Budd, emblem of innocence, does not bring himself into the world on his own but is thrown (*geworfen*) into the world; thus everyone is essentially obligated to something other than self – to that endowing, enabling, and entitling other to whom it is responsible for its being.[6] For this the voice of conscience summons us all to give thanks, and, Heidegger would add, in so thanking one is thinking.

The message that is needful in a secularized age is not just the reassurance that worldly meaning is still possible, but the certainty that this world is actually, in itself, something to be thankful for. In this connection Arendt quotes lines from Osip Mandelstam about the last year of the Great War that did more than any other sequence of events to destroy long traditions of cultural meaning: "We will remember in Lethe's cold waters/ That earth for us has been worth a thousand heavens" (quoted in *LM*, II: 185). And from the ninth of Rilke's *Duino Elegies*:

> Erde, du liebe, ich will. O glaube es bedürfte
> Nicht deiner Frühlinge mehr, mich dir zu gewinnen.
> Einer, ach ein einziger ist schon dem Blute zu viel,
> Namenlos bin ich zu dir entschlossen von weit her,
> Immer warst du im Recht. . . . (quoted in *LM*, II: 186)

Finally, W. H. Auden:

> That singular command
> I do not understand,
> *Bless what there is for being,*
> Which has to be obeyed, for
> What else am I made for,
> Agreeing or disagreeing? (quoted in *LM*, II: 186)

Such thinking as thanking scarcely supposes that the world and its denizens are either actually or potentially perfect. On the contrary, Arendt shares Heidegger's concern for what he calls the oblivion of Being, specifically the globalization of science and technology, and the will's presentment of the future as something determined in advance by the will's own calculating projects.

In the context of a discussion of will in Nietzsche and Heidegger, Arendt offers a rare but significant remark on the subject of literary genre. Nietzsche never wrote a book called *Will to Power*, she points out, but composed instead a series of jottings and fragments, constituting "a thought-experiment," a liminal literary genre tending toward poetic thinking.[7] "The most obvious analogy is Pascal's *Pensées*, which shares with Nietzsche's *Will to Power* a haphazardness of arrangement that has led later editors to try to *re*arrange them, with the rather annoying result that the reader has a good deal of trouble identifying and dating them" (*LM*, II: 160). This critical aside clearly echoes Heidegger's concern with the vicissitudes of editing, most notably in the case of Nietzsche and Hölderlin.

Turning for the last time to Homer, we encounter equivocation. On the one hand, Homer rescues the Trojan War from the oblivion that would have befallen it without poetic memorialization. On the other hand, "the very fact that so great an enterprise as the Trojan War could have been forgotten without a poet to immortalize it several hundred years later offered only too good an example of what could happen to human greatness if it had nothing but poets to rely on for its permanence" (*HC*, 197). For greatness of action to endure we need poetic testaments; yet so persistent is the passing from memory of even our highest deeds, that such testaments do not and can not suffice in themselves. If actions are to persist in cultural memory they need to be endowed, enabled, and entitled in the enduring institution of the *polis*.

Arendt's emphasis on greatness tends to follow the lead of Heidegger, for whom it is an essential criterion for judging any claimed contribution to the history of Being. In his *Introduction to Metaphysics*, he states, in a way that conceivably foreshadows Arendt's thinking about natality, that cultural beginnings are great, and he implies that the problem of any age is how to keep the original momentum going. Arendt follows Aristotle instead, in seeking and judging moments of high public action. The author of the *Poetics* "finds that greatness (*megethos*) is a prerequisite of the dramatic plot" because "the drama imitates acting and acting is judged by greatness, by its distinction from the commonplace . . ." (*HC*, 205). Homer and Pericles similarly understand that action can be judged solely by the criterion of greatness.

THE JEWISH QUESTION(S)

The texts that Arendt chooses to discuss come mainly from the same canon of German and Greek literature investigated by Heidegger. But she also writes about fellow Jews: Kafka, Broch, Benjamin, Karl Kraus, Disraeli, Proust, and Rahel Varnhagen. Her first and still neglected book, *Rahel Varnhagen: The Life of a Jewish Woman*, is an absorbing study of the vicissitudes of female Jewishness in the salons of Berlin toward the end of the eighteenth century. Varnhagen's own salon could boast of participation by such luminaries as the Humboldt brothers, Wilhelm and Friedrich, Ludwig Tieck, Clemens Brentano, Adelbert von Chamisso, Friedrich Schlegel, and Friedrich Schleiermacher. Through Rahel's struggle over her own identity as someone who was ethnically and socially both an insider and an outsider, and the relation between that identity and antisemitism, Arendt interprets her own situation as a German Jewess, while at the same time letting Rahel speak through her own historical position.

Discussing antisemitism as a motivating factor in the growth of totalitarianism, Arendt finds that Émile Zola in literature and Georges Clemenceau in politics meet her criteria for consequential public performance. She locates the greatness of the French statesman in the fact that he truly believed in ideas that looked merely "rhetorical" to others, such as the Anti-Dreyfusards – ideas like "justice, liberty, and civic virtue" – and that he acted in a manner consistent with those beliefs. What made Zola great was not, as she might have been expected to argue, his defiance of antisemitism or his defense of Dreyfus but his

defiance of one of her nemeses, the masses. Her authority for this judgment is Clemenceau himself: "Men have been found to resist the most powerful monarchs and to refuse to bow down before them, but few indeed have been found to resist the crowd, to stand up alone before misguided masses, to face their implacable frenzy without weapons and with folded arms to dare a no when a yes is demanded. Such a man was Zola!"[8]

In the same discussion Varnhagen bolsters Arendt's argument that social discrimination rather than political antisemitism created the modern notion of "the Jew." Her handling of the lyric poet Brentano in this argument is characteristic of her use of literary figures. The point of departure is a hackwork satire on the Jew as philistine: "This rather vulgar piece of literature not only was read with delight by quite a few prominent members of Rahel's salon, but even indirectly inspired a great Romantic poet, Clemens von Brentano, to write a very witty paper in which again the philistine was identified with the Jew" (OT, 61–2).

British antisemitism offers an arena in which to explore the intertwining of phenomena at once literary, political, and racial. Her treatment of Thomas Carlyle illustrates her ability to see more clearly and to see further than other critics. Putting aside conventional prejudices against the Scot, she can fault him in one context – on rather surprising grounds – and defend him in another. Carlyle, Arendt says, quoting a published claim that he had called the Prime Minister "a cursed Jew," "was clearly in the wrong when he refused a title from Disraeli's hands." She does not accuse him of antisemitism but questions his judgment in failing to see Disraeli as self-fashioning political actor *par excellence* – precisely the type of man in whom Carlyle was capable of finding greatness: "no other man fulfilled so exactly the demands of the late nineteenth century for genius in the flesh as this charlatan who took his role seriously and acted the great part of the Great Man with genuine naiveté and an overwhelming display of fantastic tricks and entertaining artistry" (OT, 72). In *Tancred* and other novels Disraeli "produced a full-blown race doctrine . . . He was ready to assert that the Semitic principle 'represents all that is spiritual in our nature,' and furthermore that 'all is race, which is the key to history' regardless of 'language and religion,' for 'there is only one thing which makes a race and that is blood' and there is only one aristocracy, the 'aristocracy of nature' which consists of 'an unmixed race of a first-rate organization'" (OT, 73).

Older founding legends, Arendt suggests, "without ever relating facts reliably, yet always expressing their true significance . . . offered a truth beyond realities, a remembrance beyond memories" (OT, 208), and the same is true of that newer founding legend through which, in a story like "First Sailor" (1891), Rudyard Kipling can be seen to legitimate British Imperialism. The British are uniquely endowed, the argument goes, by the timeless elements of water, wind, and sun, and by the technological mediation of the sea-going ship. Thus endowed, the British sailor becomes master of the world, heedless when others ignore his achievement, and getting nothing for himself "except Four Gifts – one for the Sea, one for the Wind, one for the Sun and one for the Ship that carries you . . . Long-headed and slow-spoken and heavy – damned heavy – in the hand, will they be; and always a little bit to windward of every enemy –

that they may be a safeguard to all who pass on the seas on their lawful occasions" (*OT*, 209). Noting that the pronouncement is not strictly accurate inasmuch as the world did pay heed to the navy and other British imperial forces, Arendt can yet grant that "there was a certain reality in England herself which corresponded to Kipling's legend and made it at all possible, and that was the existence of such virtues as chivalry, nobility, bravery, even though they were utterly out of place in a political reality ruled by Cecil Rhodes or Lord Curzon" (*OT*, 209).

More remarkable is Arendt's judgment of Kipling's *Kim*, which ventures beyond the "First Sailor" myth in attempting to forge a culture-founding legend. That legend is called the Great Game, which its players play with something of the "thanking thinking" discussed above: the world is judged to be wonderful in itself, and there are no rewards outside of or beyond it: "Since life itself ultimately has to be lived and loved for its own sake, adventure and love of the game for its own sake easily appear to be a most intensely human symbol of life. It is this underlying passionate humanity that makes *Kim* the only novel of the imperialist era in which a genuine brotherhood links together the 'higher and lower breeds' . . . (*OT*, 217). Kipling can have Kim speak credibly of a state of collective being, an "us" who do all that they do together: "What makes them comrades is the common experience of being . . . symbols of life itself, symbols, for instance, of happenings all over India, immediately sharing the life of it all as 'it runs like a shuttle throughout all Hind,' and therefore no longer 'alone, one person, in the middle of it all,' trapped, as it were, by the limitations of one's own individuality or nationality" (*OT*, 217). In her fascination with these symbols of "life" itself, Arendt may seem to recognize in them some greatness in action, but finally this is not the case: "Life itself seems to be left, in a fantastically intensified purity, when man has cut himself off from all ordinary social ties, family, regular occupation, a definite goal, ambitions, and the guarded place in a community to which he belongs by birth. 'When every one is dead the Great Game is finished. Not before'" (*OT*, 217). What is explicitly great, then, is the Game itself, which ironically functions despite the absence from it of traditional civic processes and supports, such as the *polis*.

Her examination of Jews in French, predominantly Gentile society, credits Disraeli with first recognizing "that vice is but the corresponding reflection of crime in society." Tolerated by society, which enjoys the *frisson* of transgression, crime and vice came to be regarded as in a sense predetermined. "If crime is understood to be a kind of fatality, natural or economic," Arendt argues, "everybody will finally be suspected of some special predestination to it." To which Proust adds that the criminal's right to his own punishment is voided when "judges . . . are more inclined to pardon murder in inverts and treason in Jews for reasons derived from . . . racial predestination" (*OT*, 81). Arendt tries to do justice to Proust's homosexuality, under the dated rubric of "inversion." What she inclines to question, moreover, are the processes by which Jewishness became fashionable among non-Jews in a way that Judaism did not: "As far as the Jews were concerned, the transformation of the 'crime' of Judaism into the fashionable 'vice' of Jewishness was dangerous in the extreme. Jews had been

able to escape from Judaism into conversion; from Jewishness there was no escape. A crime, moreover, is met with punishment; a vice can only be exterminated" (*OT*, 87).

In Arendt's judgment, antisemitism is not a narrowly political phenomenon – a matter of statutory rights or public policy. It is a matter, rather, of fundamental economic and social conditions, of the exposure to public view of the personal and the intimate, of the decline of public action and the rise of opinion influenced from "below" by those same masses that were confronted, as we saw above, by Zola. All such issues combine to create what she calls the social in contrast with the political, which for a long time has been slipping from sight.

Already in the Dreyfus affair Jews are targeted for organized abuse, a situation anticipating their later, greater sufferings, but one about which historians have had, in Arendt's judgment, too little to say. Thus her return, near the end of her commentary on Proust, to more supportive literary sources:

Social factors, unaccounted for in political or economic history, hidden under the surface of events, never perceived by the historian and recorded only by the more penetrating and passionate force of poets or novelists (men whom society had driven into the desperate solitude and loneliness of the *apologia pro vita sua*) changed the course that mere political antisemitism would have taken if left to itself, and which might have resulted in anti-Jewish legislation and even mass expulsion but hardly in wholesale extermination. (*OT*, 87)

The calmness of this remark cannot conceal the scope of its implications: the modern fate of the European Jews might have been averted if greater attention had been paid to the poets. Arendt may not have accepted Heidegger's belief in the unique founding capacity of poetry, a belief already advanced most eloquently by P. B. Shelley's "A Defense of Poetry"; but her remark testifies to the importance of the *saving* power inherent in literary representations. *Pace* Heidegger and Shelley, has anyone ever made a greater claim for literature? And is it conceivable that poets and novelists are even now telling us in their texts things that we dare not fail to comprehend?

CONCLUSION

Let me conclude this inquiry where *The Human Condition* concludes, with Arendt turning a sentence from Kafka into an epigraph for her study of the *vita activa* in the modern age: "*Er hat den archimedischen Punkt gefunden, hat ihn aber gegen sich ausgenutzt, offenbar hat er ihn nur unter dieser Bedingung finden dürfen*" (*HC*, 248).

To Arendt the paradox leads indirectly to the problem, not less important to her than to Heidegger, of the processes by which *human* being appears primarily as *animal* being, which is to say, as *animal laborans* in contrast to the human being who *works* or *acts*. Arendt attributes largely to Marx the fact that, since our main energies now go to maintaining biological functions, other endeavors, like poetry, fiction, and drama, are considered beside the point. "What was not

needed, not necessitated by life's metabolism with nature, was either superflu-
ous or could be justified only in terms of a peculiarity of human as dis-
tinguished from other animal life – so that Milton was considered to have
written his *Paradise Lost* for the same reasons and out of similar urges that
compel the silkworm to produce silk" (*HC*, 321).

Kafka's ironic perspective on leverage looks back to the opening of *The
Human Condition* which promises to "trace back modern world alienation, its
twofold flight from the earth into the universe and from the world into the self,
to its origins, in order to arrive at an understanding of the nature of society as it
had developed and presented itself at the very moment when it was overcome
by the advent of a new and yet unknown age" (*HC*, 6), symbolized by the
launching of Sputnik in 1957, the year before *The Human Condition* was pub-
lished. Now, deliberately ignoring the caution in Kafka's parable, Arendt
applies the Archimedean point "to man himself and to what he is doing on this
earth," whereupon "it at once becomes manifest that all his activities, watched
from a sufficiently removed vantage point in the universe, would appear not as
activities of any kind but as processes, so that . . . modern motorization would
appear like a process of biological mutation in which human bodies gradually
begin to be covered by shells of steel" (*HC*, 322–3).

Kafka, like Arendt, and like many of the other figures discussed above,
would have understood this terrible torsion in human experience wherein "we
look and live in this society as though we were as far removed from our own
human existence as we are from the infinitely small and the immensely large
which, even if they could be perceived by the finest instruments, are too far
away from us to be experienced" (*HC*, 323).

Kafka, like Arendt and Heidegger, is a difficult thinker – and a thinker,
which is to say a poetic thinker, is what Arendt explicitly takes Kafka to be. On
her reading part of what makes him difficult is his lack of interest in represent-
ing the historical world. Rather, he constructs *models* of *possible* worlds; his tales
are like "blueprints; they are the product of thinking rather than of mere sense
experience. Compared with an actual house, of course, a blueprint is a very
unreal affair, but without it the house could not have come into being. . . ."[9]
This creates difficulties because a given model does not conform to any other; to
comprehend it, you must learn to interpret it and judge it, somehow, on its
own terms. The same might be said of Arendt: she constructs models of worlds
and the models do not quite correspond to anyone else's; as thinker she is, like
Heidegger, disturbingly original. There are, however, points of connection
with other models and actualities, and this essay has tried to show that many of
these points possess a literary and hermeneutic dimension, and to suggest that
in discussing them we can learn something about the texts in question that we
might not have learned otherwise. The final source of difficulty is that the
writings of Arendt's authors are not only various but even, in a sense, change-
able. This is in part because we as readers change. Each new reading, conducted
in a world that is not identical today with what it was yesterday, is in some sort
a different reading and the text a different text: each is a matrix but a *moving*
matrix. Kafka goes further, and I believe that Arendt follows him, by proposing
that it is very hard to say the truth because what counts as true keeps changing.

This is probably why she liked the following aphorism by Kafka so much that she posted it as the epigraph to "Understanding and Politics" (later called "The Difficulties of Understanding"): *"Es ist schwer, die Wahrheit zu sagen, denn es gibt zwar nur eine; aber sie ist lebendig and hat daher ein lebendig wechselndes Gesicht"* (*EU*, 307).

10

THE POLITICS OF FASCISM, OR CONSUMING THE FLESH OF THE OTHER

Michael Clifford

In the *Poetics*, Aristotle considers the aesthetic and rhetorical differences between two versions of the same line of iambic verse, one from Aeschylus, the other from Euripides. The first version, from Aeschylus, is translated thus: "The ulcer that eats the flesh of my foot."[1] In the second version, Euripides substitutes a single term, *thoinaō* for *esthiō* to produce the following variation: "The ulcer that *feasts upon* the flesh of my foot." Aristotle clearly prefers the second version, which he says has "a certain dignity," as opposed to the first version, which he suggests is "mean and commonplace." The reason that we should prefer "feasts upon" to "eats," according to Aristotle, appears to be that the latter is "ordinary" and "familiar" whereas the former performs one of the key functions of metaphor, namely, to elevate the reader by raising "the diction above the commonplace."

Of course, we might observe that to say an ulcer "eats the flesh of my foot" is just as much a metaphor as to say that it "feasts upon" the same appendage. That seems obvious. Oddly, however, Aristotle appears to forget the ulcer, and the foot, for that matter, and focuses entirely on the distinction between "eats" and "feasts upon." But is it more "dignified," and therefore, presumably, preferable, to say of the ulcer that it *feasts upon* my foot? In fact, although in reality "eats" and "feasts upon" are both metaphors, in this case, the latter, "feasts upon," arguably conveys an image of something dark and monstrous, something sinister that ravages my lower limb in a frenzy of ravenous consumption. "Eats," although likewise a metaphor, conveys a more mundane image of the process through which the ulcer does whatever it does to the flesh of my foot.

Aristotle would say that context determines when a metaphor is inappropriate or excessive. But, this is precisely what is lacking from his discussion about the ulcer and its eating habits. Lifted from the context of Aeschylus' and Euripides' respective dramas, we cannot tell whether the line, "The ulcer that feasts upon the flesh of my foot," is dignified and elevating, or merely excessive and vulgar. Aristotle has obviously read both plays, but we are left to accept his judgment, the plays having been lost to antiquity. For us, no context exists that

would permit us to assess the appropriateness of the two metaphors. For us, they have lost their margins.

How do we make sense of something, anything, that has been de-marginalized? I say "de-marginalized" as opposed to marginalized, because even the periphery makes sense in terms of the center, however subordinated. But, how do we assign something a value, a meaning, *out of context*? Does it thereby become worthless, meaningless? This paper focuses on a certain kind of writing, a certain kind of textuality, that operates through active de-marginalization. I am referring to what might be called fascist inscription. Relying on Deleuze and Guattari's work, *Anti-Oedipus: Capitalism and Schizophrenia*, as well as some of the seminal texts of twentieth-century fascism, this paper outlines a cultural dynamic animated by a kind of inverse dialectic, characterized by forms of social identity whose realization depends on the eradication of its Others (Jews, Gypsies, Poles, Blacks, Non-Aryans – just to name a few of the Others of this century's most famous fascistic variant).[2] This eradication typically proceeds first through marginalization, and then through de-marginalization, processes and practices through which fascism attempts to write the Other out of existence. Those attempts to eradicate the Other for which fascism is so infamous – genocide, the Final Solution, the Red Purge, Ethnic Cleansing – can be viewed, ironically perhaps, as forms of *consumption*, in which the Other is, metaphorically speaking, eaten alive.

SUBTERRANEAN INVESTMENTS

Suppose for a moment that, despite their diversity of form and articulation, the political images with which we identify particular cultures or societies are in reality the surface manifestations of a subterranean investment of desire common to the historical formation of every civilization. Suppose that every society is a "theater of representation" exhibiting subjects whose identity is a function, and an effect, of inscriptions peculiar to the particular social fields on which they emerge. Such is the understanding of the formation of culture and human subjectivity offered by Gilles Deleuze and Félix Guattari in *Anti-Oedipus*.

According to Deleuze and Guattari, the immanent principle of all of reality is desire, not the desire of a human subject or ego since subjects are the products of desire.[3] Desire moves or manifests itself as autonomous flows which attach and detach themselves from one another in an infinite and constantly varying series of connections, breaks, and interruptions. The matrix of connected/disconnected flows of desire form *machines*, which taken together make up the process of what Deleuze and Guattari call "desiring-production."[4] Desiring-production is the real production of reality. The flows of desire connect and break apart, producing reality in manifold ways. "Everything is a machine" (*AO*, 20).

Desire is the essential force of the world. Desire produces reality *qua* machine. The flows of desire circulate by way of the machines that they produce in a "continuous, infinite flux," undifferentiated except insofar as they are cut-off, and reconnected. This flux *is* the production of reality, of the real as such. "Every 'object' presupposes the continuity of a flow; every flow, the

fragmentation of the object" (*AO*, 6). Without such breaks, or "fragmenta-
tions," there would be sheer flow and no objective world as we know it. The real
is nothing over and above the broken continuity of flows as produced by the
system of interruptions and breaks which constitute the desiring machines.

The interplay of the flows of desire seems analogous to, and may in part be
derived from, Nietzsche's ideas about the will-to-power, which Deleuze else-
where interprets as the interplay of active and reactive forces.[5] Desire oscillates
between what Deleuze and Guattari call the two poles of delirium. They illus-
trate this movement by the analogy of the pendulum swing: at one pole is the
schizophrenic, which seeks to liberate the flows of desire; at the other pole is the
paranoic-fascistic, which seeks to suppress these same flows. In between are all
the forms of representation, all the forms of social investment, which have
characterized civilization. The two poles are defined by a series of fundamental
oppositions: between nomadism and segregation, between polyvocity and
totalization, between fluidity and blockage, between potency and castration.

Whenever the flows of desire congeal to invest an entire social field, there
emerges as a result of this congealment or repression of desire what Deleuze and
Guattari call the "socius." The socius refers to desiring-production brought to
the level of *representation*, a level at which desire is invested with meaning. The
totality of manifest meanings given to the desiring-machines by social produc-
tion constitutes the full body of the socius. The term "full body" refers to a kind
of sovereign paradigm which traverses the entire field of the socius and which
dictates the manner in which the flows of desire are encoded, or inscribed.
"Civilization," say Deleuze and Guattari, "must be understood in terms
of social repression" (*AO*, 118). That is, the undifferentiated movement of
desiring-production is circumscribed by the inscribing and encoding activity of
the socius. In fact, there is no social body, no civilization, without repressing
the schizophrenic process, appropriating and encoding it in terms of the full
body of the socius.

According to *Anti-Oedipus*, thus far three major forms of socius have made
their appearance: (1) the "primitive" socius, which encodes the flows of produc-
tion on the full body of the *earth*; (2) the "barbarian" or "imperial" socius, which
encodes on the full body of the *despot*; and (3) the "civilized capitalist" socius,
whose full body is that of *money-capital*. What differentiates one socius from
another is, first of all and most importantly, the character of the inscribing
activity itself, which determines the nature of all other social manifestations;
second, the kinds of social relations characteristic of each socius; third, the types
of social identities or subjectivities which emerge on the surface of each socius;
and fourth, the specific forms of social machines in which the machines of
desiring-production "manifest" themselves.

It is *Desire*, and not the subject, which asks, "Who am I?" And it is the full
body of the socius which provides an answer. The answer *is* the subject, an effect
of the appropriation of the forces of production. But, never satisfied with an
answer, desire keeps asking the question – and each answer effects a new sub-
ject. Hence the precariousness and delicacy of subjectivity. It falls to the surface
of the socius, where it soaks into the earth, or is drunk by the despot, or is
packaged and sold by the capitalist machine. Perhaps subjectivity senses its

own fragility and clings desperately to one form rather than another, invoking claims to universality and necessity. Desire seeks instantiation. Every representation is a kind of conquest. But it is also a suppression of the schizophrenic flow. Thus, Desire is compelled to ask, again and again, "Who am I?"

THE FASCIST SOCIUS

In the preface to *Anti-Oedipus*, Michel Foucault observes that the "major enemy, the strategic adversary" of the book is fascism; and not only historical fascism, "but also the fascism in us all, in our heads and our everyday behavior, the fascism that causes us to love power, to desire the very thing that dominates and exploits us" (xiii). Deleuze and Guattari situate the emergence of fascism within capitalism, within the economy of consumption. "The fascist State has been without doubt capitalism's most fantastic attempt at economic and political reterritorialization" (*AO*, 258). Reterritorialization is a sectioning or cordoning off; it is the production of enclaves and neoterritorialities. Each of these enclaves is a potential pocket of absolutism and totalization, spaces of emergence for regionalism and nationalism. There arises a nostalgia for the *Urstaat*; the capitalist State-machine emerges and is put in the service of the technical and money-making machines. Thus, according to Deleuze and Guattari, capitalism gravitates naturally toward fascism. At any moment, it threatens to erupt into a full-fledged fascist State.

How appropriate that "fascism" is derived from the Italian word *fasciare*, which means to bind or to envelop. Fascism appropriates the forces of production/consumption by binding them together, by enveloping them, under a single transcendental rubric: the notion of racial and national superiority. This totalizing movement is what Mario Palmieri refers to as "unification . . . brought about by the triumph of a universal idea."[6] The full body of fascism is the *nation*: the Fatherland, the Seven Hills of Rome, the Land of the Rising Sun. In 1920 Alfred Rosenberg declares, "The nation is the first and *last*, that to which everything else has to be subordinated."[7] Desire is encoded on the surface of the nation-state, on which emerges a national identity which is not only geographical but consanguineous. Purity of blood is linked with the dignity and preservation of the nation. All social production is channeled toward this end, "for the sake," says Rosenberg, "of the preservation of the racial substance itself" (Rosenberg, 397). Hence the appearance of the myth of the Aryan superrace or that of the "moral and civil primacy of the Italian People."[8] The purity of the nation is threatened from both without and within. To preserve this purity, we have the triple dynamic of the fascist state: imperialism under the mantle of nationalism, racial purgation, and the total political subjugation of its people.

The great machine of the fascist socius is the War Machine: the Blitzkrieg, the Luftwaffe, the concentration camp, the gas chamber. "War alone brings up to their highest tension all human energies and puts the stamp of nobility upon the peoples who have the courage to meet it," asserts Mussolini.[9] Fascism repudiates even the possibility of (sustained) peace; force and struggle are seen as the universal principles of the world. War is the means by which the fascist

socius elevates its position in the world and asserts its superiority. War is the fulfillment of the fascist ideal. But fascism is profoundly paranoic. Even where strength has won out, it keeps its people "vigilantly and suspiciously before its eyes . . . and it does not let itself be deceived by temporary and fallacious appearances" (Mussolini, 357).

Perhaps the most disturbing aspect of the fascist socius is the type of social identity it engenders. History always asks, "How could *all those people* partake of such atrocities?" But fascism is opposed to the individualism of classical liberalism which we associate with capitalist democracies. "In this sense Fascism is totalitarian," Mussolini explains, "and the Fascist State, the synthesis and unity of all values, interprets, develops and gives strength to the whole life of the people" (352). This is not just empty rhetoric. Fascism produces a *collective* subjectivity, a subjectivity defined by a radical, inflamed nationalism that absorbs the entire social body.[10] Fascism is a mass phenomenon in which the people are, to quote Adolf Hitler, "educated consciously and systematically to fanatical nationalism" (quoted in Cohen, 411). But fascism should not be attributed to the will of a single dominant figure, a Hitler or a Mussolini, nor to the mass hypnosis of a nation and its people. "No, the masses were not innocent dupes," say Deleuze and Guattari, "they *wanted* fascism, and it is this perversion of the desire of the masses that needs to be accounted for" (*AO*, 29). There is no *single* fascist. As a form of social delirium, fascism is a case of controlled hysteria, a profound psychological investment of desire which seizes an entire nation. This is the production of the subject as *fanatic*, best exemplified by the Kamikaze.

For all its claims to genetic purity, fascism is a bastard socius. It borrows motifs from each of the three forms of socius discussed by Deleuze and Guattari, and yet it is also a marked departure from each one. Specifically, inscription in the primitive socius is characterized by directly marking the flesh: tattooing, ritual scarification, circumcision, clitoridectomy, and bodily decoration such as lip-plating and nose-piercing. Like the primitive socius, fascism encodes (at least partially) by marking the flesh: witness the tattooing of the Jews. But in fascism this has a purely negative function, pursuant to the purification of the nation; those upon whose flesh fascism inscribes are marked *out* rather than in. Like the despotic socius, it overcodes the flows of desire in supplication to an absolute sovereign. But the despot of the imperial socius is quite different from the fascist dictator. The despot requires only acquiescence and obedience from his people. The fascist dictator requires enthusiastic and dogmatic captivation. Consider two images: one of the Great Emperor in his palace, holding audience with only a few, their eyes careful not to make contact with those of the king; now imagine "Der Führer," poised on a balcony above an audience of thousands who are mesmerized by his steely gaze and inflaming oratory. The power of the fascist dictator is in his ability to incite the masses to fanatical loyalty.

Fascism shares with the capitalist socius an immanent irrationalism; it is rife with internal contradiction. "We think with our blood," declares Mussolini. Unlike capitalism, however, fascism is, ostensibly at least, against the accumulation of wealth and property for its own sake. Says Mario Palmieri, "More

important than the production of wealth is its right distribution, distribution which must benefit in the best possible way all the classes of the nation, hence, the nation itself" (381). But, perhaps the most important difference between capitalism and fascism is the fact that capitalism "schizophrenizes," while fascism unifies and totalizes.[11] Capitalism is a factory of subjectivities. Not only does it constantly produce a proliferation of different subjects, but each subject is itself schizoid, expressing different forms of identity depending on its location on the social field. "Our society produces schizos the same way it produces Prell shampoo or Ford cars," assert Deleuze and Guattari (*AO*, 245). Fascism, by contrast, seeks that one perfect, pure identity: the Aryan.

In the language of *Anti-Oedipus*, the fascist state is a pure blockage, a pure stoppage, a pure suppression of the schizophrenic flows of desire. Fascism is the triumph of social representation.[12] In the language of the oscillating movement of desire, fascism is the pendulum swing which has become locked at the paranoic-fascist pole of social investment. The functional obsession with purity means that fascism cannot even tolerate the marginalized – it must consume its Others. Thus, there is a certain terrible logic to the crematory furnaces of Dachau in which the Other is literally consumed by fire. The totalizing movement of fascism would seek to eradicate all margins, to envelop the world such that no context other than itself exists through which it might be judged. But, historically fascism has tended to be short-lived and self-consumptive. Eventually the schizophrenic flows break through and the pendulum swings free again. Thus, the question we might ask is, in consuming the Other, does fascism inevitably consume itself?

THE LOGIC OF GENOCIDE

There are, of course, at least two broad ways in which a people might cease to exist: through quiet dissipation or violent eradication. The demise of the Anasazi people is an example of the former; most anthropologists theorize that when their resources became depleted the Anasazi were forced to leave their remote living areas in the American Southwest and were eventually subsumed by the various other tribes such as the Paiute and Navajo that they encountered. By contrast, the Hittites met their end rather suddenly when the Sea Peoples swept across Asia Minor around 1200 B.C. But in neither case is the mere fact of their identity *as* a people a primary reason for the extinction of these peoples. In other words, their existence and identity as a people were not, as far as we know, defined in terms of a certain alterity, or Otherness, with regard to another people whose existence and identity were also defined and delimited to a large extent by their fractious interconnection with them. History is full of such unhappy marriages of opposition wherein two peoples are to be understood in part by their mutual and often violent otherness.

Simone de Beauvoir attempts to account for the prevalence of this phenomenon by positing Otherness as a "fundamental category" of human thought. She writes, "the category of the *Other* is as primordial as consciousness itself."[13] Beauvoir cites Hegel on the "fundamental hostility" of human consciousness to support her claims about Otherness as an essential feature of that consciousness;

but she also emphasizes the relativity of Otherness in practice, how the Other puts up a reciprocal claim. This typically provokes a response from the Subject in the form of an attempt to dominate, master, assimilate, or even kill the Other. But a close examination of Hegel shows that death – referring to the extermination of the Other – represents the extreme, the null point of *mutual* extermination, the brink towards which consciousness is drawn, but from which it must struggle to turn away, for the sake of its own self-realization *in* the Other. Says Hegel:

> Each must as much aim at the death of the other as it stakes its own life. . . . This proving through death does away, however, with the truth that was to result from it, just as much as it thereby also does away with the certainty of oneself altogether; for just as life was the *natural* position of consciousness, independence without absolute negativity, so death is the *natural* negation of consciousness, negation without independence, which therefore remains without the required sense of acknowledgment. . . . There thereby vanishes from the play of exchange the essential moment of setting oneself apart into extremes of opposed determinations; and the centre collapses into a dead unity.[14]

Hegel suggests that consciousness establishes an identity for itself by the positing of an Other to which the Self is opposed; and it is moreover through this opposition that the Self is posited and knows itself as such. However hostile this relationship might be, it must be sustained for the identities to be sustained. In this sense, and to this degree, the Self requires the Other: "In this experience self-consciousness comes to realise that life is as essential to it as pure self-consciousness is" (177). The death of the Other is the death of the Self.

However, the logic of fascist identity appears to be an inversion – or more properly, a *perversion*, in the literal Latin sense of being "turned the wrong way" – of the Hegelian dialectic. That is, whereas consciousness is normally understood (by Hegelianism) to require its Other fundamentally, such that this relationship of mutual opposition ultimately culminates in the sublimation of both, fascist identity by definition cannot tolerate Otherness – and thus fascism requires the *extermination* of its Others.

Lacoue-Labarthe and Nancy lay out the specifics of this logic in their consideration of Aryan identity in their jointly-written essay, "The Nazi Myth." Recalling Plato and his understanding of the effect of external forms (e.g., art, lyric poetry, and especially *myth*) on the human soul, Lacoue-Labarthe and Nancy characterize the formation of modern (especially Western, European, national) identity as "mimetic" in that it consists in the appropriation and repetition of tropes and figures borrowed from earlier cultures, especially the Greco-Roman. "Since the collapse of Christianity a specter has haunted Europe: the specter of imitation – which means, above all, the imitation of the Ancients" (299). While the rest of the nations of Europe had long defined themselves through their respective "imitations of antiquity," Germany as late as the eighteenth century was perceived to have no true national art and barely to have a country or even a language it could truly call its own. "Germany, in

other words, was not only missing an identity but also lacked the ownership of its means of identification," say Lacoue-Labarthe and Nancy (299). They go on to describe a process through which Germany attempts to overcome its identity crisis ("or the vertigo of an absence of identity") by the construction of an elaborate *mythos*, a "new mythology" out of which a peculiarly German national identity would emerge and be articulated. The course and construction of this new myth would run through such diverse sources as Schlegel, Hölderlin, Hegel, Schelling, Nietzsche, and Wagner, but it would ultimately receive its most concrete expression in Rosenberg's *Myth of the Twentieth Century* and Hitler's *Mein Kampf*, both of which were enormously popular in 1930s Germany.[15] Of course, the form of identity articulated within this new *mythos* was that of the Aryan race.

It is crucial, observe Lacoue-Labarthe and Nancy, to understand the Nazi myth as fundamentally *racial* in character. By contrast to the Aryan, which represents perfect racial purity, "the Jew is not simply a bad race, a defective type: he is the antitype, the bastard par excellence" (307). The Aryan, on the other hand, is not only considered to be "the founder of civilization," but also, as the one pure race, is the fount of all human typology. The Aryan is like the sun, "which causes forms to come forth as such." Both are "arche-types." "Why the Aryans?" ask Lacoue-Labarthe and Nancy. "Because they are the bearers of the solar myth. They are the bearers of this myth because, for Northern peoples, the spectacle of the sun is impressive in proportion to its rarity. The Aryan myth is the solar myth, as opposed to myths of the Night, to chthonic divinities. Whence the solar symbols, and the swastika" (309). The opposition between darkness and light is salient. The word "Aryan" derives from a Sanskrit term meaning "noble." In the Aryan this nobility refers, above all, to a certain ascendent purity of blood.[16] As the blackness of Night is antithetical to the ascendency of the Sun, so is the Jew, and other "chthonic" peoples, to the reign of the Aryan. The Jew, thus, represents absolute Otherness with regard to the Aryan. And, as such, cannot be tolerated:

> The Aryan world will have to be much more than a world ruled and exploited by the Aryans: it will have to be a world that has become Aryan (thus it will be necessary to eliminate from it the nonbeing or nontype par excellence, the Jew, as well as the nonbeing or lesser being of several other inferior or degenerate types, gypsies, for example). . . . It is neither a philosophical option nor a political choice; it is the very necessity of creation, of the creative blood. (311)

The word "genocide" – from the Greek *genos*, meaning "race" – captures with a terrible literalness exactly what must occur for the Aryan race to be realized in its truth. All races, all peoples, all types which threaten the purity of the Aryan race must be exterminated. The Nazi myth will tolerate nothing less.

It is not entirely clear exactly how far Lacoue-Labarthe's and Nancy's treatment may be generalized beyond Nazi Germany.[17] It is tempting to agree with them that the "mimetic will-to-identity," which they demonstrate to be peculiar to Nazism, also "belongs profoundly to the mood or character of the West

in general" (312). But, once we leave the rather narrow parameters of Aryan mythology and Nazi Germany, in which the death of its Others is so specifically and irrefutably prescribed, we have still to account, if possible, for fascism and its tendency toward genocide without regard to its specific geographical and/or historical instantiations. It would appear that fascism abides by a certain logic which leads it inevitably toward genocide. How may we characterize this logic? And, more importantly, through what mechanisms might this logic be disrupted?

It seems to me that Deleuze and Guattari's discussion of the processes of "deterritorialization" and "reterritorialization" as they apply to capitalism can be recast to help explain in part why fascism leads toward the eradication of its Others.

There is, and can be, they say, no fixed subject without *repression* (*AO*, 26). In fact, there can be no fixed identity, no "objective" world, at all, without circumscribing (in the most literal sense of circum-*scribing*) the non-linear, polyvocal, unorganized, transcursive network of valences and forces which constitute what they call the "body without organs."[18] It is on the surface of the body without organs that the *subject* appears. The identity of the subject is tied to the particular kind of production which characterizes each desiring-machine. But before the subject can be identified, before it can be ascribed a definable selfhood, indeed before the flows of desire take on a discernible shape, before reality as such comes into view – these codes have to be given meaning. The image-less body without organs has to be *inscribed* in some way. This is the process of repression and it is the province of social production.

There is a phenomenological parallel between desiring-production and social production. "The forms of social production, like those of desiring production involve an unengendered nonproductive attitude, an element of antiproduction coupled with the process, a full body that functions as a *socius*" (*AO*, 10). We have seen already that the socius is the field or surface of organization belonging to the level of representation. The socius is, in fact, the inscription of the body without organs, a "territorialization" of the nameless, image-less flows of desire. It does virtually the same thing as the body without organs, viz. constituting a space for the activity of desiring-machines (now social machines), but it adds another dimension to the production: it *records* the process. "The prime function incumbent upon the socius has always been to codify the flows of desire, to inscribe them, to record them, to see to it that no flow exists that is not properly damned up, channeled, regulated" (*AO*, 33). All representation is a form of repression, an appropriation of the forces of production, a blockage of the schizophrenic flows of desire. We are now at the level of "society," of discernible cultures, of "objective" reality.

The kind of inscription which is peculiar to the capitalist socius, say Deleuze and Guattari, is initially a decoding, or *deterritorialization*, of the inscriptions which preceded it. "Let us take the example of Rome: the decoding of the landed flows through the privatization of property, the decoding of the monetary flows through the formation of great fortunes, the decoding of the commercial flows through the development of commodity production, the decoding of the producers through expropriation and proletarization – all the

preconditions [of] capitalism" (*AO*, 223). This decoding is in terms of axioms, in particular the axiomatic of the market, whose principal function is to perpetuate the production of capital. This is done by engendering an immanent stupidity into the social field and an eradication of social memory. Memory was necessary to both the primitive and despotic socius: it served to establish social unity and stability. But in the capitalist socius memory is a threat; this is because, as Marx observed, the individual has become subordinate to the production of capital. Memory is a precursor to a form of (historically-informed) consciousness that would allow a cognitive recognition of that subordination and that could thereby serve as the catalyst to revolt. Hence, writing (as, contrary to Plato, a facilitator of memory) becomes obsolete in the capitalist socius. "Capitalism is profoundly illiterate," say Deleuze and Guattari. Writing is replaced by the electronic language of television, computers, and data processing. This serves as a medium both of the capitalist axiomatic – the idiom of Madison Avenue – and of the axiomatized stupidity and anti-memory which suppresses any revolutionary potential; the individual becomes so absorbed in capitalism that he or she is easily turned away from the alienation internal to capitalism, and the atrocities which occur at its peripheries, merely "by tinkering with a television set" (*AO*, 236).

Subjectivity is a commodity in the capitalist socius. But its constant production requires constant decoding and deterritorialization, the clearing away of entrenched forms of representation for the free movement of capitalist production. Hence the individual consistently finds her feet pulled out from under her, constantly bombarded with new devices for identifying and re-identifying herself. No wonder the emergence of the schizophrenic as the clinical entity of the modern socius.

But why, ask Deleuze and Guattari, if schizophrenia is the universal principle of desire, and also if the schizophrenic production of subjectivity is immanent to capitalistic production, does the capitalistic socius attempt to arrest the schizophrenic process and "transform the subject of the process into a sick person"? (*AO*, 213). This is because schizophrenia is the "absolute limit" of capitalism; the pure, free schizophrenic flow of desire would herald the death of the capitalist socius: capitalism "tends toward a threshold of decoding that will destroy the socius in order to make it a body without organs and unleash the flows of desire on this body as a deterritorialized field" (*AO*, 33). Thus, there is a revolutionary potential to the schizophrenic production of subjectivity, a potential threat which capitalism must suppress. Even while capitalism schizophrenizes, it denies schizophrenia as a genuine expression of human identity. This is the irrationality, the internal contradiction of capitalism.

We have at last arrived at what they identify as the *fascistic* side of the modern capitalistic socius. In order to stave off its own dissolution, capitalism must re-appropriate that which it has disenfranchised through the process of decoding. This is done by *reterritorialization*. "Civilized modern societies are defined by processes of decoding and deterritorialization. But *what they deterritorialize with one hand, they reterritorialize with the other*" (*AO*, 257). That is, this same social field is re-appropriated and commodified under the transcendental rubric of capitalism.

But unless it is the case that every totalizing and absolutist representation is fascistic, then it is a mistake, I think, to see fascism as an extension of capitalism, and to view the fascist State as an outcome of capitalist production. Not because capitalism is better than fascism. As Deleuze and Guattari observe, capitalism can be both brutal and dehumanizing. Certainly capitalism has its ostensibly fascist tendencies. It invests itself with an aura of necessity and indispensability. But, capitalism works best when there is choice, selection, proliferation, "free enterprise." It eventually learns that its interests are best served not by totalization, but by pluralization. So it schizophrenizes; and if schizophrenization produces revolutionary factions which threaten to destroy it, capitalism appropriates such factions through reterritorialization. But this is not so much a reterritorialization through fascist repression as it is a deflection and a diversion. For example, the Drug Culture becomes the Pepsi Generation, the Punk Underground gives rise to Chanel's Spray-In hair color and pre-torn jeans that you buy off the rack at Macy's – even the anarchist is made a screen hero, a box office attraction! Capitalism deflects revolutionary threat by maximizing its economic potential. Thus, capitalism is intrinsically pragmatic and opportunistic. It may at times *use* fascistic practices to generate capital or even to help preserve its own existence. But pure fascism, as much as unimpeded schizophrenization, would mean the demise of capitalism.

Thus I think that the mechanisms of deterritorialization and reterritorialization which define the inscription of social space peculiar to capitalism are best understood as mechanisms of marginalization and de-marginalization in fascism. These mechanisms follow similar impulses: viz., the total (re)appropriation of the social field and the identities which populate it. But for fascism there is a set of identities which it absolutely cannot accommodate, indeed, which it must strive to extirpate. Of course, these are the peoples presumed to be genetically inferior to the fascist, whose identity is based on the assumption of a certain privilege, if not purity, of constitution. But fascism installs itself at the center only by a parallel delimitation of a periphery, an act of marginalization through which its Others are constituted *as such*. Most often this takes the form of a social, economic, and political marginalization, but sometimes it approximates the literal, as happened when Saddam Hussein drove the Kurds outside the boundaries of Iraq. The very act of marginalization has an effect that is similar to the act of deterritorialization in capitalism, that of automatically *devaluing* the constituents of the space so inscribed. The inhabitants of the periphery are inferior – are literally worth-less – not because of any constitutive flaw or lack, but merely as an effect of the marginalization itself. This is to suggest that the racist rhetoric of most fascist variants is an apologetic for, not so much a cause of, the disenfranchisement of their respective Others. The acts of marginalization, real or figural, are co-extensive with the very installation of fascist identity. But, as we have seen with regard to Aryan identity, fascism cannot tolerate its Others; in order for fascist identity to be realized the Other must be eradicated and consumed through practices and processes of de-marginalization. The term "ethnic cleansing" comes as close as any to what is being accomplished by this process.

I suspect that this impulse, as much as the tendency toward totalization and

envelopment, is the defining feature of fascist identity in the modern world. Other identities have an instantiation vis-à-vis an Other through which both are mutually defined and which is hostile and violent in character. But it seems to be peculiar to the fascist identity to *require* the death of the Other as part and parcel of its very constitution. This may be due to a certain hyper-reflexivity attached to its formation, characterized by a valorization of identity *qua* identity – a phenomenon that appears to be peculiar to a modern world animated by a kind of indelible macro-narcissism, which takes various forms: nationalism, xenophobia, media-ism, and, for lack of a better term, Warholianism. In any event, one measure of fascist identity may be its ultimate impossibility – the possible impossible. Fascism appears to be the pure *potencia* that consumes itself through its attempt at self-actualization.[19] The fascist would seek no other image but his own, and, like Narcissus unable to tear himself away from the fountain that reflects his face in its pool, "cherishes the flame that consumes him."[20]

No one would be surprised to hear fascism referred to as the ulcer of the twentieth century. Fascism is viewed at once as the great evil and the pernicious psychological malady of our age – its invocation cannot help but to provoke responses which are both moral and pathological in character. Metaphorically speaking, fascism *is* an ulcer; it is a malignancy that consumes everything it touches, including, ultimately, itself. But a close examination of both ulcers and fascists reveals how genuinely alike they are: *real* ulcers also grow and expand through a necrosis of the surrounding tissue. Likewise, as with real fascists, the death, the extermination, of the surrounding tissue (the *Other* of the ulcer) is brought about typically through a process of *ischemia* – literally, a stopping of the blood. The ulcer grows as the flesh of its Other dies and is consumed. Similarly, the fascist installs itself by a marginalization of its Other. But, just as healthy flesh represents at once the inhibition of the ulcer as well as the medium of its installation – a relation of morphic imbalance to the degree that the life of the one constitutes the death of the other – likewise, the existence of the fascist's Other represents the inhibition, in fact the impossibility, of the fascist. Thus, through a process of de-marginalization the fascist literally stops the blood, the impure blood, of its Others. The Other dies, and its flesh is consumed, within the lye-filled confines of the mass grave, by the fires of the crematorium, or is literally eaten as carrion on the spot where the body is left to die.

In fact, to call fascism an ulcer would appear to do an injustice to real ulcers everywhere. For however ravaged the foot might be that the ulcer is consuming, we do not attribute a malevolent intent to the ulcer. There is nothing "evil" about what the ulcer does; thus, moral approbation of whatever sort seems entirely out of place. Not so with the fascist, of course. These are human beings who ought to hold human life in higher estimation. But what I have tried to demonstrate in part here is that, like the ulcer, the fascist follows an internal logic bound inseparably to the very identity of the fascist, a logic whose momentum is ineluctable as it moves both fascist, and ulcer, toward the extermination of the Other, toward the consumption of the flesh of the Other.

THE POLITICAL IMAGINARY

INTRODUCTION

The preceding section explored the relation of political rationality and the capacity of the social-political imaginary to respond to difference by offering a subject de-essentialized, drawn beyond the fortress of identity. Part Five describes a crux between aesthetics and the politics of postcolonialism. The common theme is not an aestheticized political ideal imported from the past or an imaginary utopia for the future, but responsiveness to cultural difference that challenges established political, legal, and linguistic categories. A point made earlier should be repeated, namely, that here "aesthetics" does not refer to art as a quasi-autonomous realm of experience ruled over by the supreme subject that determines all things and feels all things. Aesthetics is not rooted in the mimetic refiguring of the world and the responsiveness of aesthetic consciousness; it resounds with the root sense of perception (*aisthenasthai*) as the felt proximity of claims coming from beyond the framework of conceptual identities that would secure the world in understanding. It's as though feeling were an alternative circuit to categorial thinking by which we receive and respond to intimations of difference.

The crux of the aesthetic with the post-colonial submits empirical differences – ethnic, social, economic, legal, religious – to more radical philosophic and literary reflection. The practical import of these discussions need hardly be stressed in a context where globalization shrinks the world daily and multiplies the flash points of alterity. The well-intentioned, liberal *idea* of social diversity is one thing; but post-colonial recognition of the other is a more temporally complex matter. How does one confer identity upon the other without reproducing the lineaments of essentialism? The danger is that recognizing the other *as* other risks reducing the other to stasis and reproducing the politics of identity. The vis-à-vis of such static identities, whether in war or peace, shuts down – exists for the repressed purpose of shutting down – the messiness of cross purposes and the dynamics of *inter esse* that feeds the social imaginary. To foreclose or domesticate difference threatens the flows of desire that energize political life and provide the transformations of perpetual rebirth. The essays that follow ponder the proximity of political rationality and the social imaginary, and they cross from a different direction and with a different intent the site of encounter between philosophy and literature.

Moira Gatens asks the question of "Post-Colonialism and History: Are We Responsible for the Past?" What meaning can collective responsibility have in the context of philosophical individualism and the political liberalism of social contract theory? If individuals are real and collectivities imaginary, in what

sense are we responsible individually or communally for the colonial past? Must responsibility for the past be based on foundational ethical claims and therefore ultimately on power? Gatens responds to these questions with a political aesthetic in the context of relations between colonial and post-colonial peoples in the former colony of Australia. Two centuries of imperialist rule had denied legal existence to indigenous peoples under the law of *terra nullius* which judged the continent to have been uninhabited. Then the *Mabo* decision of 1992 recognized the native inhabitants and their entitlement to land. Gatens claims that colonial law had not simply denied legal identity to indigenous peoples; it had actively conferred non-identity upon them. The argument is not the liberal democratic claim that their status "ought" not to have been denied, that we "ought" to accept responsibility for peoples displaced and otherwise abused by colonialism. Instead of defending a historical or socially contingent responsibility based on ethical foundationalism or the will to political correctness, she seeks an alternative *ontology*. For that, she consults Spinoza and the notion of the "sociability of imagination and affects."

The subject, for Spinoza, is not a nodal point of identity, the Cartesian "I think" of modern liberal theory; it is a register of affects, included without break between imagination and reason, in the collective "Man thinks." That is, both individual subjects and collectivities like nation-states are constructed in the plurality of imagination. In this relational structuring of plurality, collective affects *and* passional life produce the social imaginary. In other words, political rationality is deployed within an equiprimordial social *ethos* and a communal *mythos*. Hence, remembering the past both structures diversity and enables the imagination to remain productive. In Australia the social imaginary of *terra nullius* did not simply overlook or ignore the Aborigines; it actively narrated them, could not avoid narrating them into the *mythos* of the new country. So it tried and necessarily failed to narrate them *out* of the collective imaginary. While the sovereignty of *terra nullius* erases difference, wiping out both the past and the identity of non-Western cultures, Spinoza's plurality of the imagination lets differences continuously emerge. The implication is that the social imaginary itself is at stake: political rationality may narrate the other in or narrate it out, but it cannot not respond to the other. We remember the past by recognizing indigenous peoples and allowing them to *belong* and by constructing national narratives that can account for both a colonial past and a post-colonial future.

Paul Patton extends the discussion of multicultural relations in "Indigenous-becoming in the Post-Colonial Polity." Continuing the example of indigenous Australian peoples, he focuses on the processes of creative transformation or "becoming-indigenous" of colonial societies. Deleuze and Guattari's concept of deterritorialization clarifies this process of "internal decolonization." How might dominant cultures recognize minority cultures, opening the possibility of mutual transformation? All colonial conquests involve capturing or subordinating non-Western space and peoples by imposing European structures, such as law and sovereignty, appropriating earth into "land," hence "property," and expropriating indigenous inhabitants into "people," hence productive "labor." The *Mabo* decision, Patton argues, by rejecting this marginalizing

sovereignty over indigenous peoples, deterritorializes the capture of indigenous territory. In the Australian example irreducible difference is injected into the notion of univocal sovereignty, law, and Western identity. Through opening a space of continual becoming, alterity shifts the boundaries, creating "new territories and new subjectivities" and preserving them in constant "nomadic" motion. Instead of a dialectical polarizing between center and margins or a breach of frontier by conquest, irreducible difference creates a shifting margin that perpetually decenters. Patton effectively argues that the recognition of indigenous peoples opens the field of difference, radically and irrevocably altering the institutions that once depended upon their "disacknowledgment," the possibility for what Deleuze and Guattari imagine as "a new earth and a new people."

The third essay in this section explores the issues raised by Gatens and Patton in one of the great "colonialist" works of fiction in world literature. Alfred López's essay "The Post-Colonial Threshold of Capacity: 'The Other! The Other!'" challenges a critical tradition that has often charged Joseph Conrad with imperialism and even racism. By reading with greater critical rigor than Conrad's more ideological critics, López may be understood as revealing a nonchronological "origin" or "threshold of capacity" for the post-colonial in *The Heart of Darkness*. That "heart of darkness" is at first a European metaphor for the depths of the Congo into which the narrator Marlow has penetrated and which he describes retrospectively to an audience of Europeans. Then the title becomes a contested site where the colonizing subject of imperialist discourses can be questioned and, in questioning, dismantled. In contrast with the imperialist "Mr. Kurtz" in the fiction, Marlow's enlightenment – the framing narrative of empire – reveals perplexity, even a certain inadequacy in his lexicon for capturing his experience. As darkness is the absence of light, so the *heart* of darkness can be neither located nor illumined. López shows us a *poiesis* that can describe a culturally blinded narrator as he brushes up against a frontier that remains occluded by his tale of empire. By insinuating what it cannot say, the novel sets a dark negativity to work, thematizing an untranslatable absence and opening the distant possibility of a post-colonial frontier.

11

POST-COLONIALISM AND HISTORY

ARE WE RESPONSIBLE FOR THE PAST?

Moira Gatens

I. INTRODUCTION[1]

1993 was the International Year for the World's Indigenous People. When Paul Keating, who was then Prime Minister of Australia, launched the year he said that 1993 would be "... a year of great significance for Australia." He remarked that events appeared to be coming together in a particularly propitious way. In 1992, the historic High Court *Mabo* judgment had overturned the legal fiction of Australia as *terra nullius* – thus, native entitlement to the land was recognized after 200 years of colonial occupation.[2] It was this constellation of events that led Keating to say that the International Year for the World's Indigenous Peoples

> comes at a time when we have committed ourselves to succeeding in the test which so far we have always failed. . . . It is a test of our self-knowledge. Of how well we know the land we live in. How well we know our history. How well we recognise the fact that, complex as our contemporary identity is, it cannot be separated from Aboriginal Australia. . . . That is perhaps the point of this Year of the World's Indigenous People: to bring the dispossessed out of the shadows, to recognise that they are part of us, and that we cannot give indigenous Australians up without giving up many of our own most deeply held values, much of our identity – and our own humanity. . . . The starting point might be to recognise that the problem starts with us non-Aboriginal Australians. It *begins* I think, with that act of recognition. Recognition that it was we who did the dispossessing. We took the traditional lands and smashed the traditional way of life. We brought the diseases. The alcohol. We committed the murders. We took the children from their mothers. We practised discrimination and exclusion. . . . We non-indigenous Australians should

try to imagine the Aboriginal view. . . . But there is one thing today we cannot imagine. We cannot imagine that the descendants of a people whose genius and resilience maintained a culture here through fifty thousand years or more, through cataclysmic changes to the climate and environment, and who then survived two centuries of dispossession and abuse, will be denied their place in the modern Australian nation. We cannot imagine that. We cannot imagine that we will fail.[3]

There is obviously considerable political rhetoric contained in these rousing words. However, Keating's speech cannot be dismissed as simple rhetoric. Several features of his speech will frame this essay concerning the past and responsibility: first, Keating's insistence on the collective "we" who bear responsibility, second, the centrality of the imagination – what I will call the social imaginary – in the co-constitution of identities, and finally, his claim that a present "we" should accept responsibility for things that happened in the past. Shortly, I will turn to reflect on each of these from a philosophical rather than from a party-political perspective.

Much has changed in the Australian context during the intervening years since Keating gave this speech, including a change of government which has brought with it a so-called mainstream "backlash" against indigenous people, including a sustained assault against the *Mabo* decision from farming and mining interests. The events of the recent past, and those of the present, no longer seem so propitious. What has shifted in the political and social imaginary? One of the fallout effects of the *Mabo* decision, and subsequent events, has been an apparent unwillingness, or inability, on at least some people's part, to accept *any* responsibility for the past. The Keating model of social democratic citizenship, which held up republicanism as its millennial goal, has given way to a more traditional liberal view under the present conservative Government.[4] So-called multiculturalism is now seen to be divisive of national identity. All individuals, under the present model of citizenship, should be treated equally in spite of their differences. Anything else is seen as special pleading, or special treatment, which is, in turn, seen as a form of covert discrimination against "ordinary" people.

The present Liberal coalition Government in Australia has mobilized a vocal section of the electorate who see themselves as "ordinary," "mainstream" Jane or John Does, who do not wish to be bothered by intellectuals, or "bleeding hearts," telling them to toe the "politically correct" line and to share responsibility for the type of political collectivity in which they dwell. The present poverty of conceptions of civil life in contemporary liberal democracies, decried by some, is likely to be seen by such persons as the right of the individual to pursue economic gain unburdened by duties towards different others or by responsibility for the past. What these liberal conservatives call the "black armband" view of history does not suit the polity's self-image, and the media bear witness to the struggle between asserting pride in a pioneering past and admitting shame for the indisputable savagery which characterized the nascent Australian nation's treatment of indigenous people.

The terms of this debate are not peculiar to Australia – "First Nation"

politics is now a global movement. The unwillingness of some to open history to conflicting or contested versions of the past, as well as a reluctance to acknowledge the enduring presence of the past, is of international, as well as national significance. The often bitter debates which have taken place under the names *Historikerstreit*, the Truth Commissions in Chile and Argentina, Bishop Tutu's Truth and Reconciliation Commission in South Africa, all attest to the importance of *how*, and *by whom*, national narratives of the past are constructed. Each of these debates has its own specificity which I would not want to obscure for the sake of "armchair philosophizing." Rather, my aim is to ask whether posing a collective "we" as the locus of responsibility can be philosophically justified, and, if so, whether such responsibility may be carried from the past. Who or what is this "we"?

Much contemporary moral philosophy will dismiss the notion of collective responsibility as incoherent from a philosophical or juridical perspective.[5] There may indeed be those who feel guilty about a past in which they could not act, perhaps because they did not exist, but often philosophers will consider such people to be sentimental, irrational, or muddle-headed. Guilt and responsibility accrue to *individuals*, not collectivities, and national and other group identities are not genuine identities but merely *imaginary* wholes – hypostases. To assign responsibility to these imaginary wholes, on this view, is to be misled by one's imagination. To be led in this way may produce good literature but it produces bad philosophy. I concede, immediately, that the notion of collective responsibility cannot be derived from the ontological assumptions which underpin classical liberal thought. Rather, such a notion assumes a relational account of the genesis of human subjects. Here I will sketch briefly an alternative ontology through which collective responsibility, and responsibility for the past, may be theorized. This alternative ontology derives from contemporary readings of Spinoza, particularly those offered by Étienne Balibar, Gilles Deleuze, and Antonio Negri.[6] Each of these readings of Spinoza converges on his treatment of the inherent sociability of the imagination and affects.

II. THE SOCIAL IMAGINARY AND THE COLLECTIVE

Spinoza's unorthodox stance on the status of the individual is well-known. For him, the individual is not a soul, or a subject, or a substance, but rather a modal existent which is made up of parts and which, in turn, is always a part of a greater whole. Since it is God, Nature, or Substance that is the only truly autonomous individual, the problem of individuation will always be one of scale. Consciousness cannot be the site or origin of subjects since, on this view, consciousness is the complex of ideas that express the endeavor of an individual body to persevere in its existence. Images and ideas concerning the state of my body necessarily involve the effects that other bodies have on me. Does this body aid me or harm me? Does it cause me joy or sadness? Does it increase or decrease my power for preservation? Consciousness is not the origin of individuality but the register upon which affects are traced and combined. The mind as the idea of the body is not only the registered tracings of affects but, more radically, it is the site for the imaginative organization of such

tracings into chains of signification. These chains of signification are dynamic – constructed and reconstructed, over and over again – and make meaningful narratives out of contingent encounters. The *conatus* or endeavor of each individual to persevere in its existence means that the individual is driven to organize its contingent experiences into meaningful wholes. Ideas are connected, fortuitously or habitually, in ways which produce stories through which the simple or complex individual strives to flourish. Encounters with others who threaten to decompose the stability of our typical relations do not figure in such narratives as bad *for us* but as bad *per se* or evil. Spinoza maintains that bad encounters with others may lead to universalizing the qualities of a part to the whole. He writes: "If someone has been affected with joy or sadness by someone of a class, or nation, different from his own, and this joy or sadness is accompanied by the idea of that person as its cause, under the universal name of the class or nation, he will love or hate, not only that person, but everyone of the same class or nation" (*Ethics*, III, Prop. 46). And because identity is not substantial but modal, the situation of the individual is that of an intersectional point only – a point which is unavoidably connected with more or less complex networks of sociability: the family, the group, the clan, the nation. Marcia Langton, Professor of Aboriginal Studies and indigenous activist, concurs with this understanding of identity. She writes, "the creation of 'Aboriginality' is not a fixed *thing*. It is created from our histories. It arises from the intersubjectivity of black and white in dialogue. . . . Before Cook ['discoverer' of Australia] and Phillip [first Governor of New South Wales] there was no 'Aboriginality' in the sense that is meant today." And she adds: "it is hard to figure out what is precisely meant by 'a black man' or 'a black woman': they are fictions, acts of imagining. You have to know who is doing the imagining, and why."[7] The processes through which individuals are constituted in the imaginary are the same processes through which collectivities are produced. This is why, according to Balibar, it makes sense to maintain that "the object of Spinozist analysis is, in fact, a system of social relations, or of mass relations, which might be called imagination."[8]

The contrast between those who draw upon Spinoza's account of sociability, on one hand, and the contractarian accounts which found contemporary liberalism, on the other, is a very stark one. Spinoza's challenge to the ontological assumptions which ground contemporary liberalism may be posed by placing his axiom "Man thinks"[9] alongside the founding moment of modern philosophy, the Cartesian "I think" (Balibar, *Masses*, 32). Thought, for Spinoza, is essentially a collective phenomenon, made possible by contact, collision, and collusion with other bodies. We encounter others as bodies, thoughts, words, images, which are collectively produced and collectively maintained across time. The solipsistic subject is a fiction and to assert "Man thinks" is to assert that "we think," "we feel," "we understand." Existence is not captured by "I am, I exist" but by "we are" always in concert with others.

According to Spinoza, much of what passes for ethical and political theory amounts to little more than "dreaming with one's eyes open." The "dreamers" to whom he refers are those theorists who assume that social and political order is derived from reason – and so sociability itself is seen to be the fruit of

rational, calculative reflection. The *Ethics*, along with Spinoza's political trea-
tises, may be read as sustained demonstrations of the untenability of such
views. Any particular historical set of social and political relations, he shows,
are initially constituted in and through the productivity and the positivity of
the imagination, and passional life generally. Reflecting upon a particular form
of sociability involves understanding the history of the network of ideas and
affects which have constituted that form of life as what it is. Historically, the
two great complexes of the imagination – which are intertwined – are religion
and morality. On this view, the imagination is constitutive of human sociabil-
ity and is indispensable to the maintenance and durability of collective life
across time. The *ethos* within which individuals dwell is collectively constituted
through a transhistorical and transindividual *mythos*.[10]

Imagination, as Balibar notes, is itself a transindividual network which both
produces and connects individuals in dynamic and agonistic relations. Affects
and passions – the vicissitudes of love, hate, fear, and hope – are highly con-
tagious not simply because individuals are alike – prone to mimesis and projec-
tion – but further because individuals themselves are composed out of partial
relations. It is not so much that our sociability makes us vulnerable to the
other's affective states, it is rather that our sociability is constituted through
collective affects. The chains of affects which stabilize this or that form of life
do not originate with subjects but are constitutive of subjects. As Balibar
insists, affective relations with others are always partial relations, "they are
transversal (not to mention transferential) relationships which pass from one
object to another, below the threshold of corporeal individuality and beyond it.
They are not the product of a 'consciousness' but rather produce the effect of
consciousness, that is, an inadequate knowledge of our corporeal multiplicity,
which is inseparable from desire itself, therefore from joy and sadness, fear and
hope" (Balibar, *Masses*, 27). Reason has its part to play here, to be sure, but it is
by no means a major role, and collective ethical and political life is primarily
based in, and maintained through, imaginary identifications and projections.
Put differently, every *ethos* is grounded in a *mythos*. A point to which I will
return.

III. RESPONSIBILITY FOR THE PAST

Although imagination is the primary process through which collective thought
takes place, it is not, for all that, the only process. On the horizon of Spinoza's
immanent ontology, the power of the collective resides in its endeavor to select,
create, or invent, a milieu in which its powers of acting to preserve itself may be
enhanced. That is, the imagination may be more, or less, passive, and thus, the
social imaginary may be more, or less, passively constituted. Presumably this is
why Negri, while acknowledging the destructive and superstitious tendencies
of the imagination, nevertheless highlights its potential liberatory force.[11] In a
similar vein, Deleuze sees in Spinoza's theory of the affects a pre-Nietzschean
tendency to define reason as a particularly powerful type of affect that at its *n*th
power seeks social harmony and mutual empowerment.[12] These readings of
Spinoza posit reason and affect, in non-oppositional terms.

The political and ethical problem which this account of the social imaginary presents, is its *permanence*. As Spinoza remarks, those who assume that human beings may come to act from reason alone do not produce ethical theory but merely satirical accounts of chimerical beings whom no one has ever encountered.[13] Spinoza's account of the imagination is not a theory about a "faculty" but a theory about a permanent structure in which human beings are constituted as such. Furthermore, this structure expresses an originarily relational or transindividual ontology.[14] The strength of the social imaginary is that it constructs a logic of its own – a logic which cannot be shaken or undermined simply by demonstrating the falsity of its claims, its inherent contradictions, or its aporias – since it is constitutive of, not merely reflective of, the forms of sociability in which we live. The imaginary endures through time and so becomes increasingly embedded in all our institutions, our judicial systems, our national narratives, our founding fictions, our cultural traditions.

The feeling of belonging to this or that family, clan, nation, confers upon us both benefits and burdens or obligations. One of these obligations is to take responsibility in the present for the manner in which one's constitutive imaginary harms, excludes, or silences others. It must be admitted that one hardly has to seek out such responsibilities – the ethical demand to take up responsibility comes from the other who continues to be harmed in the present. Politics is one of the arenas in which both agonistic and antagonistic conflict, contestation, and negotiation arise. But such demands are always ethical demands too. Demands that cannot and should not be reduced to rationalizations concerning equitable entitlement to material goods or social benefits. One of the social goods which we share, and which I have argued is constitutive of our very identities, is the habitation of an imaginary which enhances our powers of action by providing a ground for our feelings of belonging (*mythos*) and our claims to social and ethical entitlements (*ethos*). Ethico-political life demands that we exercise judgment, make choices, select from possible futures, and invent new strategies for coping with change. And these demands frequently issue from others whose imaginaries only partially, and perhaps involuntarily, overlap with our own.

The social imaginary binds our affects of love and hope into constructive collective projects or endeavors as well as binding affects of hate and fear into relatively stable patterns which will tend to position "our" projects in opposition to a "them" whom we fear as a threat. While there is no "outside" of the social imaginary, this does not mean that we are entirely determined by it. No social imaginary is hermetically sealed and each imaginary is itself plural and consists of multiple imaginaries within which there are different positionalities. But encounters with significantly different others may open one imaginary to another, offering perspective and opportunities for cooperation as well as occasion for conflict, the infliction of harm, and even the destruction of the other. Likewise, there is no "outside" which the philosopher could occupy – an outside from which the imaginary, or the "false consciousness," of the masses may be theorized or from which the philosopher may endeavor to "enlighten" the masses. The question is not how we remove, transcend, or shed, the social

imaginary, which is impossible, but rather, how the social imaginary may be transformed, collectively, from within.

The fundamental insight of all liberatory movements is that freedom is not the possession of the autonomous individual but rather an ethico-political practice that may be actualized only in common with others. Freedom is not a possession, much less a "right," but rather always a process of becoming-free. This collective process of becoming-free is inseparable from the broader question of understanding how we have become what we are today. While it may be incoherent to claim that we are *blameworthy* for the type of community through which we have been formed, and which "inhabits" us quite as much as we "inhabit" it, becoming-free is a practice which will inevitably involve *taking on* responsibility for the *ethos* and *mythos* of that community, to the extent that our capacities allow. We cannot collectively endeavor to become something other than what we presently are in the absence of understanding how we became what we are.

The temporal dimension of collective identity plays a crucial part in the refiguration of ethical life. If individuality is a process, or a becoming-with-others, then the ability to act in the present depends, at least in part, on how one remembers and commemorates the past as well as how one imagines the future. What we are responsible for is the way in which the past dwells in the present. Remembering the past is an obligation that every member of a collective bears, since this remembering is crucial to the continuance of the identity of the collective through time. In commemorating the past we recognize and acknowledge its present importance to our continuing identities. National narratives about the past notoriously involve quite as much forgetting as remembering. The strong motivation of one "we" to forget a particular event is almost always the source of great harm to another "we." There are strong motivations to "forget" shameful events in a nation's past – especially when making reparation for those past events is seen as impossible. Here I will schematically set out five major responsibilities that we in the present should take up in relation to the past.

We have a responsibility:

1. to *remember* the past;
2. to *recognize* the continuing effects of the past in the present, more specifically, to recognize the manner in which the dominant social imaginary continues to bestow (direct and indirect) benefits on some in the present and (direct and indirect) harms on others;
3. to *endeavor* to critically engage with those aspects of our self-constituting narratives which harm others;
4. to make *reparation* to those others, financially *and symbolically* – if such reparation is to be meaningful, it must have resonance in the dominant imaginary – and, finally,
5. to *act* on opportunities for opening the past to its own latent possibilities for change in our present which may mean seizing opportunities to transform our constitutive *ethos* by acknowledging the essential ambiguity of every *mythos*.

Allow me to return to the Australian context in order to illustrate these points. The founding *mythos* of colonial Australia – a fiction which for 200 years enjoyed the force of law – was the "discovery" of a vast and empty continent, *terra nullius* (so, of course, history-less), and therefore able to provide the *tabula rasa* for inscribing a new "Mother country." The Australian continent may be mapped according to a British and European imagination: "*New* South Wales," "Aberdeen," "Perth," and so on.[15] Furthermore, the new "Mother country" would be the bountiful and "good mother" – free of the evils of class privilege, religious persecution, and poverty. The *Mabo* judgment disturbs not only mining, farming, and other financial interests of present-day non-indigenous Australians, it also severely disturbs the social imaginary which grounds the "we" of contemporary "Australian" identity. This imaginary is the site and cause of direct and indirect harms experienced by indigenous Australians. No amount of redistribution of goods and services, compensatory financial arrangements, or (even) the return of sacred sites will erase or alleviate the past and present effects of the European imaginary on indigenous peoples. In fact the "good will" of Europeans toward Aboriginals has been the source of as much harm as an "ill will" has been. (For example, the "stolen generation" of Aboriginal children who under assimilationist policies were removed forcibly from their families "for their own good."[16]) This is not an argument *against* redistribution, compensation, or return of sacred sites. Rather, these measures, though necessary, are far from sufficient.

In 1988, the bicentenary celebrations of non-indigenous Australians were disrupted by indigenous Australians who pointed out that they had nothing to celebrate. One group's joyful celebration of the "birth" of a nation was the occasion for another group's commiseration for loss of land and the near destruction of their culture. No one alive today may properly be held responsible for acts that were committed in the eighteenth or nineteenth centuries – mass murders, the poisoning, rape, and incarceration of Aborigines. What we are responsible for is the way in which the past endures in our present. And here it may be useful to distinguish the past configured as a series of discrete *acts* on the one hand, and on the other, the past configured as *event* in the present. It is the essentially contested meaning, in the present, of the past as *event* which weighs heavily upon us. How we configure the past matters not only in relation to the present and to our present relations with different others. How we configure the past also matters to the way in which that past is converted into values which will inform our future. There is no neutral description of the event of colonization:

"Cook claimed Australia for the Crown of England."
"Cook declared war on the indigenous inhabitants of Australia."

At the extremes, both statements imply values for the way the past lives in the present. Which version of events makes it onto the public record, and so becomes embedded in a national imaginary, affects how the present and future identities of all Australians are constituted. The social imaginary in which, and through which, Australian nationhood and the categories of "black" and "white" have been formed must be transformed.

It is here that the "we" of Keating's speech resurfaces. Who – if not "we" – possess the capacity to accept responsibility for the harmful effects on others of the social imaginary which we inhabit and which have formed us as the types of persons we are? Responsibility for our social imaginary – at least in the terms I have sketched here – can *only* and necessarily be a *collective* responsibility *toward* the past.

IV. TRANSFORMING THE SOCIAL IMAGINARY

I have claimed that the event of colonization can only be thought collectively. To take up responsibility for what we are – that is, to strive to become-free – is a task which will inevitably engage "mass affects." There is good reason to fear "mass affects" or the "anonymous" affects of the collective. Mass affects have too often been synchronized and mobilized under the banner of totalitarianism, fascism, tribalism. But this fear itself frequently leads to a paralysis and failure to consider the inherent logic or "rationality" of the social imaginary. The tendency of political and ethical theorists to understand mass affects as out-breaks of irrationality, or mass hysteria, forecloses the possibility of deploying an ethico-political practice against fascism or racism. Seen as perplexing breaks in the progressive enlightenment of public reason through history, destructive mass affects are figured as a failure of reason and so remain "unthought."

The account offered here of the pervasiveness and permanence of the social imaginary is intended to be constructive as well as critical. I have shown that on Spinoza's account, and on contemporary appropriations of his account, there is no definitive or calculative break between imagination and reason, or between a passional "state of nature" and ordered, contractual political life. Rather, in each case, the latter is produced, or "selected," through a collectively achieved degree of understanding of the logic of the former. The social imaginary may be inescapable but it is not, for all that, fixed. Its reiteration and repetition through time opens possibilities for it to be (re)constituted differently. The collective power of the imagination, which Negri views as constitutive of socio-political life, may be collectively disciplined, educated, or transformed from within.

A first attempt to theorize what it may mean to transform the social imaginary in a disciplined manner, and from within, may stumble on that more ancient problem of the relation between philosophy and literature: a relation which reflects as well as helps to define the distinction between imagination and reason. Philosophy, as a self-conceived practice of reason, does not take responsibility for its imaginary because, as Michèle Le Doeuff has so convincingly shown, it quite simply does not acknowledge that it deploys one.[17] I raise this issue here in order to pose a question: Is philosophy's impotent, if wise, gaze upon the apparent irrationalities of mass politics symptomatic of its disavowal of its own imaginary? Philosophy has all but foreclosed the possibility of engaging with the aesthetics of mass politics, and literature is all but disqualified from passing philosophical judgment on politics. I have suggested that every socio-political collective creates in addition to an *ethos* a *mythos*, that is, an aesthetic of its own self-image. Political struggles of all kinds represent

themselves in aesthetic as well as political and ethical terms. Part of the becoming-free of collective movements always involves the invention of alternative imaginaries, or the creation of an aesthetic (literature, film, art), which experiments with new positionalities within a transformed social field. An alternative aesthetic provides – even if only in imagination – another world and another way of being with others. Both literature and philosophy have produced *ideal* utopic (and dystopic) visions of alternative societies. But may not philosophy and literature, together, contribute to the collective transformation of contemporary, *existing* social imaginaries from within?

The collective transformation of the social imaginary, from within, cannot be "thought" voluntaristically or relativistically as pure (re)invention of the past. Rather, it must be thought collectively, which is to say it must be thought and negotiated with actually existing different others in historical time. But historical time itself is uneven – it is not the linear time of a "past" past, a "present" present, and a "future" future. Hannah Arendt captured something important in her book, *Between Past and Future*, when she wrote that the task of thinking our present sometimes takes place, "in the odd in-between period which sometimes inserts itself into historical time when not only the later historians but actors and witnesses, the living themselves, become aware of an interval in time which is altogether determined by things that are *no longer* and by things that are *not yet*. In history, these intervals have shown more than once that they may contain the moment of truth."[18]

The *Mabo* judgment may be seen as instituting just such an interval – a "no longer" and a "not yet" which constitutes a moment of truth in which we are called upon to "think" our responsibility. It is only "we" in the shared present who have the capacity to take on the responsibility for thinking this "odd in-between" of past and future, and the manner in which we exercise this capacity will condition the milieu through which future beings will be constituted. It is in this sense that we have responsibilities *in the present* toward the past. And these responsibilities also reach into the future because the manner in which we answer the call to take up our responsibilities will affect future beings for whom our present will become their self-constituting past.

12

INDIGENOUS-BECOMING IN THE POST-COLONIAL POLITY

Paul Patton

> It is jurisprudence which is truly creative of rights.
>
> Deleuze

Colonial societies such as Australia, New Zealand, and Canada are founded upon a fundamental difference between the culture, law, and forms of land use practiced by the colonists and those practiced by indigenous peoples. In all cases, the effect of European diseases and open warfare was to dramatically reduce indigenous populations. In addition, whatever their numbers, their cultures were marginalized and indigenous peoples were soon relegated to the status of social minorities. The effects of loss of traditional lands along with forced assimilation ensure that present-day descendants of Aboriginal peoples continue to suffer higher rates of disease and mortality, unemployment, and criminalization, while remaining under-represented in the professions and institutions of public social life. Nevertheless, indigenous cultures have survived and begun to flourish. In Australia, Aboriginal art, music, and dance have become an indispensable part of public culture and ceremony. In New Zealand, forms of Maori protocol and ritual are being integrated into all aspects of social life even while claims to land, fishing rights, and compensation for breaches of the Treaty of Waitangi are still being negotiated.

In the sense that Deleuze and Guattari speak of minoritarian-becomings as processes of creative transformation or deterritorialization of the standard majority forms of social life, we can say that these developments amount to a becoming-indigenous of the colonial societies. The changes taking place at the level of popular culture express a larger transformation in the colonial societies concerned. For the first time in the history of these countries, the living conditions and aspirations of indigenous peoples have become part of the mainstream political agenda. Moves to assert legal, political, and constitutional rights on the part of indigenous peoples constitute a becoming-minoritarian which may yet transform the political institutions of these societies in such a way that they truly become post-colonial. This paper aims to offer an account of this process in terms of Deleuze and Guattari's concepts of becoming, deterritorialization, and capture. It thereby seeks to apply those concepts to the process of internal

decolonization while at the same term using this process to test the utility of the concepts.

I. COLONIAL CAPTURE

Colonization is a complex process, involving the incorporation of new territories into the economic, political, and cultural systems of the colonizing states over long periods of time. The Western European conquest of the new world extended over more than four centuries and was driven by a variety of motives including the pursuit of gold and raw materials for industry, the desire to spread Christian religion, and the attempt to gain strategic advantage in the ongoing rivalry among the European states. Nonetheless, over and above the variety of forms assumed by colonial conquest, certain essential features remained the same: colonization involved the capture of non-Western territories and peoples by means of the imposition of European sovereignty and law.

Deleuze and Guattari offer no explicit theory of colonization. However, elements of their theory of the state are particularly suited to describe this process, since they assert an intimate link between the territorial and political organization of the world into states and the concept of sovereignty: "The State is sovereignty."[1] For Deleuze and Guattari, the modern sovereign state must be understood as a particular form of expression of an abstract machine which they call the State-form. The essence of this abstract machine is capture. However, before examining more closely the concept of capture, it is helpful to note some significant features of sovereignty in the modern world. Nicholas Onuf suggests that the modern concept of sovereignty has three constituent elements, namely, unchallenged rule over a given territory, majesty, and "agency" where this means governance in the interests of those governed.[2] Each of these elements is identified in Deleuze and Guattari's account of the state-form.

First, the state is inseparable from the exercise of unchallenged authority over a given domain or "milieu of interiority." The state is sovereignty, they argue, but "sovereignty only reigns over what it is capable of internalizing (TP, 360). Second, following Georges Dumézil's analyses of Indo-European mythology, Deleuze and Guattari suggest that sovereignty has two poles. On the one hand, it invariably involves a form of "magical capture" through which authority is irrevocably imposed. In mythological terms, this corresponds to the action of the magician-king who casts the net and "captures" the people or territory by quasi-magical means. This aspect of sovereignty corresponds to what Onuf calls "majesty." In the case of modern colonialism, it is exemplified by the doctrine that certain symbolic acts (the raising of flags, the reading of proclamations) are sufficient to establish sovereignty over newly "discovered" territories. On the other hand (third), for Deleuze and Guattari, sovereignty always implies the activity of a jurist-legislator who builds a political structure by means of laws and political institutions. This aspect of sovereignty corresponds to the element of governmental agency which is characteristic of modern sovereign rule. In the colonial case, this aspect of sovereign rule comes after the initial phase in which sovereignty is asserted, when colonies become established and effective rule begins to be exercised over local indigenous populations.

From a historical point of view, these three different elements of sovereignty may appear over time in relative independence of one another. From an analytic point of view, however, they are all components of the concept of sovereignty in its modern form. Onuf suggests that the peculiarly modern combination of majesty, uncontested rule, and government in the supposed interests of those governed forms the "primary architecture" of the modern state, to the extent that it is redundant to speak of "sovereign" states: "The state is the land, the people, the organization of coercion and a majestic idea, each supporting each other, so that they become indivisible. Sovereignty describes this conceptual fusion and thus the territorial organization of early modern Europe. Simply by adding states to its margins, the early modern world irresistibly grew to its present proportions" (Onuf, 437).[3]

Colonization was the process by which the European world added states to its margins. Deleuze and Guattari suggest that the basic constituents of a nation state are a land and a people, where "land" means a deterritorialized geographical area and "people" a decoded flow of free labor (*TP*, 456). In this sense, a modern nation-state is one particular solution to the problem of society in general, involving a particular configuration of fundamental economic relations, including the division of labor and the relation to the means of labor such as land. In the colonial case, the equation is complicated by the fact that the geographical surface is already occupied by indigenous peoples with their own distinctive relation to the earth. Societies of hunter-gatherer peoples such as those found in Australia involve a very different solution to the problem of society, one which realizes an altogether different abstract machine from that expressed in the modern nation-state. In cases such as this, where the indigenous inhabitants lived in accordance with an itinerant territorial assemblage, both land and people were lacking. The colonial authorities had either to import other people in order to provide labor (slaves or convicts), or transform indigenous inhabitants into subjects of labor, but first they had to transform the earth into land fit for appropriation and exploitation. Deleuze and Guattari's account of the process of capture points to what is involved in the process of colonization.

The operation of capture always involves two things: the constitution of a general space of comparison and the establishment of a center of appropriation. In effect, the establishment of a modern nation-state involves a particular form of capture of both the earth or geographical surface and the people or their productive activity: it requires land as opposed to territory, labor as opposed to free activity. What is entailed by these forms of capture? Consider the capture of portions of the earth's surface which make them lands rather than territories. Deleuze and Guattari refer to the conditions which enable the extraction of ground rent, namely the possibility of comparing the productivity of different portions exploited simultaneously, or the possibility of comparing the productivity of the same portion exploited successively. The measure of productivity provides a general space of comparison, a measure of qualitative differences between portions of the earth's surface which is absent from the territorial assemblage of hunter-gatherer societies. Deleuze and Guattari write: "Ground rent homogenizes, equalizes different conditions of productivity by linking the

excess of the highest conditions of productivity over the lowest to a landowner" (*TP*, 441). This is, they suggest, the very model of an apparatus of capture.

However, it is by no means the only such apparatus. They go on to describe the capture of free productive activity involved in the constitution of labor, and the capture of the output of both land and labor involved in taxation. Consider the capture of human activity in the form of labor, a mechanism perfected by capitalism but already practiced in the archaic imperial States. Productive activity may proceed under what Deleuze and Guattari call a regime of "free action" or activity in continuous variation such as may be found in the territorial assemblages of hunter-gatherer societies. Once a standard of comparison is imposed, in the form of a quantity to be produced or a time to be worked, then there is the possibility of hiving off a surplus. The transformation of free activity into labor and the extraction of a surplus go hand in hand, and labor stands to free activity as land does to territory: "labor and surplus labor are the apparatus of capture of activity just as the comparison of lands and the appropriation of land are the apparatus of capture of territory" (*TP*, 442). In each case, we find the same key elements: the constitution of a general space of comparison and the establishment of a center of appropriation.

II. JURISPRUDENCE AND DETERRITORIALIZATION

Returning to the process of colonial capture and the conditions required for the extension of the European state system, it is apparent that further conditions are necessary to sustain these forms of economic capture of the earth and human activity. In order for ground rent to be extracted, the difference in productivity must be linked to a landowner. In other words, it requires private property in land. For surplus labor to be extracted in the form of profit, labor itself must become a commodity. This points to the fundamental role played by law in the capture of indigenous peoples and their territories. The precondition of the productive employment of labor was the deterritorialization of indigenous territories by their conversion into land: by this means they became an appropriable and exploitable resource. This conversion requires the establishment of a center of appropriation, a monopoly over the land which has the power to allocate ownership of portions of unclaimed land. This center is the legal sovereign and the monopoly is the assertion of sovereignty over the territories in question.

The basis of the common law of property lies in the feudal doctrine of tenure whereby all title to land is ultimately derived by tenure from the crown. The power to allocate title to land within a given territory is a fundamental aspect of sovereignty, and by virtue of its right of sovereignty or *imperium* the Crown can both create and extinguish private rights and interests in land. In this sense, the Crown is the center of appropriation of land, and Crown land amounts to a uniform expanse of potential real property which covers the earth to the extent of the sovereign's territory. It follows that the imposition of sovereignty and with it the power to appropriate or alienate land constitutes an apparatus of capture in the precise sense which Deleuze and Guattari give to this term: the sovereign is the ultimate authority with regard to ownership of land in the

given territory, the center of appropriation; and the territory over which the sovereign rules is a legally uniform space (Crown land). Thus, the legal imposition of sovereignty effects an instantaneous deterritorialization of indigenous territories and their reterritorialization as Crown land centered upon the figure of the sovereign.

Deleuze and Guattari offer a conceptual language in which to describe different processes of deterritorialization and reterritorialization. Deterritorialization is defined with deceptive simplicity as the movement or process by which something escapes or departs from a given territory (*TP*, 508). Yet it is a complex concept in a number of ways: first, because it forms a pair with the corresponding movement of reterritorialization; second, because each of these processes involves at least two elements, namely the territory being left behind or reconstituted and the deterritorializing element. A territory of any kind always includes "vectors of de-territorialization," either because the territory itself is inhabited by dynamic movements or processes or because the assemblage which sustains it is connected to other assemblages which generate such movements. In this sense, "deterritorialization is never simple but always multiple and composite" and "inseparable from correlative reterritorializations" (*TP*, 508–9).

In the period of modern European expansion, colonization was carried out by countries which sought to govern themselves and their relations with others in accordance with the rule of law. In the words of Robert A. Williams, Jr., "law, regarded by the West as its most respected and cherished instrument of civilization, was also the West's most vital and effective instrument of empire. . . . Above all . . . Europe's conquest of the New World was a legal enterprise."[4] Law was particularly important in the case of those settler societies established relatively late in the European diaspora. These were societies which from the outset purported to govern themselves in accordance with the rule of law. For this reason, the law in these countries has become a privileged site of indigenous peoples' challenges to the ongoing colonial capture of their traditional lands. Consider a typical scenario: the British Crown claims sovereignty over territory inhabited by a tribal society. It brings with it the courts and the institutions of royal government, and eventually a local assembly with limited legislative power. The progress of settlement and occupation of tribal lands proceeds more slowly. The legal institutions of the colony do not immediately impact the lifestyle of tribal communities: internal disputes continue to be settled and order maintained according to traditional customary law. The mere fact of a change of sovereignty means nothing to the indigenous tribes. However, once the reality of colonization begins to take hold, the tribes are inevitably driven to seek recognition of their rights through the institutions introduced with Crown sovereignty. In the case of British colonies, this means seeking the protection of the common law.

The fundamental jurisprudential problem of colonization is the manner in which the newly constituted uniform space of potential real property relates to the territorial claims of the prior inhabitants. Systems of legal capture may co-exist alongside indigenous customary law and forms of property in land. Long recognition of customary law in various parts of the British Empire, including

India, South Africa, and Canada, offers no shortage of legal precedents for the operation of legal pluralism with respect to indigenous inhabitants. By contrast, in Australia colonization and the legal capture of territory involved total exclusion of indigenous law and custom and denial of all competing rights to land. For this reason, recent decisions by the Australian High Court such as *Mabo v Qld* (1992) and *Wik Peoples v Qld* (1996), which have affirmed the existence of native law and the possible survival of native title to land, amount to a partial deterritorialization of the legal apparatus of capture and a potential threat to the basis of colonial rule. I propose to take the Australian situation as a case study, one which represents an extreme form of colonial capture and one which, more recently, manifests a considerable potential for the unraveling of this apparatus and consequent deterritorialization of the colonial body politic.

III. AUSTRALIA AND *TERRA NULLIUS*

Australia represents a limit case of the process by which the European world added states to its margins. Different forms of legal capture resulted from the manner in which, and the degree to which, indigenous customary law, property, and sovereignty were accommodated by the colonial legal system. A variety of legal instruments were employed, including treaties, the doctrine of conquest, and, in extreme cases, the occupation of territory under the so-called extended principle of *terra nullius*. Under this principle, inhabited land opened to settlement when the indigenous inhabitants were considered so uncivilized by European standards that they lacked the elementary forms of "political society." This "absence of law" or "barbarian" principle was the basis of the British claim to sovereignty over Australian territories. Despite the fact that Governor Phillip was under instructions to take possession of lands only "with the consent of the natives" and despite the long history of colonial negotiations and treaties with indigenous peoples in all parts of the world, the British authorities chose not to regard the indigenous inhabitants of Australia as settled peoples with their own law and government. Instead, they opted for the fiction that Australia was unoccupied land available for settlement. Accordingly, the British Colonial Secretary was advised by the Crown legal authorities in 1819 that New South Wales had been acquired "as desert and uninhabited."[5]

A common law version of the "absence of law" or "barbarian" principle also became the accepted legal basis for importing common law into the colony and justifying the continued non-recognition of Aboriginal customary law. This principle was given legal effect in a series of New South Wales judgments which refused to recognize Aboriginal custom as law. The first and most important of these was *R v Murrell* in 1836, which involved the trial of two Aboriginal men for killing another Aboriginal man. The court rejected the defense argument that the defendants should not be considered subject to British law since they were acting in accordance with tribal law, on the grounds that native laws and customs were "lewd practices" undeserving of recognition. The Aboriginal customs were considered "only such as are consistent with a state of greatest darkness and irrational superstition" (Reynolds, 62). The refusal to recognize Aboriginal customary law in relation to land became

explicit in an 1847 case, *Attorney-General v Brown*, when the judge asserted that "the waste lands of this colony are, and ever have been, from the time of its first settlement in 1788, in the Crown," for the simple reason that there was "no other proprietor of such lands."[6] The principle was later endorsed by the Privy Council in *Cooper v Stuart* (1889) which declared Australia to be a Crown colony acquired by settlement, on the grounds that it was "a tract of territory practically unoccupied without settled inhabitants or settled law" (Reynolds, 16).

The application of this principle in Australian domestic law was not overturned until 1992 when it was rejected in *Mabo* on both empirical and jurisprudential grounds. It was rejected first because it was based upon false assumptions about the nature of Aboriginal society at the time of colonization. Secondly, it was rejected because it represented a discriminatory and racist judgment about the nature of Aboriginal society which could no longer be accepted in law. In the words of one judge: "the common law of this country would perpetuate injustice if it were to continue to embrace the enlarged notion of *terra nullius* and to persist in characterizing the indigenous inhabitants of the Australian colonies as people too low in the scale of social organization to be acknowledged as possessing rights and interests in land" (*Mabo*, 41). Statements such as this are evidence of the historic moral significance of the *Mabo* judgment. They express a shift in community and judicial attitudes which lay behind the High Court's determination on this occasion to revise the common law's treatment of indigenous people. They demonstrate the sense in which the *Mabo* decision marks a profound shift in public attitudes towards the Aboriginal population and its previous treatment by the law and government. The fierce legal and political debate over native title implies a becoming-indigenous at the level of law and political institutions, the effects of which remain to be determined. However, the controversy accompanying this decision also showed that the micro-political attitudinal shift among the non-indigenous population is by no means universal. It is more a question of a crack having opened within the social imaginary, with respect to its colonial past and its treatment of the indigenous population. This may represent the beginning of a becoming-indigenous of the social imaginary, a line of flight along which legal and social change is both possible and desirable for many, or it may represent no more than a minor readjustment of the legal terms in which colonial capture was carried out. In Deleuze and Guattari's terms, it remains to be seen what kind and degree of deterritorialization of the legal apparatus of capture unfolds as a consequence of recognizing native law and custom as a basis for title to land. I will return to the question of deterritorialization below. Before doing so, we need to examine more closely the grounds and the consequences of the judicial decision in *Mabo*.

Mabo held that a form of native title to land could be recognized by the common law, even though the ground of such title did not lie within the common law but outside it in the native law and custom which existed prior to colonization and which in some areas has survived since. Second, it held that such native title could be legally recognized and enforced after the imposition of sovereignty, even in the absence of any express act of recognition on the part

of the Crown. The decision relied heavily on the rejection of a further principle that had become embedded in Australian law, according to which the acquisition of sovereignty implied the Crown's assumption of full beneficial title to the land. This was the prevailing interpretation placed upon the statement in *Attorney-General v Brown* (1847) that the waste lands of the Colony are "in the Crown." It amounted to the view that, upon settlement, the Crown became more than just the source of all title to land in the colony; it became the owner of all land. The majority judges drew attention to the distinction between the Crown's title to a colony and the Crown's ownership of land within a colony, in order to separate common law real property rights from the "radical title" to land assumed by the Crown upon settlement. In rejecting the conflation of the two, they affirmed that "it is not a corollary of the Crown's acquisition of a radical title to land in an occupied territory that the Crown acquired absolute beneficial ownership of that land to the exclusion of the indigenous inhabitants" (*Mabo*, 34). As a consequence, it follows that the importation of English property law is of itself no obstacle to the recognition of indigenous peoples' pre-existing interests in land. Of course, if the Crown had exercised its sovereign right to grant title to land or otherwise use it in ways incompatible with the existence of native title rights, then the latter were considered extinguished.

By means of this distinction, the Mabo judges were able to rewrite the legal account of the consequences of colonization while reaffirming the preeminence of Crown sovereignty. Radical title is the underlying principle of the English system of real property. Ultimately it derives from the system of feudal tenure according to which all land is held by grant from the Crown. It is therefore the basis of the Crown's power to grant or to extinguish property in land, and as such "a postulate of the doctrine of tenure and a concomitant of sovereignty" (*Mabo*, 33). It follows that Crown sovereignty over Australian territory carries with it the power to extinguish prior indigenous interests in land. Thus, on the one hand, the distinction between radical or sovereign title and ownership allows the court to find a place within the law for native title rights which have survived colonization. On the other hand, the same distinction ensures the maintenance of the Crown's right to extinguish native title, and the legality of all valid exercises of that power in the period since sovereignty was declared. The distinction between the radical title assumed by the Crown when it acquires sovereignty and ownership is the crucial specific difference which *Mabo* establishes within the law. It is on this point of law that the High Court manages to reconcile contemporary demands of justice and anti-racism with those of consistency and continuity in legal principle. But it is also at this point that the limits of the rupture in the previous legal apparatus of capture become apparent: native title persists only on land which has not been alienated by valid grant of Crown land, and its persistence remains subject to the overriding power of the Crown to extinguish native title.

IV. FRACTURED SOVEREIGNTY

In strictly legal terms, the *Mabo* decision amounts to little more than a limited and relative deterritorialization of the legal apparatus of capture of indigenous

territory. Yet while the cultural effects of colonization upon indigenous societies are irreversible, there is nevertheless a sense in which the legal recognition of indigenous law and custom returns to the fundamental jurisprudential problem of colonization. It thereby opens up the possibility that a different solution may emerge reconfiguring the constitutional form of the post-colonial polity. Consider the manner in which it implicitly raises the issue of sovereignty. Sovereignty itself was not an issue in the case, and the decision bears only upon what follows from the acquisition of sovereignty by the Crown. The central issue was whether the acquisition of sovereignty implied automatic extinction of prior interests in land or whether it allowed for the possibility that they might continue. The colonial legal precedents differed as to whether or not the assumption of sovereignty implied the automatic termination of all prior interests in land, and the subsequent recognition of only those interests which the new sovereign expressly recognized, or whether the presumption was that the prior interests of the original inhabitants should be supposed to continue unless the sovereign expressly acts against them. The preferable rule, according to the majority judges, "is that a mere change in sovereignty does not extinguish title to land" (*Mabo*, 41).

Reference to the "change in sovereignty" which came with colonial settlement is compatible either with a transition from no sovereignty to British sovereignty, or with a transition from Aboriginal sovereignty to British. To suppose that what took place was the latter would pose a fundamental challenge to the notion that Australia was *terra nullius* at the time of British settlement and therefore to the legitimacy of the British claim to have acquired sovereignty over land which was "desert and uninhabited." The judges in this case were careful to avoid the issue of Aboriginal sovereignty, and to reaffirm the doctrine that the extension of sovereignty to new territory was an "act of state" which was immune to challenge in municipal courts. Nevertheless, the judgment leaves an ambiguous legacy with regard to sovereignty. To the extent that the argument of the majority judges rejected the common law equivalent of the extended *terra nullius* doctrine – the "absence of law" or "barbarian" principle – the case poses an implicit challenge to the official doctrine that Australia was settled rather than conquered. As a number of commentators have pointed out, if the High Court accepts the prior existence of Aboriginal customary law and interests in land for the purposes of the common law, then it seems committed to the view that prior indigenous societies were "sovereign" in the sense that they saw themselves as ruled by a law which was absolute and subject to no higher authority.[7]

In effect, the terms in which the High Court recognized native title ensure an element of instability in the legal consequences of the decision. The court asserted that native title was not a concept of the common law but one grounded in native law and custom. The concept was defined in such a way that it straddles the border which separates the common law from systems of customary law external to it. In the words of Justice Brennan: "native title, though recognized by the common law, is not an institution of the common law" (*Mabo*, 42). As such, native title is neither a concept of the common law nor a concept of Aboriginal law but a hybrid concept which falls between the two

systems. Aboriginal lawyer Noel Pearson has suggested that native title should be understood as a "recognition concept," a concept which belongs to the space between two bodies of law and by means of which one recognizes the other under certain conditions: "Native title is therefore the space between the two systems, where there is recognition."[8] The consequences of this interpretation are far-reaching. To understand the concept of native title in this way is to make it clear that we are dealing with two bodies of law in relation to the land, both of which claim to be final and absolute in their own terms. Moreover, it suggests that the common law overreaches itself in claiming the right to extinguish native title. At most, it may withdraw recognition in certain cases, as when a lease has been issued for the same land.

In Deleuze and Guattari's terms, this amounts to the assertion of an irreducible difference where before there had been only a uniform legal space, the legal space of alienated or unalienated Crown land. To the extent that the legal apparatus of capture presupposes a uniform space of comparison and appropriation, what is at issue in the concept of native title, and especially in Pearson's interpretation of it, is a refusal of the primary stage of the legal apparatus of capture. It implies that there would no longer be just one body of Anglo-Australian law but two or more "law ways." To the extent that Aboriginal law would constitute distinct internal limits to the authority and jurisdiction of the common law, there would no longer be a unique locus of sovereign power, but two or more bodies of law. The concept of native title therefore opens up a fissure within the previous legal apparatus of capture.

V. ABSOLUTE DETERRITORIALIZATION?

In general terms, it can be argued that native title jurisprudence as it continues to develop in Australia, Canada, and elsewhere, threatens to deterritorialize the judicial apparatus of colonial capture. The question remains whether this will be anything more than a partial or relative deterritorialization of an antiquated and discriminatory system of legal capture, and a corresponding reterritorialization within the overall framework of the existing nation-state, or whether it carries a larger potential for transforming the colonial body politic. What would constitute a becoming-indigenous of the social, economic, and legal structure of the colonial polity? Deleuze and Guattari enable us to specify the requirements of this larger transformation.

At the end of *A Thousand Plateaus*, they outline a normative typology of processes of deterritorialization which distinguishes three distinct types. In the first type, which they call negative deterritorialization, the deterritorialized element is immediately subjected to forms of reterritorialization which enclose or obstruct its line of flight. Reterritorialization does not mean returning to the original territory, but rather refers to the different forms of reconnection or rebinding of a deterritorialized element in connection with some other assemblage. Deleuze and Guattari distinguish between the *connection* of deterritorialized flows, which refers to the ways in which distinct deterritorializations can interact to accelerate one another, and the *conjugation* of distinct flows which refers to the ways in which one may incorporate or

overcode "another thereby effecting a relative blockage of its movement" (TP, 220). In the second type, deterritorialization is positive but goes nowhere because it fails to connect with other forces or lines of flight. In this case, deterritorialization remains relative. The third, the ethically and politically most important type, is absolute deterritorialization: "Deterritorialization is absolute when it . . . brings about the creation of a new earth, in other words, when it connects lines of flight, raises them to the power of an abstract vital line . . ." (TP, 510). This refers to a type of movement qualitatively different from relative or merely quantitative change. It has to do with the creation of new territories and new subjectivities which inhabit those territories in nomadic rather than sedentary fashion. Under what conditions might the limited and relative deterritorialization of legal capture effected by native title juris-prudence break free of existing forms of capture and carry over into what Deleuze and Guattari call "a new earth and a new people"?

The *Mabo* judgment created legal grounds on which native title could be established and a quantity of indigenous land thereby reclaimed from the mass of unalienated Crown land. In strictly legal terms, this was no more than a relative deterritorialization of the legal status quo, since the overriding right of the Crown to annul such title by grants of land remained in place. Even so, in political and economic terms, it has given rise to a line of flight that threatens to disrupt important State interests such as mining investment and pastoral property values. For this reason, successive Federal governments have been impelled to undertake a secondary reterritorialization by legislative means: the Native Title Act passed at the end of 1993 served to validate mining and other leases, and to regulate the procedure by which native title claims could be made. Revisions to this legislation recently passed will have the effect of further limiting the scope for Aboriginal claims. The government's response amounts to reaffirming the integrity of a colonial society founded upon a primary reterritorialization and exclusion.

From the standpoint of the indigenous land rights movement, a variety of other responses is possible which might seek to resist the processes of secondary reterritorialization and to create new forms of economic and cultural independence for indigenous communities. One response might resist secondary reterritorialization and maintain as far as possible a legally and politically open space in which native title claims might be pursued through the courts. This would maintain a space of becoming in which as many options as possible were kept open, in Deleuzian terms, a purely negative deterritorialization. Creative reterritorialization is absent. A different response might seek to establish alliances with other agencies, groups, and movements, ranging from mining companies to environmentalists, church groups, and others concerned with addressing the ongoing effects of colonial injustice towards indigenous peoples. The aim of such initiatives would be to establish productive connections with political forces which can help to extend the indigenous line of flight throughout the post-colonial polity. Only by shifting the boundaries of the national imaginary and by setting limits to the power of the colonial state will it be possible to effect a form of absolute deterritorialization of the colonial polity and to create "a new earth and a new people."

13

THE POST-COLONIAL
THRESHOLD OF CAPACITY

"THE OTHER! THE OTHER!"

Alfred López

In this essay I hope to address a question frequently raised regarding emergent post-colonial discourses, but seldom more directly than in a recent essay by Ella Shohat: "When exactly . . . does the 'post-colonial' begin?"[1] Her question pre-supposes a certain type of anti-theoretical or "empirical" interrogation, a question which already posits the post-colonial as a sign contained by the customary signifiers used to denote first sightings ("when?" "where?" – the notion of "origin" itself). What I offer here, however, is not an originary location or moment but what we might call a limit or *boundary*. This boundary is not a generic or historical demarcation (as the question would seem to imply) nor a national border, but a certain kind of capacity or fullness – a "threshold of capacity"[2] from which we may begin to glimpse the emergence of a post-colonial textuality. Such a boundary may provide a space for beginning to read the post-colonial.

My point of departure for reading such a space provides a rich body of texts from which to begin. Joseph Conrad is often credited with having opened a door for writers of the so-called "developing" world, with finding, whether deliberately or not, a fissure in colonial thought at a point where post-colonial texts have grown and flourished.

This fissure, through a certain metaphorical displacement, becomes some-thing more – both signifier *and* signified, signal of an incipient post-coloniality *and* referent whose exterior form is a *frontier*. Since the term frontier is over-determined – "frontier" is also "margin," "threshold" is also "limit" – we will use the term to designate what one novelist encountered or defined and what others exceeded. We may begin with this favorable introduction to Conrad as the novelist who stumbles upon the frontier of colonialism and shrinks back:

> Conrad's books, I say it without fear of contradiction, have no counter-parts in the entire range of English literature. . . . The manner, as opposed to the matter, is even more striking, more original. [Conrad's work] is

wholly unlike that of any writer who has hitherto used the English lan-
guage as his vehicle of expression, and may indeed be regarded, in some
sort, as embodying a discovery of yet another use to which our tongue can
be put.[3]

Sir Hugh Clifford's assessment is less relevant for its praise of Conrad than
for what it praises in his works: "the *manner*, as opposed to the matter," the
language rather than the thematics or ideology of the texts. He finds the
language innovative, even "exotic": "yet another use to which our tongue can be
put" (Clifford, 12). This early (and mostly specious) distinction between the
discursive forms and thematic content of Conrad's fiction, with its implicit
privileging of the former, anticipates even the harshest of his post-colonial
critics. Chinua Achebe, whose ideological aversion to Conrad is well known
("Conrad was a bloody racist"), grudgingly recognizes him as "one of the great
stylists of modern fiction and a good storyteller into the bargain."[4] Edward Said
is likewise compelled to admit that the language of Conrad's texts "was far
in advance of *what* he was saying."[5] Whether Conrad's discursive talents
functioned in the service of morally or ideologically questionable interests,
whether he was a knowing accomplice in what Said calls "the duplicity of
language" (Said, 171), or indeed whether he could have done otherwise, is not
of immediate consequence here.

When Wilson Harris says that *Heart of Darkness* is a "frontier" novel, he is
not so much creating a place for Conrad alongside post-colonial texts as
acknowledging a unique space from which his texts emerged. This space is not
a delimiting line, but rather a fissure or fracture of a line; it is the "threshold of
capacity to which Conrad pointed though he never attained that capacity him-
self,"[6] a capacity, in the most general terms, for language – or more specifically,
for a discourse with the capacity for representing *difference*. Unlike homo-
geneous cultural imperatives, radical critiques of colonial discourses – *post-
colonial* discourses – must be manifold, heterogeneous; that is, they must help
create the structures of which they speak. This is what Harris tells us in "The
Frontier on Which *Heart of Darkness* Stands," an essay in which he defends
Conrad's "strange genius" against Achebe's attack:

> As I weighed this charge in my own mind, I began to sense a certain
> incomprehension in Achebe's analysis of the pressures of form that
> engaged Conrad's imagination to transform biases grounded in homo-
> geneous premises. By form I mean the novel form as a medium of con-
> sciousness that has its deepest roots in an intuitive and much, much older
> self than the historical ego or the historical conditions of ego dignity that
> bind us to a particular decade or generation or century. (Harris, 161)

Harris goes on to amplify this statement: "The capacity of the intuitive self
to breach the historical ego is the life-giving and terrifying objectivity of
imaginative art" (162). The undoing of homogeneous premises here is the
undoing of a historical ego: "This interaction between sovereign ego and intui-
tive self is the tormenting reality of changing form, the ecstasy as well of

visionary capacity to *cleave the prison house of natural bias within a heterogeneous asymmetric context* in which the unknowable God – though ceaselessly beyond human patterns – infuses art with unfathomable eternity and grace" (162, emphasis added). Harris' psychoanalytic terminology – his interrogation of a "historical" or "sovereign" ego – apparently corresponds with the absence of a fixed and "knowable" God, or of any other stable center for this "heterogeneous asymmetric context" from which he reads *Heart of Darkness*.

By its appearance, such a context would posit the epistemological or onto-logical necessity of a center as a monolithic cultural imperative – that is to say, as a historical illusion belying the heterogeneity of the discourses it systematic-ally suppresses. Two immediate consequences of such a reinscription of sup-pressed discourses merit particular attention. First, the apparent opposition between "intuitive self" and "historical ego" signifies an attempt to establish a self (not necessarily a subject in the narrow sense) outside of a linear-historical temporality. The distinction between self and ego is one of the "heterogeneous asymmetric contexts" through which Harris seeks to disrupt Western colonial notions of center, origin, or any of the signifiers that bind colonized subjects. The form of the novel in general and *Heart of Darkness* in particular serve as both tool and index of that "transformation" as Harris calls it. Second, the act of invoking colonial discourses in terms of a historical ego is a preliminary gesture that calls forth a deconstruction of the colonizing subject as constituted by a history or governing principle. A body of law, for example, conditioned histor-ically by a homogeneous cultural logic, identifies itself as natural. But in *Heart of Darkness* Harris glimpses a preliminary dismantling of the colonial ego, an implicit questioning of the "monolithic absolutes or monolithic codes of behavior" (162) that govern imperialist discourses. This beginning opens a space where questioning may continue.

William Bonney's assertion that Conrad's fiction "probes the limitations of the English language" is relevant both for its articulation of the "frontier" to which Harris refers and for its own inability to cross over into a post-colonial discourse.[7] For Bonney, the phrase "heart of darkness" is instructive for its incompleteness: the image is "founded not upon anything that exists empiric-ally either for Marlow or the reader" but upon a metaphoric vehicle ("heart") and tenor ("darkness") which exceed both Marlow and Conrad (195). The observation, while largely accurate, does not account for what that "heart of darkness" might be or for Conrad's inability to articulate it. Like Conrad, Bonney probes the *frontier*, the limitations that inevitably surface in the language, without going beyond them.

Literally, "heart of darkness" is an absurdity – a metaphor without a referent, a contradiction only compounded by its position as the title of the novella. Conrad's text would *illuminate*, would change by shedding light upon, the "heart of darkness," so that we might "see" the unseeable, but to render dark-ness visible is a contradiction in terms: darkness can remain dark only if untouched by light. Darkness cannot be illuminated, and neither Conrad nor Marlow can illuminate it for us. So, *Heart of Darkness* works against itself to reveal an *absence* of clarity, the impossibility of providing the illumination it promises. Its act of revealing, then, lies paradoxically in the revelation of its

own self-concealment – a revelation of the *absence* of light, of a matter which cannot be produced in its presence: *Lichtung* (clearing, *clairière*) rather than *Aufklärung* (illumination, E/enlightenment).[8] That the phrase "heart of darkness" was nevertheless conceived as a metaphoric vehicle *for something* – something which neither the critical nor literary text ultimately illuminate – is instructive: it indicates not only Conrad's limitations but those of a particular kind of deconstructivist analysis. For it is not enough to say that *Heart of Darkness* is absurd or is about an absurdity. As Bonney more cautiously puts it, "only a process of indeterminate imaginative regression survives the suicidal figurative inflation of the original grammatical unit" (195). Readers of the text must remain, he says, "bereft of direction and any possibility of fulfillment" and "are thus rendered even more powerless to achieve a definitive orientation than are his most sensitive characters" (195). Yet even this description remains inadequate, not only because of the implied universality of the claim but because of the suspect standard by which it judges readers. By Bonney's standard Marlow is the "most sensitive character" in the novella; yet the self-presentation of his first-person narrative qualifies his reliability. We must account for his biases – his own situatedness – as a character within the events of the narrative if we are to determine what kind of a standard Marlow represents. Only then can we critique the discursive structure which would claim Marlow as center and standard of judgment.

Certainly the earnestness of Marlow's work ethic, as well as his strong sense of what we might call an English "order" or morality, are qualities that he constantly emphasizes throughout the text – he is, by his own account, "one soul in the world that [is] neither rudimentary nor tainted with self-seeking."[9] Also unquestioned by Marlow (at least before his tenure in the Congo) is his belief in the work of empire; even after all he experiences, he can still claim a belief in the "power of devotion, not to yourself, but to an obscure, back-breaking business" (*HD*, 65). Marlow's lengthy encounter with the ruthless, predatory realities of the imperialist project clearly do some damage to these sensibilities. But while he may recoil in horror from Kurtz's anarchic, avaricious thirst for power and the "unspeakable rites" over which he may have presided, Marlow nevertheless remains safely within the confines of his English rationality (*HD*, 65). But although Marlow clings tenaciously to his "Englishness" and his Eurocentric vision, he cannot help seeing through the "hollow sham" of imperialism, a pose embodied by Kurtz as the voice of the empire's "civilizing mission." It is this ambivalence in Marlow, this discrepance between what he sees and what he can allow himself to tell, which fuels the narrative tension in *Heart of Darkness*. More importantly, we can see Marlow's ambivalence as the realization of a certain *lack*; that is, as symptomatic of the irreducible inadequacy of his language when faced with a crisis of perception, a crisis shared, I think, by Conrad. Marlow, in his encounter with colonial Otherness, can intuit a threshold – a frontier – which he cannot bring himself to cross.

Marlow hints at the ambivalence of his own moral distinctions between good and evil from the narrative's opening pages; in his opening words, he is already attempting to undo the implications of the title. Marlow's observation that "[England] also . . . has been one of the dark places of the earth" (*HD*, 19)

clearly challenges the hierarchical oppositions around which imperialist "civil-
izing missions are invariably constructed": binaries such as "light/darkness,"
"civilization/savagery," "white man/black man," the implicit privileging of the
former terms over the latter, and the subsequent conflation of these and other
oppositions under the meta-opposition "Europe/Africa." By invoking Europe's
"dark" past, Marlow blurs the boundary between the opposing terms, thereby
implicitly calling into question the validity of the other oppositions – views
shared, no doubt, by his immediate audience on the ship: Europe as a place of
civilization, E/enlightenment, and so on.

Soon after this initial interrogation of terms, however, Marlow qualifies
himself; no sooner has he begun his comparison of ancient Roman and con-
temporary British empires than he constructs his own hierarchical opposition,
apparently in the latter's defense: "Mind, none of us would feel exactly like this.
What saves us is efficiency – the devotion to efficiency. But these were not
much account, really. *They were no colonists*; their administration was merely
a squeeze, and nothing more, I suspect. *They were conquerors*, and for that you
want only brute force – nothing to boast of" (*HD*, 21, emphasis added). But
this opposition of "colonists/conquerors," with its implicit privileging of a
European "civilizing mission" over the mere plundering of invaders, is one that
Marlow already knows to be inadequate; hence his immediate undermining of
his own just-constructed terms: "The conquest of the earth, which mostly
means the taking it away from those who have a different complexion or
slightly flatter noses than ourselves, is not a pretty thing when you look into it
too much. What redeems it is *the idea only*. An idea at the back of it; not a
sentimental pretense but an idea; and an unselfish belief in the idea – some-
thing you can set up, and bow down before, and offer a sacrifice to. . . ." (*HD*,
21, emphasis added). Here Marlow effectively gives the lie to his own construc-
tion, to his own complicity in the lie of empire. By erasing the opposition
between colonist and conqueror, Marlow reveals the only difference between
the terms to be that of "an idea"; the sacking of another culture is "redeemed,"
in other words, only by the idea of the "civilizing mission," of spreading
E/enlightenment to the "dark places of the earth." Thus the deconstructive
double-bind as he uses the same hierarchical logic that he has just called into
question: Marlow accepts the discourses of empire into his narrative *in the very
act of denouncing them*, revealing a state of ambivalence that permeates the
narrative.

Marlow's suspicions about the imperialist project – and his own complicity
with it – intensify with his increasing proximity to the "dark" continent.
Additionally, Marlow's ambivalence about the "noble cause," and his own role
as an agent of it, become full-blown upon his first close encounter with the
indigenous other: "A slight clinking behind me made me turn my head. Six
black men advanced in a file, toiling up the path. They walked erect and slow,
balancing small baskets of earth on their heads, and the clink kept time with
their footsteps . . . but these men could by no stretch of the imagination be
called *enemies*. They were called *criminals*, and the outraged law, like the burst-
ing shells, had come to them, an insoluble mystery from the sea" (*HD*, 30,
emphasis added).

For Marlow, the discrepancy between signifier and signified is irreconcilable. The terms "enemies" and "criminals" are clearly inadequate to describe what is happening, what is being done to the black men in the name of the "noble cause"; yet he cannot bring himself to comment on the scene other than elliptically, and not because he lacks the appropriate words. Terms such as "slavery" and "oppression," although certainly known to Marlow, represent concepts that cannot enter the discussion of empire without exposing its nature – a truth which, if the imperialist project is to succeed, must be suppressed. Having thus encountered this frontier of language and empire, Marlow's ambivalence hints at his complicity. And then he sees this:

> Behind this raw matter one of the reclaimed, the product of the new forces at work, strolled despondently, carrying a rifle by its middle. He had a uniform jacket with one button off, and seeing a white man on the path, hoisted his weapon to his shoulder with alacrity. This was simple prudence, white men being so much alike from a distance that he could not tell who I might be. He was speedily reassured, and with a large, white, rascally grin, and a glance at his charge, seemed to take me into partnership in his exalted trust. After all, *I also was a part of the great cause of these high and just proceedings.* (HD, 30, emphasis added)

As regards his uncritical or naive view of empire, this moment is for Marlow the beginning of the end. This moment of self-reckoning, in which he is caught in the knowing gaze of the "reclaimed" guard, confirms his fears: not only is the business of empire, this "conquest of the earth," as monstrous as he had suspected, but his own synonymity with it is unmistakable. Whether or not he believes himself so, the guard clearly sees him as "a part of the great cause." Marlow's insight here, his recognition of the law as a legitimating discourse for exploitation and violence, is all the more terrifying for his own complicity with it; he has, after all, been identified as an agent of the "outraged law" come from the sea, a force only thinly veiled by its authenticating discourse of "high and just proceedings" – and a discourse more or less inaccessible to those subjected to the force of the "bursting shells," those for whom the law is little more than a wielding of power. Seen in this context, the bitter sarcasm of Marlow's final words above is palpable; it is the self-mockery of one who has seen not only the monstrousness of the hollow sham of empire but his own unwitting role as accomplice. It is this moment of self-discovery, this realization of his own coincidence with the "flabby, pretending, weak-eyed devil of a rapacious and pitiless folly" (HD, 30) – the necessity of articulating his intuition of the imperialist horror combined with the impossibility of exposing it outright – that fuels Marlow's growing sense of ambivalence. Small wonder, then, that his immediate response is one of paralysis: "For a moment I stood appalled, as by a warning" (HD, 31). To acknowledge the horror explicitly would be, for Marlow, to completely undermine not only his sense of moral propriety but the entire system of discourses upon which those beliefs are based. Despite Marlow's self-professed hatred of lies which, he says, then "appall" him, the "merry dance of death and trade" continues unabated, as does Marlow's

ambivalence – a psychic paralysis which is paradoxically also an oscillation, the ceaseless tracing of a movement between poles of a seemingly insoluble contradiction (HD, 41, 28). It is the space or index of this oscillation, of this failed gesture of illumination which reveals only its own complicity of concealment. This space (so troublesome to Conrad) opens the possibility of thinking the post-colonial. What is for Marlow/Conrad a limit becomes, for others, a *threshold*.

There is much in Wilson Harris' prefaces to his novels that may prove useful as we begin to read the post-colonial frontier, that "threshold of capacity" to which *Heart of Darkness* points yet does not itself attain. We can begin to understand what Harris values about Conrad's "strange genius" (Harris, 161) by reading Harris' prefaces and criticism. The prefatory note to *Palace of the Peacock*, his first novel, describes what he calls a "mixed metaphysic" which stands in sharp opposition to the monolithic prerogative of Marlow's outlook.[10] In fact, the dismantling of oppositional logics which is so problematic in *Heart of Darkness* is for Harris a condition to be desired, as he seeks to construct a fiction "that seeks to consume its biases through many resurrections of paradoxical imagination" (PP, 9). For Harris, then, to seek paradox is to invoke contradiction without surrendering to the reconciling impulse or attempting to account for it in terms of oppositions and hierarchies. In other words, paradox opens a space within the monolithic categories and taxonomies of Western thought and reinscribes the alterity suppressed within such systems. In short, it finds a place from which to begin to address the Other.

Implicit in this critique of colonial discourses as homogeneous constructs and imperatives is the reinscription of heterogeneity, of the radical alterity of the Other. Given the ease with which we could construct an entire history of Western domination as constituted through the comprehension and incorporation of its others, we might also produce another more recent (one might call it an "alternative" or "subaltern") history as constituted by a series of attempts to reinscribe a space or clearing for the other *as other*, to be written outside the oppositional logics of "mastery/slavery," "colonizer/colonized," etc. and thus implicitly beyond metaphysics in general. Thus Harris' positing not only of "multiple existences" but of an "unknowable God" who is only revealed outside the realm of "symmetrical contexts." For Harris, the threshold in question is one of *freedom*; not only freedom from an imperialist oppression, one that would perhaps simply substitute one dominant ideology with another, but a "freedom *to*," in this case, a freedom to construct forms of being and knowledge that celebrate otherness without absorption into the same.

We may read the disruption of the discourses of empire in this fundamental shift from the problematic paradoxes of Conrad's fiction to the *meaningful* paradoxes of Harris' fiction. The differences in narration between two otherwise similar series of events will provide a guide. Soon after Marlow's first encounter with the African "other" comes his well-known description of native workers dying in a grove: "They were dying slowly – it was very clear. They were not enemies, they were not criminals, they were nothing earthly now – nothing but black shadows of disease and starvation, lying confusedly in the greenish gloom. . . . These moribund shapes were as free as the air – and nearly as thin" (HD, 31). Clearly this is, for Marlow, a horrible sight. But more relevant for our

purposes is the way in which the dying figures are described: they are "nothing earthly," but rather mere "black shadows" of life that are as free and thin as air. Life is, in this context, represented as being *earthly*, as having a certain vigor of substance which the "moribund shapes" in the grove clearly lack. The binary logic at work here, represented by the oppositions "substance/shadow," "vigor/ listlessness," "active/passive," etc., again implicitly privileges the former terms over the latter, culminating in the conflation of oppositions under the overarch- ing binary "life/death." Under this model what horrifies Marlow is not only the physical condition of the workers but also their deviation from a state he, as European, associates with life.

Like *Heart of Darkness*, Harris' novel portrays a journey into the unknown territories of a jungle, this time the Guyanese rainforest, for the purpose of business and trade. The journey is undertaken by an ethnically and racially mixed crew. In this context, Harris portrays various transubstantiations and transmutations of life-forms considered by Western conventions to be "nothing earthly" which move beyond the logic of empire, crossing the Conradian fron- tier in search of a suitably "mixed metaphysic." In *Palace of the Peacock* Harris describes events not far removed from Marlow's experience in the grove:

> In this remarkable filtered light it was not men of vain flesh and blood I saw toiling laboriously and meaninglessly, but *active ghosts* whose labour was indeed a flitting shadow over their shoulders as living men would don raiment and cast it off in turn to fulfill the simplest necessity of being.
> (33, emphasis added)

And later:

> [Vigilance] rubbed his eyes since he felt he saw what no human mind should see, a spidery skeleton crawling to the sky. . . . Vigilance could not make up his bemused mind whether it was Wishrop climbing there or another version of Jennings' engine in the stream. He shrank from the image of his hallucination *that was more radical and disruptive of all material conviction than anything he had ever dreamt to see.* (82, emphasis added)

These two passages illustrate a difference, not only between Harris' descrip- tion and Conrad's but also between moments in Harris' own text. The imagery of the first passage bears a more than passing similarity to that in *Heart of Darkness*, with one strategic difference: unlike Conrad's listless shadows, Harris' ghosts are "active." Harris' figures, however unearthly, retain the ability to "cast off" the burdens of labor, apparently at will; they are not (or are not yet) casualties of work. That agency effectively undermines the oppositional logic prevalent in *Heart of Darkness*.

The second passage represents a more radical departure, while maintaining a certain relation to Marlow's appalled narration. Arguably, what Vigilance sees – perhaps an hallucination of his dead co-worker's skeleton "crawling to the sky" – is more shocking even than Marlow's vision of shadowy death in the grove. Let us note here also that even the name of Harris' character – Vigilance

– signifies a different attitude toward events than Marlow's, namely watchful-ness, a *willingness* to see. That watchfulness stands in opposition to Marlow's own reluctant observation – and his halting narration – of events. Moreover, the "vigilance" marks a difference from Conrad's audience upon whom, it is assumed, vision must be forced: Marlow's need "to make you see." Given the opportunity, Marlow would likely contend that he too experienced something that "no human mind should see"; and indeed, the horror in *Heart of Darkness* largely fuels the ambivalence of Marlow and of his narrative. Once again, however, there is a strategic difference: whereas in Conrad's text the lack of "earthly" substance is a sign of weakness, exhaustion, and defeat, Wishrop's metamorphosis into a "spidery skeleton" is a "transubstantiation" (*PP*, 83). If his change is not a triumph, then certainly it is an escape or liberation from the physical trials of the journey into another realm of possibility. This blurring of boundaries between the dead and the living is not limited to Wishrop, however. By this point in the text, not only has the first-person narrator inexplicably disappeared, but other characters are undergoing profound trans-formations as well: Vigilance's "immateriality and mysterious substantiality" (*PP*, 82), Donne's suspicion that he is no longer "in the land of the living" (*PP*, 83), and the crew boat's transformation into a "skeleton craft" (*PP*, 83) are all representations of a reality alien to Marlow and to a frontier of a world whose multiple existences are beyond the bounds of Marlow's English rationality. Although Marlow encounters the frontier of Otherness and steps back, Harris' novel crosses the frontier and becomes a signpost of possibility for the multiple or quantum realities of the post-colonial.

Harris' account of his first expedition into the interior of Guyana clarifies this opening into the post-colonial: "I had penetrated 150 miles. It seemed as if one had traveled thousands and thousands of miles, and in fact had traveled to another world, as it were, because one was suddenly aware of the fantastic density of place. One was aware of one's incapacity to describe it, *as though the tools of language one possessed were inadequate*" ("The Frontier," 58, emphasis added). The resemblance to the crisis of language in *Heart of Darkness* is strik-ing: like Marlow, Harris lacks "the tools of language" to adequately contain the reality of his experience. Yet in this and other encounters with the Guyanese interior, he is eventually able to construct fictional narratives that can begin to represent the "fantastic density" – for Marlow is clearly the daunting difference – of this other reality. Paradoxically, to the extent to which Harris' fiction diverges from the conventions of realism it succeeds in representing Guyana's reality of place: "All this seemed less to do with the medium of place and more to do with the immediate tool of the word as representing or signifying 'place'" ("The Frontier," 58). The impossibility of homogenization or suppression of the Other, then, sometimes threatens and sometimes liberates, depending on the context and who is suppressing or liberating whom.

The two possibilities exist more or less simultaneously in *Heart of Darkness*. There are at least two ways to articulate this "threshold of capacity": empiric-ally, as a field too large for representation, or post-structurally, as play where totalization is meaningless because of the infinite substitutability of the finite field. In Derridean terms, totalization is useless not because the area is too large,

but because it is *missing* something: a center or transcendental signified that would arrest and limit the play of substitutions/differences. This burgeoning realization in *Heart of Darkness* of a decentering of the discourses of empire, and the subsequent oscillation between desire and fear, interrogation and withdrawal, places the text on the post-colonial frontier of Harris' title.

Harris' narrative of his Guyanese expedition goes on to discuss his interest in critiquing what he calls the "static cultural imperative" of Western thought ("The Frontier," 65). This project entails, he tells us, the constant questioning of established (or imposed) modes of thought, structures which deny the polyglot nature of post-colonial reality. Harris refers to texts which seem to contain the roots of such a cultural critique:

> One would have to turn to Melville to sense the beginnings of this kind of thing in the novel, to a poet like Coleridge, *or a novelist like Conrad*. It is something that is impertinent to the homogeneous novel, though immensely consistent with the subjective crisis of twentieth-century man [*sic*]. ("The Frontier," 61, emphasis added)

If we may not read this as an *essential* origin of the post-colonial, we may sense here a threshold of a breach.

One more set of locations to illustrate Conrad's "threshold of capacity." This time the land itself. Upon confronting the African wilderness himself, Marlow finds it less passive than he may have originally believed:

> Going up that river was like traveling back to the earliest beginnings of the world, when vegetation rioted on the earth and the big trees were kings. An empty stream, a great silence, and impenetrable forest . . . And this stillness of life did not in the least resemble a peace. *It was the stillness of an implacable forebrooding* over an inscrutable intention.
> (*HD*, 48–9, emphasis added)

Marlow goes on to describe the jungle's "vengeful aspect" (*HD*, 49), a dimension of silent rage that is coherent and palpable, for him, then, the jungle does have a sense of purpose – and it is decidedly malevolent. That Marlow experiences the force of an African nature in this way, moreover, aptly illustrates both his realization of a representative otherness and his perceived oppositional relation to it. Although Marlow has, by this point, realized a margin/frontier of Otherness, he remains wedded to one side of an oppositional "rational" mentality, and thus cannot but shrink back in fear and foreboding. Finally, we come to Harris' Guyanese rainforest, where the vital multiplicity of Marlow's fears begins to manifest:

> The solid wall of trees was filled with ancient blocks of shadow and with gleaming hinges of light. Wind rustled the leafy curtains through which masks of living beard dangled as low as the water and the sun. My living eye was stunned by inversions of the brilliancy and the gloom of the forest in a deception and hollow and socket. . . . A sigh swept out of the gloom

of the trees, unlike any human sound as a mask is unlike flesh and blood. The unearthly, half-gentle, half-shuddering whisper ran along the tips of graven leaves. Nothing appeared to stir. And then the whole forest quivered and sighed and shook with violent instantaneous relief in a throaty clamour of waters as we approached the river again. (PP, 28)

Clearly a profound metamorphosis, both mimetic and teleological, that takes place between Marlow's narration and this one. Unlike Marlow's vision of a monolithic brooding, Harris' depiction reveals a multiplicity of life that contains the previous descriptions as it transcends them; for while this forest is certainly at least as perilous as the one portrayed in Conrad's text, it represents with equal clarity the possibilities for new and heterogeneous community – one that surpasses binary perceptions of the world in order to embrace all manner of paradoxical realities. Indeed, the characters' reactions of "surprise and terror" (PP, 29) are fleeting ones, and by the text's end they embrace "the inseparable moment within [them]selves of all fulfillment and understanding" (PP, 116) that comes with the overcoming of fear and the crossing of frontiers.

To call this an ending, however, would be misleading; for the rupturing of margins/frontiers is always an open-ended business, and we must, after all, continue to resist the monolithic imperatives of completeness and closure. What now remains to be addressed, however cursorily, is the future of the rupture, of this post-deconstructive moment of fissure. His fiction marks a place from which we may begin to glimpse the rupture of the ontological frontier. If this is so, then questions of homogeneity and those elements which might be "impertinent" to it assume a radical significance: why, for instance, is a critique of this type of fiction equated with crisis? An answer to such questions may lie in the very terms "impertinence" and "heterogeneity." The success of any act of "impertinence" lies in its interrogation of homogeneous texts, in its ability to call into question texts that attempt to conflate their others under the same; it is a question, in other words, of *exhuming* difference, finding a fissure in the construction of sameness through which its previously interred others may emerge. If we cannot see where this fissure may lead, what future lies before the post-colonial, we at least have found a space where Harris' term "meaningful paradox" may be reconciled in its contradictorily coherent parts.

PART SIX

EXTREME BEAUTY –
DEATH, GLORY

INTRODUCTION

Perniola ended the title essay with an enigma: the aesthetics of "extreme beauty," an ineffable beauty open to the boundless, once the domain of the sublime. Rather than reintroducing identity by essentializing the distasteful, repugnant, and abject, he restores wonder before an unthematizable difference, refulgent, glorious. This section culminates not in closure, finality, or a move beyond; it confronts us with the extreme frontier of difference. The topic opens with the radical alterity of Heidegger's being-toward-death, then follows with the enigma of the unrepresentable other in Derrida's "gift" and Levinas' "glory."

In "The Simulacrum of Death: Perniola Beyond Heidegger and Metaphysics?" Robert Burch examines *La società dei simulacri* (1980) in which Perniola reads Heidegger and Baudrillard on death. According to Burch, Perniola passes in review two traditional metaphysical views: death as access to transcendence and death as an empirical fact, both of which hold death at a distance from life. According to Perniola, this "metaphysics of death" still resounds in Heidegger's being-toward-death and constitutes an ontic account with traces of Lutheranism, especially in the "call to conscience" that interrupts the everyday oblivion of death. That is, he claims that the call of conscience makes death an awaiting of possibility, the "not-yet" of something coming down the stream of present moments. Burch defends Heidegger by claiming that Perniola conflates an ontic account of the *Faktum* of death as existential limit with death as a structural or ontological limit of finite existence. The thematic question of moment is: Does Perniola's infinite play of simulacra, where there is nothing but simulacra, erase difference?

What Perniola calls "Jesuit/baroque indifference," the "little deaths" to self and to the world, is a kind of *via negativa* that does not evacuate the world but brings it closer. If such dying evokes the "null foundation of existence" (Perniola), does it not point to the ontology of a being claimed already by its possibility of not-being? But, Burch wants to ask, is that not what being-toward-death already says? We may be left to wonder whether the metaphysics of death threatens again from both sides, from repetition and from difference: Does the "nothing but difference" of simulacra, simulations without "other," convert the play of difference into a new identity and reinstitute the all-knowing subject? Or does the critique of the infinite substitutions of simulacra itself suffer from a nostalgia for foundational values?

In "A Deadly Gift: To Derrida, from Kierkegaard and Bataille," Kenneth Itzkowitz asks: Is death a gift? And must a gift be a *good* thing? To answer, he

follows Derrida in tracing the Western ethical sense of responsibility in *The Gift of Death*. Derrida interrogates Kierkegaard's famous example of Abraham to show that the ethics of responsibility, the ethics of duty and obligation, is really irresponsible. Ethics is irresponsible because it takes a part for the whole and neglects the singular. By contrast, *absolute* responsibility responds to what, being singular, is incommunicable and silent. Not an ethics of obligation, but a primordial, an-archic ethics which originates in the unsayable summons of absolute exteriority. Itzkowitz then compares Derrida's absolute responsibility with Bataille's "hypermorality" in *Literature and Evil*. Bataille abandons the ethics of the good in favor of an ethics of the sun that, like Levinas' glory, burns with "excess and expenditure." In examples of loss and self-mutilation such as Van Gogh's ear, the gift, as sacrifice of the good, is gift without return, the impossible sacrifice of absolute loss.

Bettina Bergo's essay, "Glory in Levinas and Derrida" marks a climax to the whole series. It renews the theme of the "it feels" in Part One, the site of aesthetics in Parts Two and Three, and, most importantly, the question Perniola raises at the end of "Feeling the Difference." Bergo traces an *aesthetics* of difference and marks a relationship between Levinas' "glory" in *Otherwise than Being* and Derrida's absolute responsibility in *The Gift of Death*. When Levinas translates "glory" from theological sources into a secular discussion of ethics as first philosophy, one may wonder why. The advent of the deontological difference is describable in the secular terms of Heidegger's "ontological difference," Blanchot's "*entretien*," Lacan's Other, Kristeva's "semiotic chora," Irigaray's "hystera," Bataille's absolute waste, etc. – so why revert to glory? Because glory marks a limit between the "secular deployment of Levinas' philosophy and its religious intuitions." It is the "essence" of infinity, the sublime carried over into an ineffable, extreme beauty that shows how the theological/ ethical and the aesthetic coincide. Glory for Levinas then is a space or "force" of excess, that "burns" subjectivity to the *point* – figure without dimension – of "ashes." Glory as "essence of Infinity," of the meanings that "impel, but dissolve in our words," moving between the present time of appearing and the trace of withdrawal. Levinas situates glory within the complex structure of "substitution," which desituates the identity of the subject and, in displacing it, substitutes a radical confrontation with an unassimilable other. Hence, in the paradoxical dual move of substitution there arises a fissured self in proximity with the infinite, indefinite excess that needs the thought of the finite to think it.

Derrida responds to Levinas' glory in terms of absolute responsibility and absolute passion. He asks: What about our human condition makes religion possible as responsibility and not merely as orgiasm? How does this passional-excess, the affective drives of sensuous life, become responsibility? Is there a responsibility, a glory, out of which consciousness and the great Western religions arise to sublimate mortality? Bergo, circumventing the response of the skeptic, enjoins caution: skepticism *responds* to a decentered glory with mistrust, nostalgic for the felt certainties of the order of knowledge. In contrast, the "resplendent beauty and magnificence" of glory traced in the drives of

sensuous life by both Levinas and Derrida burns to ashes our fragile, mortal subjectivity before the dazzling splendor of an extreme beauty, enigmatic and indeterminable.

14

THE SIMULACRUM OF DEATH

PERNIOLA BEYOND HEIDEGGER AND METAPHYSICS?

Robert Burch

Ce sont les médecins avec leurs ordonnances, les philosophes
avec leurs préceptes, les prêtres avec leurs exhortations, qui
l'avilissent de coeur et lui font désapprendre à mourir.

Rousseau, *Émile*, Bk. I

In the second chapter of his *La società dei simulacri*, Mario Perniola reads Heidegger and Baudrillard on death. What unites these two figures, for Perniola, is their seeming opposition to what he terms the "theological" and "humanistic" ideas of death, both of which he regards as variants of a basic metaphysical outlook.[1] According to the first idea, death is conceived as worldly appearance in relation to the presumed, permanent reality of our *anima immortalis*. As such, it has its true significance only as the point of "access to another life" when our souls "shuffle off this mortal coil" and take up their true other-worldly abode in eternity. As for life itself, it has "nothing to do with death," since in this theological view death is "abolished" (*abolito*) by appeal to "the eternity of spirit" (*Società*, 79–80). Thus, for the elect at least, death has no sting, and the grave, no victory.

According to the second idea, death is an objective anthropological fact that follows from our biological nature. As with all living things, human beings inevitably "perish" (*verenden*), even if, as Heidegger says, in being able to envision this future before it is imminent, we "do not simply perish" but, as it were, come to a "demise" (*Ableben*).[2] In this view, death is acknowledged as a reality, and not merely "appearance." Yet whether or not one has witnessed the death of someone else, one's own death is a reality that for each of us is always yet to come, an end *to* one's life but not an end *in* one's life. In that sense, it is perhaps true to say that only other people die. Moreover, death is a reality that the humanistic view also "pretends to abolish," appealing to the "indefinite development of the scientific process" as holding out the promise that eventually we shall conquer our mortality by scientific-technological means (*Società*, 80).

Which of these two ideas offers a more salutary prospect depends on one's cast of mind. According to Perniola, however, in neither case is death thought to structure our lives. In this regard, he refers to Baudrillard: "There is no difference between atheistic materialism and Christian idealism. For although they differ on the question of survival (but whether there is something or not after death is without importance: that is not the question), they agree on the fundamental principle: life is life, death is always death – that is to say, they agree in the wish carefully to hold at a distance the one from the other."[3] Whether human being is conceived according to the theological variant as the *imago Dei*, or according to the humanistic variant as a specific biological entity, both views proceed from the metaphysical assumption that a determinate human nature is always already given. On this assumption, death is a fact, but a fact externally related to our lives. In the one instance, death marks an inescapable change of condition, yet one extrinsic to our true timeless nature. In the other, it denotes what is the inevitable end for every human organism, given the present state of science, yet an end that for each of us is always a future possibility, and one that may be forestalled indefinitely, given science's current trajectory.

According to Perniola, the fatal flaw in this "metaphysics of death" lies in a twofold objectification. It interprets human being as a material or substantial reality "present-at-hand" (*semplice-presenza*) and so misrepresents our way of being in the world. Likewise, it interprets death as a *factum brutum*, and so leaves it "extrinsically connected to human life" (*Società*, 79). Death can still be feared, wished-for, ignored, or suffered, but it cannot not truly be recognized as ontologically a part of our life. The metaphysical objectification thus allows for a recognition of the fact of death, but in such a way as to rob this fact of a truly immanent, "this-worldly" significance.[4]

That Perniola should begin this study by presuming to set aside metaphysics has an obvious rationale. For if society is to be understood as made up altogether of simulacra, then there can be no place in it for any non-substitutable, metaphysical essences or natures as the touchstone of the real. In such a society, "the simulacrum is true," not as a false or semblant representation of the real, but as the very stuff of reality as always already representation. As Baudrillard puts it, "the very definition of the real becomes: that which it is possible to give an equivalent reproduction, . . . that which is always already reproduced."[5] This definition rules out in principle the traditional metaphysical project, whereby the philosopher attempts in thought to make the absent, occluded "true in itself" fully present by means of the "literal" metaphysical word. Instead, the whole system of the real is "a gigantic simulacrum – not unreal but a simulacrum, never again exchanging for what is real, but exchanging in itself, in an uninterrupted circuit without reference or circumference" (Baudrillard, *Simulations*, 10–11). In the society of simulacra there are not essences to be discovered and embraced, but only infinite substitutions in an on-going simulacral exchange.

In Perniola's exposition of the society of simulacra, it also makes sense that he should place a discussion of death near the beginning. For on the face of it, death, of all things, would seem to be a recalcitrant, brute fact for which no

substitution or simulacral exchange could really suffice. In certain circumstances, one can of course have an other die for one (as Sydney Carton dies for Charles Darnay). Or one can "by feigned deaths to die" withdraw oneself as far as possible from worldly attachments, feigned or not. But the substitution of the martyr is only temporary, and feigned deaths are in the end no more than that. It would seem that death cannot be cheated, however one might ultimately come to reckon the business.

To situate Perniola's account better, there are at least three aspects of that metaphysics which he tends to neglect or elide that should be noted. First, in its modern form, the metaphysics of death has its "logical" matrix in the principle of sufficient reason, which obliges metaphysics to provide, in principle and in particular, a "sufficient reason" for death as such and for the deaths that appear to occur.[6] Moreover, only a reason in the realm of "final causes" would count as "sufficient," what metaphysics has to say about death in principle and anyone's death in particular being what it takes to be *necessarily* so according to reason. In contrast, the thesis that the "simulacrum is true" does not provide its own extra-metaphysical "reasons" for death, but simply abandons this matrix of questioning in favor of the happenstance of simulacral exchange.

Second, the metaphysics of death also has an "existential" matrix in the personal experience of finitude. In Sartre's *La nausée*, Roquentin muses: "Here we sit, all of us, eating and drinking to preserve our precious existence and really there is nothing, nothing, absolutely no reason for existing."[7] As Roquentin himself acknowledges, this is not to say that "life is without goal." But it does express an existential sense of the utter contingency and groundlessness of all that "is," including especially one's own particular existence. One comes to be in a certain place and time beyond one's choosing, finding oneself bound by a myriad of seeming contingencies, accidents, and fortuities. This fate appears to be utterly without "reason" in the realm of final causes. In the face of this experience, metaphysics must provide a "reason," and in a way that assuages this existential sense of *délaissement* which makes the question of death both personal and exigent. Of course, whether metaphysics can succeed or not remains open to question.[8] At the very least a condition of success would be a fundamental transformation of one's contingent point of view (as in Plato's *periagogē* or Hegel's *Umkehrung des Bewußtseins*) in order ultimately that death can be seen *sub specie aeternitatis*. Yet, with the thesis that "the simulacrum is true," no such reasons can be supplied, since reality, as the ongoing play of simulacra, is itself without "reason." Ironically, this retains the form of the metaphysical response to death, insofar as it proposes a new *theory* that presumes to transcend how the world ordinarily appears to us.

Third, if one characterizes metaphysics essentially in terms of the principle of sufficient reason, then in its response to the issue of death, the humanistic variant that Perniola cites would be metaphysical only in virtue of an "inversion" (albeit of the sort that Heidegger finds implicit in the essential origin of metaphysics).[9] By means of this inversion, the metaphysical quest for the *ultima ratio* gets resolved and fulfilled in the *human* deployment of all reality by scientific, technological means. In the event, however, the ultimate "logical

why" of metaphysical questioning is not answered.[10] Indeed, it is no longer even posed, as the metaphysical quest, for a final cause beyond the world is replaced by the calculation of efficient causes within the world. Thus the locus of metaphysical questioning in the traditional sense is abandoned. As Heidegger puts it pejoratively, in the extreme form of humanism, "*Mit dem Sein ist es nichts.*"[11] Analogously, the thesis that the "simulacrum is true" also serves to "dissolve the very concept of being" (*Società*, 65). Admittedly, it does not do so in the exact manner of humanism, that is, in the name of *material* empowerment. Rather, it dissolves the concept of being by invoking a new, liberating post-ontological *vision* of things. But in just this respect, the thesis seems more akin to traditional metaphysics than is the humanism Perniola would ask us to put aside.

"One can rescue (*sottrare*) death from metaphysics," Perniola remarks, "only by liberating (*sottrae*) humanity from metaphysics" (*Società*, 80). In espousing this view, Perniola welcomes Heidegger's move "beyond the metaphysical concepts of the 'true world' and the 'apparent world,' by means of the phenomenological method" (*Società*, 61). But in advancing the thesis that "the simulacrum is true," he cannot stay with the Heideggerian position. The structure of the "phenomenon," for Heidegger, is one of "appearing" or "self-showing" in which there is at once revealing and concealing. Such a structure maintains, as it were, a "hither" side of appearance that is to be brought to presence by thinking. Yet this would oblige thinking – even in a post-metaphysical form – to exchange the simulacrum for "truth" as the disclosure of being. To the extent that Heidegger insists upon this revealing/concealing function, Perniola charges him with retaining "in fact the old metaphysical concept whereby appearance (*apparenza*) conceals being" (*Società*, 62). On the same grounds, Perniola has also to refuse the "realist" gesture implicit in Heidegger's conception of the ontological difference, that is, his claim that "beings (*Seiende*) *are* quite independently of the experience, knowledge or conceiving by which they are disclosed, discovered or determined" (*SZ*, 183, § 39). Perniola himself does advance the notion of simulacrum as "appearance" (*apparenza*). Yet he understands "appearance" *not* as that in which something is at once revealed and concealed but "as pure presence" (*parvenza*), which in its infinite reproduction and repetition, "encompasses being entirely (*ricoprire interamente l'essere*)" (*Società*, 65).

In general, then, the thesis that the simulacrum is true is beyond metaphysics in a dual respect. First, it stands outside the rule of the principle of sufficient reason. Instead of tracing eidetic relations of the "real itself" according to a necessary phenomenological or metaphysical "logic," a philosophy of simulacra can only follow the happenstance of simulacral exchange as a process that can, and always will be, otherwise and ever new. Second, it stands beyond the metaphysics of pure presence, the simulacrum always being more or less present and absent, since infinitely substitutable. The notion of the "simulacrum" thus serves in effect to "eliminate the very possibility of an originality of being" (*Società*, 66).

Having thus "liberated" us from metaphysics, Perniola goes on to "rescue" us from the metaphysical "diversion and removal of death." Again he invokes the authority of Heidegger: "One of the fundamental contributions of *Sein und Zeit*

consists in having put aside (*messo da parte*) the metaphysical concept of death" (*Società*, 79). This Heideggerian move is irrevocable, and Perniola has no intention of resurrecting the metaphysical concept of death in a new form. Yet to invoke Heidegger here is ironic, since Perniola has already "put aside" Heidegger's phenomenology as too metaphysical. In this regard, he does concede that Heidegger successfully exorcizes the metaphysical idea of human being as a "thing" or "substance" present-at-hand. Yet, against Heidegger's own claims, Perniola regards the Heideggerian conception of being toward death as inextricably implicated in the metaphysical "removal" of death. This claim requires a more elaborate explanation and defense.

Notwithstanding the seeming affinity between Heidegger and Baudrillard in rejecting the metaphysics of death, when it comes to considering death "non-metaphysically," Perniola sees their views as "diametrically opposed" (83). He locates the concealed source of this opposition, however, in yet another apparent affinity. Not only do Heidegger and Baudrillard seem "to have in common that they reject the metaphysical consideration of death"; they also reject "the everyday attitude of tranquilization, diversion and dismissal that is at the root of metaphysics" (82). The real source of their difference, so Perniola argues, lies in the different ways in which Heidegger and Baudrillard connect the metaphysical "abolition" of death to a "rejection" (*rigetto*) of death that lies "at the base of Western everydayness" (81).

By now, Heidegger's analysis of death in *Sein und Zeit* is so familiar as to have become "textbook" doctrine. For that very reason, however, we might do well here to remind ourselves of its precise terms. According to Heidegger, the *Daseinsanalytik* provides a description and interpretation of the essential structures of that finite being (*Dasein*) whose "essence lies in *Existenz*" (*SZ*, 42 §9). These structures are "facts" of our being, not as objective givens, but limits that enter into and structure our *Existenz*.[12] What Heidegger means by "*Existenz*" is not sheer presence-at-hand. Yet neither is it (as the existentialists claim) "the series of our undertakings."[13] Rather, "*Existenz*" means for Heidegger one's projection of fundamental *interpretative* possibilities, in which lies one's essential self-constitution. This "projection" accounts for the existence of a "world" as an englobing context of meaning, the "world" being both the basis upon which we always already understand beings and the ultimate situating context within which we act. What, then, is at issue with *Existenz* is the ontological self-understanding, and hence the being, of the sort of finite being for whom, essentially, "to be" is "to understand."

Heidegger's phenomenological analysis reveals our everyday mode of being and self-understanding to predominantly "fallen" (*verfallen*). That is to say, our being/understanding is constituted through our "insistent" absorption with the world of things at hand at the expense of an authentic self-understanding in terms of the very structures of our *Existenz*. The same holds true for death. "As fallen, everyday being toward death is a constant *flight before it*" (*SZ*, 254 §51). The modes of this flight parallel the basic structures of "fallenness" itself.[14] But these are not merely negative modes of *Existenz*. Some measure of "fallenness" is necessary for us to be able to get on with things in a mundane way.

"With death, *Dasein* stands before itself in its ownmost possibility of Being" (*SZ*, 250 §50), the ultimate situating limit that structures finite *Existenz* as such. As this limit, however, death is only recognized as such in privileged moments of disclosure, that is, in radical moments of *Angst* in the face of one's very being-in-the-world. These moments are radical, since in them we recognize not just this or that thing about ourselves or the world (not even the inevitable fact of one's physical death) but our ultimate finitude. This recognition constitutes *authentic* being-toward-death to the extent that in such moments it is the "anticipation" of death as our ownmost possibility that constitutes the explicit existential self-understanding that one *is*. Thus Heidegger couples authentic being-toward-death with the call of conscience which "has the character of summoning *Dasein* to its ownmost possibility-of-being-its-self," that is, to death as the ultimate existential/ontological limit (*SZ*, 269 §54). On the one hand, "in conscience, *Dasein* calls itself," comes to understand itself *as understanding* in terms of the situating limit that gives its being as finite *Existenz* (*SZ*, 275 §57). On the other hand, in being thus called to oneself, what is also disclosed is one's essential "indebtedness." In recognizing our ultimate finiteness, we come to recognize all, ontic and ontological, to which we are "indebted" for our being.

This is the Heideggerian view that Perniola criticizes: "Heidegger's analysis of death reflects on an ontological level, an ontic experience of death typical of Lutheran (and Jansenist) spirituality," and that insofar as it reflects this experience of death, it remains bound to metaphysics (*Società*, 84). As Heidegger himself acknowledges no particular Lutheran inspiration, Perniola makes his case for such a provenance, as it were, deconstructively.[15]

"In the [fifteenth century] *Artes moriendi*," Perniola asserts, "emerge all of the fundamental aspects of Heidegger's being-toward-death: the privileging of anxiety understood as access to authentic existence; the meditation on death considered as the moment in which human being acquires conscience of him/herself; the certainty that human being is nothing more than *un mort en sursis*, a deferred death, removed to another time; as well as the acceptance of one's own radical guilt. All of these themes find their most vigorous and fertile synthesis in Luther" (86). In this same vein, Perniola claims that "the freedom for death of which Heidegger speaks has its *existenziell* roots in the devaluation of work, typical of Luther's preaching." Moreover, "the Lutheran conception of sin . . . constitutes at least the ontic and *existenziell* premise of Heidegger's ontological and existential considerations" (87, 89).

For Perniola, the decisive connection lies in the concept of "conscience": "In Luther and Heidegger being-toward-death is linked to the quality of the call of conscience" (94–5). Perniola understands the quality of this call in a way that finds no distinction between Heidegger and Luther. He also elides the ontic/ontological difference upon which Heidegger himself never fails to insist. Having already substituted the notion of simulacrum for that of "phenomenon" and "the real," this further elision gives no pause. The existential ontological analysis of *Sein und Zeit* thus appears simply to repeat the Lutheran account, effectively reducing the meaning of this analysis to ontic terms. Death as one's ownmost possibility is rendered as a "factual" end, anxiously awaited and

deferred, with the fatal implication that authentic being-toward-death amounts to another metaphysical diversion in the form of being-toward an end that is always "not-yet" present.

In presenting his alternative, Perniola's first step is to contrast Heidegger's existential ontological analysis of death with Baudrillard's psychoanalytical, historical account. Baudrillard argues that simpler societies accommodate death by a simulacrum in the form of a symbolic death inscribed in the rites of initiation of the new into the social order and community. However, in modern society, he claims, death is not accommodated but virtually abolished. The move is twofold: death is repressed, removed to the subconscious as the death impulse; and death is denied in the endless accumulation and material production of capitalist economy. The exclusion of death, Baudrillard asserts, lies at the basis of modern everydayness and of the metaphysical tradition: "There is an exclusion that precedes all the others, more radical than that of the insane, of children, of inferior races, an exclusion that precedes them all and serves them as a model, which is even at the basis of the 'rationality' of our culture: it is the exclusion of the dead and of death" (L'échange, 195 n. 1).

In a gesture of counter-reformation, Perniola sets against the supposedly Lutheran origins of Heidegger's concept of "being toward death," a Jesuit/ baroque source for Baudrillard's conception of the "simulacrum of death." According to Perniola, it is the claim of the Jesuit/baroque tradition that one who would die well must first live well – but with a twist: "One cannot live well if one is not already dead, that is, unless one has reached the 'little death,' that simulation of death which is the Ignatian indifference, the goal of the first week of the Spiritual Exercises and the *conditio sine qua non* of any further progress" (*Società*, 91). This "little death" is the Jesuit/baroque version/ simulation for our time of the primitive rite of initiation, itself already a simulacrum. The "little death" marks the *beginning* of spiritual progress, which then proceeds from indifference to "election" and finally to happiness the precondition of which is the simulacrum of death.

Here Perniola is careful to make distinctions. For example, he maintains that Jesuit indifference is not the same as classical *apatheia*. In the classical model, *apatheia* is the goal of the process, "the happy life" consisting (as Seneca writes) in "peace and constant tranquillity, that loftiness of mind will bestow."[16] By contrast, Jesuit indifference is only the first step toward the goal of "election." In this process, indifference is first and foremost a matter of discipline, a step *we* take, whereas election is bestowed by God as a grace.

Perniola also insists that Jesuit indifference is not the same as asceticism, insofar as the former enjoins indifference to worldly possessions, but not to enjoyment. The claim might recall Larry Darrell in Maugham's *The Razor's Edge*, who is said to have attained such indifference that "he forgets to eat, but when you put a good dinner before him he eats it with appetite."[17] But the example is dubious. For in the society of simulacra, indifference cannot properly be the result of "other-worldly" pre-occupations. Rather it must be indifference to possessing and holding fast to any particular given thing. "One who wants to live well . . . must be *disposed* to *taste whatever* type of life the future has in store for him" (*Società*, 92). Notwithstanding Perniola's deference to the

Jesuit tradition, a more precise image for the sort of "indifference" he intends may lie outside Western onto-theology altogether.

Perniola also insists that Jesuit indifference is not a matter of insensitivity. Instead, it "introduces a new sensitivity that departs from any present-at-hand" (92). Possessed of this new sensitivity, one can still care for and enjoy what is given, but always only "moderately," as if, so to speak, it were always already taken away.

Perniola's chief purpose in drawing these distinctions is to show that the essence of Jesuit optimism, the sort of optimism which begins in the "little death" of indifference, is "not ethico-metaphysical but operational-existential" (93). It is not ethico-metaphysical, since it does not deny *this* world for the sake of another as a final substitution, either an immanent eschatological state on earth or a transcendent celestial paradise. By means of the simulation of death, it leads instead to the affirmation of this world, albeit not in any particular state present-to-hand, but in its contingent variety, vicissitudes, and uncertainty. According to this view, "this is the best of all possible worlds not because from the perspective of value it is factually such, but because it is possible to work in such a way as to make happy and satisfied whatever type of existence. Thus the Jesuit virtue is not eschatological hope, but faith that whatever may happen one can find consolation and success, even on the deathbed and in the agony of death" (93).

Accordingly Perniola says, "death is not, as in Luther or Heidegger, something which one awaits (*attende*), the most certain possibility, but something which ever since the beginning is the null foundation of existence, upon which is constructed the great theater of the world" (94).[18] Through the little death of indifference one is always already dead, this being a negative moment. But this negative moment frees us for the possibilities of this world as an ever-changing "theater" of simulacra, and makes the free individual part of the "*decorum*" of this "theater." "Only one who is already dead, that is, indifferent, can operate in history, because history is in constant flux, becoming, which dissolves all the certainties, all fixed points, all identities" (94–5).

This thesis serves to represent reality as a "dream," and hence as something whose elements can be, and always already have been, reproduced. Of course, in the vocabulary of metaphysics, "dream" is a pejorative term. Metaphysics proper looks beyond all dreams to disclose the "real" in terms of the unchanging principle behind all appearances. In these terms, a simulacrum would be a mere likeness, not of the real itself, but of the appearance of the real, hence twice removed from reality. By contrast, on its own post-metaphysical terms, Perniola's thesis represents reality itself as a "dream" or "simulacrum," as a representation that has no "hither" side, no hidden *eidos* as the "really real" lying behind it, and hence no concealed source announced in what appears.

This "model of the dream," says Perniola, "allows us to pass from Jesuit simulation to the baroque simulacrum of death" (94), a transition already prepared by substituting the pure presence of the simulacrum for the phenomenological notion of "appearance." "In the Jesuit/baroque tradition," he adds, it is "the visibility of death [that] is at stake. Death does not listen, but is visible,

it is not voice but simulacrum. To work within the world means, after all, creating dreams, oneiric images, simulacra of death" (*Società*, 95). Again, the very distinctions upon which Heidegger insists are deliberately elided. There are no "facts" in themselves, only simulacra on the verge of "die-ing," of becoming other simulacra. In this configuration, death is both simulacrum and symbolic of the simulacral process, marking the unending substitution of representations for representations, simulacra for simulacra, without center or ground. Perniola extols this state of affairs unabashedly: "The greatness of the baroque is precisely in this connection between death and history, between the nothing and works. Death does not put an end to history, but is at the origin of any historicity. Nihilism does not terrorize or paralyze, but is the guarantor of consolation and the source of works. The fact that these works are unnatural, artificial, affected, without any correspondence with a model, derives precisely from the fact that they have nothing to do with life thought metaphysically, by comparison there is no return or regret" (96).

What "stands at the end of metaphysical faiths" is, then, not the finite thinking of being à la Heidegger, but "the great theater of the world." In contrast to both metaphysics and Heideggerian *Denken*, "the baroque welcomes all possibilities, all the games, all the parts. Its availability is total provided that it remains within the sphere of what appears, of history. If, however, man abandons the ground of history and goes looking for faiths, metaphysical or theological identities, nothing will be able to save him from grief and failure" (96–7).

Judged on these terms, Heidegger's attempt to overcome metaphysics cannot help but appear guilty of "looking for faiths." Perniola's portrayal of him in this regard is damning. Heidegger's account of death is not free of theological apparitions; it is a ghostly replica of Lutheranism, offered under the guise of ontological radicalness and purity. The consequence is a tendentious valorization of the radically isolated individual in relation to death as its only proper possibility, and hence a closing-off of the multidimensional possibilities of genuine historicity. As a seeker after faiths and identities, Heidegger himself comes to grief and failure in a dramatic way, embracing the call of *"Ein Reich, ein Volk, ein Führer."*

Perniola sharpens the criticism by focusing on two specific issues. The first distinguishes decision from election: "Decision goes toward death, understood as the only possibility of existence, and encounters *temporality*. Election, instead, comes from death, understood as a state of complete indifference and humility, and encounters *history*" (97). The concept of decision is inadequate, linked to the "ownmost" and authentic possibility of *Dasein*, the anticipation of death. In contrast, the little death of indifference does not single out one possibility as more proper than another. Death understood as a possibility to come has no privileged character with respect to the other infinite possibilities. For Perniola, the implications of this difference are crucial. In Heidegger, the situation becomes authentic because it is always already our ownmost possibility, whereas in election the situation becomes one's own (is appropriated) by making it as one's own. Whereas the invocation of the ownmost and authentic closes off possibilities and removes us from genuine history, the notion of

election opens us to all possibilities and to history because it attaches itself to no possibilities and no configuration of things in particular.

Second, Perniola focuses on the relation Heidegger's notion of "within-timeness" (*Innerzeitigkeit*) bears to political economy. "For Heidegger, *Innerzeitigkeit* is grounded on public world-time (*Weltzeit*), that is, on the very being of inauthentic *Dasein* as impersonal everydayness. In this fashion, the within-timeness (and capitalist political economy) becomes a structural dimension of existence, which cannot be overcome on the historical plane. Once again Heidegger reproduces Luther's willingness to assign to economy a secondary legitimacy but in no way attributes to it, as Calvin does, a divine task" (107). This critique is straightforward. In Heidegger's analysis, the existential account presupposes the average, everyday understanding which is not a fixed, abstract given, but historical and changing. At the present time, Perniola contends, the precepts of capitalist political economy, like work, accumulation, consumption, govern this historical understanding. If Heidegger's analysis is grounded in the everyday, he imports these precepts into authenticity, while his Lutheran gesture dismisses political economy as of secondary importance.

Between the Heideggerian account of death and the Jesuit/baroque conception, the ledger is thus neatly balanced: being-toward-death against the simulacrum of death; decision and resolution against indifference and election; Heideggerian temporality as *Sein zum Ende* against baroque historicity; authenticity and the "proper" against the loss of self; and the ontic/ontological difference against the concrete situation as simulacrum. When the account is tallied, Heidegger falls on the debit side.

Let us comment briefly on these two criticisms. Leaving aside the thorny issue of Heidegger's Nazi involvement, the baroque rejects the quest for identities and faiths as doomed to failure. Metaphysics has always recognized that we succeed in rising above our particular contingent circumstances, if at all, precariously. But the prospect of failure need not vitiate the attempt. The search for identities and for a faith from which to assess the meaning of our lives may be inescapable. We come to grief not in the attempt but in the dogmatic refusal to confront other, alternative identities and faiths.

With respect to Perniola's claim that Heidegger's concept of temporality is "inadequate," the question is, inadequate to what? Inadequate to the baroque concept of history which has no place for the ontic/ontological difference or for the distinction of authentic from inauthentic. As Hegel once remarked, "one bare assurance of truth is as good as any other," and it is no refutation of a thesis that it is inadequate to a conflicting doctrine, the terms of which it rejects *au fond* (*Phänomenologie*, 66). Such conflicts can be resolved only in the direct confrontation between the conflicting views. In this regard Perniola might be accused of misrepresenting Heidegger. He presents the *Daseinsanalytik* as an ahistorical account of the human condition, which he then claims is vitiated insofar as it suppresses its own concealed historical grounds. However, the existential analytic of *Dasein* is explicitly not an account of *the* human condition, but only "a preparatory procedure by which the horizon for the most primordial way of interpreting being can be laid bare" (*SZ*, 17 §5). That horizon itself is a *historical* event, gift of tradition, that does not happen just

anywhere and at all times. To be sure, the structures Heidegger claims to uncover are deemed to be a priori and universal. Yet, the truth of their universality is not separate from their historical realization. The existential-ontological truth of death is "true" only as it is realized, through the authentic possibility of this realization granted by a particular tradition. Yet in being realized, it is realized as *universally* true.

Perniola speaks of death in Heidegger as our ownmost possibility in a way that elides the difference between the *Faktum* of death (its reality as an existential, ontological limit) and the *Tatsache* of death (its reality as an inevitable end) and illicitly gives precedence to the latter. Whereas Heidegger means by death the ultimate situating limit that is "in each case always mine" and that opens possibilities, Perniola reads him as saying that death is my death as one ontic possibility among others. Likewise, he speaks as if for Heidegger in being-toward-death a specific ontic situation becomes authentic, thereby valorized as the *eschaton* or final state. But in Heidegger's own terms, authenticity and inauthenticity are modes of our being and self-understanding, constituting the horizon within which we deal with ontic states of affairs, however we judge them.

Heidegger is the first to admit that the existential analysis of authentic being-toward-death is a "fantastic undertaking," residing in an hermeneutic circle. "It is *never possible* to withdraw from this everyday interpretedness into which *Dasein* has initially grown. In it, out of it, and against it, all genuine understanding, interpreting, and communicating, all-rediscovering and appropriating anew, are accomplished. In no case is a *Dasein* untouched and unseduced by this interpretedness, set before the open country of a 'world' in itself so that it just beholds what it encounters" (*SZ*, 169 §35). Existential interpretation rests on *existenziell* understanding, while the existential analysis decides what *existenziell* understanding is authentic. So precarious is this undertaking that it requires an interpretive "counter-thrust" against the everyday: "The *Freilegung* of the original being of *Dasein* must be *wrested* from *Dasein in opposition* (*im Gegenzug*) to the ontico-ontological tendency of interpretation" (*SZ*, 311 §63).

Turning now to Perniola's celebration of the simulacrum of death, I shall focus on five points. (1) It might be argued that existentially/operationally death is neither a phenomenon nor a simulacrum, but the *essence* of phenomenality and "simulacrity." As such it cannot be supplemented or substituted but is presupposed in all such exchanges. Hence death is not a *problem* to be solved or dissolved, either as being-toward-death or as simulacrum. Instead, our finite being appears in the world from nowhere and disappears into nowhere, a context of appearance and disappearance within which we make sense of things. "Failure and grief" lie not in the quest for identities and faiths, but in the metaphysical attempt to reduce the meaning of our finite being to a problem of cognition solvable by the principle of sufficient reason.

(2) It may not be so easy to dispense with the realist moment as Perniola (following Baudrillard) seems to think. Whether construed as phenomena or simulacra, we make sense of things through our lived-body in relation to a reality that resists us as "other." Even if one grants Perniola's claim that "to

work within the world means creating dreams, oneiric images, simulacra of death," there are still *ontic* limits to a creation discovered only through dreams, images, and simulacra. It is one thing to say, following Heidegger, that all description of the real is interpretive, that there are no facts except in virtue of interpretations; it is quite another to say, following Baudrillard, that there are only simulacra. The former maintains a distinction between interpreting and what is interpreted; the latter erases this difference in the play of substitutions.

(3) Whereas the metaphysics of death presumes to redeem and reconcile our finite existence, Nietzsche contends that this quest is animated by the spirit of revenge against the contingency, variety, and gratuitousness of life. Yet with the death of metaphysics, we are not simply freed from the spirit that animates it. As Nietzsche also claims, what comes in its wake is the nihilism of the last men for whom God is dead and everything is permitted. One is freed for all possibilities, yet no one possibility over any other. The freedom of the last men is freedom for nothing and in this lies their happiness: "We have invented happiness, say the last men, and they blink!"

To overcome the last man and the spirit of revenge that informs the meta-physics of death, Nietzsche teaches *amor fati* and eternal return, the former reconciling us to our particular "thrownness," the latter investing our actions in a finite world with the "greatest weight" of significance and responsibility. In the transition to baroque historicity, indifference serves the role of *amor fati*, an exercise by which we reconcile ourselves to this finite world and our own place in it, in all of its contingency and "unreason." In one sense this indifference is closer to *amor fati* than it is to the Jesuit spiritual exercise. For, loosed from its theological underpinnings, the process of indifference and election would be entirely a matter of one's own work, a question, as Nietzsche might say, of "giving oneself grace." Whereas Jesuit election was an exercise to be met by divine grace, like *amor fati*, this indifference is an act of will. Yet, it would also seem to be a kind of *amor fati* without real *amans*, a "simulacrum" of love in the old metaphysical sense. Indifference reconciles us to the world by celebrating the world as a "great theater" in its sheer theatricalness, but without celebrating anything in particular. To the doctrine of eternal return, there is no parallel in baroque historicity. It welcomes "all games, parts, possibilities" indiscriminately and hence without measure or weight. Although not *apatheia* and insensitivity, Jesuit/baroque indifference is not *so* indifferent as to be indifferent to its own happiness. But, then, it must judge and discriminate among simulacra, not accepting all possibilities indifferently. If, instead, happiness lies in a blanket indifference, the distinction between this and *apatheia* becomes blurred.

(4) In terms of Jesuit indifference and election, what one does, one does *ad majorem Dei gloriam*. This sensibility and conviction make sense, insofar as the spiritual exercises of the Jesuit presuppose a faith that this world is not utterly God-forsaken, however much God may "hide His face." Such a faith is able to console its adherents "in whatever state or condition they may be thrown," because underlying it is the conviction that even *in extremis* we are never *wholly* abandoned. But in the society of simulacra, the same indifference construed *post Deum mortuum* implies that every act is only, so to speak, *ad majorem Simulacri*

gloriam, the measure of "glory" being only the continuing indifferent and indiscriminate simulacral substitution itself. As we have seen, Perniola celebrates the openness of this indifference as "welcoming all games, parts, possibilities." The assumption is that the Jesuit can simply be carried over from the work and the world of the Society of Jesus to the life of the postmodern intellectual committed not to God but to the "theater of the world" in its ever-changing productions. The substitution seems dubious, an imputation of piety without content or purpose.

(5) In the society of simulacra, there is no place for mourning what has passed away, insofar as one is appropriately indifferent to whatever *is* in the first place. There remains no sense of celebration of the simulacral society *itself* as the sort of world we are granted and in which we live. Nor is there responsibility for that world, for working toward the realization of one state of affairs as better than another.

The ubiquity of myth attests that human beings strive to make sense of their finite existence. To those stories that we tell ourselves the tradition of metaphysics lends universality and necessity. Nothing apparently compels us to enter the circle of metaphysical explanation, but once inside, once we have posed the "ultimate question" of metaphysics, there is no easy philosophical escape. Instead, we would seem to be left only *to will* to disclaim the questions that we are impelled to ask, "*cultiver notre jardin*," as Candide counsels, or simply to pursue what *divertissements* we can.

Perniola's thinking attests to the difficulty of that philosophical escape. Though it is not *apatheia*, the Jesuit/baroque indifference that Perniola recommends resembles Hegel's account of the skeptics' *ataraxia*, unperturbed by the world of changing appearances because it accords to the elements of that world no permanence. In this respect, "skepticism is the realization of that which stoicism is merely the concept: it is the actual experience of freedom of thought" (*Phänomenologie*, 154).

Perniola seems to reproduce all the key elements of Hegel's account of skepticism. First, "skepticism," Hegel writes, "is a moment of self-consciousness to which it does not *happen* that its truth and reality vanish without its knowing how, but which, in the certainty of its freedom, *makes* this 'other' which claims to be real, vanish" (*Phänomenologie*, 156). Against our common-sensical attitudes that posit the fixed identities of things, Jesuit/baroque indifference denies the present-at-hand, rendering all reality as simulacra and indefinitely reproducible. Second, "through this self-conscious negation, skeptical consciousness procures for its own self the certainty of its freedom, generates the experience of that freedom, and thereby raises it to truth." Jesuit/baroque indifference rejects all quests for identities and faiths and thereby establishes itself as *the* attitude of liberation. Third, "what skepticism causes to vanish is not only objective reality as such, but its own relationship to it. . . . What vanishes is the determinate element or the moment of difference, which whatever its mode of being and whatever its source, sets itself up as something fixed and immutable. It contains no permanent element, and must vanish before thought, because the 'difference' is just this, not to be in possession of itself, but to have its essential being only in an other." In Jesuit/baroque

indifference, the world consists of simulacra, the changing identities of which are played out in on-going simulacral reproduction and substitution. Likewise, the self that "works within the world" is a simulacrum, unstable and variously reproduced, continually defined and redefined in simulacral reproduction. Fourth, "thinking . . . is the insight into the nature of this 'different,' it is the negative essence simpliciter." For Jesuit/baroque indifference, thinking does not make present and secure an occluded, absent truth after the fashion of metaphysics or phenomenology. It simply follows the production of the "theater of the world," reveling in its ephemerality.

Thus described, skeptical consciousness, for Hegel, is self-contradictory: "Skeptical consciousness is finally nothing but a contingent imbroglio, the dizziness of a disorder which continually engenders itself. This is what this consciousness is for itself, for it is consciousness itself that nourishes and brings forth the movement of this confusion" (*Phänomenologie*, 157). In its Jesuit/baroque form, skeptical consciousness welcomes all concrete situations by negating them. It *always already* negates them. For in its attitude of indifference, it renders all concrete situations as simulacra, constituted by inessential differences whose inessentiality such consciousness both exposes and reflects. It thus transcends the contingencies of this world not by denying them but by affirming contingency *in extremis*. Nevertheless, a skeptic always remains entangled in such a situation, bound by the ruling orders, practices, and *meta-récits* that he knows to be an ephemeral product of the world theater, but with which he must still deal in the world. Caught between indifference in general and the particular contingent situation in which willy-nilly it finds itself thrown, skeptical consciousness is an unhappy consciousness. There, I would venture, is where we shall find the Jesuit/baroque simulacrum and its consciousness.

15

A DEADLY GIFT

TO DERRIDA, FROM
KIERKEGAARD AND BATAILLE

Kenneth Itzkowitz

Is death a gift? Is a particular kind of death a gift? In pondering such matters, it is important to remember that the expression "gift of death" is and will always remain entirely ambiguous. In the first place, we cannot speak from a knowledge of death since, as Bataille liked to point out, to have an experience of death would not be to know but to die. In the second place, then, as nothing can be known about death, anything can be said about it, in the sense that no claim about death can be disproved. Indeed, much will always be said about death because although we cannot know it, the question of its meaning is a timeless concern for us.

Given this concern, one of the most common assumptions about death is that it is a kind of gift. An extreme example is the recent mass suicide of the members of the group calling itself "Heaven's Gate," who consumed lethal amounts of vodka and barbiturates in the hope of leaving Earth as passengers on a spaceship trailing the Hale-Bopp comet. But even without extremes of this kind, there are countless individuals, both in and out of organized religion, who hope for a better life to come – those who often strenuously believe that death is a gift, with the understanding that such a gift is a good thing.

But *is* a gift a good thing? This is a difficult question to pursue: if a gift is a bad thing, it is not truly a gift. One legacy from Plato is that we presume gifts to be good; that any so-called gift that makes things worse would be akin to the bad leader or bad doctor of Book One of the *Republic*, the one who is not really a leader or doctor at all, except in name. Such thinking stipulates that only when the good is produced can leaders, doctors, and gifts be present. When the good is not produced, language deceives us: we may speak of these things, including gifts, but without having them. In other words, the only gifts that make things worse would be those misconstrued from the deceitfulness of our words.

Yet when Derrida speaks of the gift of death, it is precisely the goodness of the gift that is at issue. In opposition to the dominant Platonism of philosophy,

which defines the gift as necessarily good, as unthinkable if not good, Derrida is aligned with Kierkegaard and Bataille in identifying the gift with *sacrificing* the good. Philosophy has generally said that sacrificing the good is bad and that such a gift would be bad, a false gift, a gift in appearance only. According to this alternative alignment, however, we must now reconsider the bad gift. Kierkegaard, Bataille, and Derrida all speak according to a logic of inversion whereby, in the name of the gift, the bad is better than the good and the good less good than the bad; whereby, in the name of the gift, we are more responsible to the bad than to the good. In short, according to this logic of inversion, there is a kind of responsibility to seek nothing less than the loss of the good through transgressions never to be redeemed in the name of the good or in the name of any law serving the good.

What is to be gained by such an inversion, with its disturbing elevation of loss and sacrifice? In *The Gift of Death* Derrida ties the sacrificial gift of Kierkegaard's Abraham to a radical critique of the ethical good. What, then, do we gain by disrupting ethics, instead of remaining with traditional alternatives that would leave ethics untroubled and undisturbed? What do we gain by following Derrida, Kierkegaard, and Bataille in their questioning of ethics in such a radical way?

In *The Gift of Death*, Derrida makes this case: the problem with leaving ethics alone is that despite all appearances and pretensions to the contrary, the ethical good is itself *irresponsible*. Ethics is irresponsible because it takes one part (of which there are two) for the whole of responsibility. It identifies all of responsibility with its own kind, with the responsibility that is *general*, that makes us always accountable to each other through the good by which we are *interchangeable* with each other. Derrida puts it this way: "For common sense, just as for philosophical reasoning, the most widely shared belief is that responsibility is tied to the public and to the nonsecret, to the possibility and even the necessity of accounting for one's words and actions in front of others, of justifying and owning up to them."[1]

In short, according to *The Gift of Death*, our understanding of responsibility has been tied down to ethical generality: to the public, to explicit justifications, to giving accounts before others. Can it be that such a tie is itself somehow irresponsible? Derrida puts forth that our responsibilities are not always public and general, in this way not always ethical. To identify all responsibility with generality is reductive: it gives part of the picture for the whole while omitting the other part. Indeed the relation between ethics and responsibility is deeply troubled. "According to Kierkegaard," Derrida tells us,

> ethical exigency is regulated by generality; and it therefore defines a responsibility that consists of *speaking*, that is, of involving oneself sufficiently in the generality to justify oneself, to give an account of one's decision and to answer for one's actions. On the other hand, what does Abraham teach us, in his approach to sacrifice? That far from ensuring responsibility, the generality of ethics incites to irresponsibility. It impels me to speak, to reply, to account for something, and thus to dissolve my singularity in the medium of the concept. (*GD*, 60–1)

Based on the fuller picture of responsibility offered by *Fear and Trembling*, Derrida now points out how "to speak, to reply, to account for something" can all be *irresponsible* behaviors. In Kierkegaard's portrayal of Abraham they are characterized as temptations. In such cases, in face of the gift that is not good, the urge to be good does not equal being responsible. The ethical impulse rather "incites to irresponsibility." Derrida coins the term *irresponsibilization* and declares: "This is ethics as 'irresponsibilization.'" The problem with ethics in the case of Abraham stems from the vast, irreconcilable difference between the two responsibilities, characterized by Derrida as the "insoluble and paradoxical contradiction between responsibility *in general* and *absolute* responsibility. Absolute responsibility is not a responsibility, at least it is not general responsibility or responsibility in general. It needs to be exceptional or extraordinary, and it needs to be that absolutely and par excellence . . .: it must therefore be irresponsible in order to be absolutely responsible" (61).

Given the contradiction between the two responsibilities, general and absolute, "ethics as irresponsibilization" might as well be phrased "ethics *is* irresponsibilization." With responsibility self-divided in this way, ethics will always deny and also fail to recognize its denial of absolute responsibility. In this double-denial, absolute responsibility will always be omitted from the general responsibility of ethics. There will never be a place in ethics for the exceptional rather than ruled, the singular rather than the universal, indeed the irresponsible rather than responsible.

To be sure, given the predominance of "ethics as irresponsibilization," as this leaves little or no place for the exceptional as such, the common portrayal of Abraham ends up as the image of a very good man, as if the sacrifice of Isaac counted for nothing at all, for at most a mere trifle. "Ethics as irresponsibilization" perpetuates a whitewashed, secretly dangerous, violently constrained image of Abraham, one that *Fear and Trembling* consistently attacks and ridicules for treating Abraham like a kind of father-of-faith hero. "[W]e are unwilling to work," Kierkegaard proclaims, "and yet we want to understand the story. We glorify Abraham, but how? We recite the whole story in cliches: 'The great thing was that he love God in such a way that he was willing to offer him the best.' This is very true, but 'the best' is a vague term. Mentally and orally we homologize Isaac and the best, and the contemplator can very well smoke his pipe while cogitating, and the listener may very well stretch out his legs comfortably."[2]

The failure of the ethical perspective is that it lacks the means to avoid making Abraham into someone who is good, despite the fact that he is entirely ready to sacrifice his son. The ethical perspective lacks the means to speak of a greatness or glorious gift that is *not* good, which in the case of Abraham is a problem, since to pay attention to what went on in this particular case makes it readily apparent that "[t]he ethical expression for what Abraham did is that he meant to murder Isaac" (30). Ethics is irresponsibilization in that its denial of the murder follows from its identification of the gift and the good – for Kierkegaard an identification that is soporific and anaesthetic. *Fear and Trembling* paints it this way: "So we talk and in the process of talking interchange the two terms, Isaac and the best, and everything goes fine. But just suppose

that someone listening is a man who suffers from sleeplessness – then the most terrifying, the most profound, tragic, and comic misunderstanding is very close at hand. He goes home, he wants to do just as Abraham did, for the son, after all, is the best" (28).

In other words, Kierkegaard is adamant that everything does *not* go just fine. What ethics refuses to see is that with Abraham, we stand before the possibility of a responsibility that is absolute and not general, the responsibility to respond to the absolute, as the most glorious gift, whereby the good itself becomes only an irresponsible temptation. We have arrived at the failure of ethics, the irresponsibility that is ethics, the shunting aside, in the name of ethics, of our meta-, non-, or absolute responsibility of and to the singular. Ethics now shows itself to be paradoxically too clear about our responsibilities: it stands up only for the part of responsibility conceivable as general and good, while neglecting the inconceivable part, the part that is absolute and singular. Ethics wrongly abandons the rift between the two responsibilities; it wilfully ignores the complete lack of communication between them. The ethical ideal of a unified concept of responsibility jettisons the break in communication, as if extraordinary singularity, the sacrifice of ethics itself, played no role in being responsible.

Derrida addresses these ethical shortcomings by drawing special attention to this unique lack or break in communication, designating it "the aporia of responsibility." This designation of an aporia provides the recognition that responsibility taken as a whole goes against itself; it already plunges and fails at the very moment it is conceived. "[O]ne always risks not managing to accede to the concept of responsibility in the process of forming it" – thus Derrida characterizes this plunge as an aporia (*GD*, 61).

Ethics mishandles the aporia; the alternative to ethics is to treat responsibility as twofold in a nonethical, inevitably torturous manner. The crux is to hold onto singularity – an ungeneralizable responsible singularity. To be responsible now includes attending to, besides and against ethics, a strict singularity without accountability. Being responsible now includes a unique, secret, and silent singularity – one that is both more and less than ethics, never a part of ethics, never to be another ethics. For unlike ethical generality, singularity is incommunicable. (Hence the deed of absolute responsibility never makes sense no matter how close we may be to the doer.)

The upshot is that we are now faced with the recognition that beyond all morality, there is an ultimate, absolute, singular, sacred demand that cannot be contained by moral imperatives, a demand to sacrifice morality, to destroy the things we love, to destroy them even because we love them. Prior to this recognition, there seemed to be only one responsibility in the sense of a general responsibility to the good. Innocent of this recognition, we could be assured that by being responsible we would be doing good deeds and that we would be able to keep on accumulating these by continuing to be responsible.

But when we are no longer innocent about the goodness of the gift – "the gift of infinite love . . . that makes us tremble in the *mysterium tremendum*" (*GD*, 55) – we are confronted by two radically disturbing prospects, both concerning the insufficiency of morality, of general responsibility alone. The first, as

Derrida clearly enunciates it, is that "The ethical can . . . end up making us irresponsible. It is a temptation, a tendency, or a facility that would sometimes have to be refused in the name of a responsibility that doesn't keep account or give an account, neither to man, to humans, to society, to one's fellows, or to one's own. Such a responsibility . . . refuses to present itself before the violence that consists of asking for accounts and justifications, summonses to appear before the law of men" (61–2).

The second and more disturbing prospect is directly related to this first one, as the form responsibility will now take in the glorious and exceptional moments when accountability is rendered irresponsible. Absolute duty takes the form of "a gift or sacrifice that functions beyond both debt and duty, beyond duty as a form of debt" (63). Here Derrida claims that the "gift of death" must come into play because in our relation to the absolute, "a duty of hate is implied" (64). The disturbing prospect here, Derrida insists, is nothing less than that "I must sacrifice what I love. I must come to hate what I love, in the same moment, at the instant of granting death. I must hate and betray my own, . . . not insofar as I hate them, but insofar as I love them. . . . It is not a matter of hating, betraying by one's breach of trust, or offering the gift of death to what one doesn't love" (64).

To be sure, the duty to hate upsets the figure of Abraham as edifying to us. Can we still relax with this figure who gives death? Can we still smoke our pipes and stretch out our legs, as Kierkegaard jokes, or are we now sufficiently troubled by the outbreak of unanticipated violence so that Abraham's faith and its glory now make us tremble? What does it mean to tremble? Derrida says that "the event that makes one tremble portends and threatens still. It suggests that violence is going to break out again, that some traumatism will insist on being repeated" (54). Also we tremble as a kind of intimation that this traumatism cannot be controlled, that the source of the sudden violence is a unique secret or concealment, always unseeable and unknowable, always unapproachable, unpredictable, in general ungovernable. To tremble before the figure of Abraham means to sense the lack of control as having threatened and somehow threatening violence still. We tremble, says Derrida, "first of all because we don't know from which direction the shock came, . . . whether it is going to continue, start again, insist, be repeated: whether it will, how it will, where, when; and why *this* shock. . . . I tremble at what exceeds my seeing and my knowing although it concerns the innermost parts of me, right down to my soul, down to the bone, as we say" (54).

Now whereas the first disturbing prospect is that goodness isn't good enough, and that we are going to have to do better than simply striving to be good, the second prospect (which follows from the first) begins to spell out the repulsive detail of how doing "better" is going to mean doing *worse* better, i.e., *hating* better. Derrida asks, "How does one hate one's own?" (65), a question that is already itself enough to make one tremble. Derrida answers this question with a similarly disturbing explication of Kierkegaard. We must "hate . . . [those we love] not out of hatred . . . but out of love. . . . Abraham must love his son absolutely to come to the point where he will grant him death, to commit what ethics would call hatred and murder" (65).

This is the strategy for hating one's own, for doing worst best. The strategy is to love as much as possible and then to hate precisely those who are so loved because, as so loved, they are the ones most suitable to be sacrificed, to be given death. Moreover, this strategy is the way to respond to a command that is infinite, unconditional, and beyond all human law. If we look closely at Abraham's faith, at his willingness to sacrifice Isaac, this strategy of hate over love becomes apparent. Is seeing this enough to make us tremble before the figure of Abraham? Is seeing this enough to make us tremble *now* – before the figures of those who love us and whom we love?

Undeniably, much of what is so disturbing about this second prospect, about the form absolute duty takes, is that this unconditional duty now turns maximal love from a benefit, even a cure of hatred, into a *hatred-occasion*. Love is inverted by unconditional duty into an incitement to sacrifice, to give a gift of involuntary death to those we love the most, precisely as loved the most. Love is inverted by absolute duty to give an involuntary death to us too as loved the most, precisely because we are loved the most. To tremble before the figure of Abraham is to admit that this may be so, to admit that this violence, to repeat Derrida's words cited above, "concerns the innermost parts of me, right down to my soul, [right] down to the bone."

It needs to be said at this point that if we weren't concerned to the utmost, in the soul and to the bone, it would be absurd to even discuss a strategy to hate one's own. To even discuss this would represent a real and unnecessary decline in human relations. Surely, the very prospect of a duty to hate what one loves the most is entirely disagreeable – a point that must not be lost on us, and one upon which Kierkegaard, Derrida, and Bataille all insist. If we were not concerned to the utmost, if hating our own were merely a perversion afflicting a troubled minority, a treatable or random disorder, then we should forget about Abraham and his gift-sacrifice that elevates terror and immorality to hitherto unimagined heights and depths.

But we cannot forget about such gift-sacrifices, even if this be our preference. Throughout his writings, both early and late, the overriding concern of Georges Bataille is to recognize and explain that such sacrifices correspond to a fundamental need, one "as inevitable as hunger."[3] The event of sacrifice corresponds to a need that will be given its due, regardless of the prohibitions morality puts in its way. The only question is how this is to occur. In his essay "The Jesuve," Bataille laments that "[t]he practice of sacrifice has today fallen into disuse and yet it has been, due to its universality, a human action more significant than any other . . . with the goal of answering a need as inevitable as hunger. It is therefore not astonishing that the necessity of satisfying such a need, under the conditions of present-day life, leads an isolated man into disconnected and even stupid behavior" (73).

Bataille's point is that sacrifice corresponds to a need that will be satisfied no matter how subterranean it may have become, even when this means engaging in bizarre and grotesque behaviors. This need is so fundamental that it must be satisfied. Of course many would readily object that stupid behaviors deserve to fall into disuse. But for Bataille, although such an insistence is not without some value, it neglects the main issue at hand, concerning the fact that some of

our behaviors – our most profound and consuming expenditures – take on a meaning that is compelling and absolute.

One of the works that deals extensively with this issue has the descriptive title "Sacrificial Mutilation and the Severed Ear of Vincent Van Gogh." This essay advances the theme cited above, that "the custom of sacrifice [is] in full decline" at the same time that the need behind the custom remains as strong as ever. Bataille says that the continued vitality of such a need is manifested by acts of destruction and mutilation "of which the automutilation of madmen is only the most absurd and terrible example."[4] One of these terrible examples is that of Van Gogh cutting off his own ear. We shall consider the other two examples Bataille presents, which are equally if not even more horrendous. The mutilations are certainly on a level far beyond that of the usual piercings or tatooings, so that they would be almost impossible to imagine doing. This impossibility is seminal to Bataille.

First there is Gaston F., the 30-year-old embroidery designer admitted to the hospital on January 25, 1924 after biting off his own finger. Bataille cites part of the doctor's report:

> *he stared at the sun, and, receiving from its rays the imperative order to tear off his finger*, without hesitation, without feeling any pain, he seized between his teeth his left index finger, successively broke through the skin, the flexor and extensor tendons, and the articular ligaments at the level of the pha-langeal articulation; using his right hand, he then twisted the extremity of the dilacerated left index finger, severing it completely. He tried to flee from several policemen, who nevertheless succeeded in overpowering him, and took him to the hospital. (61)

It is natural to be repelled by this description; can one even imagine such a thing? In "The Jesuve" Bataille says "I . . . allude to a series of trifles, of mean gestures, of errors, of a sort that no one would want to linger over . . ., and it is almost odious that certain things have not remained in the unconscious state" (73–4). Despite this discomfort, to pay attention to the odious, such as the behavior of Gaston F., enables Bataille to bear witness to the extravagance in life that exceeds accountability. There are acts that are too hideous and impos-sible to imagine yet they are performed. Bataille argues that to be able to take place, such performances must be *absolutely* compelled. In this way an instance of horrendous automutilation is a kind of absolute act, as such akin to Abraham's absolute response to God. It is a kind of absolute expenditure, one that is carried out *at all costs*, in a realm of awareness that gives no account, one that is without regard for finite future consequences or benefits. "Once a decision is reached with the violence necessary for the tearing off of a finger," Bataille writes, "the order that the teeth had to carry out so brusquely must appear as a need that no one could resist" (62). The crucial point is that no one could resist, making the need *irresistible*, making it absolute as one to be met *at all costs*. Moreover, the need is absolute, although, as is readily apparent from its descrip-tion, it cannot be conceived as good. The response to the need is the giving of the gift, the gift not of the good but of the sacrifice of the good. Gaston F.

himself commented later: "It did not seem very hard . . . after contemplating suicide, to bite off a finger. I told myself: I can always do that" (62).

Bataille also tells the story of the automutilation of a 34-year-old woman who had been made pregnant by her employer and then lost the infant a few days after birth:

> She was placed in a mental hospital. One morning, a guard found her tearing out her right eye: the left ocular globe was completely removed, and in the empty socket shreds of the conjunctiva and cellular tissue could be seen, as well as adipose tissues; on the right there was a very pronounced exophthalmos. . . . [T]he patient stated that she had heard the voice of God and, some time later, had seen a man of fire: "Give me your ears, split open your head," the phantom told her. . . . The pain caused by her first efforts was extreme, but the voice urged her to overcome the pain and she did not give up. She claims to have lost consciousness at that point and cannot explain how she managed to completely tear out her left eye.
>
> (66–7)

Now again the key issue for Bataille is how to get beyond the obvious aversion, the feeling of certitude that here is an act that should not have happened, we are better off if it never happens again, and that is all there is to say. Bataille acknowledges this sentiment but insists we shake off the conclusion. He refers to the woman's disastrous behavior as an example of "the Oedipal enucleation," of what he calls "the most horrifying form of sacrifice" (67).

Beyond the obvious disaster, for Bataille, there looms the deeper matter of how it could be done, of the motive, the point of origin, the source of energy for carrying out such an odious task. What kind of a need motivates and enables someone to carry through a self-mutilation of the most extreme kind? Bataille again insists that this need must be powerful enough to exceed the limits of all calculation, similar to the case of Gaston F. The need is experienced as *absolute*, as *irresistible*, as one to be met *at all costs*. Skeptics will say that these are merely two isolated cases of madness. Bataille himself sees in such madness an indication of our general condition, one which includes a realm of irresistible impulses and expenditures, paradoxically not of the good but of the sacrifice of the good.

Accordingly, his best-known essay, entitled "The Notion of Expenditure," proposes, as a principle of consumption (for purposes other than production), the inverted goal of unproductive expenditure. This principle of expenditure is one of seeking absolute waste and loss, applying not only to isolated madmen and women (although these cases are the most "absurd and terrible"), but as a general principle, applying equally to all. So that we will not confuse wasteful expenditures with failed investments, Bataille says he will "reserve the use of the word *expenditure* (*dépense*) for the designation of . . . unproductive forms . . . [where] in each case the accent is placed on a *loss* that must be as great as possible in order for that activity to take on its true meaning."[5]

Moreover, such expenditure as loss is how we engage the realm of the sacred,

the realm of meaning in our lives – a point Bataille continued to emphasize until his death. In his later work *Death and Sensuality*, in a chapter on Sade, he highlights this role of expenditure as the source and meaning of the extravagance of eroticism, boldly proclaiming that "Our only real pleasure is to squander our resources to no purpose, just as if a wound were bleeding away inside us; we always want to be sure of the uselessness or the ruinousness of our extravagance. We want to feel as remote from the world where thrift is the rule as we can. As remote as we can: – that is hardly strong enough; we want a world turned upside down and inside out. The truth of eroticism is treason."[6]

Now earlier in this paper, with the distinction between two responsibilities formulated by Derrida in reading Kierkegaard, we already followed a line of thought bringing extravagance into play with Abraham's sacrifice of Isaac, Abraham's response to "the gift of infinite love" (*GD*, 55) which, as the always hidden source of sudden uncontrollable violence, makes the ever-observant poet-narrator Johannes de Silentio tremble. There are many important ways in which this extravagance is the same as the one we find in the texts of Bataille, most especially in its unredeemably transgressive character. Kierkegaard marks a turning point in thinking about our relation to the absolute because of this thoroughgoing, unrelenting insistence that the infinite gift is not good. This gift demands a sacrifice; it is a gift in which the violence of hatred looms, emerging suddenly at any time without warning to destroy the very things we love the most. To put it strongly, we tremble before this gift of infinite love as the destroyer of worlds. If we are responsive to it like Abraham, we have to be responsive without any preconditions, without any limitations, without any regard for the impact the response will have on anyone else. In short, like the self-mutilators Bataille describes in his Van Gogh essay, to respond to the "voice" of the absolute implies breaking all the boundaries of finitude to sacrifice anything and everything we may love. It is to respond *at all costs – no ifs, ands, or buts.*

But despite the enormous, also incomprehensible achievement of Kierkegaard's text in which the gift and the good are first made to diverge, Bataille takes this line of thought even further. One way to see this is by noting how Kierkegaard speaks often of judging Abraham like anyone else. He likes to remind the reader that if Abraham were just a criminal, then we wouldn't have to be concerned any longer with his errant behavior, because there would be no glorious gift of infinite love involved. "If faith cannot make it a holy act to be willing to murder his son, then let the same judgment be passed on Abraham as on everyone else" (Kierkegaard, 30). Abraham could then, as Kierkegaard puts it, be canceled out. His sacrifice of Isaac would have no direct bearing on us. Indeed, if there is nothing to be horrified by in faith, then let us end all of this business with Abraham and God. Abraham would be a murderer. There would be no absolute responsibility to God. The book on Abraham could be closed.

But with this dismissal of the merely "criminal" Abraham, Kierkegaard still ties Abraham to a certain responsibility and goodness, to a kind of ghost of the good as God's authorization. God's command cannot be known or measured in any way but nonetheless is a condition of Abraham's exemplarity. That there is a command to be heard remains a condition of the "legitimacy" of faith such

that Kierkegaard would simply lose interest in Abraham if God or the voice of God were not somehow present. Abraham could be *canceled out* if he were just a criminal, if there were no divine voice for him to follow.

But how can Kierkegaard speak of such divine authorization? What can hearing God's command mean in Kierkegaard where God is so present but only as so absent that it would be impossible to distinguish between the mind of delusion and the mind of faith? How exactly can the minds of delusion and faith differ when truth is subjectivity, when there is no experience of contemporaneity in which God is ever known, when even to the one who claims faith, God can always only be given at second hand, by observing the unorthodox, transgressive behavior of the one acting in the name of God, the one who is said to act in response?

Unlike Kierkegaard, Bataille is free from ghosts of authorization and the good. The absolutely compelling sense of having to act *at all costs* may always be delusional: to Bataille, this in itself makes no difference whatsoever. Bataille has abandoned the good altogether in his understanding of the (absolute) gift. There are countless glorious deeds performed in the world, but strictly speaking none are glorious as being good. They are glorious because they are absolute, extravagant, memorable, more than human, on fire, absolutely wasteful, magnificently losing expenditures. They are glorious in that by them we become the coronations of the instant. But such deeds are neither ethically nor infinitely good. Nor do they seek authorization by contact with another source, an alien source, a sign from a ghost, a sign from an absent spirit. Bataille dismisses the good God altogether. There is only excess and expenditure. When it comes to the gift, there are and will always be sacrifices; Abraham's would be only one of the most interesting but not in any lasting sense unique except, perhaps, as the occasion for our own slowness in relinquishing the thought that sacrifice is performed in response to a gift offered in the name of an absolute good.

But if it is not the matter of authorization or delusion at the moment of expenditure, then what does make a difference to Bataille when it comes to the gift? Indeed, Bataille does attempt to formulate a direction for a new kind of ethics, one he refers to in *Literature and Evil* as *hypermorality*. This would be an ethics not of the good but of the gift which is the sacrifice of the good. It would be an ethics that recognizes the absolute in moments of sacrificial expenditure in human experience but regards these as (1) expenditures without the authorization of a transcendent good or God and, therefore, as (2) expenditures to be given their due but not in any way worshiped as good or transcendent. The purpose of such an ethics is to teach us to regard our sacrificial expenditures in a life-affirming manner. We learn to regard them as adults look after children, as a playfulness we encourage for its intimacy and sense of meaning, but a potentially dangerous playfulness that has costs that should and can be regulated in the name of preserving and affirming this world in which we live. One major problem in this regard with the gift that is conceived as good (and with common morality in general) is that the playfulness of wasteful expenditure goes unregulated because of the assumption that no regulation is required.

Bataille breaks with common morality in putting forth what could be called

an ethics not of the good but of the sun. Hypermorality is an ethics of the extravagance of the sun. As such, it is an inversion of the order in Plato's *Republic*, where the good rules over the sun, where an extravagance of order rules over an extravagance of the energy of life. In Bataille's writings culminating in *The Accursed Share*, in contrast, energy rules over order, the activity of the sun rules over the good. This energy sets all living things including ourselves in motion, and there is no finite, anthropocentric or other species-specific purpose that can ever erase or overcome this fundamental configuration and our role in it. As Bataille puts it, there is "one crucially important fact: Solar energy is the source of life's exuberant development. The origin and essence of our wealth are given in the radiation of the sun, which dispenses energy – wealth – without any return. The sun gives without ever receiving."[7]

At first glance, this extravagance may appear to us to be a good thing: we imagine that we can control this energy and put it to work for us. According to Bataille, however, the sun's surplus is simply unfathomable and too great. We are faced with the problem of dissipating energy, of how to "digest" it all and move it along. This is where the paradoxical need to squander comes from and why sacrifice, in turn, is a gift. All life exists first in a system Bataille calls the *general economy* in which consumption for no other purpose than itself is the demand the extravagance of the sun makes. In the general economy, we are part of the general movement of exudation. Like all living things we are busy oozing and exuding. We have no choice whether to ooze but only some influence concerning how. As Bataille puts it, "energy is always in excess; the question is always posed in terms of extravagance. *The choice is limited to how the wealth is to be squandered.* . . . [M]an is not just the separate being that contends with the living world and with other men for his share of resources. The general movement of exudation (of waste) of living matter impels him, and he cannot stop it. . . . If he denies this . . ., his denial does not alter the global movement of energy in the least" (*Accursed Share*, 23, emphasis added).

Now the ultimate oozing would be to squander life itself. It would be to die. This paper began with the question of whether death is a gift. What Bataille wants us to see is that under the illusion of the sovereignty of the good, in the false belief that it is good, we have given the name *gift* to what is nothing less than *death itself*. To put this another way, under the illusion of the sovereignty of the good, there is a secret death-wish *in the name of what is called a gift*. But to receive this gift would be to receive only death. This so-called gift gives nothing but the ultimate expenditure, meaning the taking of life itself. Yet we are always construing the gift as good instead of seeing it for the exhaustion of the good that it is.

Bataille shows how even the potlatch with all of its excesses misconstrues the gift. He characterizes potlatch finally as "the specific manifestation, the meaningful form of luxury" (76). Potlatch is the means by which wasteful expenditure is converted into grandeur, into achievements then marked by rank. Bataille insists "there remains the prestige *acquired* by the one who wastes. The waste is an ostentatious squandering to this end, with a view to a superiority over others that he attributes to himself by this means" (72–3). In short, the goal is to gain the prestige. Under the false sovereignty of the good,

expenditure is again converted into a seductive and alluring event *in the name of something precious, in the name of the glory* that will be the consequence of achieving this superiority. Under the false sovereignty of the good, the fact of losing is converted into the power of the gift when "this action . . . is brought to bear on others" (70). But the fact remains for Bataille that the ultimate oozing squanders life. In and behind the gift is the expenditure without return, the "gift" of death itself.

What does Derrida receive from Bataille? The last chapter of *The Gift of Death* revolves around the issues of wasteful expenditure, economy, and morality that have just been discussed. I will conclude this discussion touching on them in a manner that if not conclusive may be evocative.

First Bataille's analysis of the conversion of expenditure into a good is fundamental for Derrida's analysis of the gift, of how calculation infects it, of how "the alteration of the gift into a form of calculation immediately destroys the value of the very thing that is given; it destroys it from the inside" (*GD*, 112). For Bataille, the gift wavers on the boundary between the calculable and the incalculable; but the incalculable expenditure without return, for the sake of loss (giving) itself, ultimately exhausts the gift. The gift is the appearance of expenditure under the illusion that the good is sovereign. The gift is ostensibly beyond calculation.

But to abandon calculation would mean, as Bataille shows, to abandon the good as sovereign and hence to abandon the gift. In the complete absence of the good we would never use the word "gift" to describe the currents of oozing energy as they consume us in their swirling expenditures. We only use the word "gift" because we have imagined that such ultimate expenditures are in the service of the good; hence that we gain by them. We have always imagined that the excess is contained, that what is beyond the immediate good will be recouped by the greater good. Bataille says quite bluntly, "Definitively, men lie; they do their best to relate . . . liberation to interest, but this liberation carries them further" (*Accursed Share*, 74–5).

Indeed this is a most pervasive and persuasive lie, the one that makes expenditure into the gift, that makes the gift good, that makes the gift our own. Derrida also speaks this lie or transgression as at the origin/originary intention of philosophy itself. In the piece "Tympan" in *Margins of Philosophy*, for example, he makes the bold accusation that

> believing itself interminable, . . . philosophy – doubtless the only discourse that has ever intended to receive its name only from itself . . . – has always . . . insisted upon assuring itself mastery over the limit. . . . [I]n order better to dispose of the limit, [it] has transgressed it. *Its own limit* had not to remain foreign to it. Therefore . . . it has believed that it controls the margin . . . and that it thinks its other.
>
> Philosophy has always insisted upon . . . thinking its other. Its other: that which limits it, and from which it derives its essence, its definition, its production.[8]

The key question here is that of the other. Is the other within or without,

controllable or uncontrollable, a source of profit or loss, a gift or an expenditure? Philosophy has always appropriated the expenditure as if it were a gift, as if it were good. It has done this by assuring itself that it can do so. What Derrida says in *The Gift of Death* about the Book of Matthew – here making use of Bataille's own terminology – can be applied in this critique of philosophy too: "Such an economic calculation integrates absolute loss. It breaks with exchange, symmetry, or reciprocity" (*GD*, 102). Like Bataille, Derrida takes careful note of the integration of what necessarily remains outside – an impossible integration that will incorporate absolute loss but unbeknownst to itself, under the name of God, under the illusion of Authority, the illusion of the sovereignty of the good.

Finally, there are the questions concerning morality: the critique of common moral reasoning and the directions that a new morality can take. These are obviously the largest questions of all with the future of our well-being and even survival at stake. Bataille's critique of common morality is based on recognition of its oblivion to the danger of the good as harboring expenditures that it can neither acknowledge nor control. Derrida takes exactly the same initial approach. There are two important passages in *The Gift of Death* to this effect: the main contribution of common morality with regard to the problem of absolute expenditure is to cover it up as a problem so that it can be ignored altogether, at least until the sudden outbreaks of violence that come from nowhere and then cannot be ignored – that, however, will only be dealt with after the fact. In chapter three, Derrida mocks moralism and issues this complaint:

> In terms of the moral of morality, let us here insist upon what is too often forgotten by the moralizing moralists and good consciences who preach to us with assurance every morning and every week, in newspapers and magazines, on the radio and on television, about the sense of ethical or political responsibility. Philosophers who don't write ethics are failing in their duty, one often hears, and the first duty of the philosopher is to think about ethics, to add a chapter on ethics to each of his or her books and, in order to do that, to come back to Kant as often as possible. What the knights of good conscience don't realize, is that "the sacrifice of Isaac" illustrates – if that is the word in the case of such a nocturnal mystery – the most common and everyday experience of responsibility. (67)

A second passage, in chapter four, takes this accusatory line of thought farther:

> [T]he smooth functioning of . . . [our] society, the monotonous complacency of its discourses on morality, politics, and the law, and the exercise of its rights . . . are in no way impaired by the fact that . . . that same "society" *puts to* death or *allows* to die of hunger and disease tens of millions of children . . . without any . . . tribunal ever being considered competent to judge such a sacrifice, the sacrifice of others to avoid being sacrificed oneself. Not only is it true that such a society participates in this incalculable sacrifice, it actually organizes it. The smooth functioning of

its economic, political, and legal affairs, the smooth functioning of its moral discourse and good conscience presupposes the permanent operation of this sacrifice. (85–6)

These are forceful ideas, raising the possibility (as does Bataille) of whether the common morality of the belief that the gift is good does its damage in secret, performs its unknown number of sacrifices invisibly, beneath the complacent veneer of "righteousness." Derrida's repetition of the word "smooth" conveys the senses of opacity, impenetrability, methodicity, efficiency, and other distancing qualities that we live with more and more in an age of technology. The suggestion is that our society continues to move blindly in the directions that give the gift of death. The ascent of technology under the simple moralistic belief in ethics as ethical makes the already doubly-hidden gift of death less and less visible. Under the joint-dominion of moralism and technology, the gift of death now becomes harder than ever to fathom and face.

If this is indeed the situation of the present age, it is appropriate to end by underscoring the importance of one of the questions asked when this paper began, now after having gained from Kierkegaard, Bataille, and Derrida an awareness of this question's unique leverage: *Is a gift a good thing?*

16

GLORY IN LEVINAS AND DERRIDA

Bettina Bergo

Dieu se manifeste à Adam; la créature et le Créateur s'entre-
tiennent ensemble: *il parlent de la solitude*. Nous supprimons les
réflexions. La solitude ne *vaut rien à l'homme* . . .
Chateaubriand, *Génie du Christianisme*, Vol. I, p. 229

I. INTRODUCTION

Glory has many senses from the Latin "fame" to the ecclesiastical Latin refer-
ring to the radiance of the opened heavens, to the light emanating from the
saints or the "inspired." For Levinas, glory is comparable to the Greek *phainein*,
but with the increased intensity of radiance. There is both a visible and an
invisible component to the notion, both the exaltation and honor paid to
someone. Under the entry for "glory" in the *Oxford English Dictionary*, one finds
the phrases "resplendent beauty or magnificence" and "splendour and bliss of
heaven." Let us hold these two registers in mind: first, the sense of light and
visibility carried to a hyperbolic, blinding magnificence; second, the honor and
exaltation that accompany beauty or greatness. At this point of coincidence
between aesthetic and ethical spheres, Levinas appropriates the theological
term glory for the non-phenomenal force of alterity.

"Glory" first appears in Levinas' *Otherwise than Being or Beyond Essence*. Indeed
it appears unexpectedly in the midst of a host of traditionally religious terms
borrowed from Jewish and Christian sources.[1] In Derrida, by contrast, "glory"
is little used after *Glas*. Yet the themes of the dissymmetry of the other and
transcendence in immanence are present throughout *The Gift of Death*. There,
the scandal and secret truth of faith as absolute responsibility and absolute
passion respond to Levinas' "glory," while redirecting his use of the term.
History bears the trace of glory as responsibility, as a secret. I will suppose that
glory in *Otherwise than Being* denotes *at once* something visible and beyond the
visible that prepares the way for Derrida's remarks about the secret and the
"gift of death." For Levinas, glory has a dimension of theologico-ethical exalt-
ation, which he calls "*illeity*." In this sense the notion of glory rejoins Derrida's
discussion of "the radical form of responsibility that . . . exposes me dissym-

metrically to the gaze of the other . . ." and "presents itself neither as a theme nor as a thesis, [giving itself] without being seen."[2] This hybrid quality of glory – encompassing elements of visibility and non-visibility – will confront the questions of justice and history in both Levinas' and Derrida's texts. It does so, however, in different ways.

II. GLORY IN LEVINAS' *OTHERWISE THAN BEING*

To approach glory in Levinas, I will focus on chapter V, the penultimate chapter of the work, the second part of which is entitled "The Glory of the Infinite." This chapter follows what Levinas called the heart of the book, "Substitution" which presents the "event" of transcendence in immanence as a dual movement of contraction and opening of the self. In the subject "obsessed" by the desituating alterity of the other, we find a recoil behind itself and prior to its present of consciousness. But there is also an opening-out, through which the identity-less subject "exists" for the other and expresses this "substitution." This sequence is not experientially determinable as "b" follows "a," and there may be no need to argue that persecution and obsession lead simply to substitution and disinterestedness. The "logic" is a complex unity: that of the interruption which affects one at the level of his skin, prior to thought. But this "affectation" is paradoxical because the interruption, as transcendence within immanence, is not an idea. It comes from something external, unassimilable, and transcendent. Moreover, Levinas does not banish from this interruption a religious and theological redolence. Indeed, without this redolence, we could imagine the affectation to be similar to Merleau-Ponty's precognitive "presences," which are "present *as* absent" in all perception.[3] In any event, the interruption, as obsession, substitution, and witness, is invariably depicted as a surplus of pre-thematic meaning, which gives it a hermeneutic indeterminacy that Levinas does not always pursue. Instead, he frames this indeterminacy by arguing that it gives rise to our idea of "God," but also to gratuitous expressions like "after you, Sir."

The task of chapter V, in which "glory" is explicated, brings the fissured self of substitution into thematic proximity with the Infinite, or that to which we refer in the third person singular, expressing both deference and indetermination. "Subjectivity and Infinity" does not indicate to what extent it recapitulates the entirety of the Levinasian ethical and ontological *topos*. However the chapter does elucidate the "structure" of that *topos*, through something like a neo-Platonic schema, which is open at its apex with the Infinite, but also at the base with the Levinasian *apeiron*, the "There is." It is subjectivity's curious "position" to stand between, and be pulled by both poles, though the "There is" is a "force" only in a limited sense. To be sure, it has been characterized elsewhere as a "force on-going" (*force qui va*) and as "being carrying on its train of being."[4] But this "base," this *apeiron*, along with the Infinite, represents Levinas's polemical reinterpretation of Heidegger's ontological difference and invites a reassessment of the latter's history of Being. Hence, the term "force" is both appropriate and inappropriate.

The polemic, in the chapter's first section, entitled "The Subject Absorbed

by Being," is of primary import: "We should first recall the way being carries on on the objective side, absorbing the subject which is correlative with an object, and triumphing, in the truth of its 'move.' . . . Objectivity concerns the being of entities that bears it; it signifies the indifference of what appears to its own appearing. The phenomenality of essence and of the terms that are true is at the same time . . . the epiphenomenality of this phenomenality" (*OB*, 131). The "There is," unlike Heidegger's Being, issues no call. It is indifference and non-differentiation, or – and here Levinas's polemic shifts toward Hegel – insofar as such a substratum can be thought, it is a thought without form or content, yet one that is "a permanent presupposition of the philosophical tradition of the West" (132). But *qua* indeterminacy, the *esse* of Being is dependent upon thought to think it: essence, he concludes, thus "is finite" (132).

The inspiration of Schelling and Rosenzweig in this polemic shows that some aspect of "subjectivity" is not absorbed into the schemas of intelligibility. Levinas will argue that the unabsorbable and reflectively non-assemblable has a dignity that even Kant failed to recognize when he adumbrated the transcendental apperception as a condition of possibility of the "pure exhibition of being in intuition" (*OB*, 134). And so we have the paradox, for Levinas, of the processual Being of being, or *esse*, which is *finite*, yet which unfailingly absorbs the subject when viewed from the perspective of "what is." "[As] other than the true being, as different from the being that shows itself, subjectivity is nothing," he writes. "Despite or because of its finiteness, being has an encompassing, absorbing, enclosing essence" (*OB*, 134). The task remains to ask how it is that the *nothingness* of the ontic subject, caught up in the history of being and thinking that history, might be other than a cipher if one could "view" it from another perspective. Ethics, responsibility, substitution, are in that precise sense a different "optic," as Levinas often repeats.

The third section of chapter V, entitled "The Subject as a Speaking That Is Absorbed in the Said," pursues this problematic and brings us still closer to the *topos* of glory. It employs an informal, negative method to designate the *possibility* of a gap in Western philosophy's assimilation of Being and the subject of knowledge. Debate in this section is engaged with semiotics understood as "[a] science . . . able to totalize being at all levels of its *esse* by fixing the ontological structures that articulate being" (*OB*, 134–5). For such a science, words, even proper nouns, perpetuate a movement of signification that welds being and sense together even at the level of the speaking subject. Although an unthematizable reservoir of signification is presupposed beneath any utterance, following Saussure's schema against which Levinas is reacting, this reservoir (whether Saussure's "paradigmatic axis" or Heidegger's silent call of Being) is always a potential representation. That is, it brings with it nothing that exceeds the enclosure of being and its meaning. Levinas writes, "The said can indeed be understood to be prior to communication and the intersubjective representation of being. Being would have a signification, that is, would manifest itself as already invoked in silent and nonhuman language, by the voices of silence . . . the language that speaks before men and harbors the *esse ipsum*" (*OB*, 135). If remarkable within their respective logics, the semiotic reservoir of meaning and the Heideggerian proto-language of silence both function at a more radical

level than those contained in much of Western modernity. But the outcome of these accounts is nonetheless analogous – and more pernicious, because now nothing may legitimately claim to surpass discursive meaning. The synthesizing *élan* of Western thought thus gets extended poetically and speculatively beyond itself, yet it never leaves its own movement.

In this polemic Levinas first speaks of a "gift" (*OB*, 135). This gift is perplexingly immanent, like a talent or special capacity; but Levinas' concept of gift would suggest an opening in the subject and outside of itself. This gift is freedom understood as the spontaneity of our power. But such a gift is not an aptitude of the subject: "the psyche in the subject then consists . . . in its gift for synchronizing, commencing, that is, [in] its gift of freedom . . ." (*OB*, 135). Here the polemical characterization of the history of philosophy, insistently denoted as "Western," as Athenian *par excellence*, comes to an end.

The fourth section, "The Responsible Subject That Is Not Absorbed in Being," moves toward a positive reinterpretation of ethics as first philosophy. It does so, as we know from elsewhere in Levinas' work, because ethics is not first the question, "what *should* one do?" but the response demonstrated by the fact "*that* one has done." Without hearing a call or pondering alternatives, we have already responded, and with unchosen sincerity. Although this is neither the act of free agency, nor its implicit capacity for engagement, the pre-thematic responsibility is characterized frequently as activity *at the level of signification*. Levinas says, "It signifies outside of all finality and every system. . . . The models of being and the subject–object correlation . . . do not depict signification, [or] the-one-for-the-other. [Signification] shows itself in the said, but does so only after the event . . ." (*OB*, 135). Important here is the *way* in which the arguments are tied to signification, setting up a movement beyond phenomenology into a semiotics of responsibility *qua* Saying. Glory will play a significant but complex role in this schema. For glory is one of the qualities of being-for-the-other and of its expression. And "glory" resonates with Biblical prophetism and forges a *path* through rabbinic thought, between Biblical commandments, halakhic interpretation, and the ethical hermeneutic of Judaism to which Levinas is heir.[5]

The final section, chapter V, part I, or "The-One-for-the-Other Is Not a Commitment," completes the polemical elucidation of responsibility as "dislocation" and an "inwardness without secrets."[6] Here, responsibility is a witnessing that requires not so much language as a "gift" that is different from the first gift or aptitude for initiative. Levinas describes the "gift of my own skin." This gift characterizes an understanding of the human which does *not* start with transcendental apperception (*OB*, 138–9).

In the second part of chapter V glory is the *leitmotif*. The language of this section draws heavily on Biblical figures and terms, from the Talmud, the New Testament, and Jewish and Christian mysticism. These terms include "glory," "inspiration," "pneuma," "election" (*OB*, 141); "exile" (*OB*, 142); "life without death"; the figure of being flushed from the "thickets of paradise" (*OB*, 144), the self leaving the clandestinity of its identity (*OB*, 145); "revelation," "epiphany" (*OB*, 149), "kerygma" (*OB*, 151).[7] More evidently than elsewhere in his work, Levinas effects a significant transposition of

terms and figures from an aggregate of religious sources into a "secular" philosophy.

The discussion and transposition of glory begins with the gift at the intersection of two actions and two "forces": first, obedience to a command that is never present, yet passes through giving and its (present) time. Second, the invisible order whose "voice" I recognize in my own, thanks to "the *trace* of its reclusion" (*OB*, 140). Glory will move between these poles of the present time of appearing *and* the trace without a temporal reference. Thus glory is a trace whose "cause" is approached through its effects: like an event that is glorious because it exceeds itself. Yet should we not be shocked by the strange idea that glory "appears," moves us, and "is" glorious? The tendency is strong in linguistic practice to make "glory" a noun, but the glory of the face or the sun depends upon these, even as it goes beyond them and makes them invisible. So a figure like glory works at the same time as a quality of something and as a medium which can be approached for itself. This double status has ontological implications. For Levinas, traces, glory, and unheard commands create partial mediations between the subject and the Infinite. But these mediations do not insert the subject and the Infinite into a traditional dialectic. Here too, in the same paragraph, Levinas' contrast between a gift of self and the idolatrous gift is apt: certain of the "inspired" books of the Bible, like Samuel which Levinas cites, face a comparable task of keeping the gift and the name *out* of an idolatrous logic, keeping these away from certain types of rituals, and preventing the name from thaumaturgy. If this appears to be a task irrelevant to philosophy, it is what Levinas does when he speaks of the subject in relation to the Infinite. And so, as if to anticipate this, he announces that "Being fails in the diachrony of transcendence" (*OB*, 140). But sometimes diachrony also fails, for glory enters with difficulty into the text. And idolatry, as the reification of glory, is always possible.

For this reason the paragraph that follows changes its voice. It shifts to indirect witness, like a middle stance between argument and prophetism: "This book has exposed the signification of subjectivity. . . . This book has exposed my passivity" (*OB*, 141).[8] Yet Levinas does not stay with this voice, he turns back to interpret it philosophically, and his interpretation seems to be a secondary moment in his giving. That is, in Levinas' text, his gift is certainly a speaking to us, very much like the address of the prophets, but it doubles itself with its own interpretation, like a midrash: "There is a claim laid on the same by the other in the core of myself, the extreme tension of the command exercised by the other in me over me. . . ." Then he interprets: "Through this alteration, the soul animates the object; it is the very pneuma of the psyche" (*OB*, 141). Here, remarkably, Athens and Jerusalem do not seem far apart: we have only to think of *pneuma* in light of Biblical accounts of inspiration. Yet for Levinas this animation leaves one sick, for the self is "already a psychosis" (*OB*, 142).

With Levinas' reconception of the soul as obsession, with his reversal of the order of beginning and his placing of an abyss in the site of the "*arché*" of subjectivity – with all this it becomes possible to revisit notions like "intelligibility" and "identity." They may now be understood like the surface of an

agate, alluring and complex thanks to the layers of luminosity. Intelligibility points toward a "signifyingness" and a "restlessness that drives me outside the nucleus of my substantiality" (*OB*, 142). This rethinking of intelligibility is the purpose of the section.

The following section, "Inspiration and Witness," prevents the movement inaugurated by inspiration from opening a passage that is a transcendence-without-return, that is, a transcendence that would be the irrecuperable loss of self. If this stratagem appears to defeat Levinas' long-pursued purpose of defining ethical transcendence as that from which one does *not* return, it points to one of two major difficulties in his text: how is it that the fissured self is not psychosis pure and simple, and how can its gift be "felt" as giving bread from one's mouth is "felt" and "understood"? The difficulty is to preserve enough reflective freedom so that the approach of the other does not become the *alibi* for divine necessity. Without this freedom, the gift would become unequivocal. There would be "nothing," no subject to make the approach to the Infinite: "An ultimate substantiality of the ego [subsists] even in the very vulnerability of sensibility, and at the same time, or in turn, ambiguously, the infinite path of the approach" (*OB*, 142). The difficulty of determining an order of "events" and reasons threatens the project at this point: vulnerability must revert to freedom and activity, yet the moment of vulnerability's openness must "persist" long enough for signification to be non-thematic, meaningful yet extra-linguistic: in a word, "glorious."

This tension between passivity and activity, freedom and command is characteristic of Levinas' philosophical and religious writings; it becomes the ethical limen of the experiences to which theodicies and mystical readings of rabbinic discussions address their response.[9] One thinks of the Talmud's preservation of the Pharisaic sages' remark, "All is foreseen, yet permissiveness is given." The transposition of the gift from an economy of exchange into sincerity for nothing, which *holds forth something like its own freedom as its gift* to the other, parallels the secular transposition of Talmudic teaching into his transcendental ethics. So it is no accident that Levinas opens *Otherwise than Being* with citations from Ezekiel *and* Rachi's enigmatic commentary on Ezekiel: "Do not read 'begin at my sanctuary' [i.e. the site set apart as site of the Infinite], but 'begin with those that sanctify me.' . . ." Human freedom and action are more than ingredient to "glory," significant elements of rabbinic thought hold that human action completes, even creates, divine glory.[10] Such speculation is never lost on Levinas: he calls this vulnerability of the self, which opens *and* closes because freedom is never lost entirely, "living infinity" and the "life of the Infinite or its glory" (*OB*, 142).

As fire and light, glory – understood in its ambiguity as action, obedience, but especially as the force of excess at the heart of sincerity and giving – this glory *burns*. He speaks of the "glory of the Infinite" burning subjectivity to the point of "ashes from which an act could not be born anew" (*OB*, 143). Nothing is said of the incendiary effect of the gift upon the receiver partly because the inspired one prophesies in receiving the gift, so glory "glorifies" as the fire of the self receiving and saying. But what if the "scandal of sincerity" and its exposure of self for-the-other had a different effect, indirectly, say, on the

others? The question concerns the passage of "ethical" glory, or the saying of a revelation, into history. If this passage into history is possible, it cannot be made in the form of a dogmatic eschatology, nor in that of an orphic sacrality. Derrida will remind us that for Jan Patocka, religion transforms the pagan sacred into responsibility.[11]

Levinas, in his discussion of prophetism, must keep his prophetism ethical, and protected from orphism. This means that prophetism must remain separated from all fascination with the infinite materiality of "There is": the gift is first a gift of self; and, although our hands are not empty in the giving of a gift, it is not possible for the gift to be concentrated in its "substance." So the first gift Levinas mentioned, our "gift" for representation and for having the "present," always risks being false, simply an *eidolon tou logou*. But Levinas makes his task easier than it actually is by avoiding extensive discussions of history in his ethics, though elsewhere he speaks of history and the Jews and of history as a Jew.

Two limits must be drawn: the one between the religious meaning *eo ipso* of Levinas' thought *and* the secular deployment of it; the other between the complex ethical inspiration of the subject *in glory and* the ramifications of glory in history. It may be miraculous that the others treat Levinas as an other (*OB*, 159–60), but the others also fail to do so – and, horrifically, that failure may also be the occasion for the glorification of glory, but then glory becomes resistance, requiem, or a dark light. I am chiefly interested, here, in the first limit, that between the secular deployment of Levinas' philosophy and its religious intuitions. "Glory" is an apt concept with which to approach this limit.

"Sincerity and the Glory of the Infinite" (section c) underscores the duality of the movement between the subject and the Infinite. The problems this duality poses to thought are less resolvable in Levinas' philosophy than they are in his religious writings. In his philosophy, the human other carries the trace of the Infinite and approaches "me" as I also approach the other. A figure for this dual approach is found in "A Religion of Adults," where he identifies a Talmudic passage as illustrating it precisely: "Never did God descend upon Sinai," and "never did Moses ascend to the heavens. But God folded the heavens like a blanket, covered Sinai with it, and thus found Himself on earth without ever quitting the Heavens." Of this figure, Levinas declares, "There we have a desacralization of the Sacred" (*Difficile Liberté*, 34). Paradoxically, this is *not* a secularization: it is because the Sacred remains other, *and* sacred, that justice may be given or "rendered" to the neighbors *as something more than the Greek* dikaion *or just proportion.*

If justice *joins* charity here, Levinas' desacralization must also interrupt itself and not try to deny the sacred "origin" of justice, or the sacredness (and unthinkableness) of origin *tout court.* That is, it is not Moses who folds the heavens, although for Moses this "event" constitutes his "divine psychosis." What is more, it is not essence that is infinite. Glory does not come from essence, glory *is* the "essence" of Infinity. As Levinas puts it, glory is the "infinition of infinity" (*OB*, 144) – and infinity is never a reified or ontic continuum posited repeatedly in time as time's own standard. The infinition of

infinity is a recommencement without an agent, whether human or divine: "Glory is but the other face of the passivity of the subject" (*OB*, 144). Not, for all that, the subject's activity. We might even say that it is the inconceivable "other face" and other name. As the "other face," glory opens the possibility of a glorious repair by the creature of all that composes the creator. I make this point because in neo-Platonist and Judaic mystical traditions "glory" denotes the filling of the cosmos by the movement of the divine. There, glory is the "pleroma," the site of excess *qua* divine excess itself. At this point in *Otherwise than Being*, Levinas is anything but removed from a neo-Platonist logic – astonishing, however, is his secularization of that logic.

We understand as much when he refers to the expansion, intensification, and elevation of glory in the approach of the *subject* to the Infinite: "Glory is glorified by the subject's coming out of the dark corners of the 'as-for-me' which [are] like the thickets of Pardes in which Adam hid himself upon hearing the voice of the eternal God [and] . . . in which the position of the ego . . . and the very possibility of origin, [are] shaken" (*OB*, 144).

Here begins prophetism. But the prophet, burning bright, is the meeting point of the two approaches of subject and Infinite, and if justice and charity are born from this "encounter" (better, justice as charity), some commentators have suggested that a "spectacle" and a "paroxysm" are likewise born there, with the prophet prophesying. Thus, Levinas' friend and associate, André Néher, remarked in regard to the "spectacle" of Ezekiel, "One must be able to read these verses (Ez. 33:30–33) in the Hebrew text, for the translation can only attenuate . . . the subtle nuances of a feigned irony, which hides with difficulty . . . the agitation before a situation as unexpected and hurtful for God as for his prophet."[12] The irony is precisely that this glorious approach, thoroughly spiritual, must find its way into language and into a style apt to carry it. This, of course, is almost impossible. As Néher puts it, "in the perspective of the spectators" (he adds, "of the Chaldean Tel-Aviv where the Judean 'deportees' are living"), "the prophecy [of Ezekiel] attains the absolute degree of a *game*" ("*Ezéchiel*," 75). The "game" here is the play between the *form* of the testimony and the *message* of the prophet. Ezekiel's spectators desire to hear him. Néher writes, they "enter profoundly into the game; they experience with delectation that a psychophysical accord is established between the spectacle and their intimate personalities; they are seduced and transported into the universe where they have the impression of discovering *themselves, by themselves*, in their essential tendencies" (75, emphasis added). Here Levinas' famous ambiguity between the Saying and the Said is differently elucidated – these hearers "simultaneously . . . remain outside the game; . . . after the spectacle's end, they find themselves again, identical to themselves . . .; the spectacle slides down upon them, without tomorrow, nor engagement, with, at the most, the memory of a melody on their lips, and the desire to hear the star again . . ." (75). Is this where we find ourselves as well, we who have walked with the improbable thematic unfolding of Levinas' secular thought? Has glory, as the quality, the exaltation of this unfolding, exploded into a false pleroma of letters? Do we have a sense of a game, here?

The story Néher recounts does not end there. Following the investigations of

the Viennese psychologist and Biblicist, Jacob Moreno, Néher adds an ultimate twist. In "this *reduction*, suggested by the scene in its entirety, of the *contents* of the Word to its exclusive *aesthetic form*, this *supplement of piquant atmosphere* provoked by the deliberate confusion between the Biblical pathos of conjugal symbolism and the lyricism of ribald erotic poems: all this would constitute a sufficient sum of factors for *scandal,* . . . if another factor did not add to this scandal a supplementary point which carries it to the paroxysme . . ., that is, that *God consents to make himself complicit with this scandal and obliges the prophet to enter, with Him — and the auditors — into the game!"* (76).

How should we place the actors of this "scene" within Levinas' discussion of glory? There are two scandals here, one to avoid, one to embrace. If we remain faithful to the "idea" of the Infinite, and the "glory of infinity" (*OB*, 145), as meanings which impel, but dissolve in our words, then we avoid reifying God in the way that an initial reading of Néher's account of Ezekiel might do.[13] That is the scandal which must be refused, because the scandal of reifying God obturates justice and responsibility by setting the players into ontico-mythical roles. The scandal that cannot be avoided is the *paradox* of the approach discussed above and of "glory" as its forces and intensities. There is, then, a recurring risk of aestheticism in these pages of *Otherwise than Being*. Levinas is aware of it as he "makes [himself] a sign" (143) and bears witness "to the glory of the Infinite" (146).

However, aestheticism and comedy are not Levinas' primary apprehension. He embraces the risk and is not without irony when he cites Paul Claudel (quoting the Portuguese proverb), "God writes straight with crooked lines" (147). We too must embrace this scandal in order to approach revelation as responsibility *in* (our) history. This is what Derrida, following Patocka, called the "reduction" incumbent on religion and idealism. It is not the task of a dramatic, formal reduction: its capacity to become historical depends upon preserving "glory" without irony, as glory enters everyday responsibility, which itself hesitates between proportion and measurelessness. This task takes Levinas and Derrida in different directions. It leads Derrida to the question of the responsibility beneath the history of Europe, thus to a secret history of responsibility, while for Levinas, the reduction of "divine psychosis" into everyday responsibility also founds social life, albeit more abstractly. His reduction produces signs and texts: "Glorification is saying, that is, a sign given to the other, . . . responsibility for the other to the extent of substitution" (*OB*, 148). This characterization of glory brings us to Derrida's discussion of the gift of death.

III. DERRIDA'S ELLIPSIS OF "GLORY"

In this section we observe how Derrida honors the site of glory by declining its name. The reduction "incumbent" on religion opens a circle of questioning that runs through *The Gift of Death*. The circle looks like this: If philosophy, then religion (as Platonism and Christianity) had the task of sublimating and repressing orgiasm in favor of responsibility, then the secret history of the West is the history of responsibility. The circle comes back to its starting point with

the following question: what is it about our mortal condition that makes religion possible *as responsibility* and not merely as orgiasm? Here responsibility rests on the possibility of a gift that makes a sacrifice. To enter this circle, Derrida examines a single essay of Patocka entitled "Is Technical Civilization a Civilization of Decline, and Why?"[14]

The essay's interest for Derrida lies in the larger question to which it is a response: Is there a phenomenological approach to history and the ethical forces that shape it? Patocka's essay (his own essay on technology and Europe) develops the argument that the history of Christian Europe is founded upon an historical "conversion" (*GD*, 10) of three mysteries: "orgiasm," "Platonism," and "Christianity." The real mystery is what Levinas would call the drives of sensuous life. In this "life" humans establish ritual and symbolic connections with a transcendent *topos* that sets certain drives apart from the everyday. But "orgiasm" – understood as the "genius of paganism" (with its multiple divinities and its ability to symbolize and narrate the vicissitudes of the *conatus essendi*) – appears *destined* to be sublimated, first by Platonism, as if the sacralizing of natural necessity threatened culture less by the excesses it acted out, than by the denial it made possible of human's mortality and, as a result of this, its destruction of the possibility of an ethical gift.

Platonism never fully submerges orgiasm. Though it frees the soul to receive the death of the body, it holds the Good beyond human actions and so, for Patocka and Derrida, it creates freedom but does not complete the transformation of passional excess into responsibility. This will be the task of Christianity. Nevertheless both Platonism and Christianity contain the mystery of orgiasm and the mystery brought about by orgiasm's repression.[15] So Platonism and Christianity also become, each in its way, mysterious and abyssal. Both of them are haunted by thaumaturgy and theiurgy. Yet, as the form of the secret history of Europe, they also bring with them revolutions in the structure and self-conception of the European subject *qua* soul and *qua* moral actor. Despite the inordinate, subterranean violence implicit in these, as in any "conversions," despite the fact that running parallel to a reflection on conversion is the *violence* of twentieth-century European wars, Patocka contends that this history (written and unwritten) has brought itself to decline because the meaning of the Christian subject or "person" (*GD*, 24) has never been "adequately thematized" (25) within Christianity (or philosophy) itself.

Is this what Derrida would argue was Levinas' contribution: the elucidation of the unexamined structure of ethical subjectivity? It is hard to doubt it. Rather than giving Levinas' gift back to Levinas, Derrida addresses Levinas through the Christian "others." The reasons for the inadequacy of reflection on the subject are many. Derrida believes they depend upon the secrecy of the impetuses that subordinate orgiasm. So these reasons open the question of what leads to a thinking that could convert sensuous excess into responsibility and monotheism. For the Platonic "incorporation" of orgiasm was unaware of its "deep" motivation, and the Christian "repression" placed the pandoran box within the confines of the "Mysterium tremendum" or the idea of a gaze that watches me but which I can never see. This made possible a "subject" at once judged from within and ransomed from without, one whose "situation" was

known to him yet beyond his knowing in its integrity. For Derrida, the Christian repression rebuilt the *forum interioris*, making it the site in which the departed *eschaton* or the risen messiah could speak. Thus the pairs monotheistic sacred/religious secret and sensuous desire/responsibility share an intrigue whose motivation and consequences now call for rethinking. This summons opens the possibility of setting Levinas' responsibility and justice (as radical heteronomy, gratuity, and elevation of the other/s) alongside a phenomenology (in the Hegelian sense) of the Platonic and Christian West as the historical site *par excellence* of their symbolic transformation.

However, genealogies of responsibility and the sacred are not the sole privilege of Jan Patocka, and we might wonder why Derrida did not turn to Freud or Nietzsche, Frazer or Toynbee as his representatives in exploring these themes. It is not accidental that Derrida gives Patocka, as a Christian and a historian of European responsibility, so much space, for he takes the history of Europe seriously as a history of Platonic-Christian struggles against and for responsibility as well as for the signs, names, and sites connoting its recipience of a gift and a "right" of election (*droit, Recht*) whose ground is neither human nor "natural."

Derrida holds in suspense the question of Christianity's debt to Judaism and to Jews. I suspect that posing the question of responsibility to Christianity – especially when Heidegger, Kierkegaard, Jesus, and Nietzsche provide the food for thought in his chapters – does one of two things or both. First, it avoids confronting Levinas' description of responsibility, and so also avoids the tension between his philosophy and his Talmudic hermeneutics, while passing on his gift to the others (Christians and, arguably, postmoderns). Second, it approaches Levinas' thought and his gift obliquely. Thus it takes to task Judaism's "onto-theological" offspring (Christianity), in which the *eschaton* is simultaneously human, historical, *and* divine. The history of Christianity *and* the structure of its teaching permit Derrida to pose the question of history and responsibility differently than does Levinas. Moreover, in Derrida's essay, Judaism appears in conjunction with Christianity and Islam, as if the problems of responsibility and Western subjectivity had to surpass any single monotheism. But Judaism is not just any monotheism. Be that as it may, the philosopher Levinas appears in conjunction with Kierkegaard and in contrast with Heidegger. Yet the questions of the work always rejoin him: What is responsibility, and what "absolute responsibility"? Where do history and the quotidian stand in relation to these? Is history possible without them? What, indeed, is our consciousness that absolute responsibility might go unrecognized, yet somehow be *understandable* when a philosopher "describes" it to us? Finally, what is it to be, or to act, from absolute responsibility?

The presence-absence of Levinasian glory goes together with the recuperation, in chapter three, of five explicitly Levinasian themes: substitution, the extra-temporal moment of responsibility, ethical singularity, disinterestedness, and witnessing. Yet Derrida redirects these into his own remarks on what may be two impossibilities: the economy of pure sacrifice and the unspeakable responsibility which gives the gift of infinite love, without a commensurate and parallel irresponsibility (*GD*, 77). Further, Derrida refuses to set down whether

or not eschatology – in Levinas' sense of the ethical optics that does *not* belong to history – can or cannot enter history as glorious and gratuitous.

IV. THE STRUCTURE OF *THE GIFT OF DEATH*

The Gift of Death has an aporetic form incongruent with *Otherwise than Being* unless that aporia should prove to be something like the glorification of Levinas' glory. To begin with, the voice in *The Gift* is polemical, interrogative. The aim is neither to bear witness to glory, nor to elaborate a "positive" philosophy. The work is not programmatical. Nor is it Derrida's last word on Levinas.

The text is divided into four chapters. The first, "Secrets of European Responsibility," to which we have referred already, relies upon Patocka for a propaedeutic to the notion of the history of Western responsibility. It uses Patocka's essay, further, to explore a conjunction between this history and a series of "secrets" that accompany each of its spiritual revolutions, and determine their deployment.

Chapter two, "Beyond," brings to mind the final chapter of *Otherwise than Being*, which bears the short title "Outside." But Derrida's "Beyond" is a passage *beyond* the question of the transformation of orgiasm into responsibility, *beyond* as the "gift of death," what *we all receive* from the fact of our mortality, namely, the ethico-existential meaning of our irreplaceability. The "gift of death" also denotes the impossibility of giving our lives, or our deaths, to another: no sacrifice from us can take the other's own death from her. This means that the economy of sacrifice is *de facto* limited (*GD*, 43ff.): it may be enacted personally or represented in symbols, it may be witnessed to, but the gift we give from our irreplaceability as mortal subjects debars us from substituting ourselves for the other. In "Death and Time" Levinas says, "I am responsible for the death of the other to the extent of including myself in that death," and Derrida asks, "What can be meant by 'including myself in that death'? Until we are able to displace the logic or topology that prevents *good sense* from thinking that of 'living' it, we will have no hope of coming close to Levinas' thinking, or of understanding what death teaches us, or gives us to think beyond the giving and taking, in the adieu" (*GD*, 46–7). Yet the logic *preventing* "good sense" from thinking such an inclusion here proves to be beyond Derrida's intention to displace it.

Ironically, this is *also* one of the meanings of the "beyond" that entitles the chapter. Derrida will go "beyond" Patocka, but does he "come close" to Levinas? Perhaps he does so, modestly and ultimately, by refusing to foreclose the possibility that "good sense" and, in a direct reference to Nietzsche, what he will call "belief" are themselves abyssal, where belief contains more than the greatest of the iconoclasts could see. "Coming close" to Levinas *also means* – outside of any lesson of Heidegger about irreplaceability, being toward death, and particular sacrifice – "understanding what death . . . gives us to think." The "or" that connects the words "Levinas's thinking" and "understanding what death teaches us" is inclusive. But Derrida postpones it to a future examination of the "ethical dimension of sacrifice" (48).

The impossibility of giving our death to someone (it is still *we* who die, there

and then), the impossibility of taking the other's death from her (44ff.), permit Derrida a "deduction of responsibility and freedom," and an initial deepening of his thinking on the subject (51, 46, 45). Yet this deduction is really Patocka's and, like any deduction, it functions openly, and so destroys a quality Derrida claims is intrinsic to responsibility: secrecy. For his part, Derrida will *use* the deduction of responsibility from mortality to impugn Levinas' notion of substitution.[16] This amounts to a provisional and incomplete critique of Levinasian glory and prophetism. But again, Derrida does so *via* Christianity. For the deduction of responsibility which, along its historical itinerary, began with Platonism and "turned" into a gift of love in Christianity (40), will turn again, in Patocka's logic, into responsibility-culpability. Thus historical Christianity and that of Patocka himself (48), meet in a new demand for the ransom of culpability with an *absolute* gift. This is the gift of infinite love which is infinite because it can, or must, forget itself *qua* gift. Everything henceforth turns upon the possibility, doubled by the absurdity, of an absolute gift absolutely forgetting itself, and the subject who enacts this complexity. In this way too the Derridean text lines itself with the Levinasian one with this proviso: Levinas' gift need not forget itself because it is not recollectable *qua* event. So the danger that threatens the Levinasian gift is not "anamnesia" or failing to forget absolutely, but the skepticism philosophy reserves for transcendental descriptions (*OB*, 165–71).

Three ideas lead us to chapter three: first, the appearance of responsibility with Platonism; second, the "deduction" of the possibility of responsibility from the meaning of Dasein's mortality in Heidegger; third, Christianity's sublimation of responsibility-culpability into a gift. In this chapter, "Whom to Give to" or "Knowing Not to Know," Derrida examines the paradox of responsibility at the heart of Christianity, this time, as interpreted by Kierkegaard.

Kierkegaard's Christianity, which is *not* that of Patocka *or* Western history, rules out as superficial any "open" deduction of responsibility. For Kierkegaard, there is no simultaneous deduction of responsibility and freedom! The impossibility of substitution noted earlier, also gets re-opened as a question, since, by his return to Kierkegaard's Abraham, Derrida makes it clear that if Abraham gives death to Isaac, he also gives it to himself as he offers Isaac to God.

The words in the chapter's title, "whom to give to" are declarative and interrogative. As a question, "whom to give to" is not an issue for Levinas. It is no more an issue than what follows, because "to know not to know" is, for Derrida reading Kierkegaard, Abraham's affair, not Levinas'. Abraham knows what he must do, he knows whom to give Isaac to, just as he knows to whom he would give himself. However, he does not *know* what he knows; at least, he knows he cannot "tell" the command he has "heard." If he did so, he would cede to a temptation to make that command a matter of a fantastic, public knowledge or even prophesy, and Abraham would return to an everyday, moral responsibility. But the question here is as it was for Patocka: is there a responsibility, call it a glory, from which "religion" – Christianity under the circumstances (no small effacement of "Jerusalem") – could arise (*GD*, 50ff.)? Beneath this question lies another: did the Platonic Good, as Patocka claims, descend

from the eidetic into the realm of human "action" as goodness and love? If so, what made *it* possible?[17] Derrida will not rest satisfied with the co-originarity of guilt and responsibility *taken as the motivations for infinite love*. If he accepts that co-originarity, he does so knowing that it motivates a gift, and destroys its own motivation. Whatever he would conclude about Levinas' "glory," he would not see glory in that. For then the infinite gift of forgetful love is not glorious but culpable; or worse, when it is given, it anticipates a heavenly reward. The old economy of favor and recompense would return in a dogmatic, exaggerated form. Glory would be empty hyperbole. How then does Derrida stand in regard to glory?

The final chapter "Tout autre est tout autre" – translated as "every other is every bit other" – answers this question ambivalently, the same "ambivalence" that Levinas proclaims is the duty of philosophy to thematize and so, to reduce and betray (*OB*, 148, 152). There is something tragic or ironic about the indeterminacy of this epigram, which Derrida likens to a *shibboleth* – but which is redolent of Melville's Bartleby, "I would prefer not to." Does it express an "either/or"? That is, either every last person is irreducibly different and other, and so I have a duty to betray them in order to serve one other.[18] Or every other is just every other, and a logic of identity reasserts itself. If we choose the first option, Derrida explains, then neither Kierkegaard nor Levinas can hold the ethical and the religious apart. They become as mirror images of each other: how, after all, should Levinas maintain the infinite alterity and glory of the absolute, divine other and the infinite alterity of the human other? Where does glory come from? If it is mundane, then it is a metaphor for fame. If it is otherworldly, then in its metaphoric exaltation it slides into a *megala psuche* that is secret nonetheless, because as both Plato and Ezekiel knew, with too much light we see nothing. Derrida realizes this and speaks of the Christian secret as a love (a glory?) that "burns" and "sees" (*GD*, 88).

The question of glory is this: Can a secret dimension of the sacrificial economy save it from the quotidian economy of exchange? This might be possible if the secret were hidden because "it extends beyond the visible," like glory (89). But this is not the path of Christianity. There the ultimate source of the ethico-religious dissymmetry lies in the gaze that sees me without my seeing it. Derrida cites Jesus' promise in the gospel of Matthew, "your father who sees in secret" (91). But the subject who receives itself, in faith, as seen by the wholly other whom it does not see, carries within itself an "interior light" or a glory such that this subject has no further secrets to anyone (100). What is responsibility without a secret dimension, or as Levinas puts it, without an enigma? Derrida pushes the gospel's logic to a final, Eckhardtian extreme and goes where Levinas would not go. This subject, the visible vehicle of transcendence in immanence, is more than the practical translation of the Platonic Good, as Patocka argued. The public and secret (109) light in me is "what I call God in me." And what I call God in me allows me to call God to me, or "to call myself God" (109). The ambivalence of the French is better, "*je m'appelle dieu*."

What are we to do with this *other* drama of the soul? It presents both a mystical hyperbolism and something like Hegelian logic compressed within it. What happens to glory when "*je m'appelle dieu*"? How can there be glory

without some preservation of alterity between "me" and God – but then, are we sure that alterity has been lost when we call (unto) ourselves God? I ask this because this drama does not look quite like Néher's or Levinas' prophetic drama.

Derrida reminds us that this was what Patocka was seeking in the unthought depths of Christian subjectivity, viz., a different drama, that "of redemption and grace" (Patocka, "Technical Civilization," 114; GD, 94). Yet the drama of redemption and grace is not so different. It mimes the worldly economy because the promise of redemption is also the promise of a reward unthinkably great. So the secret, the glory of the interior light, retains its secret. That is, it retains the secret indeterminacy of the economy of redemption: is redemption merely a reward for the burden of a faith that would escape the economies of exchange but which slides more deeply into them as it drifts into history and institutions? Or is redemption an "other" economy? Derrida does not decide about glory. Instead, he leaves us with the responses of Baudelaire and Nietzsche. The first exclaims, "Impossible to take a step, to speak a word without stumbling into something pagan" (GD, 110).[19] The second, Nietzsche, concludes that the God "who personally immolat[es] himself for the debt of man" represents the "stroke of genius" for a tortured humanity, without, one should add, a covenant.[20]

The wager on glory is clear enough in Derrida. What, however, is the wager on Levinas? Can it be less clear? Let us recall a text of Nietzsche with which Derrida is familiar. This is Nietzsche's response to the question "For what should Europe be thankful to the Jews?" "For a lot, for good and bad, and most of all for that one thing that is simultaneously the worst and the best: for the great moral style, for the awe-fulness and majesty of the absolute demands, of the absolute interpretations, for the . . . sublimity of the moral dubiousness."[21] Is this Judaism, or indeed, a Derridean Kierkegaard? Is Levinas a great moral stylist? Does he "speak with blind alleys about the face-to-face, about its expatriate meaning," as Celan once wrote?[22] That is not, perhaps, an either/or, and Derrida does not answer us, now.

ABBREVIATIONS

AO Gilles Deleuze and Félix Guattari, *Anti-Oedipus: Capitalism and Schizophrenia.* Translated by Robert Hurley *et al.* Minneapolis: University of Minnesota Press, 1983.

BT Martin Heidegger, *Being and Time.* Translated by John Macquarrie and Edward Robinson. San Francisco: HarperCollins, 1962.

CC *Cronenberg on Cronenberg.* Edited by Chris Rodley. London: Faber and Faber, 1997.

CQVM Benedetto Croce, *Ce qui est vivant et ce qui est mort dans la philosophie de Hegel.* Translated by Henri Buriot. Paris: Giard et Brière, 1910.

DMD Pierre Cabanne, *Dialogues with Marcel Duchamp.* Translated by Ron Padgett. New York: Da Capo Press, 1987.

EE Elzbieta Ettinger, *Hannah Arendt/Martin Heidegger. Eine Geschichte*, "aus dem Amerikanischen von Brigitte Stein." (*Hannah Arendt – Martin Heidegger* [abbreviated English ed.]) Munich and Zürich: Piper, 1994. Translated by Ettinger. New Haven: Yale University Press, 1995.

EU Hannah Arendt, *Essays in Understanding, 1930–1954: Uncollected and Unpublished Works by Hannah Arendt.* Edited by Jerome Kohn. New York: Harcourt Brace, 1994.

GD Jacques Derrida, *The Gift of Death.* Translated by David Wills. Chicago: University of Chicago Press, 1995.

HC Hannah Arendt, *The Human Condition.* Chicago: University of Chicago Press, 1958.

HD Joseph Conrad, *Heart of Darkness.* New York: St. Martin's, 1989.

LM Hannah Arendt, *The Life of the Mind.* 2 vols. New York: Harcourt Brace Jovanovich, 1977.

MDT Hannah Arendt, *Men in Dark Times.* New York: Harcourt Brace Jovanovich, 1968.

N André Breton, *Nadja.* Translated by R. Howard. New York: Grove Press, 1960.

OB Emmanuel Levinas, *Otherwise than Being or Beyond Essence.* Translated by Alphonso Lingis. Dordrecht: Kluwer Academic, 1991.

OC André Breton, *Oeuvres complètes.* 2 vols. Edited by Marguerite Bonnet, P. Bernier, E.-A. Hubert, and J. Pierre. Paris: Gallimard, 1988 and 1992.

OR Hannah Arendt, *On Revolution.* New York: Viking, 1963; reprint, Harmondsworth: Penguin, 1979.

OT Hannah Arendt, *The Origins of Totalitarianism*, second enlarged edition. New York: Harcourt Brace Jovanovich, 1951.

PN G. F. W. Hegel, *La philosophie de la nature de Hegel* (Hegel's Philosophy of Nature), 2 vols. Translated by Augusto Véra. Paris: Ladrange, 1863–66.

PP Wilson Harris, *The Palace of the Peacock*. London: Faber & Faber, 1960.

PS G. F. W. Hegel, *Phenomenology of Spirit*. Translated by A. V. Miller. New York: Oxford, 1977.

SP André Breton, *Surrealism and Painting*. Translated by Simon Watson Taylor. New York: Harper and Row, 1972.

SS Martin Heidegger, lecture course, University of Marburg, summer semester, 1925.

SZ Martin Heidegger, *Sein und Zeit*. Tübingen: Niemeyer, 1972. The English translations include the German pagination.

TP Gilles Deleuze and Félix Guattari, *A Thousand Plateaus*. Translated by Brian Massumi. Minneapolis: University of Minnesota Press, 1987.

WMD *Salt Seller: The Writings of Marcel Duchamp*. Edited and translated by Michel Sanouillet and Elmer Peterson. New York: Oxford University Press, 1973.

WS Martin Heidegger, lecture courses, University of Marburg, winter semesters, 1924–25, 1925–26.

NOTES

GENERAL INTRODUCTION (JAMES E. SWEARINGEN AND JOANNE CUTTING-GRAY)

1 Maurice Blanchot, *The Space of Literature*, trans. Ann Smock (Lincoln: University of Nebraska Press, 1982), 242–3.

2 Emmanuel Levinas, *Otherwise than Being or Beyond Essence*, trans. Alphonso Lingis (Dordrecht: Kluwer Academic Publishers, 1991), 40. Cited hereafter in the text as *OB*.

3 Jacques Lacan, *The Ethics of Psychoanalysis 1959–1960*, trans. Dennis Porter (New York: Norton, 1997), 243–87.

PART ONE: AN OTHER BEAUTY

CHAPTER 1

FEELING THE DIFFERENCE (MARIO PERNIOLA)

1 Mario Perniola, *Estetica del Novecento* (Bologna: Il Mulino, 1997).

2 Jacques Derrida, *La verité en peinture* (Paris: Flammarion, 1978); trans. Geoff Bennington and Ian McLeod as *Truth in Painting* (Chicago: University of Chicago Press, 1987). Gilles Deleuze, *Francis Bacon. Logique de la sensation* ([Paris:] Éditions de la différence, 1984).

3 Roland Barthes, *Le plaisir du texte* (Paris: Seuil, 1973); trans. Richard Miller as *The Pleasure of the Text* (New York: Hill and Wang, 1975).

4 Roland Barthes, *Roland Barthes* (Paris: Seuil, 1975).

5 Especially in his autobiographical essay *Roland Barthes* and in his posthumous *Incidents* (Paris: Seuil, 1987).

6 Mario Perniola, *Il sex appeal dell'inorganico* (Turin: Einaudi, 1996). See also the interview with John O'Brian, "The Art Is Getting Slippery," *World Art* 1 (1996).

7 Mario Perniola, *Enigmas: The Egyptian Moment in Society and Culture*, trans. Christopher Woodall (New York: Verso, 1995).

8 Daniel Paul Schreber, *Denkwürdigkeiten eines Nervenkranken* (Leipzig, 1903); trans. Ida Macalpine and Richard A. Hunter as *Memoirs of My Nervous Illness* (London: W. Dawson, 1955).

9 Wilhelm Dilthey, *Die drei Epochen der modernen Aesthetik und ihre heutige Aufgabe* (1892), Vol. 6 of *Gesammelte Schriften* (Stuttgart and Göttingen, 1961).

10 Georg Lukács, *Wider den missverstandenen Realismus* (Hamburg: Claasen, 1958); trans. John and Necke Mander as *The Meaning of Contemporary Realism* (London: Merlin Press, 1963).

11 Bret Easton Ellis, *American Psycho* (New York: Vintage Press, 1991). James Ellroy, *My Dark Places* (New York: Random House, 1996).

12 For example, *Helter Skelter* (Museum of Contemporary Art of Los Angeles, 1992), *Documenta* 9 (Kassel, 1992); *Posthuman* (Turin: Castello di Rivoli, 1992); *Hors limites. L'art et la vie* (Paris: Centre national d'art et de culture Georges Pompidou, 1994); see also the reviews *Bloc Notes* (Paris, 1993–98) and *Virus. Trimestrale delle mutazioni* (Milan, 1993–98).

13 T. Macri, *Il corpo postorganico. Sconfinamenti dell performance* (Genoa: Costa & Nolan, 1996).

14 Mario Perniola, "Towards Visual Philosophy," *Estetica News*, nos. 20–21 (May–December 1994): 1–4.

15 Jacques Derrida, "Economimesis," *Diacritics* 11, no. 2 (1981).

16 Julia Kristeva, *Pouvoir de l'horreur. Essai sur l'abjection* (Powers of Horror: An Essay on Abjection; Paris: Seuil, 1980); trans. Leon S. Roudiez as *Powers of Horror* (New York: Columbia University Press, 1982).

17 A shocking example of this tendency is offered by Jean Maillard, *Louise du Néant, ou Le Triomphe de la pauvreté et des humiliations* [1732] (Paris: J. Millon, 1987).

PART TWO: ART AND THE TURN TO THE POSTMODERN

CHAPTER 2

BRETON'S POST-HEGELIAN MODERNISM
(JEAN-MICHEL RABATÉ)

1 See Peter Bürger, *Theory of the Avant-Garde*, trans. Michael Shaw (Manchester: Manchester University Press, 1984). See also Peter Nicholls, *Modernisms: A Literary Guide* (Berkeley: University of California Press, 1995), 279–302.

2 Gwendoline Jarczyk and Pierre-Jean Labarrière, *De Kojève à Hegel: 150 ans de pensée hégélienne en France* (Paris: Albin Michel, 1996).

3 André Breton, *Oeuvres complètes*, I and II, eds. Marguerite Bonnet, P. Bernier, E.-A. Hubert, and J. Pierre (Paris: Gallimard, 1988 and 1992), I: 262. Cited hereafter as *OC*.

4 Ezra Pound, *Guide to Kulchur* [1938] (New York: New Directions, 1968), 95.

5 Pierre-Albert Birot, *SIC* (republ. Paris: J. M. Place, 1993), 26.

6 Lautréamont, *Oeuvres complétes d'Isidore Ducasse* (Paris: Livre de Poche, 1963), 418.

7 André Breton, *Nadja*, trans. R. Howard (New York: Grove Press, 1960), 72. Cited hereafter as *N*.

8 The term was found by Breton in a footnote added by Véra to his translation *La philosophie de la nature de Hegel*, 2 vols, trans. and annotated by Augusto Véra (Paris: Ladrange, 1863–66), Vol. 2, 113 n. 1. Cited hereafter as *PN*. Translated from the German by A. V. Miller as *Hegel's Philosophy of Nature* (Oxford: Clarendon Press, 1970). Véra quotes a fragment of a letter by Hegel thanking Goethe for the gift of a colored glass. This experiment apparently proved Goethe's thesis that light cannot be decomposed and aimed at refuting

Newton's color theory. I develop this analysis in *The Ghosts of Modernity* (Gainesville: University Press of Florida, 1996), 58–64.

9 Benedetto Croce, *Ce qui est vivant et ce qui est mort de la philosophie de Hegel*, trans. Henri Buriot (Paris: Giard et Brière, 1910), 51–2. The reference is glossed in *OC* I: 1561–2. Cited hereafter as *CQVM*. Translated by Douglas Ainslie as *What Is Living and What Is Dead of the Philosophy of Hegel* (Lanham, MD: University Press of America, 1985).

10 Jacques Lacan, *Écrits: A Selection*, trans. Alan Sheridan (New York: Norton, 1977), 236.

11 André Breton, *Mad Love*, trans. Mary Ann Caws (Lincoln: University of Nebraska Press, 1987), 11.

12 André Breton, *Surrealism and Painting*, trans. Simon Watson Taylor (New York: Harper and Row, 1972), 346. Cited hereafter as *SP*.

13 G. W. F. Hegel, *The Phenomenology of Mind*, trans. J. B. Baillie (New York: Harper and Row, 1967), 105. I have modified the original 1910 translation.

14 Benedetto Croce, *Aesthetic*, trans. Douglas Ainslie (New York: Farrar, Straus and Giroux, 1969), 302–3.

15 See Vincent Descombes, *Modern French Philosophy*, trans. L. Scott-Fox and J. M. Harding (Cambridge: Cambridge University Press, 1980), 27–48; also Jarcyk and Labarrière, *De Kojève à Hegel*.

16 James Joyce, *Ulysses*, ed. Jeri Johnson (Oxford: Oxford University Press, 1993), 182.

CHAPTER 3

POSTPONING THE FUTURE: MARCEL DUCHAMP
AND THE AVANT-GARDE (DALIA JUDOVITZ)

1 Clement Greenberg, "Counter-Avant-Garde," *Art International* 15, no. 5. Reprinted in *Marcel Duchamp in Perspective*, ed. Joseph Masheck (Englewood Cliffs, N.J.: Prentice Hall, 1975), 122–3.

2 For an analysis of Duchamp and his relations to the Dada movement, see my "Dada Cinema: At the Limits of Modernity," *Art & Text* 34 (Spring 1989), 46–63.

3 This emphasis on notions of mechanical reproduction, as an antidote to and critique of painting, distinguishes Duchamp's efforts from his Cubist, Dada, and Surrealist peers. For an analysis of the prevalence and impact of this notion in Duchamp's works, see my *Unpacking Duchamp: Art in Transit* (Berkeley: University of California Press, 1995).

4 My elaboration of Duchamp's playful evocations of mechanical reproduction is based on Walter Benjamin's seminal essay, "The Work of Art in the Age of Mechanical Reproduction" (1936), in *Illuminations*, ed. Hannah Arendt, trans. Harry Zohn (New York: Schocken Books, 1978), 217–51. However, it is important to note that unlike Benjamin's pessimistic account of the impact of this notion on the devaluation of art, Duchamp's conceptual deployment explores the possibility of revalorizing the relation between original and copy in order to redefine the meaning of artistic production.

5 Most quotations from Duchamp's writings come from the following sources: Pierre

Cabanne, *Dialogues with Marcel Duchamp*, trans. Ron Padgett (New York: Da Capo Press, 1987), cited henceforth as *DMD*; *Salt Seller: The Writings of Marcel Duchamp*, ed. and trans. Michel Sanouillet and Elmer Peterson (New York: Oxford University Press, 1973), henceforth *WMD*; and *Marcel Duchamp, Notes*, ed. and. trans. Paul Matisse (Boston: J. K. Hall & Co., 1983), henceforth *Notes*.

6 Quoted in *Marcel Duchamp*, eds. Anne d'Harnoncourt and Kynaston McShine (New York: Museum of Modern Art, 1973), 256.

7 For Duchamp's discussion of the influence of Marey's chronophotography on the *Nude*, see *DMD*, 34–5.

8 Octavio Paz, *Marcel Duchamp: Appearance Stripped Bare*, trans. Rachel Phillips (New York: The Viking Press, 1978), 2.

9 See Duchamp's qualification of abstraction in the *Nude* as more cubist than futurist (*DMD*, 28–9).

10 Masheck, "Introduction," *Marcel Duchamp in Perspective*, 7.

11 In 1916 Duchamp exhibited "Two Ready-mades" at the Bourgeois Gallery, New York, *Exhibition of Modern Art*, April 3–29, 1916, no. 50, without identifying them. He also exhibited the ready-made "Pharmacy" at the Montross Gallery, New York: *Exhibition of Pictures by Jean Crotti, Marcel Duchamp, Albert Gleizes, Jean Metzinger*, April 4–22, 1916, no. 27.

12 Roger Dadoun, "Rrose Sschize: Sschize d'un portrait théorie de Marcel Duchamp en Jésus sec célibataire," *L'Arc*, no. 59 (1974), 25.

13 Cf. Thierry de Duve, "The Readymade and the Tube of Paint," *Artforum* 24, no. 9 (May 1986), 115.

14 All that is left of *Fountain* today is the documentation surrounding a non-event, since this work was refused exhibition, and a non-existing object, since the original was lost and replaced by other mass-produced urinals of varying shapes. Alfred Stieglitz's famous photograph was published as the cover to *The Blind Man*, no. 2 (May, 1917), accompanied by an unsigned editorial entitled "The Richard Mutt Case," and Louise Norton's "Buddha of the Bathroom."

15 Duchamp's enigmatic note in *The Box of 1914* inscribes this "feminine" potential into *Fountain*, in an almost brutal sense: "one only has: for *female* the public urinal and one *lives* by it."

16 Masheck, "Introduction," in *Marcel Duchamp in Perspective*, 11; Thierry de Duve elaborates the reiterative structure of the ready-made in terms of its temporal aspects, see "Le Temps du ready-made," in *Marcel Duchamp: Abécédaire: Approches critiques* (Paris: Centre national d'art et de culture Georges Pompidou, 1977), 166–84.

17 Recent critical approaches to *The Large Glass* include a focus on its linguistic and interpretative character as a puzzle (Paz, 1978), alchemical and esoteric interpretations (Schwarz, 1970; Burnham, 1974; Calvesi, 1975); psychoanalytic interpretations (Held, 1973); N-dimensional geometry (Adcock, 1983); and perspective/optics (Clair, 1975).

18 Quoted by Calvin Tomkins in *The Bride and the Bachelors* (New York: Viking Press, 1965), 24.

19 When the *Glass* cracked while in transit, these glass strips, described as the "Bride's garment," "Gilled cooler," or simply, "Horizon," were replaced by a thin strip of glass held between two aluminum bars, to provide additional support.

20 For a description of the two versions of the *Chocolate Grinder* (the first painted perspectively; the second painted with added thread sewn to the canvas), see Schwarz, "Éros c'est la vie," in *The Complete Works of Marcel Duchamp* (New York: Harry N. Abrams, 1970), xxi; and Richard Hamilton's discussion of its transposition to the *Glass*, "The Large Glass," in d'Harnoncourt and Mcshine, 60–1.

CHAPTER 4

WHEN LESS IS MORE, MORE OR LESS (PETER WILLIAMS)

1 These descriptions have been applied to minimalism by a number of critics. See Michael Fried, "Art and Objecthood," in *Minimal Art: A Critical Anthology*, ed. Gregory Battcock (New York: Dutton, 1969), 125. See also Richard Wollheim's "Minimal Art" in the same volume, 387–99.

2 "On the other hand, conversely, could it be that the Greeks became more and more optimistic, superficial, and histrionic precisely in the period of dissolution and weakness – more and more ardent for logic and logicizing the world and thus more 'cheerful' and 'scientific'?": Friedrich Nietzsche, *The Birth of Tragedy*, trans. Walter Kaufmann (New York: Vintage, 1967), 21.

3 In one of his numerous references to mastery, Wittgenstein says, "The grammar of the word 'knows' is evidently closely related to that of 'can', 'is able to'. But also closely related to that of 'understands'": Ludwig Wittgenstein, *Philosophical Investigations*, trans. G. E. M. Anscombe (New York: Macmillan, 1958), #150, 59e.

4 Nelson Goodman, *Ways of Worldmaking* (Indianapolis: Hackett, 1978), 21.

5 Georg Hegel, *Phenomenology of Spirit*, trans. A. V. Miller (New York: Oxford, 1977), #80, 52. Hereafter cited as *PS*.

6 Quoted in William Rubkin, *Frank Stella* (New York: Museum of Modern Art, 1970), 41–2.

7 Theodor Adorno, *Aesthetic Theory*, trans. C. Lenhardt (New York: Routledge & Kegan Paul, 1984), 121.

8 *The Collected Poems of Robert Creeley, 1945–1975* (Berkeley: University of California Press, 1982), 283.

9 John Ashbery, "The New Spirit," in *Three Poems* (New York: Viking, 1972), 3.

10 Samuel Beckett, "Still," in *Fizzles* (New York: Grove, 1976), 47–51.

11 Samuel Beckett, *Company* (New York: Grove, 1980), 12.

12 Quoted in Barbara Haskell, *Agnes Martin* (New York: Whitney Museum of Modern Art, 1994), 145.

13 Emmanuel Levinas, "The Glory of Testimony," in *Ethics and Infinity*, trans. Richard A. Cohen (Pittsburgh: Duquesne University Press, 1985), 107.

PART THREE: THE IMPOSSIBLE PLACE OF LITERATURE

CHAPTER 5

CHORA AND CHARACTER: MIMESIS OF DIFFERENCE
IN PLATO'S *TIMAEUS* (MAX STATKIEWICZ)

1 Naomi Schor, "This Essentialism Which Is Not One: Coming to Grips with Irigaray," in *Engaging with Irigaray: Feminist Philosophy and Modern European Thought*, eds. Carolyn Burke, Naomi Schor, and Margaret Whitford (New York: Columbia University Press, 1994), 67.

2 "*Praxis* is not a substitute for Truth of an unshakable philosophy. It is, on the contrary, what shakes philosophy; it is this other, which, in its entire history (under the form of an errant cause or of class struggle), philosophy has never been able to subdue": Louis Althusser, *Sur la philosophie* (Paris: Gallimard, 1994), 153. Where not specified, translations are mine.

3 *Khōra* ("land," "country," in general "place," in the *Timaeus* "region of all regions") and *kharaktēr* ("engraving," "impress," "distinctive mark," "personal disposition").

4 Plato, *Platonis Opera*, ed. John Burnet, Vol. 4 (1902, reprint, Oxford: Oxford University Press, 1984). Maurice Merleau-Ponty, *The Visible and the Invisible*, trans. Alphonso Lingis (Evanston: Northwestern University Press, 1968).

5 See Jacques Derrida, *Truth in Painting*, trans. Geoff Bennington and Ian McLeod (Chicago: University of Chicago Press, 1987), 165f.

6 *Republic*, 595b, translation modified from *The Dialogues of Plato*, trans. Benjamin Jowett, Vol. 1 (1892, reprint, New York: Random House, 1937), 852.

7 See A. E. Taylor, *A Commentary on Plato's Timaeus* (1928, reprint, New York: Garland, 1987), 3ff.; Paul Friedländer, *Plato*, trans. Hans Meyerhoff, Vol. 3 (Princeton: Princeton University Press, 1969), 447ff.

8 To do so follows a long tradition of interpretation beginning at least with Proclus. See A. J. Festugière, *Proclus' Commentaire sur le Timée*, Vol. 1 (Paris: Vrin, 1966), 33f.

9 To all appearances the initial plan of Socrates will not be realized. The historical-mythical narrative of Critias will be first temporarily suspended by Timaeus' cosmological myth, and then, in the *Critias*, definitely interrupted with the dialogue itself.

10 See Edward S. Casey, *The Fate of Place* (Berkeley: University of California Press, 1997), 34. Comparing the ancient Pelasgian, Hebraic, and Greek, cosmogonies, Casey notes the common "intolerability of no-place-at-all" (6).

11 Plato made his character Parmenides question the argument at least in respect to the One (*Parmenides*, 138a–b). For Zeno, see Aristotle, *Physics*, IV, 3, 209a23, 210b22; for Gorgias, see Sextus Empiricus, *Against the Logicians*, I, 77 and [Aristotle], *On Melissos, Xenophanes and Gorgias*, 979a–980b.

12 The impossibility of making the circles of the Same and of the Other coincide, after having bent the arms of the chiasm, epitomizes such material resistance.

13 Luc Brisson, *Le Même et l'Autre dans la structure ontologique du Timée de Platon: Un commentaire systématique du Timée de Platon* (1974; reprint, Sankt Augustin: Academia Verlag, 1994), 35–54.

14 See Luce Irigaray, *Speculum of the Other Woman*, trans. Gillian C. Gill (Ithaca: Cornell University Press, 1985), 195, 265 *et passim*; and Judith Butler, *Bodies That Matter: On the Discursive Limits of "Sex"* (New York: Routledge, 1993), 31ff.

15 On the "logic of *pharmakon*" see Jacques Derrida, "Plato's Pharmacy," in *Dissemination*, trans. Barbara Johnson (Chicago: University of Chicago Press, 1981), 61–171.

16 Paul Ricoeur, *Être, essence et substance chez Platon et Aristote* (Paris: Société d'enseignement supérieur, 1982), 108.

17 The *cosmic mise en ordre* in the soul of the world corresponds to the catharsis in the soul of philosopher as described in Plato's *Phaedo*, if one interprets, with Luc Brisson, the circle of the same and the circle of the other in terms of intellectual and sensible knowledge respectively (*Le Même et l'Autre*, 527).

18 See Francis M. Cornford, *Plato's Cosmology: The Timaeus of Plato Translated with a Running Commentary* (1937; reprint, London: Routledge, 1966), 177; Richard D. Mohr, *The Platonic Cosmology* (Leiden: E. J. Brill, 1985), 88; and Jean-François Mattéi, *Platon et le miroir du mythe: De l'âge d'or à l'Atlantide* (Paris: Presses Universitaires de France, 1996), 208f.

19 On the gender of chora see Jacques Derrida, "*Khōra*," trans. Ian McLeod, in *On the Name*, ed. Thomas Dutoit (Stanford: Stanford University Press, 1995), 95; on the space of indeterminacy see René Girard, *Violence and the Sacred*, trans. Patrick Gregory (Baltimore: The Johns Hopkins University Press, 1977), 49ff. *et passim*.

20 "Plato's *Hystera*," in Irigaray, *Speculum*, 307; see "Volume–Fluidity" in the same volume, 227–40; see also *This Sex Which Is Not One*, trans. Catherine Porter with Carolyn Burke (Ithaca: Cornell University Press, 1985), especially 26ff., 108ff., 122, 214f.; and "Place, Interval: A Reading of Aristotle, *Physics* IV," in *An Ethics of Sexual Difference*, trans. Carolyn Burke and Gillian C. Gill (Ithaca: Cornell University Press 1993), 34–55.

21 Elizabeth A. Grosz, "Woman, *Chora*, Dwelling," in *Space, Time and Perversion: Essays on the Politics of Bodies* (New York: Routledge, 1995), 116.

22 Cf. Cornford, *Cosmology*, 172.

23 According to Casey, *khōra* consists of "regionalization" (34).

24 Demiurge is literally a painter of constellations, *Timaeus*, 55c; cf. Cornford, *Cosmology*, 219.

25 *Khōra* is perhaps related etymologically to *khoros*, "emplacement for the dance, chorus," and thus to the origin of Attic drama: see Pierre Chantraine, *Dictionnaire étymologique de la langue grecque: Histoire des mots* (Paris: Éditions Klincksieck, 1984), 1269f.; cf. Mattéi, *Platon et le miroir du mythe*, 200, 211f. *Khōra* evokes not only the ground for the performance of the ancient theater but also, perhaps chiefly, the modern Brechtian scene of *Verfremdung* (*to atopon kai aēthes* in Timaeus' vocabulary). It is not without reason that the "epic theater" has been called "Platonic," and its emblematic hero compared to Socrates. Walter Benjamin might have thought of *khōra* in the *Timaeus* when he noted in Brechtian characters a lack of "fidelity to any single essence of one's own" and "a continual readiness to admit a new essence": Walter Benjamin, "What Is Epic Theatre?" [first version], in *Understanding Brecht* (London: Verso, 1973), 9.

26 Julia Kristeva, *Revolution in Poetic Language*, trans. Leon S. Roudiez (New York: Columbia University Press, 1984), 29f.

27 Luce Irigaray, "The Power of Discourse and Subordination of the Feminine," in *This Sex Which Is Not One*, 76.

28 Cf. Derrida's assessment of the conclusion of the dialogue in *On the Name*, 104.

29 Socrates' "own" marginality, which in the *Timaeus* parallels that of *khōra*, is often associated with femininity: his "midwifing" (*Theaetetus*), his association with women-teachers (Diotima in the *Symposium*, Aspasia in the *Menexenus*), his constant reference to weaving, his being courted (e.g. by Alcibiades in the *Symposium*), even his "feminine" oath: *nē tēn Hēran* (e.g. *Phaedrus*, 230b).

CHAPTER 6

THE PLACE OF BOREDOM (PIERRE LAMARCHE)

1 Marcel Proust, *Remembrance of Things Past*, Vol. I: *Within a Budding Grove*, trans. C. K. Scott Moncrieff and Terence Kilmartin (New York: Vintage, 1981), 623–4.

2 Joseph Libertson, *Proximity: Levinas, Blanchot, Bataille and Communication* (The Hague: Martinus Nijhoff, 1982), 2.

3 The connection to Hegel emphasizes an affinity between the *oeuvre/désoeuvrement* and Bataille's notion of *General Economy* in *La Part maudite*. Bataille and Blanchot provide parallel counterpoints to Hegel's dialectical, teleological conception of work, which is inscribed within what Libertson would term an "economy exhausted by the principles of autonomy and power" (7).

4 Maurice Blanchot, *The Space of Literature*, trans. Ann Smock (Lincoln: University of Nebraska Press, 1982), 182. Ann Smock translates *désoeuvrement* as "idleness."

5 Twenty-five hundred pages after the passage from *Within a Budding Grove* quoted at the outset, the narrator returns to the issue of this "famous work" which does not come: "Really, I said to myself, what point is there in forgoing the pleasures of social life if, as seems to be the case, the famous 'work' which for so long I have been hoping every day to start the next day, is something I am not, or am no longer, made for and perhaps does not even correspond to any reality" – Marcel Proust, *Remembrance of Things Past*, Vol. III: *Time Regained*, trans. Andreas Mayor (New York: Vintage, 1982), 887.

6 Maurice Blanchot, *Le livre à venir* (Paris: Éditions Gallimard, 1959), 21.

7 Proust, *Jean Santeuil*, ed. Pierre Clarac (Paris: Pléiade, 1971), 398–9. Cf. Julia Kristeva, *Time and Sense: Proust and the Experience of Literature*, trans. Ross Guberman (New York: Columbia University Press, 1996), 202–3.

8 *Livre*, 33. The metaphors of "stars" – *les étoiles* – which stand out against the "emptiness of space," against a darkened sky, should recall to us Blanchot's use of *astre* and *dés-astre* in *L'Écriture du désastre*, as well as his motifs of "the desert," and also the "nocturnal," or "night" – "Night becoming day makes the light richer and gives to clarity's superficial sparkle a deep inner radiance": *The Space of Literature*, 167.

9 Samuel Beckett, *Proust, and Three Dialogues* (London: John Calder, 1965), 50, 16.

10 See Gilles Deleuze, *Proust and Signs*, trans. Richard Howard (New York: George Braziller, 1972), 15–24.

11 Martin Heidegger, *The Fundamental Concepts of Metaphysics*, trans. William McNeill and Nicholas Walker (Bloomington: Indiana University Press, 1995). The point is repeated in 1961, in the address on the occasion of the Seventh Centennial of the town of Messkirch: "Messkirch: Seventh Centennial," trans. Thomas J. Sheehan, *Listening* 8 (1973), 40–57.

12 Proust, *Remembrance of Things Past*, Vol. III, *The Captive*, 400.

13 Proust, *La prisonnière* (Paris: Éditions folio, 1985), 406.

14 For an amusing discussion of the enormity of this gift, see Alain de Botton, *How Proust Can Change Your Life* (New York: Pantheon Books, 1997). De Botton sees in, perhaps not the boredom, but certainly the languor of *À la recherche* – the prodigious length, and corresponding snail's pace that galls so many impatient readers who will not allow themselves to waste time on an author who refuses to get to the point – an attempt to redeem the everydayness of life in its precious uniqueness, in the meaningfulness of life's tiny details that are overlooked in our dreary, myopic busyness.

CHAPTER 7

LITERATURE, FILM, AND VIRTUALITY:
TECHNOLOGY'S CUTTING EDGE (JOEL BLACK)

Note: Portions of this essay appear in *The Reality Effect: Film, Culture and the Graphic Imperative* (New York: Routledge, 2002).

1 Chris Rodley, ed., *Cronenberg on Cronenberg* (London: Faber and Faber, 1997), 201. Hereafter cited as *CC*.

2 Quoted by Mark Danner, "Guardian Angels," *The New Yorker* (Nov. 25, 1996), 47.

3 "Unsettling Visions of the Erotic," *New York Times* (March 30, 1997).

4 Salman Rushdie, "Crash," *The New Yorker* (Sept. 15, 1997), 68.

5 Georges Bataille, *Death and Sensuality: A Study of Eroticism and the Taboo*, trans. Mary Dalwood (New York: Walker, 1962).

6 Istvan Csicsery-Ronay, Jr., "Editorial Introduction: Postmodernism's SF/SF's Postmodern-ism," *Science-Fiction Studies*, 18, pt. 3 (Nov. 1991), 307.

7 J. G. Ballard, *Crash* (1973; reprint, New York: Noonday Press, 1994), 101.

8 Marshall McLuhan, *Understanding Media: The Extensions of Man* (1964; reprint, New York: New American Library, n.d.), 56.

9 Garry Wills, "Dostoyevsky Behind a Camera," *The Atlantic Monthly* (July 1997), 98.

10 When *The Atrocity Exhibition* (1970) was reissued in 1990, Ballard provided a contextual frame for the novel with documentary annotations in extra-wide margins.

11 Quoted by Ralph Rugoff, "The Atrocity Exhibitionist," *LA Weekly* (March 21–27, 1997), 32.

12 Claudia Springer, *Electronic Eros: Bodies and Desire in the Postindustrial Age* (Austin: University of Texas Press, 1996), 8.

13 Jean Baudrillard, "Ballard's *Crash*," *Science-Fiction Studies* 18, pt. 3 (Nov. 1991), 319.

14 See Sobchack's defense of Ballard against Baudrillard: Vivian Sobchack, "Baudrillard's Obscenity," *Science-Fiction Studies* 18, pt. 3 (Nov. 1991), 328f.

15 Asked about the preponderance of rear-entry or anal sex in the film, Cronenberg responded that he "liked the way it looked. It felt right, getting both the actors looking towards the camera and not at each other. It helped that sort of 'disconnected' thing" (198).

16 Quoted in Rugoff, "The Atrocity Exhibitionist," 32.

17 Rugoff, 32. Noting that Vaughan drives a 1963 Lincoln – "the same make of vehicle as the open limousine in which President Kennedy had died" (64) – the narrator asks whether he sees "Kennedy's assassination as a special kind of car-crash," to which Vaughan responds "The case could be made" (130).

18 Cf. Ballard's hypothesis that mass murderers may "see the whole of society as endlessly and unsettlingly bland, and [are] desperate to restore reality of some kind" (quoted in Rugoff, 30).

PART FOUR: THE RHETORIC OF THE POLITICAL

CHAPTER 8

RHETORIC, POLITICS, ROMANCE: ARENDT AND HEIDEGGER, 1924–26 (THEODORE KISIEL)

1 Winter Semester, 1924–25; Summer Semester, 1925; Winter Semester, 1925–26.

2 Martin Heidegger, *Sein und Zeit*, (Tübingen: Niemeyer, 1972). Cited hereafter in the text as *SZ*. Martin Heidegger, *Being and Time*, trans. John Macquarrie and Edward Robinson (San Francisco: HarperCollins, 1962). The English translations include the German pagination.

3 The two texts: a rejected journal article of Nov. 1924, "Der Begriff der Zeit" (the original 70-page manuscript is in the hand of Elfride Heidegger), and the lecture course of SS 1925, "Geschichte des Zeitbegriffs" (*History of the Concept of Time*, trans. Theodore Kisiel for Indiana University Press [1985]). The interim "Kassel Lectures" of April 1925 on "Wilhelm Dilthey's Research Work and the Present Struggle for a Historical Worldview" borrow from both texts between which they were held. See Theodore Kisiel, *The Genesis of Heidegger's "Being and Time"* (Berkeley: University of California Press, 1993; cited hereafter as *Genesis*), esp. chapters 7 and 8.

4 Letter from Hannah Arendt to Martin Heidegger dated October 28, 1960. Elzbieta Ettinger, *Hannah Arendt/Martin Heidegger. Eine Geschichte*, "aus dem Amerikanischen von Brigitte Stein" (Hannah Arendt–Martin Heidegger [abbreviated ed.], 114) (Munich and Zürich: Piper, 1994), trans. Ettinger (New Haven: Yale University Press, 1995), 121. Hereafter in the text as *EE*.

5 Heidegger's letter to Karl Löwith of August 19, 1921, elaborating Heidegger's attitude toward his best students in the context of university politics, is published in *Zur philosophischen Aktualität Heideggers*, Vol. 2: *Im Gespräch der Zeit*, ed. Dietrich Papenfuss and Otto Pöggeler (Frankfurt: Klostermann, 1990), 27–32, esp. 31f. An English translation of the

letter, by Gary Steiner, is to be found in Karl Löwith, *Martin Heidegger and European Nihilism*, ed. Richard Wolin (New York: Columbia University Press, 1995), 235–9, esp. 238.

6 Hannah Arendt, *The Human Condition* (Garden City: Doubleday Anchor, 1959). Hereafter cited in the text as *HC*.

7 Theodore Kisiel, "Heidegger's *Gesamtausgabe*: An International Scandal of Scholarship," *Philosophy Today* 39 (1995), 3–15; "Edition und Übersetzung: Unterwegs von Tatsachen zu Gedanken, von Werken zu Wegen," in *Zur philosophischen Aktualität Heideggers*, Vol. 3: *Im Spiegel der Welt: Sprache, Übersetzung, Auseinandersetzung*, ed. Dietrich Papenfuss and Otto Pöggeler (Frankfurt: Klostermann, 1992), 89–107.

8 Hannah Arendt, "Concern with Politics in Recent European Philosophical Thought," in *Essays in Understanding (1930–1954)*, ed. Jerome Kohn (New York: Harcourt Brace, 1994), 443 (my italics), 446.

9 The still unpublished Marburg course of SS 1924, "Ground Concepts of Aristotelian Philosophy," is nevertheless available in the typescript by Herbert Marcuse made from the transcript of Walter Bröcker, available from the Marcuse Archive in the University of Frankfurt Library. This typescript of 134 pages is cited by page number in the text.

10 Dana Villa, *Arendt and Heidegger: The Fate of the Political* (Princeton: Princeton University Press, 1996), 114.

11 Margaret Canovan, *Hannah Arendt: A Reinterpretation of Her Political Thought* (Cambridge: Cambridge University Press, 1992), 138.

12 Seyla Benhabib, *The Reluctant Modernism of Hannah Arendt* (Thousand Oaks: Sage, 1996), 107.

13 For a summary see *Genesis*, 281–301.

14 Pierre Bourdieu, *The Political Ontology of Martin Heidegger*, trans. Peter Collier (Stanford: Stanford University Press, 1991), 79.

15 Michael G. Gottsegen, *The Political Thought of Hannah Arendt* (Albany: SUNY Press, 1994), chapter 1.

16 Arendt, "Concern with Politics," 432f.

17 Hannah Arendt, *Men in Dark Times* (New York: Harcourt Brace, 1968) (cited hereafter in the text as *MDT*), ix. Cf. Jeffrey Barash, "The Political Dimension of the Public World: On Hannah Arendt's Interpretation of Martin Heidegger," in *Hannah Arendt: Twenty Years Later*, ed. Larry May and Jerome Kohn (Cambridge: MIT Press, 1996), 251–68.

18 Hannah Arendt, "What Is Existenz Philosophy?," *Partisan Review* 13, no. 1 (1946), 51.

CHAPTER 9

HANNAH ARENDT: LITERARY CRITICISM AND THE POLITICAL (DAVID HALLIBURTON)

1 Hannah Arendt, *The Human Condition* (Chicago: University of Chicago Press, 1958), 169–79, hereafter cited parenthetically as *HC*.

2 Quoted in *HC*, 168 n. 39,

3 Hannah Arendt, *Between Past and Future: Eight Exercises in Political Thought* (London: Faber and Faber, 1961), 262.

4 Hannah Arendt, *The Life of the Mind*, 2 vols. (New York: Harcourt Brace Jovanovich, 1977), Vol. I, 192. Cited hereafter as *LM*.

5 Hannah Arendt, *On Revolution* (New York: Viking, 1963; reprint Harmondsworth: Penguin, 1979), cited hereafter as *OR*.

6 On the offices of endowing, enabling, and entitling, see David Halliburton, *The Fateful Discourse of Worldly Things* (Stanford: Stanford University Press, 1997), 85ff. *et passim*.

7 Cf. David Halliburton, *Poetic Thinking: An Approach to Heidegger* (Chicago: Chicago University Press, 1981).

8 Hannah Arendt, *The Origins of Totalitarianism*, second enlarged edition (New York: Harcourt Brace Jovanovich, 1951), 114. Hereafter cited as *OT*.

9 Hannah Arendt, *Essays in Understanding, 1930–1954: Uncollected and Unpublished Works by Hannah Arendt*, ed. Jerome Kohn (New York: Harcourt Brace Jovanovich, 1994), cited hereafter as *EU*.

CHAPTER 10

THE POLITICS OF FASCISM, OR CONSUMING THE FLESH OF THE OTHER (MICHAEL CLIFFORD)

1 *Aristotle, Horace, Longinus: Classical Literary Criticism*, trans. T. S. Dorsch (New York: Penguin Books, 1965), 63–5.

2 Gilles Deleuze and Félix Guattari, *Anti-Oedipus: Capitalism and Schizophrenia*, trans. Robert Hurley, Mark Seem, and Helen R. Lane (Minneapolis: University of Minnesota Press, 1983). Hereafter cited in the text as *AO*.

3 That the subject is a surface effect of the flows of desire, that there is no ego at the center in which to situate desire, is influenced by the work of Jacques Lacan. See, especially, *The Four Fundamental Concepts of Psycho-Analysis*, trans. Alan Sheridan, ed. Jacques-Alain Miller (New York: Norton, 1978), 203–44.

4 On desire as pure difference and repetition, see Gilles Deleuze, *Différence et répétition* (Paris: Presses Universitaires de France, 1968), 23; trans. Paul Patton (New York: Columbia University Press, 1994).

5 Gilles Deleuze, *Nietzsche and Philosophy*, trans. Hugh Tomlinson (New York: Columbia University Press, 1983), 39–73.

6 Mario Palmieri, *The Philosophy of Fascism* [translator unknown.] (Chicago: The Dante Alighieri Society, 1936), reprinted in *Communism, Fascism, and Democracy*, ed. Carl Cohen (New York: Random House, 1962), 384.

7 Alfred Rosenberg, "The Myth of the Twentieth Century" [translator unknown] (n.p., 1930), passages reprinted in Cohen, 398, from *National Socialism*, a report prepared by the

Division of European Affairs, U.S. Department of State (Washington, D.C.: United States Government Printing Office, 1943).

8 The title of a book by Vincenzo Gioberti, published in 1845, which was a seminal text of Italian Fascism.

9 Benito Mussolini, "The Doctrine of Fascism" (*Enciclopedia Italiana*, 1932), reprinted in Cohen, 356, from *The Social and Political Doctrines of Contemporary Europe*, ed. Michael Oakeshott (Cambridge: Cambridge University Press, 1939).

10 According to Philippe Lacoue-Labarthe and Jean-Luc Nancy, "It must certainly not be forgotten that one of the essential ingredients in fascism is *emotion*, collective, mass emotion": "The Nazi Myth," trans. Brian Holmes, *Critical Inquiry* (Winter 1990), 294.

11 "Schizo" and "schizophrenization" should be distinguished from their narrowly clinical definitions. Deleuze and Guattari use "schizo" for an identity of displacement and fragmentation, connected to the clinical definition through the experience of disorientation and loss of sense of self. This condition, they claim, is the norm in modern capitalist societies and becomes a "disease" only when the person becomes delusional and dysfunctional. However, Lacoue-Labarthe and Nancy argue that German identity (as it precipitates National Socialism) suffers a "double, contradictory injunction," part of the clinical definition of schizophrenia: "The malady, in the precise sense of the term, that seems always to have menaced Germany is schizophrenia, to which so many German artists would appear to have succumbed": "The Nazi Myth," 300.

12 For an account of Hitler's sadomasochism, see Robert G. L. Waite, *Adolf Hitler: The Psychopathic God* (New York: Basic Books, 1977), 271–81.

13 Simone de Beauvoir, "From *The Second Sex*," in *Existentialism*, ed. Robert C. Solomon (New York: Modern Library, 1974), 288.

14 G. W. F. Hegel, *Hegel: Selections*, ed. M. J. Inwood (New York: Macmillan, 1989), 176.

15 Rosenberg's book "was practically required reading" and was in its 42nd reprint by 1934; whereas *Mein Kampf* had sold over two million copies by 1936. See "The Nazi Myth," 304.

16 Lacoue-Labarthe and Nancy: "The race, the people, is linked to *blood*, not to language ['Aryan' may refer to a bloc of Indo-European languages]. This affirmation is repeated ceaselessly by Rosenberg and Hitler: blood and soil – *Blut und Boden*": "The Nazi Myth," 308.

17 They begin with the claim that "Nazism is a specifically German phenomenon," and they largely restrict their claims to that nation and era. However, by the end of the essay they warn that it is not possible to "simply push [Nazism] aside as an aberration, still less as a past aberration" (312).

18 The "body without organs" refers to the surface or space formed by the lines of convergence between the machines of desiring-production. Although production occurs on this space, in fact the production of reality, it is not the production of "any-thing." It is difference without identity, repetition without resemblance, body without organs. See *AO*, 19.

19 Jean-Luc Nancy says, "The logic of Nazi Germany was not only that of the extermination of the other, of the subhuman deemed exterior to the communion of blood and soil, but also, effectively, the logic of sacrifice aimed at all those in the "Aryan" community who

did not satisfy the criteria of *pure* immanence, so much so that – it being obviously impossible to set a limit on such criteria – the suicide of the German nation itself might have represented a plausible extrapolation of the process: moreover, it would not be false to say that this really took place, with regard to certain aspects of the spiritual reality of this nation": *The Inoperative Community*, trans. Peter Connor *et al.* (Minneapolis: University of Minnesota Press, 1991), 12.

20 Thomas Bulfinch, *Bulfinch's Mythology* (New York: Avenel Books, 1979), 103.

PART FIVE: THE POLITICAL IMAGINARY

CHAPTER 11

POST-COLONIALISM AND HISTORY: ARE WE RESPONSIBLE FOR THE PAST? (MOIRA GATENS)

1 Many thanks to Glenda Sluga for helpful comments on an earlier version of this essay.

2 For an explanation of the *Mabo* judgment see Richard H. Bartlett, *The Mabo Decision* (Sydney: Butterworths, 1993).

3 *Ministerial Document Service* no. 116/92–93 (Friday, 11 December, 1992), 4790–4.

4 In Australia, the two main political parties are Labor and Liberal. Perhaps contrary to one's intuitions, the Liberal Party is the conservative party.

5 When philosophers do allow a notion of collective responsibility (for example, in the case of companies or corporations), it is often merely by lending to such corporations the metaphorical status of a "superindividual." Such cases are not, I think, relevant to my purposes here but see Genevieve Lloyd, "Individuals, Responsibility and the Philosophical Imagination," in *Feminist Perspectives on Autonomy*, eds. Catriona Mackenzie and Natalie Stoljar (Oxford: Oxford University Press, 1998).

6 The themes of this paper are explored further in Moira Gatens and Genevieve Lloyd, *Collective Imaginings: Spinoza and an Ethics of Difference* (London: Routledge, 1999).

7 Marcia Langton, *Well, I heard it on the radio and I saw it on the television* (Woolloomooloo, Sydney: Australian Film Commission, 1993), 31–2, 51–2.

8 Étienne Balibar, *Masses. Classes. Ideas* (New York: Routledge, 1994), 28–9.

9 Spinoza, *Ethics*, PII, Axiom 2, in *The Collected Works of Spinoza*, Vol. 1, ed. and trans. Edwin Curley (Princeton: Princeton University Press, 1985).

10 These terms are used here in a loose rather than classical or technical sense. By *ethos* I mean the context in which a being dwells and develops a sense of his or her "value," including that to which she or he is deemed to be rightfully entitled; by *mythos* I mean the set of narratives, fictions, images, and so on, which constitute the imaginary through which a community, nation, or collective creates an identity for itself.

11 Antonio Negri, *The Savage Anomaly* (Minneapolis: University of Minnesota Press, 1991), 86.

12 Gilles Deleuze, *Expressionism in Philosophy*, trans. Martin Joughin (New York: Zone Books, 1990), 255–72.

13 Spinoza, *A Political Treatise*, trans. R. H. M. Elwes (New York: Dover Publications, 1951), 287.

14 Étienne Balibar, "Spinoza: From Individuality to Transindividuality" (typescript of lecture delivered in Rijnsburg, May 15, 1993), 26.

15 In a similar vein, Morris-Suzuki has written: "In their first efforts at self-definition, settler states almost always sought to define themselves as utopian versions of the Mother country . . . Australia was to be Britain without the snobbery and class-consciousness . . . these forms of self-definition, in other words, involved a mental *terra nullius* in which indigenous inhabitants and their history had no part": "Collective Memory, Collective Forgetting: Indigenous People and the Nation-State in Japan and Australia," *Meanjin* 53, no. 4 (1994), 67.

16 For an extensive account of the practice of the removal of indigenous children from their families, including the devastating effects of that practice on those children when grown, see Human Rights and Equal Opportunity Commission,*Bringing Them Home: Report of the National Inquiry into the Separation of Aboriginal and Torres Strait Islander Children from Their Families* (Sydney: Sterling Press, 1997).

17 Michèle Le Doeuff, *The Philosophical Imaginary* (London: Athlone Press, 1989).

18 Hannah Arendt, *Between Past and Future: Six Exercises in Political Thought* (London: Faber and Faber, 1961), 9 (emphasis added).

CHAPTER 12

INDIGENOUS-BECOMING IN THE
POST-COLONIAL POLITY (PAUL PATTON)

1 Gilles Deleuze and Félix Guattari, *A Thousand Plateaus*, trans. Brian Massumi (Minneapolis: University of Minnesota Press, 1987), 360. Hereafter cited in the text as *TP*.

2 Nicholas Greenwood Onuf, "Sovereignty: Outline of a Conceptual History," *Alternatives* 16, no. 1 (1991), 426.

3 Cf. R. B. J. Walker, *Inside/Outside: International Relations as Political Theory* (Cambridge: Cambridge University Press, 1993), 165: "The modern principle of state sovereignty has emerged historically as the legal expression of the character and legitimacy of the state."

4 Robert A. Williams, Jr., *The American Indian in Western Legal Thought* (New York: Oxford University Press, 1990), 6.

5 Henry Reynolds, *Aboriginal Sovereignty* (Sydney: Allen & Unwin, 1995), 110.

6 See *Attorney-General v Brown*, (1847) 1 Legge 312. Cited in Richard H. Bartlett, *The Mabo Decision* (Sydney: Butterworths, 1993), 16, 27 (hereafter referred to in the text as *Mabo*). Other cases in this series include *Cooper v Stuart*, (1889) 14 App Cas 286; *Williams v Attorney-General (NSW)*, (1913), 16 CLR 404; *Randwick Corp v Rutledge*, (1959) 102 CLR 54; *New South Wales v Commonwealth*, (1975) 135 CLR 337.

7 Paul Patton, "Sovereignty, Law and Difference in Australia: After the Mabo Case," *Alternatives* 21 (1996); Duncan Ivison, "Decolonizing the Rule of Law: Mabo's Case and Postcolonial Constitutionalism," *Oxford Journal of Legal Studies* 17 (1997), 253–79.

8 Noel Pearson, "The Concept of Native Title at Common Law," in *Our Land Is Our Life: Land Rights – Past, Present, Future*, ed. Galarrwuy Yunupingu (St. Lucia, Queensland: University of Queensland Press, 1997), 150–61.

CHAPTER 13

THE POST-COLONIAL THRESHOLD OF CAPACITY: "THE OTHER! THE OTHER!" (ALFRED LÓPEZ)

Note: A version of this essay with a different thematic emphasis appears under another title in *Posts and Pasts: A Theory of Postcolonialism* (Albany: SUNY Press, 2001).

1 Ella Shohat, "Notes on the 'Post-Colonial,'" *Social Text*, nos. 31/32 (1992), 103.

2 The term is Wilson Harris'; I will have recourse to it again later.

3 Sir Hugh Clifford, C.M.G., "The Genius of Joseph Conrad," in *Joseph Conrad: Third World Perspectives*, ed. Robert Hamner (Washington, D.C.: Three Continents, 1990), 11–12 (emphasis added).

4 Chinua Achebe, "An Image of Africa," in Hamner, 120, 124.

5 Edward Said, "Conrad: The Presentation of Narrative," in Hamner, 171.

6 Wilson Harris, "The Frontier on Which *Heart of Darkness* Stands," in Hamner, 162.

7 William W. Bonney, *Thorns and Arabesques: Contexts for Conrad's Fiction* (Baltimore: Johns Hopkins University Press, 1980), 195.

8 This distinction belongs to Martin Heidegger's philosophical project, where *Lichtung* is an act of "clearing" or opening up of a space in which things may be revealed in their presence. See "The End of Philosophy and the Task of Thinking," in *Basic Writings*, ed. and trans. David Farrell Krell (San Francisco: HarperCollins, 1993), 441.

9 Joseph Conrad, *Heart of Darkness* (New York: St. Martin's, 1989), 66. Hereafter cited in the text as *HD*.

10 Wilson Harris, *The Palace of the Peacock* (London: Faber & Faber, 1960), 10. Hereafter cited in the text as *PP*.

PART SIX: EXTREME BEAUTY – DEATH, GLORY

CHAPTER 14

THE SIMULACRUM OF DEATH (ROBERT BURCH)

1 "L'essere-per-la-morte et il simulacro della morte," in Mario Perniola, *La società dei simulacri* (Bologna: Cappelli, 1980). Cited hereafter as *Società*. English translation in *Ritual Thinking*, trans. Massimo Verdicchio (Amherst, NY: Humanity Books, 2001).

2 Martin Heidegger, *Sein und Zeit*, twelfth edition. (Tübingen: Niemeyer, 1972), 247 (§49). Cited hereafter as *SZ*. Trans. John Macquarrie and Edward Robinson as *Being and Time* (San Francisco: HarperCollins, 1962). The English translations include the German pagination.

3 Jean Baudrillard, *L'échange symbolique et la mort* (Paris: Éditions Gallimard, 1976), 225 n. 1, quoted in *Società*, 3; trans. Iain Hamilton Grant as *Symbolic Exchange and Death* (London: Sage, 1993).

4 This critique of the metaphysics of death has been articulated by existential philosophers, notably by Karl Jaspers. See *Philosophie* (Berlin, Göttingen, and Heidelberg: Springer-Verlag, 1956), Vol. II, 220–9; trans. E. B. Ashton, 3 vols. (Chicago: University of Chicago Press, 1969–71).

5 Jean Baudrillard, *Simulations*, trans. Paul Foss, Paul Patton, and Philip Beitchman (New York: Semiotext(e), Inc., 1983), 1, 146.

6 On the principle of sufficient reason as the "great principle" of metaphysics, see Leibniz, *Principes de la nature et de la grace, fondés en raison*, §7 and *Essais de Théodicée*, §44; trans. Roger Ariew and Daniel Garber as *Philosophical Essays* (Indianapolis: Hackett Publishing Co., 1984).

7 Jean-Paul Sartre, *La nausée* (Paris: Gallimard, 1938), 159.

8 Hegel seems to shatter Perniola's image of metaphysics. Far from denying death by a metaphysical flight from the world, Hegel argues for its rational *necessity* – in nature (e.g., *Enzyklopädie der philosophischen Wissenschaften* [Frankfurt: Suhrkamp, 1970], Vol. II, 537, §376), in human life (e.g., *Phänomenologie des Geistes*, ed. J. Hoffmeister [Hamburg: Meiner, 1952], 144ff.; trans. J. B. Baillie as *The Phenomenology of Mind* [New York: Harper and Row, 1967]), and even in the life of the necessary being itself. See also *Vorlesungen über die Philosophie der Religion*, ed. G. Lasson (Hamburg: Meiner, 1966), Vol. II, 167; trans. R. F. Brown *et al.* as *Lectures on the Philosophy of Religion* (Berkeley: University of California Press, 1988) and *Phänomenologie des Geistes*, 545 (hereafter cited in text as *Phänomenologie*).

9 See Martin Heidegger, "Platons Lehre vom der Wahrheit," in *Wegmarken* (Frankfurt: Klostermann, 1967), 141–2; trans. as *Pathmarks*, ed. William McNeill (New York: Cambridge University Press, 1998).

10 G. W. Leibniz, *Principes de la nature et de la grace*, §7. See also Martin Heidegger, *Introduction to Metaphysics*, trans. Ralph Manheim (New Haven: Yale University Press, 1959); F. W. J. von Schelling, *Sämtliche Werke* (Stuttgart and Augsburg, 1856–61), Vol. II, 3.242.

11 Martin Heidegger, "Nietzsches Wort 'Gott ist tot,'" in *Holzwege* (Frankfurt: Klostermann, 1950), 239; trans. William Lovitt in *The Question Concerning Technology and Other Essays* (New York: Harper and Row, 1977).

12 The case of death can serve here as a useful illustration. On the one hand, if death is an *actual* limit constitutive of *Existenz*, then it must be ontologically "other" than this being's existential, interpretive acts of self-constitution. If it were not, then the "fact" of death would be subject to possible elimination through acts of self-transcendence, and hence not ultimately a *limit* at all. On the other hand, if it were wholly other, then death would not be an *existential* limit, but simply an external "fact" to which such a being would be subject, like all other finite living things, regardless of its projects. But if that were the case, then such a being would not "exist" (*existiert*) in Heidegger's specific sense of the term. Rather, like all other finite living things, it would simply be "present-at-hand" for a determinate span of time.

13 Jean-Paul Sartre, *L'existentialisme est un humanisme* (Paris: Nagel, 1946), 58.

14 *SZ*, 177ff., §38, 252ff., §51.

15 For Heidegger's references to Luther see *SZ*, 10 §3 and 190 n. 1.

16 Seneca, *Ad Lucilium epistulae morales*, 92.3.

17 W. Somerset Maugham, *The Razor's Edge* (Harmondsworth: Penguin, 1963), 186.

18 In this instance, Perniola's language is revealing, since in the standard Italian version of *Sein und Zeit attendere* translates Heidegger's *erwarten*, that is, the ontic term Heidegger himself distinguishes from *vorlaufen*.

CHAPTER 15

A DEADLY GIFT: TO DERRIDA, FROM KIERKEGAARD AND BATAILLE (KENNETH ITZKOWITZ)

1 Jacques Derrida, *The Gift of Death*, trans. David Willis (Chicago: University of Chicago Press, 1995), 60. Hereafter cited as *GD*.

2 Søren Kierkegaard, *Fear and Trembling, and Repetition*, Vol. 6 of *Kierkegaard's Writings*, ed. and trans. Howard and Edna Hong (Princeton: Princeton University Press, 1983), 28.

3 Georges Bataille, "The Jesuve," in *Visions of Excess*, ed. and trans. Alan Stoekl (Minneapolis: University of Minnesota Press, 1985), 73.

4 Georges Bataille, "Sacrificial Mutilation and the Severed Ear of Vincent Van Gogh," in *Visions of Excess*, 67.

5 Georges Bataille, "The Notion of Expenditure," in *Visions of Excess*, 118.

6 Georges Bataille, *Death and Sensuality: A Study of Eroticism and the Taboo*, trans. Mary Dalwood (New York: Ballantine Books, 1962), 166–7.

7 Georges Bataille, *The Accursed Share*, Vol. I, trans. Robert Hurley (New York: Zone Books, 1988–91), 28.

8 Jacques Derrida, "Tympan," in *Margins of Philosophy*, trans. Alan Bass (Chicago: University of Chicago Press, 1982), x.

CHAPTER 16

GLORY IN LEVINAS AND DERRIDA (BETTINA BERGO)

1 For example, "Kenosis," "to empty oneself" (borrowed from Philippians 2:7); see *Otherwise than Being or Beyond Essence*, trans. Alphonso Lingis (Dordrecht: Kluwer Academic Publishers, 1991), chapter V. Cited henceforth as *OB*.

2 Jacques Derrida, *The Gift of Death*, trans. David Willis (Chicago: University of Chicago Press, 1995), 27. Hereafter cited as *GD*.

3 See Maurice Merleau-Ponty, *Phenomenology of Perception*, trans. Colin Smith (London: Routledge and Kegan Paul, 1986).

4 For his discussions of being as "having-to-be" and as carrying on its process of being see

"De la déficience sans souci" [Of Carefree Deficiency] in *De Dieu qui vient à l'idée* (Paris: Vrin, 1986), 81; see "Dieu et la Philosophie," in the same collection. Trans. Bettina Bergo as *Of God Who Comes to Mind* (Stanford: Stanford University Press, 1998), 45–6, 55–78.

5 See Emmanuel Levinas, "De la lecture juive des écritures," in *L'Au-delà du verset* (Paris: Minuit, 1982), 125–42.

6 Levinas rarely himself uses the term "secret," he speaks of the "ambiguity" or the "enigma" of transcendence in immanence or of revelation (*OB*, 156ff.). But he also insists that "The refusal that the infinity opposes to assembling by reminiscence does *not* come to pass in the form of a veiling" because "the unknowable would still refer to a present, would form a structure in it, would belong to order" (*OB*, 154).

7 Levinas' sources are Isaiah, Ezekiel, the first Book of Samuel, and the Book of Job.

8 For the parallelism and the tension of intent between Levinas' "book" and Jewish Biblical interpretation see *OB*, 141 and Catherine Chalier, "L'Utopie messianique," in *Répondre d'autrui Emmanuel Levinas*, ed. Jean-Christophe Aeschlimann (Neuchâtel: Éditions de la Bacconière, 1989), 53–71.

9 In *Difficile Liberté* he writes, "The ethical relation is prior to the opposition of liberties," but it does not exclude these altogether. He adds, "my freedom [before the other] is discovered as arbitrary": in *Essais sur le Judaïsme* (Paris: Albin Michel, 1976), 34, 32; trans. Seán Hand as *Difficult Freedom: Essays on Judaism* (Baltimore: Johns Hopkins University Press, 1990).

10 Cf. M. Idel: "because he concentrates more upon action than upon thought, the Jew is responsible for everything, including God, since his activity is crucial for the welfare of the cosmos in general": "Kabbalistic Theurgy" in *Kabbalah: New Perspectives* (New Haven: Yale University Press, 1988), 179, emphasis added. Compare this with Levinas' remarks in "De la lecture juive des écritures" in *L'Au-delà du verset*, 141–2; and his "*Lecture Talmudique sur la justice*," in *Cahier de l'Herne. Levinas*, eds. M. Abensour and C. Chalier (Paris: Éditions de l'Herne, 1991), 104.

11 See Jan Patocka, *Essais hérétiques sur la philosophie de l'histoire*, French translation by E. Abrams (Lagrasse: Verdier, 1981); English translation by Erazim Kohák (Chicago: Open Court, 1996).

12 André Néher, "*Ezéchiel* 33, 30–33: Un paroxysme du psychodrame prophétique," in *Textes pour Emmanuel Levinas*, ed. François Laruelle (Paris: Éditions Jean-Michel Place, 1980), 74 (my translation).

13 Néher and Moreno do *not* permit it, even as they write of God's entry into the drama. Levinas will follow a similar path: "[Transcendence] needs the diachrony that . . . does not succeed in assembling the time of modern humanity, in turn passing from prophecy to philology and transcending philology toward prophetic signification" (152).

14 *Essais hérétiques*, 105–27.

15 See *GD*, 40 where Derrida begins to describe these moments as "conversions."

16 Later, he *appears* to be taking this deduction as his own by describing it as the act of a first person plural "subject": "We have thus deduced the possibility of a mortal's accession to responsibility through the experience of his irreplaceability, that which an approaching death . . . gives him" (*GD*, 51).

17 Derrida asks, "On what condition is responsibility possible?" and answers in a Patockan vein, "On the condition that the Good no longer be a transcendental objective . . . but the relation to the other, a response to the other; an experience of personal goodness and a movement of intention" (51).

18 Like Abraham's "duty to hate" what he most loves so that he may sacrifice it? (See *GD*, 64–5.)

19 Quoted from Charles Baudelaire, "The Pagan School," in *Baudelaire as Literary Critic*, eds. and trans. Lois Boe Hyslop and Francis E. Hyslop (University Park: Pennsylvania State University Press, 1964).

20 Friedrich Nietzsche, *The Genealogy of Morals*, Vol. 13 of *The Complete Works of Friedrich Nietzsche*, ed. Oscar Levy (New York: Gordon Press, 1974), 70; cited in *GD*, 113.

21 Friedrich Nietzsche, *Beyond Good and Evil: Prelude to a Philosophy of the Future*, trans. Walter Kaufmann (New York: Random House, 1966), §250 in "Peoples and Fatherlands," 185; translation modified following Josef Simon. For the original German see *Jenseits von Gut und Böse*, "Völker und Vaterländer," in the *Kritische Studienausgabe* eds. Giorgio Colli and Mazzino Montimari (Berlin: de Gruyter, 1987), Vol. 5, 192.

22 Paul Celan, "Mit den Sackgassen," in *Schneepart* in *Gesammelte Werke*, Vol. II (Frankfurt/ Main: Suhrkamp, 1986), 358; trans. Katherine Washburn and Margret Guillemin, in *Last Poems. Paul Celan* (San Francisco: North Point Press, 1986), 118–19.

BIBLIOGRAPHY

Adcock, Craig. *Marcel Duchamp's Notes from The Large Glass: An N-Dimensional Analysis*. Ann Arbor: UMI Research Press, 1983.

Adorno, Theodor. *Aesthetic Theory*. Translated by C. Lenhardt. New York: Routledge & Kegan Paul, 1984.

——*Negative Dialectics*. Translated by E. B. Ashton. New York: Continuum, 1973.

Agamben, Giorgio. *Language and Death*. Minneapolis: University of Minnesota Press, 1991.

Allison, David, ed. *The New Nietzsche*. Cambridge, MA: MIT Press, 1985.

Althusser, Louis. *Sur la philosophie*. Paris: Gallimard, 1994.

Arendt, Hannah. *Between Past and Future: Eight Exercises in Political Thought*. London: Faber and Faber, 1961. Reprint, New York: Harcourt Brace Jovanovich, 1968.

——*Essays in Understanding, 1930–1954: Uncollected and Unpublished Works by Hannah Arendt*. Edited by Jerome Kohn. New York: Harcourt Brace, 1994.

——*The Human Condition*. Chicago: University of Chicago Press, 1958; Garden City: Double-day Anchor, 1959.

——*The Life of the Mind*. 2 vols. New York: Harcourt Brace Jovanovich, 1977.

——*Men in Dark Times*. New York: Harcourt Brace Jovanovich, 1968.

——*On Revolution*. New York: Viking, 1963. Reprint, Harmondsworth: Penguin, 1979.

——*The Origins of Totalitarianism*. Second enlarged edition. New York: Harcourt Brace Jovanovich, 1951.

——"Philosophy and Politics." *Social Research* 57, no. 1, Spring 1990, 73–103.

——*Rahel Varnhagen: The Life of a Jewish Woman*. Translated by Richard and Clara Winston. New York: Harcourt Brace Jovanovich, 1974.

——*Vita activa oder Vom tätigen Leben*. Stuttgart: Kohlhammer, 1960.

——"What Is Existenz Philosophy?" *Partisan Review* 13, no. 1, 1946, 34–56.

Aristotle. *Minor Works*. Translated by W. S. Hett. 1936. Reprint, Cambridge, MA: Harvard University Press, 1993.

——*The Physics*. Translated by Philip H. Wicksteed and Francis M. Cornford. 1929. Reprint, Cambridge, MA: Harvard University Press, 1980.

Aristotle, Horace, Longinus: Classical Literary Criticism. Translated by T. S. Dorsch. New York: Penguin Books, 1965.

Ashbaugh, Anne F. *Plato's Theory of Explanation: A Study of the Cosmological Account in the Timaeus*. Albany: SUNY Press, 1988.

Ashbery, John. *Three Poems*. New York: Viking, 1972.

Ashcroft, Bill, *et al.*, eds. *The Post-colonial Studies Reader*. London: Routledge, 1995.

Baker, Peter. *Deconstruction and the Ethical Turn*. Gainesville: Florida University Press, 1995.

Balibar, Étienne. "Spinoza: From Individuality to Transindividuality," typescript of lecture delivered in Rijnsburg, May 15, 1993.

——"Spinoza, the Anti-Orwell: The Fear of the Masses." In *Masses. Classes. Ideas*. New York: Routledge, 1994.

Ballard, J. G. *Crash*. 1973. Reprint, New York: Noonday Press, 1994.

——"Introduction to *Crash*" [1974]. Edited by V. Vale and Andrea Juno. San Francisco: Re/Search Publications, 1984.

Barash, Jeffrey. "The Political Dimension of the Public World: On Hannah Arendt's Interpret-ation of Martin Heidegger." In *Hannah Arendt: Twenty Years Later*. Edited by Larry May and Jerome Kohn. Cambridge, MA: MIT Press, 1996.

Barthes, Roland. *Le plaisir du texte*. Paris: Seuil, 1973. Translated by Richard Miller as *The Pleasure of the Text*. New York: Hill and Wang, 1975.

——*Roland Barthes*. Paris: Seuil, 1975.

——*Incidents*. Paris: Seuil, 1987.

Bartlett, Richard H. *The Mabo Decision*. Sydney: Butterworths, 1993.

Bataille, Georges. *The Accursed Share*. Translated by Robert Hurley. New York: Zone Books, 1988–91.

——*Death and Sensuality: A Study of Eroticism and the Taboo*. Translated by Mary Dalwood. New York: Ballantine Books, 1962.

——*Inner Experience*. Translated by Leslie Anne Boldt. Albany: SUNY Press, 1988.

——*Literature and Evil*. Translated by Alastair Hamilton. London: Calder & Boyars, 1973.

——*Visions of Excess: Selected Writings, 1927–1939*. Edited and translated by Alan Stoekl. Minneapolis: University of Minnesota Press, 1985.

Battcock, Gregory, ed. *Minimal Art: A Critical Anthology*. New York: Dutton, 1969.

Baudrillard, Jean. "Ballard's *Crash*." *Science-Fiction Studies* 18, pt. 3, November 1991, 313–20.

——*L'échange symbolique et la mort*. Paris: Gallimard, 1976. Translated by Iain Hamilton Grant as *Symbolic Exchange and Death*. London: Sage; 1993.

——*Simulations*. Translated by Paul Foss, Paul Patton, and Philip Beitchman. New York: Semiotext(e), 1983.

Beckett, Samuel. *Company*. New York: Grove, 1980.

——*Fizzles*. New York: Grove, 1976.

——*Proust, and Three Dialogues*. London: John Calder, 1965.

Benhabib, Seyla. *The Reluctant Modernism of Hannah Arendt*. Thousand Oaks: Sage, 1996.

Benjamin, Walter. *Understanding Brecht*. London: Verso, 1973.

——"The Work of Art in the Age of Mechanical Reproduction." 1936. In *Illuminations*. Edited by Hannah Arendt and translated by Harry Zohn. New York: Schocken Books, 1978.

Birot, Pierre-Albert. *SIC*. Paris: J. M. Place, 1993.

Blanchot, Maurice. *The Infinite Conversation*. Translated by Susan Hanson. Minneapolis: University of Minnesota Press, 1993.

——*Le livre à venir*. Paris: Gallimard, 1959.

——*The Space of Literature*. Translated by Ann Smock. Lincoln: University of Nebraska Press, 1982.

——*Writing of the Disaster*. Translated by Ann Smock. Lincoln: University of Nebraska Press, 1995.

Bloc Notes. Paris, 1993–98.

Bonney, William W. *Thorns and Arabesques: Contexts for Conrad's Fiction*. Baltimore: The Johns Hopkins University Press, 1980.

Bourdieu, Pierre. *The Political Ontology of Martin Heidegger*. Translated by Peter Collier. Stanford: Stanford University Press, 1991.

Breton, André. *Mad Love*. Translated by Mary Ann Caws. Lincoln: University of Nebraska Press, 1987.

——*Nadja*. Translated by Richard Howard. New York: Grove Press, 1960.

——*Oeuvres complètes*. 2 vols. Edited by Marguerite Bonnet, P. Bernier, E.-A. Hubert, and J. Pierre. Paris: Gallimard, 1988 and 1992.

——*Surrealism and Painting*. Translated by Simon Watson Taylor. New York: Harper and Row, 1972.

Brisson, Luc. *Le Même et l'Autre dans la structure ontologique du Timée de Platon: Un commentaire systématique du Timée de Platon*. 1974. Reprint, Sankt Augustin: Academia Verlag, 1994.

Bulfinch, Thomas. *Bulfinch's Mythology*. New York: Avenel Books, 1979.

Bürger, Peter. *Theory of the Avant-Garde*. Translated by Michael Shaw. Manchester: Manchester University Press, 1984.

Burnet, John, ed. *Platonis Opera*. 1902. Reprint, Oxford: Oxford University Press, 1984.

Burnham, Jack. *The Great Western Salt Works: Essays on the Meaning of Postformalist Art*. New York: George Braziller, 1974.

Butler, Judith. *Bodies That Matter: On the Discursive Limits of "Sex."* New York: Routledge, 1993.

Cabanne, Pierre. *Dialogues with Marcel Duchamp*. Translated by Ron Padgett. New York: Da Capo Press, 1987.

Calvesi, Maurizio. *Duchamp invisibile – La construzione del simbolo*. Rome: Officina Edizioni, 1975.

Canovan, Margaret. *Hannah Arendt: A Reinterpretation of Her Political Thought*. Cambridge, UK: Cambridge University Press, 1992.

——ed. *Literature and the Question of Philosophy*. Baltimore: The Johns Hopkins University Press, 1987.

Casey, Edward S. *The Fate of Place*. Berkeley: University of California Press, 1997.

Celan, Paul. *Last Poems. Paul Celan*. Edited by Katherine Washburn and Margret Guillemin. San Francisco: North Point Press, 1986.

——"Mit den Sackgassen," in *Schneepart* in *Gesammelte Werke*, Vol. II. Frankfurt/Main: Suhrkamp, 1986.

Chalier, Catherine. "L'Utopie messianique." In *Répondre d'autrui Emmanuel Levinas*. Edited by Jean-Christophe Aeschlimann. Neuchâtel: Éditions de la Bacconière, 1989.

Chantraine, Pierre. *Dictionnaire étymologique de la langue grecque: Histoire des mots*. Paris: Klincksieck, 1984.

Chave, Anna. "Minimalism and the Rhetoric of Power." *Arts Magazine* 64, January 1990, 44–63.

Clair, Jean. *Marcel Duchamp, ou, Le Grand Fictif: Essai de mythanalyse du "Grand Verre."* Paris: Galilee, 1975.

Clifford, Hugh, C.M.G. "The Genius of Joseph Conrad." In *Joseph Conrad: Third World Perspectives*. Edited by Robert Hamner. Washington, D.C.: Three Continents, 1990.

Cohen, Carl, ed. *Communism, Fascism, and Democracy*. New York: Random House, 1962.

Conrad, Joseph. *Heart of Darkness*. 1899. New York: St. Martin's, 1989.

Cornell, Drucilla. *The Philosophy of the Limit*. New York: Routledge, 1992.

Cornford, Francis M. *Plato's Cosmology: The Timaeus of Plato Translated with a Running Commentary*, 1937. Reprint, London: Routledge, 1966.

Creeley, Robert. *The Collected Poems of Robert Creeley, 1945–1975*. Berkeley: University of California Press, 1982.

Croce, Benedetto. *Ce qui est vivant et ce qui est mort de la philosophie de Hegel*. Translated by Henri Buriot. Paris: Giard et Brière, 1910. Translated by Douglas Ainslie as *What Is Living and What Is Dead of the Philosophy of Hegel*. Lanham, MD: University Press of America, 1985.

——*Aesthetic*. Translated by Douglas Ainslie. New York: Farrar, Straus and Giroux, 1969.

Csicsery-Ronay, Jr., Istvan. "Editorial Introduction: Postmodernism's SF/SF's Postmodernism." *Science-Fiction Studies* 18, pt. 3, November 1991, 305–8.

Dadoun, Roger. "Rrose Sschize: Sschize d'un portrait théorie de Marcel Duchamp en Jésus sec célibataire." *L'Arc*, no. 59, 1974, 25.

Danner, Mark. "Guardian Angels." *The New Yorker*, November 25, 1996.

——*The Transfiguration of the Commonplace*. Cambridge, MA: Harvard University Press, 1981.

Davies, Paul. "The work and the absence of work." In *Maurice Blanchot: The Demand of Writing*. Edited by Carolyn Bailey Gill. London: Routledge, 1996.

de Beauvoir, Simone. "From *The Second Sex*." In *Existentialism*. Edited by Robert C. Solomon. New York: The Modern Library, 1974.

de Botton, Alain. *How Proust Can Change Your Life*. New York: Pantheon Books, 1997.

de Duve, Thierry. "The Readymade and the Tube of Paint." *Artforum* 24, no. 9, May 1986, 115.

——"Le Temps du ready-made." In *Marcel Duchamp: Abécédaire: Approches critiques*. Paris: Centre national d'art et de culture Georges Pompidou, 1977.

Deleuze, Gilles. *Différence et répétition*. Paris: Presses Universitaires de France, 1968. Translated by Paul Patton. New York: Columbia University Press, 1994.

——*Expressionism in Philosophy*. Translated by Martin Joughin. New York: Zone Books, 1990.

——*Francis Bacon. Logique de la sensation*. [Paris:] Éditions de la différence, 1984.

——*Negotiations 1972–1990*. Translated by Martin Joughin. New York: Columbia University Press, 1995.

——*Nietzsche and Philosophy*. Translated by Hugh Tomlinson. New York: Columbia University Press, 1983.

——*Pourparlers 1972–1990*. Paris: Éditions de Minuit, 1990.

Deleuze, Gilles. *Proust and Signs*. Translated by Richard Howard. New York: George Braziller, 1972.

——*Spinoza: Practical Philosophy*. Translated by Martin Joughin. New York: Zone Books, 1992.

Deleuze, Gilles and Félix Guattari. *Anti-Oedipus: Capitalism and Schizophrenia*. Translated by Robert Hurley, Mark Seem, and Helen R. Lane. Minneapolis: University of Minnesota Press, 1983.

——*A Thousand Plateaus*. Translated by Brian Massumi. Minneapolis: University of Minnesota Press, 1987.

Demske, James. *Being, Man and Death*. Lexington: University of Kentucky Press, 1970.

Derrida, Jacques. "Avances." Introduction to *Le tombeau du dieu artisan*, by Serge Margel. Paris: Les Éditions de Minuit, 1995.

——*Dissemination*. Translated by Barbara Johnson. Chicago: University of Chicago Press, 1981.

——"'Eating Well', or the Calculation of the Subject: An Interview with Jacques Derrida." Translated by Peter Connor and Avital Ronnell. In *Who Comes After the Subject?* Edited by Eduardo Cadava, Peter Connor, and Jean-Luc Nancy. New York: Routledge, 1991.

——"Economimesis." *Diacritics* 11, no. 2, 1981, 55–93.

——*The Gift of Death*. Translated by David Willis. Chicago: University of Chicago Press, 1995.

——*Margins of Philosophy*. Translated by Alan Bass. Chicago: University of Chicago Press, 1982.

——*Of Grammatology*. Translated by Gayatri Chakravorty Spivak. Baltimore: The Johns Hopkins University Press, 1976.

——*On the Name*. Edited by Thomas Dutoit. Stanford: Stanford University Press, 1995.

——*La verité en peinture*. Paris: Flammarion, 1978. Translated by Geoff Bennington and Ian McLeod as *Truth in Painting*. Chicago: University of Chicago Press, 1987.

——*Writing and Difference*. Translated by Alan Bass. Chicago: University of Chicago Press, 1978.

Descombes, Vincent. *Modern French Philosophy*. Translated by L. Scott-Fox and J. M. Harding. Cambridge, UK: Cambridge University Press, 1980.

d'Harnoncourt, Anne and Kynaston McShine, eds. *Marcel Duchamp*. New York: Museum of Modern Art, 1973.

Dilthey, Wilhelm. *Die drei Epochen der modernen Aesthetik und ihre heutige Aufgabe* (1892). Vol. 6 of *Gesammelte Schriften*. Stuttgart and Göttingen, 1961.

Duchamp, Marcel. *Marcel Duchamp, Notes*. Edited and translated by Paul Matisse. Boston: J. K. Hall, 1983.

——*Salt Seller: The Writings of Marcel Duchamp*. Edited and translated by Michel Sanouillet and Elmer Peterson. New York: Oxford University Press, 1973.

Eagleton, Terry. *Ideology: An Introduction*. London: Verso, 1991.

Ellis, Bret Easton. *American Psycho*. New York: Vintage Press, 1991.

Ellroy, James. *My Dark Places*. New York: Random House, 1996.

Ettinger, Elzbieta. *Hannah Arendt/Martin Heidegger. Eine Geschichte*, "aus dem Amerikanischen von Brigitte Stein." Munich and Zürich: Piper, 1994. Translated by Ettinger. New Haven: Yale University Press, 1995.

Fanon, Frantz. *Black Skin White Masks*. Translated by Charles Lamm Markmann. New York: Grove Weidenfeld, 1967.

Festugière, A. J. *Proclus, Commentaire sur le Timée*. Vol. 1. Paris: Vrin, 1966.

Friedländer, Paul. *Plato*. Translated by Hans Meyerhoff. Princeton: Princeton University Press, 1969.

Gasché, Rodolphe. "The Felicities of Paradox: Blanchot on the Null-space of Literature." In *Maurice Blanchot: The Demand of Writing*. Edited by Carolyn Bailey Gill. New York: Routledge, 1996, 34–69.

Gatens, Moira and Genevieve Lloyd. *Collective Imaginings: Spinoza and an Ethics of Difference*. London: Routledge, 1999.

Girard, René. *Violence and the Sacred*. Translated by Patrick Gregory. Baltimore: The Johns Hopkins University Press, 1977.

Gombrich, Ernst. *Art and Illusion*. New York: Pantheon, 1960.

Goodman, Nelson. *The Languages of Art*. Indianapolis: Hackett, 1976.

——*Ways of Worldmaking*. Indianapolis: Hackett, 1978.

Gottsegen, Michael G. *The Political Thought of Hannah Arendt*. Albany: SUNY Press, 1994.

Graver, Lionel and Raymond Federman, eds. *Samuel Beckett: The Critical Heritage*. London: Routledge and Kegan Paul, 1979.

Greenberg, Clement. *Art and Culture*. London: Thames and Hudson, 1973.

——"Counter-Avant-Garde." *Art International* 15, no. 5. Reprinted in *Marcel Duchamp in Perspective*. Edited by Joseph Masheck. Englewood Cliffs, N.J.: Prentice Hall, 1975.

Grosz, Elizabeth A. *Space, Time and Perversion: Essays on the Politics of Bodies*. New York: Routledge, 1995.

Halliburton, David. *The Fateful Discourse of Worldly Things*. Stanford: Stanford University Press, 1997.

——*Poetic Thinking: An Approach to Heidegger*. Chicago: University of Chicago Press, 1981.

Hamner, Robert, ed. *Joseph Conrad: Third World Perspectives*. Washington, D.C: Three Continents, 1990.

Harris, Wilson. *Explorations: A Selection of Talks and Articles, 1966–1981*. Edited with introduction by Hena-Maes Jelinek. Mundelstrup: Dangaroo Press, 1981.

——*The Four Banks of the River of Space*. London: Faber & Faber, 1990.

——*The Palace of the Peacock*. London: Faber & Faber, 1960.

Harrison, Charles and Paul Wood, eds. *Art in Theory, 1900–1990*. Oxford: Blackwell, 1992.

Haskell, Barbara. *Agnes Martin*. New York: Whitney Museum of Modern Art, 1994.

Hayles, N. Katherine. "The Borders of Madness." *Science-Fiction Studies* 18, pt. 3, November 1991, 321-2.

Hegel, G. W. F. *Enzyklopädie der philosophischen Wissenschaften*. Edited by Eva Moldenhauer and Karl Markus Michel. Frankfurt: Suhrkamp, 1970.

——*Hegel: Selections*. Edited by M. J. Inwood. New York: Macmillan, 1989.

——*Phänomenologie des Geistes* Edited by J. Hoffmeister. Hamburg: Meiner, 1952. Translated by J. B. Baillie as *The Phenomenology of Mind*. New York: Harper and Row, 1967. Translated by A. V. Miller as *Phenomenology of Spirit*. New York: Oxford, 1977.

——*La philosophie de la nature de Hegel*. 2 vols. Translated and annotated by Augusto Véra. Paris: Ladrange, 1863–66. Translated from the German by A. V. Miller as *Hegel's Philosophy of Nature*. Oxford: Clarendon Press, 1970.

——*Vorlesungen über die Philosophie der Religion*. Edited by G. Lasson. Hamburg: Meiner, 1966. Translated by R. F. Brown *et al.* as *Lectures on the Philosophy of Religion*. Berkeley: University of California Press, 1988.

Heidegger, Martin. *Basic Writings*. Edited by David Farrell Krell. San Francisco: HarperCollins, 1993.

——*The Fundamental Concepts of Metaphysics*. Translated by William McNeill and Nicholas Walker. Bloomington: Indiana University Press, 1995.

——"Ground Concepts of Aristotelian Philosophy." Marburg lecture course of summer semester 1924, 134-page typescript by Herbert Marcuse. From the transcript of Walter Bröcker. The Marcuse Archive, University of Frankfurt Library.

——*History of the Concept of Time*. Translated by Theodore Kisiel. Bloomington: Indiana University Press, 1985.

——*Introduction to Metaphysics*. Translated by Ralph Manheim. New Haven: Yale University Press, 1959.

——Lecture course. University of Marburg. Summer semester, 1925.

——Lecture courses. University of Marburg. Winter semester, 1924–25, 1925–26.

——"Messkirch: Seventh Centennial." Translated by Thomas J. Sheehan. *Listening*. 8, 1993: 40-57.

——"Nietzsches Wort 'Gott ist tot.'" In *Holzwege*. Frankfurt: Klostermann, 1950. Translated by William Lovitt in *The Question Concerning Technology and Other Essays*. New York: Harper and Row, 1977.

——*Platon: Sophistes*. Frankfurt: Klostermann, 1992. Translated by Richard Rojcewicz and André Schuwer. Bloomington: Indiana University Press, 1997.

Heidegger, Martin. "Platons Lehre vom der Wahrheit." In *Wegmarken*. Frankfurt: Klostermann, 1967. Translated as *Pathmarks*. Edited by William McNeill. New York: Cambridge University Press, 1998.

——*Poetry, Language, Thought*. Translated by Albert Hofstadter. New York: Harper & Row, 1971.

——*Sein und Zeit*. Tübingen: Niemeyer, 1972. Translated by John Macquarrie and Edward Robinson as *Being and Time*. San Francisco: HarperCollins, 1962. Translated by Joan Stambaugh. Albany: SUNY Press, 1996.

Held, René. "Marcel Duchamp: L'imposteur malgré lui, ou le Grand Canular et la surréalité." In *L'oeil du psychanalyste. Surréalisme et surréalité*. Paris: Payot, 1973.

Helter Skelter. Museum of Contemporary Art of Los Angeles, 1992. *Documenta* 9. Kassel, 1992.

Horkheimer, Max and Theodor W. Adorno. *The Dialectic of Enlightenment*. New York: Seabury, 1972.

Hors limites. L'art et la vie. Paris: Centre national d'art et de culture Georges Pompidou, 1994.

Husserl, Edmund. *The Crisis of European Sciences and Transcendental Phenomenology*. Translated with introduction by David Carr. Evanston: Northwestern University Press, 1970.

——*Ideas: General Introduction to Pure Phenomenology*. Translated by W. R. Boyce Gibson. 1938. Reprint, New York: Collins, 1962.

Hyslop, Lois Boe and Francis E. Hyslop, eds. *Baudelaire as Literary Critic*. University Park: Pennsylvania State University Press, 1964.

Idel, M. "Kabbalistic Theurgy." In *Kabbalah: New Perspectives*. New Haven: Yale University Press, 1988.

Irigaray, Luce. *An Ethics of Sexual Difference*. Translated by Carolyn Burke and Gillian C. Gill. Ithaca: Cornell University Press, 1993.

——*Speculum of the Other Woman*. Translated by Gillian C. Gill. Ithaca: Cornell University Press, 1985.

——*This Sex Which Is Not One*. Translated by Catherine Porter with Carolyn Burke. Ithaca: Cornell University Press, 1985.

Jarczyk, Gwendoline and Pierre-Jean Labarrière. *De Kojève à Hegel: 150 ans de pensée hégélienne en France*. Paris: Albin Michel, 1996.

Jaspers, Karl. *Philosophie*. Berlin, Göttingen, and Heidelberg: Springer-Verlag, 1956. Translated by E. B. Ashton. 3 vols. Chicago: University of Chicago Press, 1969–71.

Jauss, Hans Robert. *Literaturgeschichte als Provokation*. Frankfurt: Suhrkamp, 1970. Translated by Timothy Bahti as "Literary History as a Challenge to Literary Theory," in *Toward an Aesthetics of Reception*. Minneapolis: University of Minnesota Press, 1982.

Jowett, Benjamin, trans. *The Dialogues of Plato*. 1892. Reprint, New York: Random House, 1937.

Joyce, James. *Ulysses*. Edited by Jeri Johnson. Oxford: Oxford University Press, 1993.

Judd, Donald. "Some Aspects of Color in General, and Red and Black in Particular." *Artforum* 70, Summer 1994, 70–114.

Judovitz, Dalia. "Dada Cinema: At the Limits of Modernity." *Art & Text* 34, Spring 1989, 46–63.

——*Unpacking Duchamp: Art in Transit*. Berkeley: University of California Press, 1995.

Kierkegaard, Søren. *Fear and Trembling*. In *Fear and Trembling, and Repetition*. Edited and translated by Howard and Edna Hong. Princeton: Princeton University Press, 1983.

Kisiel, Theodore. *The Genesis of Heidegger's "Being and Time."* Berkeley: The University of California Press, 1993.

——"Heidegger's *Gesamtausgabe*: An International Scandal of Scholarship." *Philosophy Today* 39, 1995, 3–15.

Kristeva, Julia. *Language: The Unknown: An Initiation into Linguistics*. New York: Columbia University Press, 1989.

——*Pouvoir de l'horreur. Essai sur l'abjection*. Paris: Seuil, 1980. Translated by Leon S. Roudiez as *Powers of Horror: An Essay on Abjection*. New York: Columbia University Press, 1982.

——*Proust and the Sense of Time*. Translated by Steven Bann. New York: Columbia University Press, 1993.

Kristeva, Julia. *Revolution in Poetic Language*. Translated by Leon S. Roudiez. New York: Columbia University Press, 1984.

——*Time and Sense: Proust and the Experience of Literature*. Translated by Ross Guberman. New York: Columbia University Press, 1996.

Kuhn, Reinhard. *The Demon of Noontide: Ennui in Western Literature*. Princeton: Princeton University Press, 1976.

Lacan, Jacques. *The Four Fundamental Concepts of Psycho-Analysis*. Translated by Alan Sheridan and edited by Jacques-Alain Miller. New York: Norton, 1978.

——*Écrits: A Selection*. Translated by Alan Sheridan. New York: Norton, 1977.

——*The Ethics of Psychoanalysis 1959–1960*. Translated by Dennis Porter and edited by Jacques-Alain Miller. New York: Norton, 1997.

Lacoue-Labarthe, Philippe and Jean-Luc Nancy. "The Nazi Myth." Translated by Brian Holmes. *Critical Inquiry*, Winter 1990.

Langton, Marcia. *Well, I heard it on the radio and I saw it on the television*. Woolloomooloo, Sydney: Australian Film Commission, 1993.

Lautréamont, comte de. *Oeuvres complètes d'Isidore Ducasse*. Paris: Livre de Poche, 1963.

Le Doeuff, Michèle. *The Philosophical Imaginary*. London: Athlone Press, 1989.

Leibniz, G. W. *Principes de la nature et de la grace, fondés en raison*, and *Essais de Théodicée*. In *Philosophische Schriften*. Edited by Hans Heinz Holz. Darmstadt: Wissenschaftliche Buchgesellschaft, 1985. Vols. I and II/i. Translated by Roger Ariew and Daniel Garber as *Philosophical Essays*. Indianapolis: Hackett Publishing Co., 1984.

Levin, Charles. *Jean Baudrillard: A Study of Cultural Metaphysics*. New York: Prentice-Hall, 1996.

Levinas, Emmanuel. *L'Au-delà du verset*. Paris: Minuit, 1982.

——*Collected Philosophical Papers*. Translated by Alphonso Lingis. Boston: Kluwer, 1993.

——*Difficile Liberté: Essais sur le Judaïsme*. Paris: Albin Michel, 1976. Translated by Seán Hand as *Difficult Freedom: Essays on Judaism*. Baltimore: Johns Hopkins University Press, 1990.

——*De Dieu qui vient à l'idée*. Paris: Vrin, 1986. Translated by Bettina Bergo as *Of God Who Comes to Mind*. Stanford: Stanford University Press, 1998.

——*Ethics and Infinity*. Translated by Richard A. Cohen. Pittsburgh: Duquesne University Press, 1985.

——*"Lecture Talmudique sur la justice."* In *Cahier de l'Herne. Levinas*. Edited by M. Abensour and C. Chalier. Paris: Éditions de l'Herne, 1991.

——*Otherwise than Being or Beyond Essence*. Translated by Alphonso Lingis. Dordrecht: Kluwer Academic Publishers, 1991.

——*Totality and Infinity*. Translated by Alphonso Lingis. Pittsburgh: Duquesne University Press, 1969.

Libertson, Joseph. *Proximity: Levinas, Blanchot, Bataille and Communication*. The Hague: Martinus Nijhoff, 1982.

Lloyd, Genevieve. "Individuals, Responsibility and the Philosophical Imagination." In *Feminist Perspectives on Autonomy*. Edited by Catriona Mackenzie and Natalie Stoljar. Oxford: Oxford University Press, 1998.

Löwith, Karl. *Martin Heidegger and European Nihilism*. Edited by Richard Wolin. New York: Columbia University Press, 1995.

Lukács, Georg. *Wider den missverstandenen Realismus*. Hamburg: Claasen, 1958. Translated by John and Necke Mander as *The Meaning of Contemporary Realism*. London: Merlin Press, 1963.

Macri, T. *Il corpo postorganico. Sconfinamenti dell performance*. Genoa: Costa & Nolan, 1996.

Maillard, Jean. *Louise de Néant, ou Le Triomphe de la pauvreté et des humiliations*. [1732.] Paris: J. Millon, 1987.

Margel, Serge. *Le tombeau du dieu artisan*. Paris: Éditions de Minuit, 1995.

Masheck, Joseph, ed. *Marcel Duchamp in Perspective*. Englewood Cliffs, N.J.: Prentice-Hall, 1975.

Mattéi, Jean-François. *Platon et le miroir du mythe: De l'âge d'or à L'Atlantide*. Paris: Presses Universitaires de France, 1996.

Maugham, W. Somerset. *The Razor's Edge*. Harmondsworth: Penguin, 1963.

McEvilley, Thomas. "Grey Geese Descending: The Art of Agnes Martin." *Artforum* 25, Summer 1987.

McLuhan, Marshall. *Understanding Media: The Extensions of Man.* 1964. Reprint, New York: New American Library.

Merleau-Ponty, Maurice. *Phenomenology of Perception.* Translated by Colin Smith. London: Routledge and Kegan Paul, 1986.

——*The Visible and the Invisible.* Translated by Alphonso Lingis. Evanston, Illinois: Northwestern University Press, 1968.

Miyoshi, Masao. "A Borderless World?" *Critical Inquiry* 18, Summer 1993, 21–36.

Mohr, Richard D. *The Platonic Cosmology.* Leiden: E. J. Brill, 1985.

Morris-Suzuki, Tessa. "Collective Memory, Collective Forgetting: Indigenous People and the Nation State in Japan and Australia." *Meanjin* 53, no. 4, 1994.

Nancy, Jean-Luc. *The Inoperative Community.* Translated by Peter Connor *et al.* Minneapolis: University of Minnesota Press, 1991.

Negri, Antonio. *The Savage Anomaly: The Power of Spinoza's Metaphysics and Politics.* Minneapolis: University of Minnesota Press, 1991.

Néher, André. "*Ezéchiel* 33, 30–33: Un paroxysme du psychodrame prophétique." In *Textes pour Emmanuel Levinas.* Edited by François Laruelle. Paris: Éditions Jean-Michel Place, 1980.

Nicholls, Peter. *Modernisms: A Literary Guide.* Berkeley: University of California Press, 1995.

Nietzsche, Friedrich. *Beyond Good and Evil: Prelude to a Philosophy of the Future.* Translated by Walter Kaufmann. New York: Random House, 1966.

——*The Birth of Tragedy.* Translated by Walter Kaufmann. New York: Random House, 1967.

——*The Genealogy of Morals.* Vol. 13 of *The Complete Works of Friedrich Nietzsche.* Edited by Oscar Levy. New York: Gordon Press, 1974.

——*Jenseits von Gut und Böse.* Vol. V of *Kritische Studienausgabe.* Edited by Giorgio Colli and Mazzino Montimari. Berlin: de Gruyter, 1987.

Onuf, Nicholas Greenwood. "Sovereignty: Outline of a Conceptual History," *Alternatives* 16, no. 1, 1991, 425–45.

Papenfuss, Dietrich and Otto Pöggeler, eds. *Zur philosophischen Aktualität Heideggers.* Vol. 2: *Im Gespräch der Zeit.* Frankfurt: Klostermann, 1990.

——"Edition und Übersetzung: Unterwegs von Tatsachen zu Gedanken, von Werken zu Wegen." In *Zur philosophischen Aktualität Heideggers.* Vol. 3: *Im Spiegel der Welt: Sprache, Übersetzung, Auseinandersetzung.* Frankfurt: Klostermann, 1992.

Paradeau, Jean-François. "Être quelque part, occuper une place. Τόπος et χώρα dans le Timée." *Les Études philosophiques* 3, July–September 1995, 375–99.

Patocka, Jan. *Essais hérétiques sur la philosophie de l'histoire.* French translation by E. Abrams. Lagrasse: Verdier, 1981. *Heretical Essays in the Philosophy of History.* English translation by Erazim Kohák. Chicago: Open Court, 1996.

Paz, Octavio. *Marcel Duchamp: Appearance Stripped Bare.* Translated by Rachel Phillips. New York: The Viking Press, 1978.

Pearson, Noel. "The Concept of Native Title at Common Law." In *Our Land Is Our Life: Land Rights – Past, Present, Future.* Edited by Galarrwuy Yunupingu. St. Lucia, Queensland: University of Queensland Press, 1997.

Perniola, Mario. "The Art Is Getting Slippery." Interview by John O'Brian. *World Art* 1, 1996.

——*Enigmas: The Egyptian Moment in Society and Culture.* Translated by Christopher Woodall. New York: Verso, 1995.

——*Estetica del Novecento.* Bologna: Il Mulino, 1997.

——*Il sex appeal dell'inorganico.* Turin: Einaudi, 1996.

——*La società dei simulacri.* Bologna: Cappelli, 1980. English translation in *Ritual Thinking.* Translated by Massimo Verdicchio. Amherst, NY: Humanity Books, 2001.

——"Towards Visual Philosophy." *Estetica News* 20–21, May–December 1994, 1–4.

Plotnisky, Arkady. *In the Shadow of Hegel.* Gainesville: University Press of Florida, 1993.

Posthuman. Turin: Castello di Rivoli, 1992.

Pound, Ezra. *Guide to Kulchur.* New York: New Directions, 1968.

Proust, Marcel. *Jean Santeuil.* Edited by Pierre Clarac. Paris: Pléiade, 1971.

——*La prisonnière.* Paris: Éditions folio, 1985.

———*Remembrance of Things Past.* 3 vols. Translated by C. K. Scott Moncrieff, Terence Kilmartin, Andreas Mayor. New York: Vintage, 1981.

Rabaté, Jean-Michel. *The Ghosts of Modernity.* Gainesville: University Press of Florida, 1996.

Reynolds, Henry. *Aboriginal Sovereignty.* Sydney: Allen & Unwin, 1995.

Ricoeur, Paul. *Être, essence et substance chez Platon et Aristote.* Paris: Société d'enseignement supérieur, 1982.

Robert, Bernard-Paul. *Antécédents du Surréalisme.* Ottawa: Presses de l'Université d'Ottawa, 1988.

Robinson, Gillian and John Rundell. *Rethinking Imagination: Culture and Creativity.* London: Routledge, 1994.

Rodley, Chris, ed. *Cronenberg on Cronenberg.* London: Faber and Faber, 1997.

Ropars-Wuilleumier, Marie-Claire. "On unworking: the image in writing according to Blanchot." Translated by Roland-François Lack. In *Maurice Blanchot: The Demand of Writing.* Edited by Carolyn Bailey Gill. London: Routledge, 1996.

Rose, Gillian. "Potter's Field: death worked and unworked." In *Maurice Blanchot: The Demand of Writing.* Edited by Carolyn Bailey Gill. London: Routledge, 1996.

Rubkin, William. *Frank Stella.* New York: Museum of Modern Art, 1970.

Rugoff, Ralph. "The Atrocity Exhibitionist." *LA Weekly,* 21–27 March 1997, 32–3.

Rushdie, Salman. "Crash." *The New Yorker,* September 15, 1997, 68–9.

Sartre, Jean Paul. *La nausée.* Paris: Gallimard, 1938. Translated by Lloyd Alexander. New York: New Directions Publishing Corp., 1969.

———*L'existentialisme est un humanisme.* Paris: Nagel, 1946.

Schelling, F. W. J. *Sämtliche Werke.* Edited by K. F. A. von Schelling. Stuttgart and Augsburg, 1856–61.

Schmitt, Carl. *The Concept of the Political.* Translated by George Schwob. Chicago: University of Chicago Press, 1996.

Schor, Naomi. "This Essentialism Which Is Not One: Coming to Grips with Irigaray." In *Engaging with Irigaray: Feminist Philosophy and Modern European Thought.* Edited by Carolyn Burke, Naomi Schor, and Margaret Whitford. New York: Columbia University Press, 1994.

Schreber, Daniel Paul. *Denkwürdigkeiten eines Nervenkranken.* Leipzig, 1903. Translated by Ida Macalpine and Richard A. Hunter as *Memoirs of My Nervous Illness.* London: W. Dawson, 1955.

Schwarz, Arturo. *The Complete Works of Marcel Duchamp.* New York: Harry N. Abrams, 1970.

Seneca. *Ad Lucilium epistulae morales.* Edited by L. D. Reynolds. Oxford: Oxford University Press, 1977.

Sextus Empiricus. *Against the Logicians.* Translated by R. G. Bury. 1935. Reprint, Cambridge, MA: Harvard University Press, 1983.

Shohat, Ella. "Notes on the 'Post-Colonial.'" *Social Text* nos. 31/32, 1992, 98–108.

Sobchack, Vivian. "Baudrillard's Obscenity." *Science-Fiction Studies* 18, pt. 3, November 1991, 327–9.

Spacks, Patricia Meyer. *Boredom: The Literary History of a State of Mind.* Chicago: University of Chicago Press, 1995.

Spinoza, Benedict. *The Collected Works of Spinoza.* Edited and translated by Edwin Curley. Princeton: Princeton University Press, 1985.

———*A Political Treatise.* Translated by R. H. M. Elwes. New York: Dover, 1951.

Spivak, Gayatri Chakravorty. *In Other Worlds: Essays in Cultural Politics.* New York: Methuen, 1987.

Springer, Claudia. *Electronic Eros: Bodies and Desire in the Postindustrial Age.* Austin: University of Texas Press, 1996.

Taminiaux, Jacques. *The Thracian Maid and the Professional Thinker: Arendt and Heidegger.* Translated and edited by Michael Gendre. Albany: SUNY Press, 1998.

Taylor, A. E. *A Commentary on Plato's Timaeus.* 1928. Reprint, New York: Garland, 1987.

Tomkins, Calvin. *The Bride and the Bachelors.* New York: Viking Press, 1965.

Villa, Dana. *Arendt and Heidegger: The Fate of the Political.* Princeton: Princeton University Press, 1996.

Virus. Trimestrale delle mutazioni. Milan, 1993–98.

Waite, Robert G. L. *Adolf Hitler: The Psychopathic God*. New York: Basic Books, 1977.

Walker, R. B. J. *Inside/Outside: International Relations as Political Theory*. Cambridge, UK: Cambridge University Press, 1993.

Williams, Robert A., Jr. *The American Indian in Western Legal Thought*. New York: Oxford University Press, 1990.

Wills, Garry. "Dostoyevsky Behind a Camera." *The Atlantic Monthly*, July 1997, 96–101.

Wittgenstein, Ludwig. *Culture and Value*. Translated by Peter Winch. Oxford: Oxford University Press, 1980.

——*On Certainty*. Edited by G. E. M. Anscombe and Georg von Wright. New York: Harper and Row, 1972.

——*Philosophical Investigations*. Translated by G. E. M. Anscombe. New York: Macmillan, 1958.

Wollheim, Richard. *Painting as an Art*. Princeton: Princeton University Press, 1987.

Young-Bruehl, Elisabeth. *Hannah Arendt: For Love of the World*. New Haven: Yale University Press, 1982.

INDEX

References in **bold** indicate the major discussion of the entry.

CONTRIBUTORS

Bettina Bergo, a fellow at Harvard University's Radcliffe Institute for Advanced Study (2000–2001), teaches philosophy at Duquesne University. She is the author of *Levinas Between Ethics and Justice* (Kluwer, 1998), translator of Levinas, *Of God Who Comes To Mind* (Stanford, 1998), *Of 'God, Death, and Time'* (Stanford, 2000), *Evasion: On Escape* (Stanford 2002). She is presently writing on the history of anxiety in psychoanalysis and philosophy.

Joel Black teaches comparative literature and film at the University of Georgia. He is the author of *The Reality Effect: Film Culture and the Graphic Imperative* (2002) and *The Aesthetics of Murder: A Study of Romantic Literature and Contemporary Culture* (Johns Hopkins, 1991) as well as numerous articles. Currently, he is currently working on a study of Oscar Wilde's aesthetic legacy.

Robert Burch is Associate Professor of Philosophy and Graduate Studies Coordinator in the Department of Philosophy at the University of Alberta. His publications are in the areas of Phenomenology, Philosophy of Technology, and Philosophy and Literature. He is editor (with Massimo Verdicchio) of *Between Philosophy and Poetry*, also appearing in this Continuum Textures series.

Michael Clifford is Associate Professor of Philosophy in the Department of Philosophy and Religion at Mississippi State University. He recently published a book on modern political idenity, *Political Genealogy After Foucault: Savage Identities.*

Moira Gatens teaches philosophy at the University of Sydney and has held visiting appointments at the University of Massachusetts, Boston; The University of Waikato, New Zealand; and Australian National University. Her extensive publications include *Feminism and Philosophy: Perspectives on Difference and Equality* (Indiana, 1991), *Imaginary Bodies* (Routledge, 1996), and *Collective Imaginings: Spinoza and the Ethics of Difference* (with Genevieve Lloyd).

David Halliburton is Professor of English, Comparative Literature, and Modern Thought and Literature at Stanford University. His publications include *Edgar Allan Poe: A Phenomenological View* (Princeton, 1973), *Poetic Thinking: An Approach to Heidegger* (Chicago, 1981), *The Color of Sky: A Study of Stephen Crane* (Cambridge, 1989) and *The Fateful Discourse of Worldly Things* (Stanford, 1997).

Kenneth Itzkowitz has written on the themes of otherness and difference, and on related issues of ethical responsibility and moral values, in the works of Bataille, Kierkegaard, and Derrida. He received his Ph.D. from the State University of New York at Stony Brook in 1987 and is currently Associate Professor of Philosophy and Director of the Honors Program at Marietta College in Ohio.

Dalia Judovitz is Professor of French in the Department of French and Italian at Emory University. She is the author of *Subjectivity and Representation in*

Descartes: The Origins of Modernity (Cambridge, 1988), *Unpacking Duchamp: Art in Transit* (California, 1995) and co-editor of *Dialectic and Narrative* (1993). She is completing a new book entitled *Endgame Strategies: Duchampian Legacies*.

Theodore Kisiel is Presidential Research Professor of Philosophy at Northern Illinois University. He has written extensively in hermeneutic phenomenology, philosophy of science, and twentieth-century continental philosophy. His most recent books are *The Genesis of Heidegger's "Being and Time"* (California, 1995) and *Reading Heidegger from the Start*, (SUNY, 1994), and *Heidegger's Way of Thought: Critical and Interpretative Signposts* (Continuum, 2002).

Pierre Lamarche, Assistant Professor of Philosophy at Utah Valley State College, has published articles on Pyrrhonian Scepticism, and on intersections in the work of Jacques Derrida and Sarah Kofman, and on the aesthetics of Heidegger and Benjamin. He is author of the forthcoming "Ontology of Boredom."

Alfred López is Assistant Professor of English at The University of Mississippi. He is author of *Posts and Pasts: A Theory of Postcolonialism* (SUNY 2001) and editor of the forthcoming collection *Postcolonial Whiteness: A Critical Reader*.

Paul Patton is Professor of Philosophy at The University of New South Wales. He has translated works by Foucault, Deleuze and Baudrillard and edited *Nietzsche, Feminism and Political Theory*, (Routledge, 1993) and *Deleuze: A Critical Reader* (Blackwell, 1996) and is co-editor of *Political Theory and the Rights of Indigenous Peoples* (Cambridge, 2000). His most recent book is *Deleuze and the Political* (Routledge, 2000).

Mario Perniola is Professor of Aesthetics and former Director of the Department of Philosophical Research at the University of Rome. He also serves as director of the review *AGALMA*. Among more than a dozen books on aesthetics and contemporary culture, his works in English translation include *Enigmas: The Egyptian Moment in Society and Art* (Verso, 1995) and *Ritual Thinking: Sexuality, Death, World* (Humanity Books, 2001).

Jean-Michel Rabaté, Professor of English at the University of Pennsylvania, has published books on Joyce, Pound, Beckett, Bernhard, Barthes, literary theory and esthetics, most recently *Lacan in America* (edited, The Other Press, 2000), *James Joyce and the Politics of Egoism* (Cambridge, 2001), *Jacques Lacan and the Subject of Literature* (Palgrave, 2001) and *The Future of Theory* (Blackwell, 2002). He is editor of the forthcoming *Cambridge Companion to Jacques Lacan* (Cambridge, 2003).

Max Statkiewicz is Assistant Professor of Comparative Literature at the University of Wisconsin-Madison. He has published articles on ancient and modern quarrels between philosophy and theater from Plato and Aristotle to Artaud, Brecht, Althusser, and Derrida.

Peter Williams has taught at Monash University in Australia, and is currently a Research Associate in the Department of English at the University of Sidney where he is completing a book on literary minimalism. His publications are in twentieth-century literature, the visual arts, and aesthetics.

EDITORS

James E. Swearingen is a retired Professor of English. He taught and chaired departments at Loyola University, New Orleans; Marquette University; and The University of South Alabama. He is author of *Reflexivity in Tristram Shandy* (Yale) and has published on an array of figures in eighteenth-century studies, and philosophy and literature, including John Dryden, Jonathan Swift, Thomas Gray, Laurence Sterne, Hans-Georg Gadamer, and William Blake.

Joanne Cutting-Gray is author of *Woman as "Nobody" in the Novels of Fanny Burney* and has published on various figures in eighteenth-century studies, feminism, and American literature, especially Hannah Arendt, Benjamin Franklin, and (with James Swearingen) Alexander Pope, and James Fenimore Cooper.

The editors currently reside in Savannah, Georgia.